NIKON

A CELEBRATION

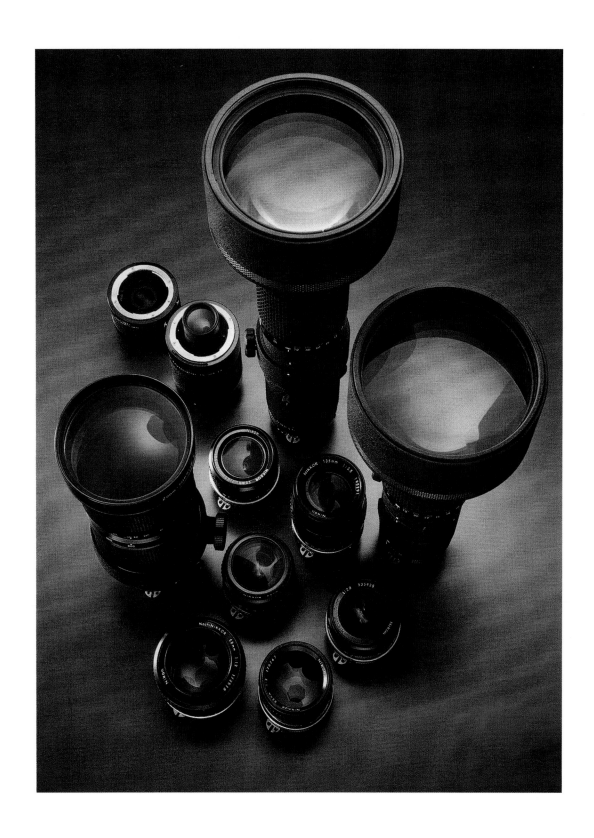

日 本 光 学 工 業 株 式 会 社

NIKON
A CELEBRATION

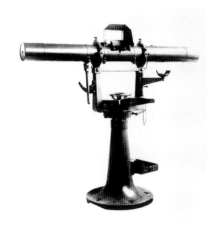

BRIAN LONG

THE CROWOOD PRESS

First published in 2006 by
The Crowood Press Ltd
Ramsbury, Marlborough
Wiltshire SN8 2HR

www.crowood.com

British Library Cataloguing-in-Publication Data
A catalogue record for this book is available from the British Library.

ISBN 1 86126 831 9
EAN 978 1 86126 831 0

Typefaces used: Stone Sans (main text); Frutiger (captions and head-
ings); Rotis Sans Serif (running heads).

Typeset and designed by
D & N Publishing
Lambourn Woodlands, Hungerford, Berkshire.

Printed and bound in Singapore by Craft Print International.

ACKNOWLEDGEMENTS

I'VE NOW WRITTEN MORE than forty motoring books over the last two decades, usually concentrating on the history of individual models. I've also done company histories that have included fields outside the automotive realm, but this is my first book on cameras. As such it would simply not have been possible to complete this project without the help and support of many people.

Special mention must be made of Kazuhiko Mitsumoto (professional photographer, motoring journalist, TV personality, and all-round good guy), who put me in touch with Nikon, and as such put his enviable reputation on the line for me. Another good friend of mine, Yoshihiko Matsuo (designer of the Datsun 240Z and a real old camera buff), has followed the project closely, not to mention the staff at my favourite camera shops – Sanai Camera in central Chiba, and Ohba Camera in Shimbashi, Tokyo.

I've even managed to inspire people who weren't really into cameras as we've talked about the project – former car engineers catching the bug in much the same way as I did many years ago (sorry, Koby!) – even to the point of suggesting we need more general awareness of what Nikon has achieved from a technical angle.

As you can imagine, the pressure to deliver the goods is therefore every bit as overwhelming as it is with one of my motoring titles. In this regard, I am so lucky to have Kenichi Magariyama as my contact at Nikon head office. Now in charge of the Web Communication section, Magariyama-san is a former camera designer who dearly loves to promote the Nikon brand.

While most of the advertising has come from either my collection or that of my stepfather in the States, Ken Hoyle, virtually everything else has been sourced through Nikon in Japan. For this, both I – and you, the reader! – have to thank Mikio 'Mickey' Itoh for going to great lengths to satisfy my many requests for photographic material and to fill in the gaps in my information. Itoh-san is a former optical measuring instrument engineer who now looks after Nikon's archives. His enthusiasm is what has made this book into something I can be proud of, and I only hope that he, Magariyama-san *et al.* will also be pleased with the results.

Without the help of my wife, Miho, it would have been almost impossible to relay the Japanese side of the story. Between us, we've gone through more than 10,000 pages of reference material! One day I must get around to thanking her properly for all the translation work she's done for me, as well as making contact with the good people at the JCII Camera Museum & Library (in particular, Shinji Miyazaki and Yoshio Inokuchi), Ei Mook and Bungei Shunju, along with ace photographer Bunyo Ishikawa.

BRIAN LONG
Chiba City, Japan

A 1968 advert that seems to sum up everything.

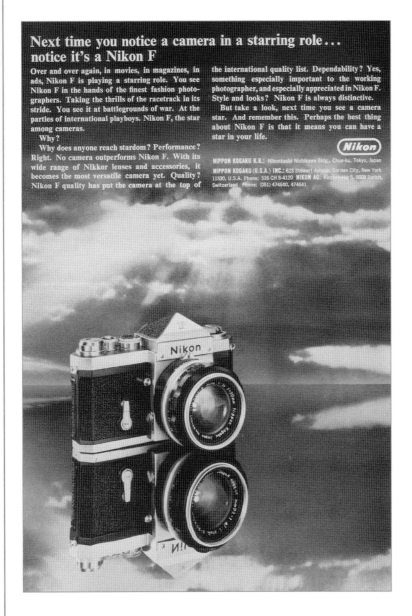

Next time you notice a camera in a starring role... notice it's a Nikon F

Over and over again, in movies, in magazines, in ads, Nikon F is playing a starring role. You see Nikon F in the hands of the finest fashion photographers. Taking the thrills of the racetrack in its stride. You see it at battlegrounds of war. At the parties of international playboys. Nikon F, the star among cameras.

Why?

Why does anyone reach stardom? Performance? Right. No camera outperforms Nikon F. With its wide range of Nikkor lenses and accessories, it becomes the most versatile camera yet. Quality? Nikon F quality has put the camera at the top of the international quality list. Dependability? Yes, something especially important to the working photographer, and especially appreciated in Nikon F. Style and looks? Nikon F is always distinctive.

But take a look, next time you see a camera star. And remember this. Perhaps the best thing about Nikon F is that it means you can have a star in your life.

Nikon

NIPPON KOGAKU K.K.: Nihonbashi Nishikawa Bldg., Chuo-ku, Tokyo, Japan
NIPPON KOGAKU (U.S.A.) INC.: 623 Stewart Avenue, Garden City, New York 11530, U.S.A. Phone: 516 CH 8-4120 NIKON AG: Kirchenweg 5, 8008 Zurich, Switzerland Phone: (051) 474640, 474641

INTRODUCTION

AS A TEENAGER, PHOTOGRAPHY was one of my main hobbies. In my younger days, armed only with a screw-mount Praktica, I'd dream of owning an F3, and the F4 simply blew my mind when it came out. Unfortunately work soon consumed much of my life, and the opportunities to take pictures – other than those related to my job – became fewer and fewer as the years rolled by. The fascination with photography, however, remained as strong as ever and, now working with the Nikon system, I found myself being drawn to the beauty of the cameras and lenses rather than the act of taking shots, which, in reality, I was never that good at anyway. Coming from an engineering background, I could appreciate the dedication and skill that went into these miniature sculptures: my love of the Nikon brand stems from this appreciation.

It took me a long while to buy my first F4, but, during my time in Japan and the gradual shift from user to user/collector, it has been augmented by about thirty more Nikons, all but one of them (the D100 for everyday use) older than the F4, and many of them older than me! I keep telling my poor wife that cameras are really living things, and they breed when no-one is looking. Of course, she just assumes I'm crazier than she originally thought, but how else can you explain how they keep mysteriously appearing in the house at such regular intervals?

At the same time, Nikkor lenses have gradually filled my cabinets. After my first batch of film was developed using these fabulous masterpieces, there was to be no turning back – the quality of the Japanese-made Nikkor is simply beyond reproach.

As well as enjoying the modern zooms for work, I'm constantly amazed by the function and beauty of the brass screw-mount 13.5cm Nikkor I have attached to my pre-war Leica – this combination looks and feels as good today as it did more than half a century ago. And it never ceases to impress me that the early 5cm lens seems to weigh almost as much as the Nikon S it is mounted on!

I'm very lucky to be surrounded by so many like-minded friends in Japan. Members of the RJC (the Researchers' & Journalists' Conference of Japan) and JAHFA (the Japan Automotive Hall of Fame), two organizations with which I'm heavily involved, are often obsessed not only with cars, but also share my enthusiasm for old cameras and mechanical watches. Most of these guys, however, were using Nikons for a living before I was born, and I'm looking forward to the day when my collection will equal that of some of my esteemed colleagues.

I hope this book is a reflection of why so many of my friends and I love and respect the Nikon brand. I will try to present a picture of what makes it special in a format that will inspire you, and make you want to thumb through the pages, not just to learn technical specifications, but to wallow in the photographs and wonderful adverts from Nikon's earliest days to the present.

This publication does not include any tips on how to get the best from each camera or lens – there are plenty of good books on the market that already cover this aspect, written by people far better qualified than me – but it does include the company's history, the way its products have developed over the years, and all the little details that tend to absorb collectors.

The logo used on Nippon Kogaku's very early letterheads.

The symbol used on the company flag, designed in 1930.

The official Nippon Kogaku logo, circa 1930.

The logo adopted just after the birth of the Nikon camera.

NIPPON KOGAKU K. K.

日 本 光 学 工 業 株 式 会 社

LEFT: The English and Japanese typeface styles used from May 1954.

The revised company logo, widely adopted from 1962.

An alternative logo to the 1962 version, used from July 1967.

NIKON CORPORATION

株式会社 ニコン

LEFT: The English and Japanese typeface styles registered in 1987 but used from April 1988, plus the new company logo introduced at the same time.

INTERNATIONAL EXCHANGE RATES

YEAR	USA $1–	UK £1–	GERMAN DM1–	FRENCH FF1–	EEC EURO1–	SWISS SF1–
1950	360	1000	85	90	–	85
1955	360	1000	85	85	–	85
1960	360	1000	85	75	–	85
1965	360	1000	85	75	–	85
1970	360	865	85	65	–	85
1975	270	620	100	65	–	100
1980	220	485	110	50	–	120
1985	240	290	80	25	–	95
1990	140	270	90	25	–	110
1995	100	150	60	20	–	75
2000	110	165	–	–	105	65
2005	105	205	–	–	140	90

This table shows spot rates for selected years, with the approximate amount of Japanese yen (¥) each specified currency would buy during any given year. This overview will help put much of the text and details in the appendices into perspective.

THE EARLY DAYS

JAPAN HAD BEEN LARGELY isolated from the outside world until the American commander, Commodore Matthew C. Perry, first sighted the Land of the Rising Sun from his 'black ships' in 1853. Perry's visit, basically one to demand trading rights, coincided with the people's wish to see an end to the feudal society that had existed in Japan for more than 600 years. The days of rule by the sword were numbered, and the brief war of 1868 (known as the Meiji Restoration) finally put an end to the Tokugawa regime.

For several years before the Meiji Restoration, however, cities open to business with the West were few and far between, including only Yokohama (close to where Perry first dropped anchor), Kobe, Hakodate, Niigata and Nagasaki, the oldest trading post of the Edo era (1600–1868). If one goes today to the northern port of Hakodate, which escaped the heavy bombing Japan suffered during the Second World War, one can see an eclectic mix of architecture from around the world, providing the visitor with a glimpse into the past when this great nation first felt foreign influence.

Mutsuhito, or Emperor Meiji, was only fifteen years old when he took up the role of head of state in Edo (later renamed Tokyo) following the death of his father a year earlier, becoming the 122nd emperor. The Meiji era (1868–1912) brought about a new dawn and, as time passed, a far greater willingness to deal with and adopt the ways of the West. Emperor Meiji built up a particularly good relationship with Britain and other parts of Europe, helping Japan to model its railways and roads, its postal system and growing navy on that of the UK. Grand, European-style buildings sprang up in the business quarters of the major cities, with Western clothing gradually replacing traditional Japanese attire in the country's bustling city streets as the nineteenth century came to a close.

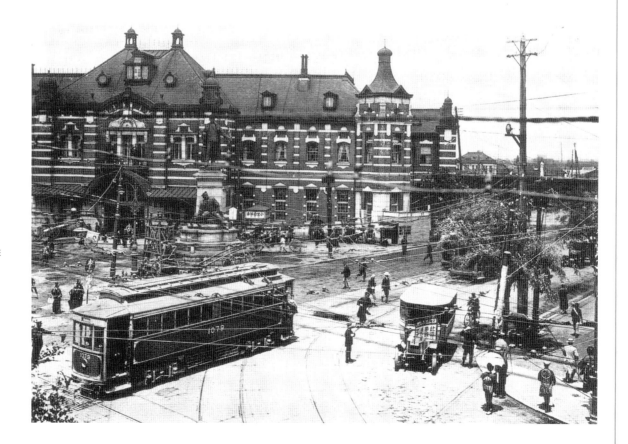

This interesting Tokyo street scene from before the Great Kanto Earthquake shows the European influence on Japanese life brought about by the Meiji Restoration. COURTESY NATIONAL SCIENCE MUSEUM, TOKYO

It was an exciting era of change and growth, but, unfortunately, Emperor Meiji fell ill at the start of 1912 and died that July. His son, Yoshihito, was duly sworn in as Emperor Taisho. Europe, which provided Japan with a great deal of trade and also supplied it with the majority of its industrial and military requirements, however, was about to be plunged into turmoil.

The First World War – a Catalyst

The Russo-Japanese war of 1904–5 had been fought and won by Japan with British-built ships and armaments, German and French binoculars, and, notably, English rangefinders. European countries were quick to realize that modern warfare called for good optical equipment – after all, firing one shell on target is far more effective than firing 10,000 if they all miss!

During the years following its victory over Russia, the Imperial Japanese Navy grew in strength, but, despite the fact that Japan had been studying the production of optical equipment since 1892 (such as microscopes, cameras and surveying instruments), virtually all of its military technology continued to be bought in from abroad.

This situation was all well and good until the First World War brought an abrupt halt to supplies from Europe. When Germany and her supporters first clashed with the Allied forces in the summer of 1914, military exports stopped almost overnight. Indeed, most of Europe's trade with the Far East was suspended, as domestic considerations were given priority in countries with which Japan was in league, and Germany became the enemy on 23 August 1914.

This unexpected development in Europe speeded up Japan's resolve to produce its own military equipment. In fact, several high-ranking officers had been saying that Japan needed its own optical industry for some years before the First World War. One of the key visionaries to preach the importance of becoming self-sufficient in this area was a naval officer named Akira Ando, who approached the Tokyo Imperial University in 1906 to study mathematics and physics with a view to furthering lens technology. His later role as an armaments inspector only strengthened his views regarding the need for domestic expertise.

With the help of Tokyo Keiki Co. and Fujii Lens, Ando successfully made a pair of rangefinders to his original designs in 1913. By this time a few small Japanese companies were commercially producing microscopes and camera obscura (traditional camera bodies). Although high-quality camera lenses and shutters were still beyond the ability of these pioneering concerns, the seeds for an optical industry had definitely been sown.

When the time came to equip Japan's latest battleship, *Haruna*, with its telescope and rangefinders, Britain was at war and the order could not be fulfilled. The Navy therefore approached Fujii Lens regarding the telescope on the main armament, and Tokyo Keiki for the 1.5m and 4.5m rangefinders. While the 1.5m item was duly produced in 1915, the larger rangefinder proved too difficult to make with such limited experience. Ando's worst fears had been confirmed, but Japan took the initiative to send two naval engineers to Britain to learn as much as possible about rangefinder technology.

Meanwhile, the First World War brought a great deal of business the way of Japan's fledgling optical firms, as the UK, France and Russia ordered items such as field binoculars from their Japanese ally.

Ando, now a Rear Admiral, was Japan's naval attaché in England during the war. He learnt that a Fujii Lens representative was in America, exhibiting binoculars at the exposition held to celebrate the opening of the Panama Canal, and requested a meeting in London to obtain a number of military contracts with the Allies. Various French prisms and other items were procured from the British government, and a deal signed and sealed.

The problems only really started when supplies of optical glass (originally ordered from Germany) dried up, and shipments from other European countries could not get through, largely due to submarine attacks. Fujii Lens was therefore forced into recycling old instrument lenses and developing flint glass with Tokyo Denki – the forerunner of Toshiba.

In the background, Iwaki Glass was in the process of producing optical lenses by 1914. The company, today recognized as one of Japan's foremost spectacle glassmakers, had been founded in 1883 and manufactured all manner of household glassware; it also supplied industrial products as and when required, and was held in high regard by the Japanese Navy for its large mirrors.

The Imperial Navy itself commissioned the Tokyo Kogyo Institute of Technology to look into the process of manufacturing lenses, but, after a number of unsuccessful attempts at producing suitable glass, this line of research did not provide anything worthwhile until February 1918. Ironically, the Imperial Army had already perfected the art of making lenses by 1915, and after a joint conference between officers of both forces, the technology was duly handed over to the naval authorities, who were later charged with developing the nation's military optics.

The Birth of Nippon Kogaku

In 1916 the Imperial Navy approached Mitsubishi with a view to building a submarine to combat the threat from German U-boats. A key problem, however, was how to secure a suitable periscope, as Japan's allies were already overstretched with their own domestic demands. This situation ultimately led to the formation of a Japanese company that could produce military optics, with Mitsubishi at the helm.

The rise of Mitsubishi was truly staggering. Founded in 1873, the Mitsubishi concern was born out of a small shipping company established by Yataro Iwasaki three years earlier. By the turn of the century, having gained state backing on the lucrative Yokohama–Shanghai route, Iwasaki was, without doubt, the most powerful shipping magnate in the whole of Japan. He was also clever: instead of using profits to buy more ships to augment the forty he already had in his fleet, he diversified. Mitsubishi duly secured large swathes of land, and bought into mining, railways, ironworks, chemicals and a number of financial institutions.

With Yataro's nephew, Koyata Iwasaki, now in the President's office, Mitsubishi continued to blossom. A Cambridge graduate who became head

of the business empire (or *zaibatsu*) in July 1916, he encouraged Mitsubishi to build its first car (introduced in 1917, and based on the contemporary Fiat); the company was already producing ocean-going craft the equal of anything in the world at the time, and would later also turn its hand to the manufacture of aircraft.

With regard to the optics business, Koyata Iwasaki took advice from a number of sources and approached Tokyo Keiki, Iwaki Glass and Fujii Lens to propose the foundation of a joint-company. Tokyo Keiki and Iwaki Glass were happy to join Mitsubishi on this project, readily separating the related departments to start this new venture, but the Fujii brothers were fearful that this move would spell the end of Fujii Lens's existence.

On 25 July 1917 Nippon Kogaku Kogyo KK – or Japan Optical Manufacturing Co. Limited – was formed with a capital of ¥2 million. Registered in the Koishikawa district of Tokyo, initially, three of the nine directors were from Mitsubishi (holding 20,010 of the 40,000 shares available) and six were chosen from Tokyo Keiki; the first President was Yoshikatsu Wada, the long-serving head of the latter firm.

By the following month Nippon Kogaku had taken over the optical instrument department at Tokyo Keiki and the industrial mirror section at

The Nippon Kogaku works at Oimachi, pictured here in 1921.

The machine shop at Oimachi.

Iwaki Glass, enabling business to begin with the existing workforce. At the same time a factory was duly secured at Oimachi (pronounced *oh-e-ma-che*) to the west of downtown Tokyo, covering a total of more than 17,000 square metres. It was an ideal site, with a recently built railway station serving a number of small manufacturing plants in the area, a good source of water readily available, and solid bedrock on which to build.

In December, three months after Koyata Iwasaki joined the Board as a named Director, the new concern started laying the foundations for a merger with Fujii Lens (then making about 150 telescopes and 1,000 sets of binoculars a month). It was brought into the Nippon Kogaku fold in early 1918, by which time the first phase of building at Oimachi had been completed.

Further investment from Mitsubishi took Nippon Kogaku's capital up to ¥30 million by the summer of 1918, but events in Europe were about to change immediate requirements and the pace of lens development once more. On 11 November 1918 the armistice was signed, bringing an end to four years of warfare.

The Treaty of Versailles that was validated seven months later brought about an opportunity for German technicians to work in Japan, and vice versa. Fujii engineers duly went to Germany (as well as to Italy, France, England and America) and actually negotiated a possible merger with Carl Zeiss. This deal eventually fell through, but, having placed advertisements in various newspapers, they returned to Japan with eight German specialist workers, including the famous Max Lange, and a great deal of machinery.

The Post-War Years

Even though war had ended in Europe, Nippon Kogaku still had a number of ongoing military contracts to fulfil. Rangefinders, telescopes, periscopes, binoculars and searchlight mirrors continued to be produced for the Imperial Navy, along with vast quantities of binoculars for export.

There were quality issues with the rangefinders, however, and there were still problems with making good optical glass. For a time the latter was imported from Germany, although a furnace and glass-testing department set up in a new, second factory at the Oimachi site (augmenting the original Nippon Kogaku works and the Fujii plant at Shiba in Tokyo) brought domestic production a step closer to reality.

Nippon Kogaku continued to grow, with excellent testing facilities and new factories springing up to allow the company to keep pace with orders. The future looked bright, too, with Japan planning a massive new fleet of battleships with no expense spared. Indeed, Japan's defence budget accounted for 49 per cent of its annual spending at this time, against 23 per cent for the USA and Britain.

As expected, Nippon Kogaku received the order and budget for rangefinders, but it was later cancelled after Japan signed up to the Washington Disarmament Conference in 1921. Altogether the Imperial Navy was to lose 244 vessels. While this setback involved no loss of money for the company, it was nonetheless a major disappointment, leaving many hands idle, and the grand project would doubtless have furthered technology.

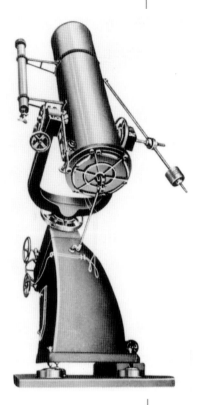

ABOVE: **This impressive 508mm (20in) telescope was built for the 1922 Tokyo Peace Memorial Expo, held in Ueno Park.**

The company flag, designed by a Nippon Kogaku worker in 1930. There was also a company anthem released by Columbia Records.

LENS TYPES SUGGESTED FOR PRODUCTION BY HEINRICH ACHT			
TYPE	ELEMENTS/GROUPS	APERTURE	FOCAL LENGTH
Anytar	4 in 3	4.5	7.5cm
			10.5cm
			12cm
			15cm
			18cm
Doppel Anastigmat	6 in 2	6.8	7.5cm
			10.5cm
			12cm
			15cm
			18cm
Dialyt Anastigmat	4 in 4	4.5	12cm
		6.3	7.5cm
			10.5cm
			12cm
Flieger Objektiv	3 in 3	4.8	50cm
		5.4	50cm
Porträt Objektiv	3 in 3	3.0	24cm
		3.5	30cm
Projektions Objektiv	6 in 2	2.0	7.5cm

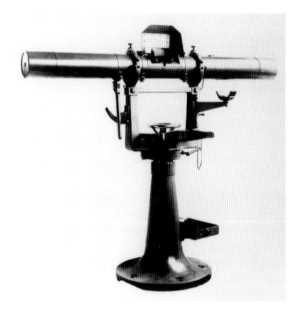

A Type 14 1.5m rangefinder, introduced in 1925.

There was another disaster in the early 1920s, but this time a natural one – the Great Kanto Earthquake of September 1923, the biggest in Japan's history. Tokyo and the surrounding area were completely devastated. Tens of thousands were killed, and virtually all the infrastructure around Tokyo Bay, where the country's population is concentrated, was laid to waste. The Nippon Kogaku factory was extremely lucky to escape serious damage and none of the workers was injured, although the rebuilding process and a general lack of food and water closed the plant for seventeen days when the business could ill afford any more bad luck. Sales fell to one half of 1922 levels, yet there were still wages to pay, as well as loans for foreign equipment and consultancy fees. These were indeed hard times.

Fortunately, the Japanese government and military leaders could see the worth of the optical industry and stepped in to save the company, passing on all existing programmes to Nippon Kogaku. There was a major reshuffle in the top management, including the resignation of the Fujii brothers in April 1924. The Army's optical research facility, destroyed in the earthquake, was merged with that of Nippon Kogaku. With a series of new orders and a more streamlined operation (including the sale of some land and the retention of just one German technician, Heinrich Acht), the firm's survival was secured, and the number of employees jumped from 600 in 1923 to 900 two years later.

By this time Nippon Kogaku was augmenting its income by producing shell casings for the military, and also accepted orders for optics for civilian use, such as camera lenses and microscopes, which like other scientific instruments were often sold under the Joico brand name in the early days. The company's debts were eventually cleared and, in the background, with the Japanese government becoming more and more nationalistic, the future once again looked bright for the men at Nippon Kogaku.

Nikkor Lenses

Nippon Kogaku's lens technology was significantly advanced following the arrival of German technicians in Japan after the Great War, both from a design and manufacturing point of view.

Heinrich Acht, a microscope specialist when he was in Germany, was instrumental in the development of Nippon Kogaku's camera lenses. Acht gathered together and analysed as many existing lenses as possible, compiling a handwritten database of all their technical details and optical performance. This information was then used as the starting point for the engineers in Japan and provided the foundation stone for the legendary Nikkor lenses.

Through Acht's research, which went some way towards justifying the fact that he was drawing the same wage as Nippon Kogaku's President and every day was driven by a chauffeur to and from a specially built guest house, several types of lens were put forward for production (*see table, above*).

With Acht's reference manual, scripted in Japanese, Kakuya Sunayama took over Acht's work following his departure in February 1928. Sunayama continued to study the lenses of the famous European houses, bringing back a Tessar f/4.5 and Triplet f/5 from a research mission abroad.

In 1929 Acht's theories and calculations were put to the test when the Japanese military requested a batch of lenses for aerial photography. The Flieger Objektiv details were refined, but the end result was not satisfactory. Ultimately a design based on the Triplet (with a slightly smaller element on one side of the centre lens, instead of two the same size forming the sandwich) proved to be much more successful, and the order for 50cm f/4.8 lenses was duly completed.

While the latter lens was being made, a 12cm f/4.5 Anytar was developed for general camera use. By 1931 the design had been perfected, with test results showing an optical performance that was easily the equal of the contemporary Zeiss Tessar, which was similar in construction. Encouraged by this success, further 7.5cm, 10.5cm and 18cm prototypes were made, and the decision to market them commercially quickly received the approval of the management.

The 'Nikkor' brand name was chosen for Nippon Kogaku's lenses, 'Nikko' being a shortened version of the company name, with the 'r' being added on the end to give the product a European-sounding moniker. The application for the Nikkor trademark was sent off in 1931 and approved in April 1932.

The first Tessar-type Nikkors were available with focal lengths of 7.5, 10.5, 12 and 18cm for general use, while Triplet-type 50 and 70cm 'Aero-Nikkor' lenses were listed for aeronautical applications.

Although sales were slow initially, this side of the Nippon Kogaku business was nurtured, ironically via the Kwanon concern. Named after the goddess

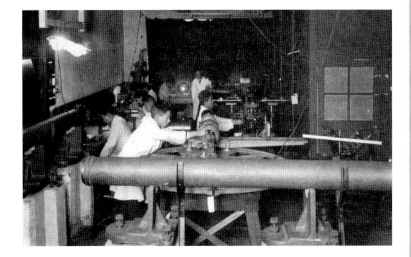

LEFT: **The Nippon Kogaku testing department, circa 1930.**

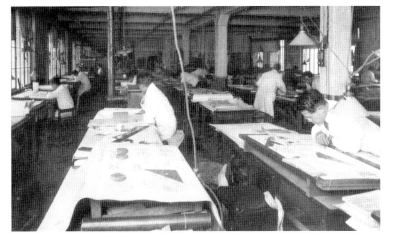

LEFT: **The design department from the same period.**

BELOW LEFT: **Long-range 18cm binoculars dating from 1932.**

BELOW: **The new factory at Nishi-Oi, pictured in 1933. It was designed by the well-known architect Toshiro Yamashita.**

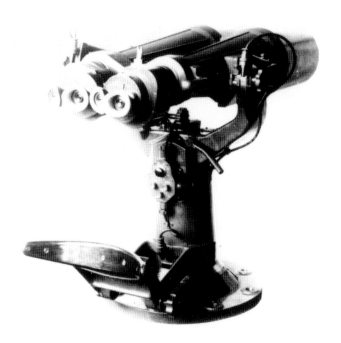

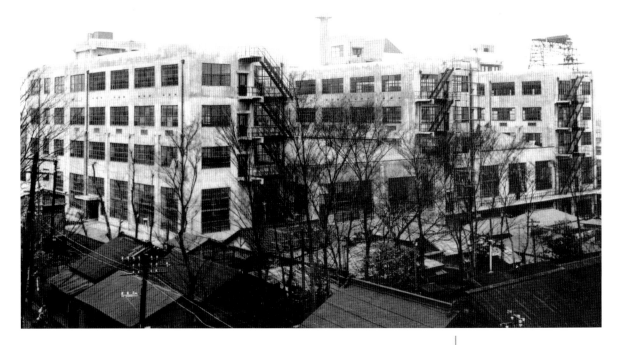

RIGHT: An early 10.5cm f/4.5 Tessar-type Nikkor lens.

MIDDLE RIGHT: The early Canons were generally sold through the Omiya Photo Supply business, which applied the Hansa trademark to most of its products (as indeed it does to this day). Interestingly, one of the Fujii brothers was employed by Canon as a consultant when the 35mm camera project was instigated, and even the enlarger in the picture is related to Nippon Kogaku – the 5.5cm f/3.5 lens being a Nikkor made for Canon with the Hermes name on it. This British advert dates from 1938.

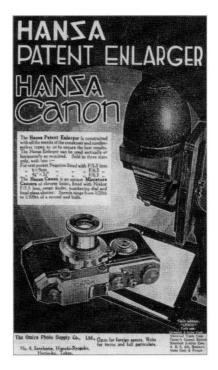

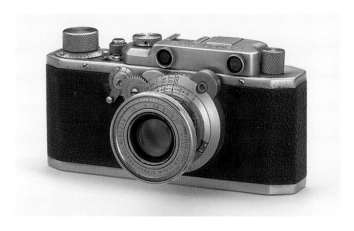

ABOVE: The elegant Canon S of 1939. This example is held in Canon's collection in Japan, and is seen here with a Nikkor 5cm f/2.8 lens. This combination would have cost ¥480, including a case. The cheapest variant was the S with a 5cm f/4.5 Nikkor at ¥335, while the f/3.5 Nikkor added ¥55. Specifying the F2 Nikkor took the price up to a heady ¥550 (equivalent to about $125 if converted into American dollars at that time). COURTESY CANON CORPORATION

RIGHT: One of the first Hansa Canons with a 5cm f/3.5 Nikkor lens.
COURTESY JCII CAMERA MUSEUM, TOKYO

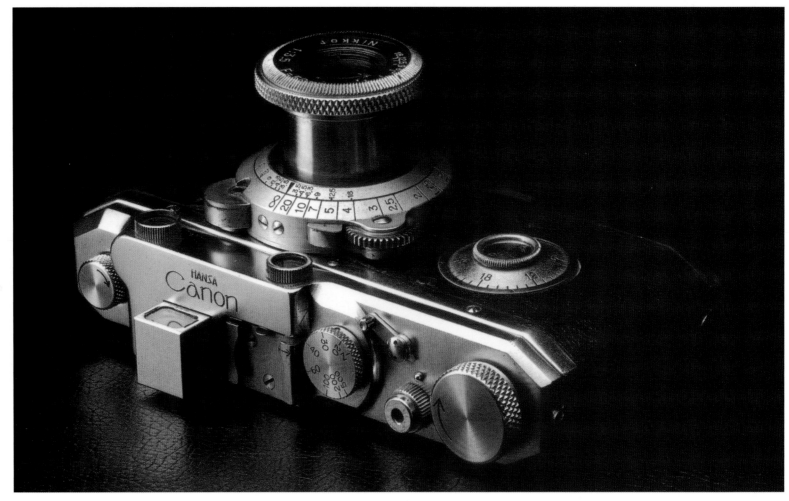

of mercy, the first products to reach the shops carried the Canon badge. Canon (Seiki Kogaku) had approached Nippon Kogaku in November 1933, requesting help with lenses and a miniature rangefinder for a 35mm camera designed by Goro Yoshida. The work was duly completed. When Canon started producing its Hansa Canon at the end of 1935, Nippon Kogaku supplied the rangefinder and unusual lens mount, and, naturally, Nikkors were the lenses of choice, usually 5cm normals of f/4.5, f/3.5 or f/2.8 from August 1937 (serial numbers started with 5021, 5011 and 5021, respectively), or occasionally f/2s.

An even faster 5cm f/1.5 had also been developed by January 1939, along with a coated 3.5cm f/3.5 wide-angle lens (all Nikkors were coated from 1939 onwards using a technique involving chemicals applied in a vacuum, perfected in the USA a couple of years earlier), but the Second World War interrupted civilian production. In fact, Japan had been at war with China for several years, but war with the USA and its allies would have a massive impact on the daily running of the Nippon Kogaku works.

Uncertain Times

The Japanese Army marched through Manchuria at the end of 1931 and the fighting became increasingly fierce as they pushed towards Shanghai at the start of the following year. Naturally the military's suppliers, Nippon Kogaku included, had full order books for specialist equipment (such as rangefinders, binoculars and aerial cameras, plus a batch of 300cm f/20 long-range cameras), prompting a massive expansion programme at Oimachi, including the building still in use at Nishi-Oi.

The conflict continued even after Manchuria was declared an independent state in February 1932, leading to castigation by the League of Nations. Japan eventually withdrew from the Assembly and the nationalistic government in Tokyo ordered the Imperial Army to take city after city until a truce was signed in May 1933, neutralizing a huge part of northern China. Still the push continued, this time to create a buffer zone between Manchuria and central China. Events came to a head in 1937 when Japan took Peking.

ABOVE: **Hand-held binoculars were produced for both general use and the armed forces, although after the conflict in Manchuria only military orders were catered for. Popular pre-Second World War models included the Atom, Novar, Orion, Bright, Luscar and Mikron. This picture shows the Novar 7 × 50 version.**

LEFT: **The Type 96 aerial camera from the mid-1930s. This is classed as a hand-held camera, with an 18cm lens and cabinet frame size, although there was a smaller Type 99 version that ultimately used a 7.5cm lens and standard Leica (36 × 24mm) film.**

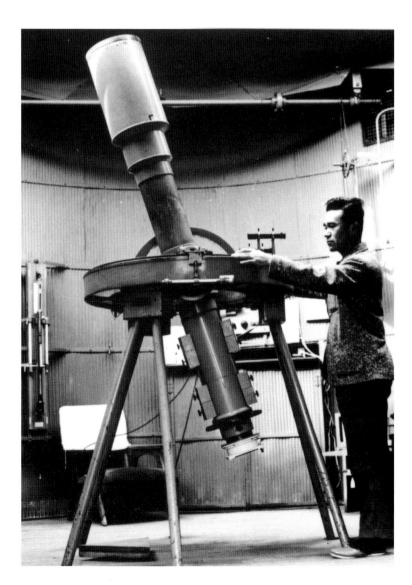

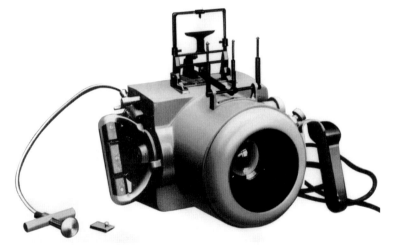

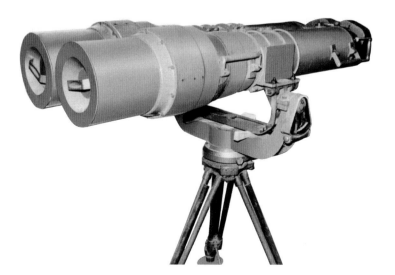

LEFT: **Long-range 25cm binoculars for military use. This particular type was introduced in 1936 and can be seen here with its lens covers in place.**

FAR LEFT: **A large floating telescope completed in 1939 to check the rotation of the Earth on its axis. It was in service at the Iwate National Observatory until 1987.**

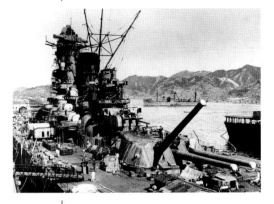

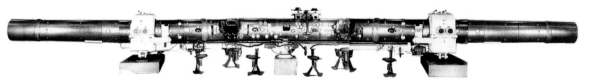

ABOVE: One of the 15m rangefinders built for the flagships of the Imperial Navy.

LEFT: A view of the legendary battleship *Yamato*, pictured in 1941, and equipped with Nippon Kogaku rangefinders and other optical equipment. COURTESY US NAVAL ARCHIVE

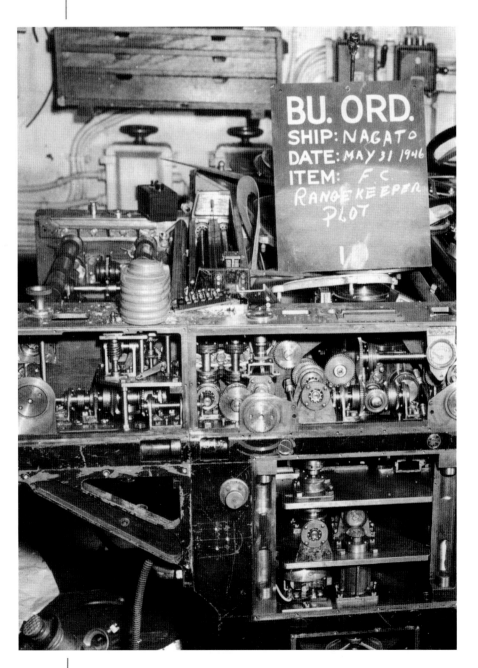

LEFT: A Type 94 range plotter to intercept the path of enemy aircraft. This extremely complicated machine was operated by seven people. Eighty-one plotters were completed between May 1937 and the end of the war.

In the background the Japanese Navy was flexing its muscles, planning the fearsome battleships *Musashi* and *Yamato*. Tsurayuki Yagi, later Nippon Kogaku's Vice-President, was dispatched by the naval authorities to Germany, where he stayed for almost three years in the early 1930s. During his stay he liaised with Carl Zeiss to learn as much as possible about large optics, in readiness for the domestic design and production of stereo-type, long-range rangefinders required for the new ships. The 15m Nippon Kogaku rangefinders that resulted were so advanced and accurate that it has often been said that not even Zeiss could have made them at that time.

Interestingly, Japan's thirst for acquiring European technology was never stronger than it was during this period. Researching for different projects, the author has come across a number of instances when Japanese attachés spent a great deal of time in German factories. A Nissan representative, for example, stayed several months with the Porsche family during the first years of the Volkswagen project. Indeed, the gentleman even secured blueprints of the VW, but, because the deal never evolved into an obvious link at the Japanese end, it remained previously unrecorded. Stories like this are quite common in various leading industrial companies.

After remaining neutral for some time regarding the situation in Manchuria, America spoke out in October 1937, calling Japan an invader. The USA finally put a trade embargo on Japan just before war broke out in Europe, having a drastic effect on the Japanese silk industry, one of the country's most lucrative exports. The situation was made all the worse by a bad season for the farming community, inclement weather putting many out of business overnight after losing a crucial harvest.

Nippon Kogaku, however, was booming on the back of military orders, doubling its normal annual income in 1938, by which time it had a satellite factory in Manchuria (christened Manshu Kogaku), built at the request of the government. Firmly established as the country's leading supplier of optical

equipment – well ahead of the other big makers, such as Tokyo Kogaku (Topcon), Chiyoda Kogaku (Minolta), Takachiho Kogaku (Olympus), Konica, Fujifilm and Hoya, in terms of production volume – it was often difficult to keep up with demand at home and even more factory space had to be secured.

Meanwhile the situation in Europe was becoming increasingly tense: there was civil war in Spain, and the rise of the pact between Hitler, Mussolini and Stalin threatened to bring an end to an uneasy peace that had existed for two decades. Japan aligned itself with Germany as the so-called 'phony war' in 1939 quickly escalated into a very real one, and Europe was plunged into a full-scale world war once more.

The Nippon Kogaku Kawasaki works, started in late 1938 but not completed until 1940. One can sense the feeling of national pride prevalent at the time.

ABOVE: A Nippon Kogaku share certificate issued in October 1941. During the war years the company made enormous profits, although 1945 brought about a complete reversal of its fortunes.

Second World War

Nippon Kogaku again proved invaluable to Japan's military campaign. In 1940 the company had a workforce of 7,585 people. By 1943, led by President Yoshio Hatano, it had increased to almost 16,000; by the end of the conflict it boasted a total of more than 25,000 workers and no fewer than twenty-six manufacturing facilities, including twelve shadow factories.

Most people know of the devastation caused by the atomic bombs dropped on Hiroshima and Nagasaki, but few realize the level of bombing suffered by Tokyo. The capital city was hit hard on numerous occasions, with firebombs ripping through the predominantly wooden buildings (even today, most houses are built in wood, as they are better able to withstand earthquakes), hence the need for shadow factories outside Tokyo to augment the existing plants.

While the budget and time for most research and development projects were cut to zero, at least the company's technicians were kept busy in their quest for superior materials, 100 per cent reliability and weight reduction, and they were able to continue their work on rangefinders and lenses for aerial photography. Nippon Kogaku also inherited production orders from other companies. A large aerial camera was being made by an outside concern, but the military authorities issued a command stating that Nippon Kogaku should take over production in 1944 to ensure quality. This was a fascinating camera, with automatic operation, a motor drive and a 50cm f/5.6 lens. Around 600 were built at the Kawasaki factory before the end of the war.

With fighter aircraft evolving rapidly, firing sights had to keep up with them. Lightweight, accurate sights were a must, and for testing purposes Nippon Kogaku had its own aeroplane called 'Nikko-Go' kept at Haneda Airport from 1937 onwards.

Before the end of the war Nippon Kogaku had been involved with literally dozens of interesting projects, including the development of night vision equipment ('Nocto-Vision'), specialist gun sights (including the use of infrared light), a 1.6cm fisheye weather observation camera lens, measuring equipment, and even underwater motion detectors. By 1945 Nippon Kogaku was, without doubt, one of the world's leading technical innovators, but in September Japan's industry was thrown into turmoil following the country's unconditional surrender aboard the USS *Missouri*.

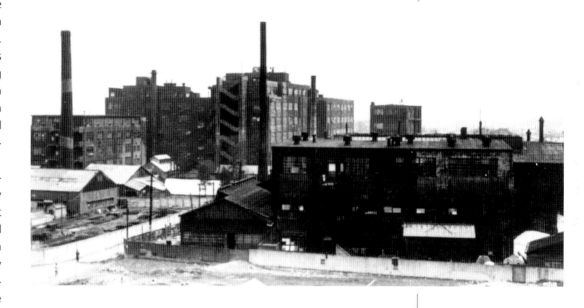

Rising from the Ashes

Having had its production facilities, and even design drawings and research data, for anything remotely linked to the military taken away, this once flourishing concern, which had posted record profits in 1944, was reduced to just 1,700 workers at its main plant in today's Nishi-Oi, plus, for a short time at least, a small shadow factory in Shiojiri, Nagano, a long way to the west of Tokyo.

As with so many Japanese companies, General Douglas MacArthur (as Supreme Commander for the Allied Powers, or SCAP) quickly expunged all the power vested in Nippon Kogaku by breaking up the big *zaibatsu* that controlled them. On VJ Day Mitsubishi Heavy Industries was the firm's main shareholder, with around 145,000 shares, while another arm

ABOVE: The Nishi-Oi works photographed in 1945, with Kogaku Dori (or Optical Road) running past it. These buildings are still in use today, surrounded by more modern facilities.

It was in 1921 that Crown Prince Hirohito became Japan's Regent, as his father was gravely ill. Emperor Taisho died on 25 December 1926, when Hirohito's troubled 'Showa' reign began. Often blamed for the war, in his defence Hirohito rightly pointed out: 'The Emperor cannot on his own volition interfere or intervene in the jurisdiction for which the ministers of state are responsible. I have no choice but to approve it whether I desire it or not.' Here the Emperor is seen addressing his loyal subjects (including the author's grandmother) during a 1947 tour of the country. In his free time he was often seen crouched over a Nippon Kogaku microscope or another piece of scientific equipment produced by the company.

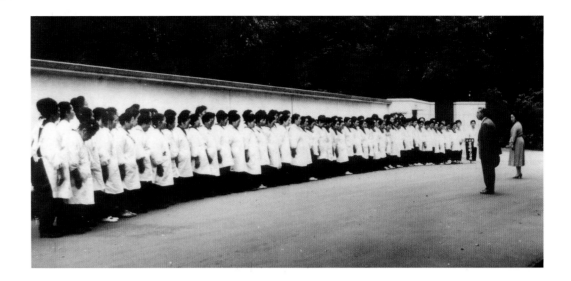

POST-WAR LENS MAKING

After being checked for quality, the glass is cut and ground into the rough size required for the lens. It is then put on a curve-generating machine, and made smooth with a finer sand compound before being polished by experienced artisans. Once perfect, lenses are glued together to produce the correct number of elements and groups, and then the lens is centred and matched to a barrel. Following coating and quality control tests, it is finally dressed with its metal components before being tested once more and released to the dispatch department. All lenses were produced and tested alongside each other, as seen in the final shot of a large format 45cm f/9 Apo-Nikkor lens receiving its anti-reflection coating in a glass bell jar; the Apo-Nikkor line was often used in the film industry or for photo-engraving.

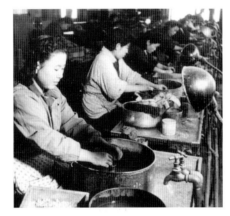
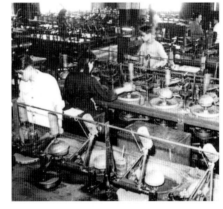
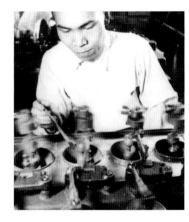

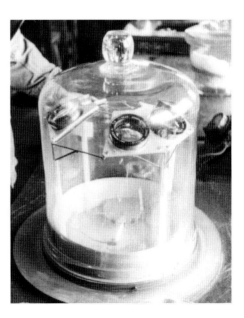

of the Mitsubishi empire owned 22,000, a little less than Asahi Glass, the only other major stockholder at that time.

A meeting was convened in Tokyo on 16 August 1945 to consider the options available, but the future looked gloomy for a company that received most of its income from military orders. To keep the business going, albeit on a small scale, having lost so much factory space and around 23,000 workers (if one includes the 4,000 or so that had joined the armed forces during the conflict), Hatano declared that Nippon Kogaku should remain in the optics business. At another meeting held on 1 September it was decided that the company would aim to produce seventy-three different lines of optical equipment in fifteen categories that could be used in civilian applications, including such things as measuring and surveying instruments, eyeglasses, binoculars, opera glasses, telescopes, microscopes and projector lenses. The most important items on the list were without doubt the proposal to market a camera and the reintroduction of its pre-war camera lenses.

Interestingly, several technicians who had reluctantly been made redundant by Nippon Kogaku set up their own lens-making businesses, which goes a long way towards explaining the proliferation of small lens companies

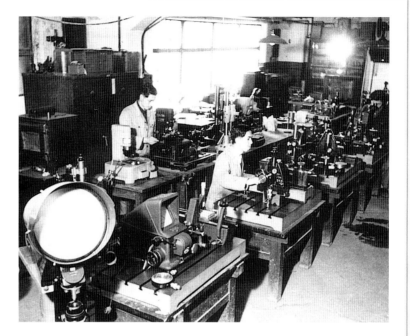

LEFT: Production at the short-lived Shiojiri plant. GHQ soon put an end to its work on rangefinders, meaning it had to concentrate on surveying equipment and microscopes. The plant closed its doors for good in August 1950.

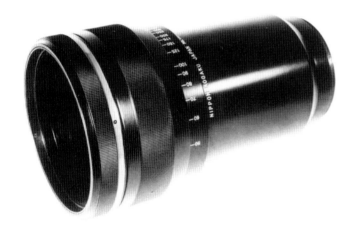 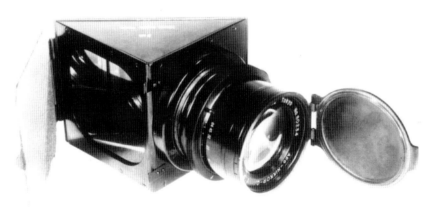

ABOVE: The Pro-Nikkor movie projector lens proved very popular just after the war. Studio camera lenses, some being developed before the conflict, were also produced.

ABOVE RIGHT: Based on the wartime Tessar 38cm f/8 design, the Apochromat lens design was duly refined into the 38cm f/9 Apo-Nikkor. In 1949 Japan's first Apochromat lenses, available in 30, 45 and 60cm sizes, were put on the market, effectively putting an end to the import of German and British versions. All optical calculations had to be done by hand at this time (no fewer than 100 people were employed to double check the mathematics!), and the development of each design sometimes took up to three years to complete.

in post-war Japan. Few Japanese, however, were in a position to afford such luxuries. Most people, even wealthy individuals in the upper classes, had lost everything in the relentless bombing of the capital, and those that managed to escape this misfortune had much of their assets stripped once the air raids stopped and MacArthur and his men moved into town.

By 20 September Nippon Kogaku's production committee had dropped plans for a camera body. While lenses and rangefinders for miniature cameras were approved, it was felt that the Japanese market was not yet ready for an expensive product, and to sell a cheap camera bearing the Nippon Kogaku name would be bad for the company's enviable image.

ABOVE: Having made sure that Nippon Kogaku had a new direction to follow, Yoshio Hatano stepped down from office in May 1946. The new President was Hideo Araki, but Araki's reign was to be short. In January 1947 it was announced that Masao Nagaoka, shown here, was to head the company. Nagaoka remained in the President's office until May 1959, when he was appointed Chairman.

A typical Nippon Kogaku microscope from the early post-war years.

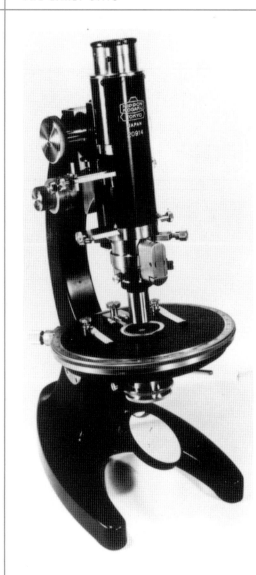

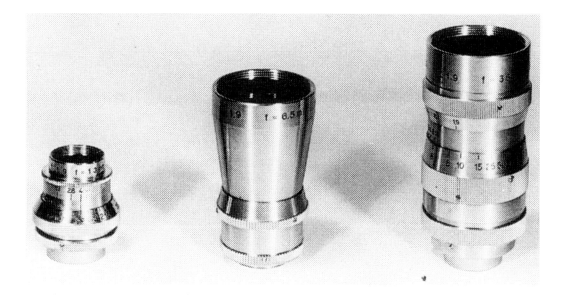

BELOW: A Japanese Elmo 8mm cine camera with early and late versions of the D-mount 13mm Cine-Nikkor lens; early types were marked 'INF', whereas later lenses had an infinity symbol and a 'Nippon Kogaku Japan' marking added to the front ring at the same time. The 1955 Elmo 8-AA was a development of the 8-A of 1940 vintage, itself based on a Bell & Howell camera. The box and lens case belong to a 38mm Cine-Nikkor.

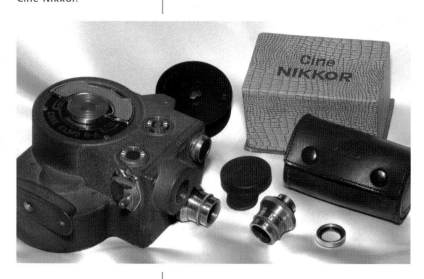

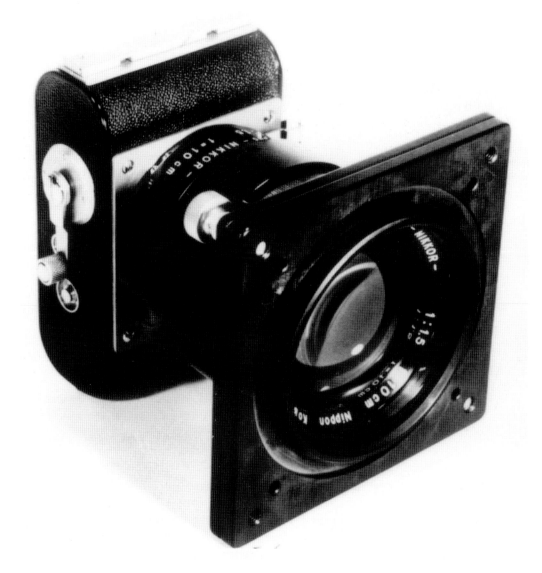

TOP RIGHT: Nikkor 8mm cine camera lenses were ordered by the American Revere concern in 1949. Between January 1950 and September 1953 a total of 84,000 lenses in three different sizes were supplied. After 1955, 16mm cine lenses were made available.

BOTTOM RIGHT: The Regno-Nikkor series was for photographing X-rays using 6 × 6 film.

RIGHT: Telescopes were made in large quantities after the war. This particular device, however, is called a coronagraph, allowing a perfect view of a total eclipse of the sun. It was ordered for the Tokyo Observatory.

BELOW: Nippon Kogaku found a ready market for its Mikron 6 × 15 binoculars. Note the 'Made In Occupied Japan' marking stamped underneath the company logo.

ABOVE: The blueprints for the 6 × 6 TLR Nikoflex camera, with its 80mm f/3.5 lens. Giving twelve frames on 2.25in square negative film, it resembled the famous Rolleiflex, and a number of later Japanese cameras, such as the Ricohflex, the Primoflex from Tokyo Kogaku (later Topcon), the Aires, the Yashica Pigeonflex and Yashicaflex, the Beautyflex, the Walzflex, the Minolta Autocord, the Nikkenflex, the Zenobiaflex and the first Mamiyas.

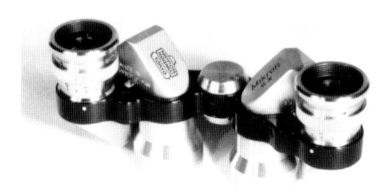

to survive, it would look into developing its own camera to sell alongside its respected Nikkor lenses; just like the first post-war cars, the earliest lenses and camera equipment made available following the cessation of hostilities were basically pre-war designs that were duly dusted off and reintroduced.

With a new executive committee, albeit still led by Hatano, and a glimmer of hope for the future, during the spring of 1946 a 6 × 6 TLR (twin lens reflex) camera was designed for 120 film, based on the famous Rolleiflex series (one was purchased, dismantled and examined to provide inspiration), along with a 35mm rangefinder model with a focal plane shutter. The TLR design was dropped a few months later (as it had been in a Nippon Kogaku aerial camera application some years before), since the Pronter-type shutter was not up to the reliability standards required by the Nippon Kogaku engineers, while a Compur version would have cost too much to tool up for. The RF camera, however, was considered worthy of further development, unwittingly sowing the seeds for the Nikon brand.

The design was approved on 15 April 1946 and an order for twenty cameras was placed with the production department in June. These were classed

Notwithstanding, at a Board meeting held in October 1945 (the month in which General Headquarters gave its approval for civilian production to commence), the management at Nippon Kogaku decided that, in order

ABOVE: A Nikkor lens advert from July 1947.

RIGHT: Nicca made good use of the fact that it sold its cameras with Nikkor lenses, as can be seen in this 1951 advert. The Nicca brand was gradually phased out after its owners merged with Yashica in the late1950s.

FAR RIGHT: From July 1951 Nikkor lenses were also supplied to Aires, the makers of a Rolleiflex-type camera and a few compact 35mm models. This advert confirms that the Z Type camera employed Nikkor optics mounted on a Seiko shutter, as did the Aires Automat from a couple of years later. Like the Nicca, some Aires models found their way to America, where they were badged as Tower cameras.

as experimental, but the body numbers issued for identification were later continued on the series production models. Under Masahiko Fuketa the Nikon camera design (nowadays known as the Nikon I) was duly finalized in September 1946; although a wooden mock-up was displayed internally on the company's twenty-ninth anniversary, it would be another year and a half before it was released to the public.

Meanwhile, Nippon Kogaku generated income through selling expensive goods through Post Exchange (PX) shops attached to GHQ. Many components were left over from wartime production, allowing items like binoculars to be built up and sold quickly. Against the odds, being without the support of the military or the Mitsubishi *zaibatsu* thanks to the GHQ directive, the newly streamlined company was doing reasonably well financially, at least until Japan started to suffer from the ill effects of high inflation a couple of years after the war ended.

Win Some, Lose Some

The decision for Nippon Kokagu to produce its own camera probably had a lot to do with Canon withdrawing its custom, as the two concerns had long-established links with each other. About 2,550 Nikkor lenses were supplied for the Canon S, JII and SII from December 1945. In fact, Nikon made all of Canon's lenses up until March 1948. During this time the unusual bayonet fitting of pre-war days, when the Hansa Canon was being produced, had given way to the Leica screw mount when the all-new SII was introduced during 1946. Canon started producing its own lenses in 1947, tending to follow the pattern established by Ernst Leitz. This ended a long-standing business arrangement and sparked off a bitter rivalry that has lasted to this day. It should be noted that these early Canons, whilst very similar to the contemporary Leicas in many respects, were not replicas of the German camera.

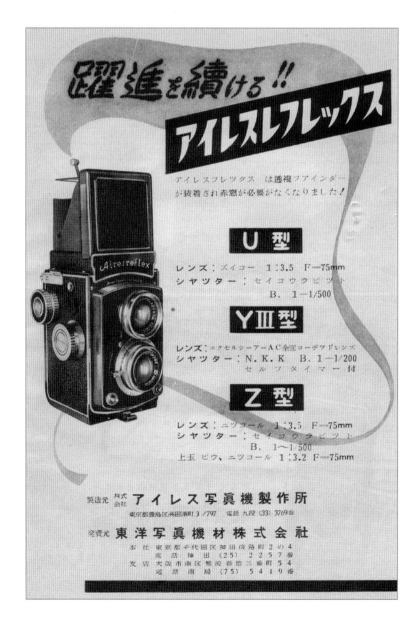

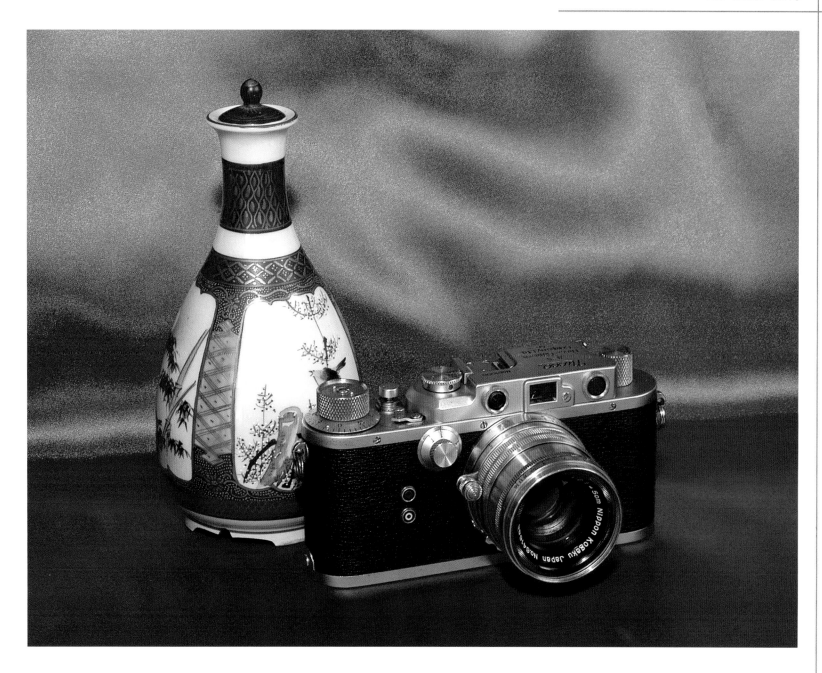

Several Leica replicas were produced in Japan in the immediate post-war era, however, the most famous being the highly successful Nicca. Ironically, the Nicca brand was founded in 1940 by technicians originally associated with Hansa Canon. Although originally established to repair and upgrade old Leicas and Canons, the Kogaku Seiki Company, as it was first known, produced a replica Leica during the war and put it on general release as the Nicca (or the Tower Type 3 in the USA). Some Niccas used Chiyoda, or occasionally Canon, optics, but they were usually mated with screw-mount Nikkor lenses (made from April 1946), as the latter already had an excellent reputation. A number of lenses were also supplied to Mamiya.

Nippon Kogaku's reputation for high quality was justly deserved. In reality, of course, one has to remember that the company grew on the back of pre-war military orders, and quality is always of greater importance than cost when it comes to supplying the armed forces with precision instruments. This also goes a long way towards explaining why Nikon equipment has always been expensive compared to the offerings of many of its contemporary rivals: the use of the best materials and leading-edge technology was bred into the firm's engineers from its earliest days and, not wishing to be drawn into a price war, this added cost simply has to be passed on. As the old saying goes: 'Pay your money, and take your choice.'

RIGHT: The Nikkenflex camera of late 1950 vintage was not related to Nippon Kogaku in any way, although the company name – Nippon Koken Camera Works – and its Nikken lenses, angered the executives and marketing people at Nishi-Oi. The threat of legal action probably explains the rarity of the TLR Nikkenflex, despite its good performance and relatively low price.

FAR RIGHT: An interesting camera – the Russian Kiev 4a. This was a faithful replica of the Contax II, even down to the lens mount. The quality was poor, though, compared to the Stuttgart original, and the Nikon that was inspired by it.

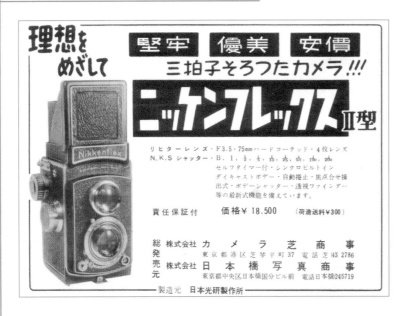

RIGHT: The author's pre-war Leica IIIa with a selection of post-war, screw-mount Nikkors (including a 5cm f/2 normal, a 3.5cm f/3.5 wide-angle and 13.5cm f/3.5 telephoto), and a Nippon Kogaku finder.

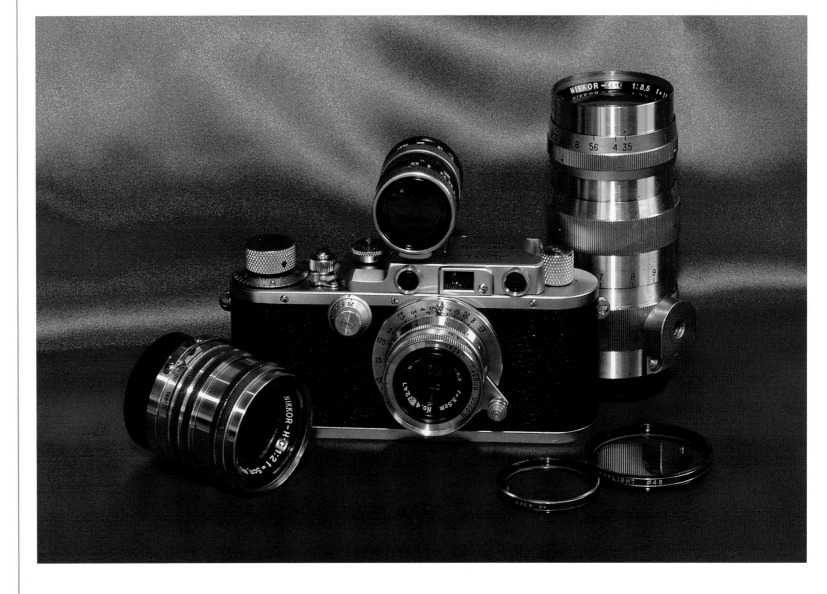

THE RANGEFINDER YEARS

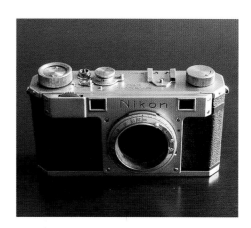

ABOVE: Original blueprint for the Nikon 35mm camera.

THE NAME NIKOFLEX CAN be seen on the design drawings for the medium-format TLR camera. Other names under consideration for Nippon Kogaku's first camera included (in alphabetical order): Bentax, Nicca (yet to be used by the people at Kogaku Seiki), Nikka, Nikkorette, Niko, Niko-ret, Pannet, and Pentax – the latter being another name that would soon be registered as a Japanese trademark, as the camera produced by the Asahi Kogaku Company changed from being known as the Asahiflex to the Asahi Pentax, and eventually only the Pentax moniker was used.

Nikkorette would have made sense, with Nikkor lenses already having a good image among domestic professionals and well-heeled enthusiasts, but Nikon was the name ultimately chosen by Nippon Kogaku's executives, as it sounded stronger. The 'Nikon' trademark was officially announced in March 1947, by which time it was hoped that Nippon Kogaku would have a product to sell.

However, due to the perfectionist attitude of Masahiko Fuketa and Nippon Kogaku's other engineers, who had already decided to accept nothing less than a high-quality product, prototyping did not finish until February 1948, about fourteen months behind schedule. The '609' designation marked on the experimental cameras is thought to represent September 1946 (the completion date of the finished design), so one can see the huge amount of time spent testing and refining the first Nikon, despite the pressure to get the new camera into the marketplace as soon as possible.

Nippon Kogaku was first and foremost an optical company, so the lens was always going to play an unusually important role in the package. While Canon had moved away from the bayonet mount to the M39 screw thread favoured by Leica, Nippon Kogaku decided to adopt the Contax-style bayonet mount.

The die-cast body's styling actually resembled the German Contax II, too, but it certainly was not a copy. In fact, it is fair to say the first Nikon brought together the best features of the contemporary Contax and Leica models: the rugged exterior and lens mounting system of the former, and the shutter of the latter for greater simplicity and ease of manufacture. With an RF system notable for its straightforward layout compared to the German cameras, this really was an ideal combination, and played a large part in helping to establish Nikon's reputation for strength and exceptional reliability in the field.

LEFT: The very first Nikon camera, now lacking its *Habutae* rubberized cloth focal plane shutter, which took the technicians so much time to perfect. Produced during the winter of 1947, body 6091 laid the foundations for the Nikon legend.

ABOVE: Prototype body 6094, which has survived the test of time far better than 6091 and features the larger 'Nikon' script that was adopted on production models. Very strict quality control measures were enforced from the design stage onwards.

BELOW: The first Nikon camera advert, placed in the October 1947 issue of *Kouga Monthly*. Masahiko Fuketa must have thought this day would never arrive. He once said development of the Nikon I was rather like 'trying to think of solutions whilst running at full speed.' Fuketa later became the top field engineer, solving problems experienced by end users, before returning to the design section for the S2.

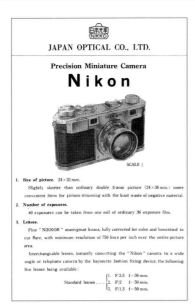

ABOVE: **Early promotional paperwork featuring body 6091. Note the lack of a Nippon Kogaku badge on the top plate: only simple script was used on the prototypes, but the familiar triangular trademark overlaid with a lens appeared on all production models.**

ABOVE: **The first Nikon instruction book was in English, as it was assumed few Japanese would be in a position to buy an expensive camera so soon after the war ended. The assumption was probably correct, but the Nikon's unique selling point – its frame size – actually worked against it in export markets, and hardly any were sold abroad.**

RIGHT: **A Nikon I on display at the JCII Camera Museum in central Tokyo. Note the collapsible lens on this early model, body number 609387, complete with its elegant lens cap.**
COURTESY JCII CAMERA MUSEUM, TOKYO

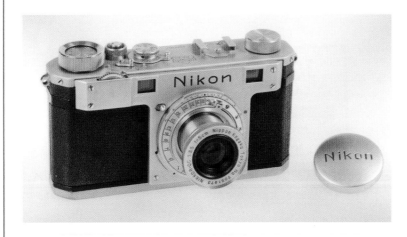

RIGHT: **A Nikon I (body number 609471) mounted with an early 5cm f/2 normal.**

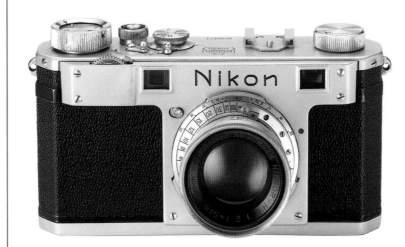

Interestingly, a 32 × 24mm frame size was chosen to give the Nikon its own unique selling point. The frame composition was nice, and in an era when film was still very expensive, a 32mm width was originally thought to be the 'golden ratio', giving an extra four prints for every 36-shot roll without much image loss. The Japanese Ministry of Education accepted this as a regular slide mount size, but the plan backfired, however, when Americans simply rejected this format as it was not suitable for automatic cutting machines.

Indeed, very few Nikon Is were exported anywhere, as the 32 × 24mm frame size was not compatible with regular slide mounts outside Japan. More than fifty units went to Hong Kong and a handful were sent to Singapore, the USA and Europe, but it was obvious that Nippon Kogaku needed to change to a bigger frame size if it was to break into the lucrative export business on which the management was pinning the company's future. After all, as GHQ was quick to recognize, the domestic market was still very small in the immediate post-war years, and exports were seen as the main source of sales.

Anyway, the first prototype (body 6091) was used in a number of adverts that had began to appear after October 1947, although production models had a heavier 'Nikon' logo above the lens, and the simple 'Nippon Kogaku Tokyo' script was replaced by the company's triangular trademark on the top plate. There were other minor differences, too, but it was a fair representation of what could be bought in the shops, assuming one had the money.

The Nikon I had a 'chrome' body trimmed with hard-wearing black leather, embossed to resemble lizard skin, although at least one is known to have been produced with a completely black body. Black was favoured by photo-journalists, especially those working in war zones, and so several were made to special order as the years passed. More and more requests for black bodies were received, not only from professional photographers, but normal enthusiasts, too. This ultimately led to chrome and black body options being listed in the catalogue, officially starting with the introduction of the S2 and being offered on almost every Nikon thereafter until the 1980s.

A 5cm lens was included in the price; some adverts mention the f/3.5 Nikkor, which had gained a new, larger barrel in June 1948, but it was usually the faster and significantly more modern looking, collapsible mount f/2 that was supplied as standard fare. An f/1.5 version was also listed in early paperwork, but did not become available until the start of 1950. Other lenses initially included the rigid mount 3.5cm f/3.5 wide-angle and 13.5cm f/4 telephoto, although neither was actually sold until several months after the camera body made its debut. Like the camera baseplate, these early lenses were marked 'Made In Occupied Japan', a sign of the times following the 1945 Armistice.

The first twenty prototypes were duly numbered 6091 through to 60920, and one further prototype (60921) was produced before sales of the Nikon I started in March 1948 (with body number 60922 being the first Nikon camera released to the public). Numbers were issued consecutively thereafter, although the Nikon I was to be short lived, production ending after 758 units (including the twenty-one prototypes) had been built, with the debut of the M model only eighteen months later.

It should be pointed out at this stage that 'Nikon I' is actually a retrospective name, rather like the Jaguar sedan that preceded the Mk.II – officially it was known simply as the 'Jaguar saloon', but the term Mk.I was later coined to differentiate the two, and it is a moniker that has stuck with the car ever since. Similarly Nippon Kogaku's first camera was simply called the 'Nikon Camera'.

can be seen in the M, which is not really surprising. The same situation exists in the car world, where manufacturers use whichever parts are available, revising many along the way as reports filter back from the field. Once a design has been refined to a certain point, modifications are fewer and, as sales increase, more components are bought in bulk to reduce production costs, again leading to fewer visible changes.

The 'M' prefix attached to the body number engraved on the top plate (situated between the accessory shoe and shutter speed dial) was an

The Nikon M

The second camera was christened the M (the M standing for *mutatio* – Latin for change, or alteration). Although the Nikon I and the M look the same, the body number on the top plate was given an 'M' prefix to let interested parties know that the frame size was slightly bigger than that of the original Nikon. The M used a 34 × 24mm format, but it was still smaller than the 36 × 24mm employed by Leica. Unlike the I, though, which employed seven perforations per frame, the M matched Leica's eight, making it much more acceptable abroad.

Other than the frame size and subtle refinements in the film spools to allow quicker and easier loading, however, the M was basically the same as its predecessor, since time and the added cost of producing a new body were against the company at this stage.

The last few Ms had the 'Made In Occupied Japan' marking moved from the baseplate to a more subtle position stamped into the lower left-hand part of the 'leather' on the rear cover, although many minor variations

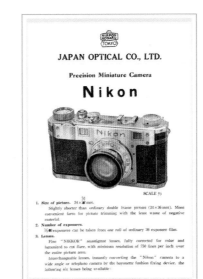

LEFT: **With little cash to spare for promotion, this leaflet for the Nikon M is evidently much the same as the one issued for the Nikon I, stamped on alterations saving the cost of resetting the typeface. The camera is actually too early to be an M, but, apart from the body number, they looked similar from the outside anyway.**

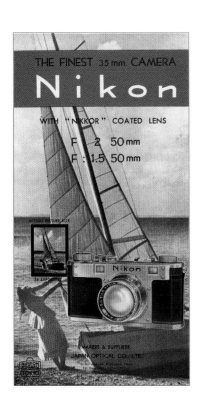
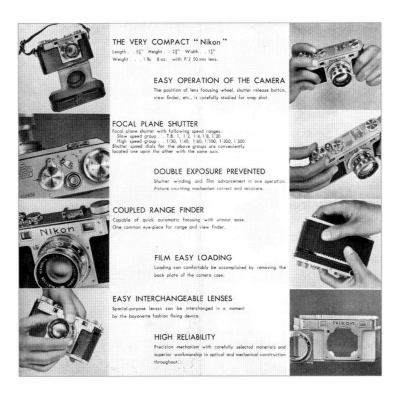
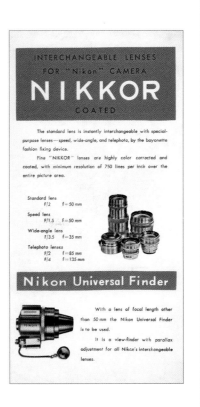

LEFT: **An English-language Nikon M catalogue.**

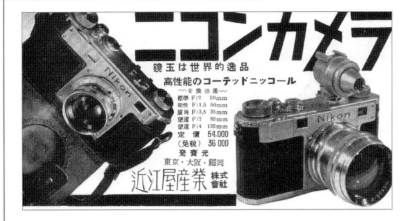

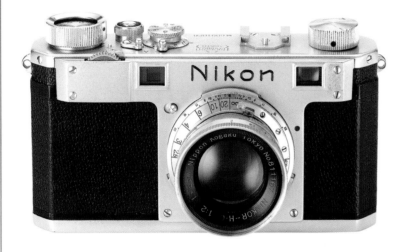

example of bulk purchasing, and one that would ultimately cause much confusion for collectors in later years. Existing top plates were used for the first S models, introduced in December 1950, so early Ss have an M prefix in the body number. As far as Nikon is concerned, however, any camera with factory synch is an S, regardless of whether the body number starts with an M or not, so that is the definition that I shall be using in this book.

A 5cm f/1.8 lens was advertised for the Nikon M, but it was never made, and the f/3.5 version that was also noted in the first paperwork issued relating to the M was simply not supplied at this time. The f/2 lens continued as the norm until the long-awaited and ultimately short-lived f/1.5 came on line to augment it. The 3.5 and 13.5cm lenses were carried over, joined by an 8.5cm f/2 telephoto that had been launched in spring 1949. As well as the Nikon bayonet mount, the latter was also available in Leica M39 and Contax bayonet mounts; the Contax version was readily distinguished by the small 'C' engraved on the lens barrel or focusing ring.

The 5cm f/1.5 was replaced by a faster and extremely popular f/1.4 version in July 1950, and the f/2 was modified from a collapsible to a rigid mount in the following month. While this increased weight (the new lens, with its chrome on brass barrel, was slightly larger than its predecessor), optical performance was improved, and all the Nikkors that followed (with the exception of the 5cm Micro-Nikkor) would have a rigid mount.

Of the ninety-four businesses involved in the camera and optical trade that sprang up in the immediate post-war years, Nippon Kogaku was leading the way in Japanese lens technology at this time, with new internal coatings and materials being introduced regularly, but development and manufacture of its high-quality glass was taking its toll on the company's finances. Other firms found themselves in a similar position and eventually, with government support, joined forces with Nippon Kogaku

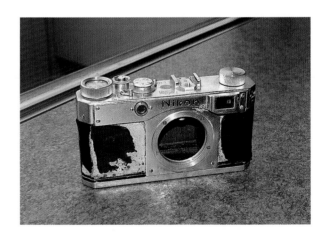

to produce glass using the extremely expensive lanthanum and thorium elements. In September 1951 Nippon Kogaku found itself working alongside Konica, Fujifilm, Chiyoda Kogaku and Ohara Kogaku on this project, with Nippon Kogaku fronting the operation, which led to the introduction of eight different glasses.

Meanwhile, from August 1949 (although sales did not actually begin until October), a total of 1,643 Nikon Ms were produced before the company's third camera was brought out in December 1950 – the Nikon S.

The Nikon S

There were actually very few differences between the M and the S – the main one being that the Nikon I and M had no flash synch, whereas the S did, in response to American requests made in spring 1950. At the same time as the flash synch facility was introduced, a flashgun (type BCB) was marketed, giving the user the option of straightforward flash photography.

A handful of Ss were made with black bodies, although after the first thousand or so Ss were produced (still with the M prefix on the top plate) the chrome body finish was a touch brighter, thus giving the camera a slightly less industrial look. Changes had been made inside by this time, too, with the old gravity-fed die-casting method being superseded by casting under pressure for greater manufacturing efficiency.

On the subject of the M prefix, with the benefit of being able to compare various RF Nikons with this marking, it is quite obvious that the engraving was done separately, after the original numbers. Once the top plates engraved with the M prefix were used up, serial numbers continued consecutively without any prefix.

Early examples still carried the 'Made In Occupied Japan' marking (these all had the M prefix), although a small number have the combination of an M prefix and a simple 'Japan' mark stamped on one of the rear cover

releases. Then, just as things settled down to a more orderly form of series production, build numbers (for the Nikon I, M and S combined) broke through the 10,000 units barrier. As a result it is possible to find what is termed an 'eight-digit S': around 1,200 were produced before the numbering system changed to a constant seven digits, '610' and four numbers being the first combination. This was then followed by a '611' prefix in front of four numbers, and so on, all the way up into the upper reaches of the 612 series.

An adjustable, accessory shoe-mounted eyepiece corrector was available for these earliest Nikons, bringing them into line with the Leicas, which came with a neat built-in dioptre corrector from the mid-1930s. Later Nikons had the facility to screw a correction lens directly into the viewfinder.

Meanwhile the BCB I flash replaced the original BCB unit in July 1951, but only lasted a year before the BCB II was introduced. In reality, all three flash units looked very similar. As for lenses, there were the 5cm f/2 and f/1.4, the 3.5cm f/3.5 wide-angle, the 8.5cm f/2 telephoto, and the 13.5cm model, upgraded from f/4 to f/3.5 specification at the same time as the S body was launched, although the f/4 soldiered on into the early part of 1952. The new version of the 13.5cm lens featured a tripod socket, to avoid excess pressure on the camera body's socket, and a larger filter size, giving it a more modern appearance.

Over the next few years the 3.5cm lens was improved internally, and eventually gained a filter attachment thread in 1954. In the meantime an f/2.5 version was introduced to augment the traditional f/3.5 item. The longer 13.5cm lens also received modified internals, as did the 8.5cm model, taking the aperture clickstops up from f/16 to f/32. The 13.5cm version came with Nikon, M39 screw, Contax and – for a short spell at least – Exakta mounts.

February 1953 saw the introduction of a faster 8.5cm f/1.5, but this was expensive and heavy, and therefore sold in relatively small numbers despite being available in a variety of mounts. It does, however, hold the honour of being the first Nikkor lens with a black barrel. Eventually, this would become the norm, but at the time it was something quite new.

ABOVE: Tasteful Japanese advertising heralding the arrival of the Nikon S.

ABOVE: The Zeiss Ikon people in Stuttgart at last got around to updating their pre-war II and III models five years after the end of the conflict. The Contax IIa was launched in 1950, while the IIIa, with its built-in exposure meter, came out in the following year. Nikon had to compete with the S, seen here.

FAR LEFT: English version of the Nikon S instruction book.

LEFT: Japanese instruction book for the Nikon S, seen here with the 5cm f/1.4 lens. This f/1.4 Nikkor was an extremely fast lens for the day, made possible by the use of barium flint glass.

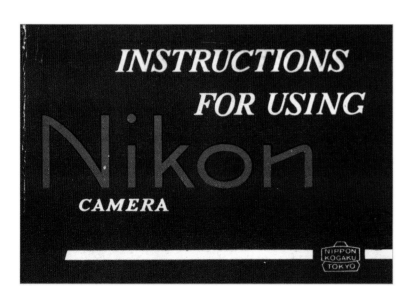

RIGHT: The BCB flashgun was introduced in late 1950 as the perfect accessory for the Nikon S. Two synchronization contacts were provided – a fast setting at the front of the camera, and a slow setting at the rear.

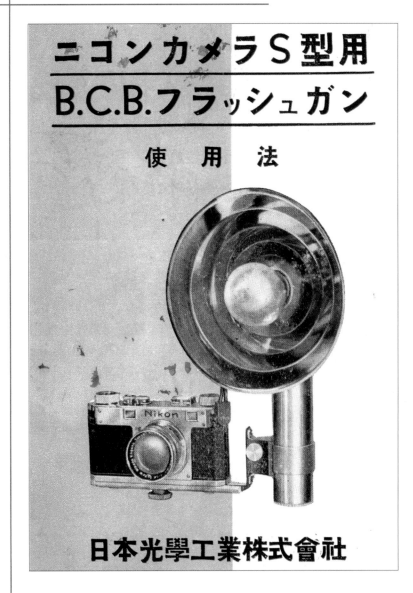

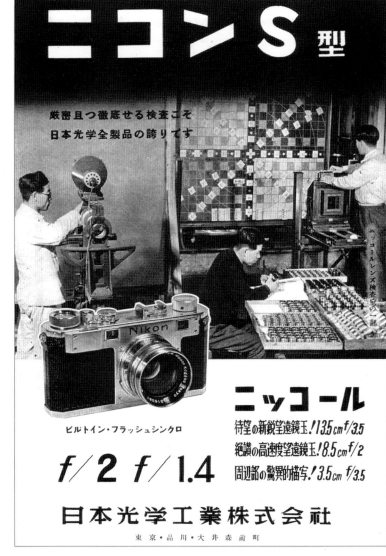

RIGHT: An October 1951 advert from Japan Photo Service of Tokyo, showing the price of the Nikon S and some of its contemporaries. From other lists, we can see that just about the only cameras more expensive than a Nikon at this time were the Leica (almost double the price of an S in Japan) and the Contax. Surprisingly, the Nicca, with Nikkor optics, was only slightly cheaper.

ABOVE RIGHT: Japanese advertising from winter 1951. This fascinating picture shows the quality control technicians hard at work, with the company's plane chart for checking a lens's resolving power dominating the shot. Nippon Kogaku's testing equipment and procedures were the equal of any American or European specialist firm.

RIGHT: The Allied Occupation of Japan was as good as over following the signing of treaties in September 1951. It was not until April 1952, however, that it officially came to an end. Interestingly, at about the same time as the 'Made In Occupied Japan' marking was deleted from Nikkor lenses, the front ring engraving changed from 'Nippon Kogaku Tokyo' to 'Nippon Kogaku Japan,' as seen here in this 1953 advert, and serving as a good indicator of a lens's vintage. Pre-war lenses did not carry a location, just the company and 'Nikkor' names.

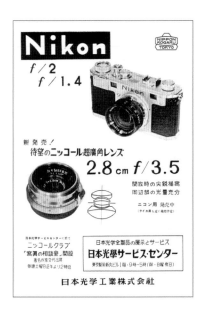

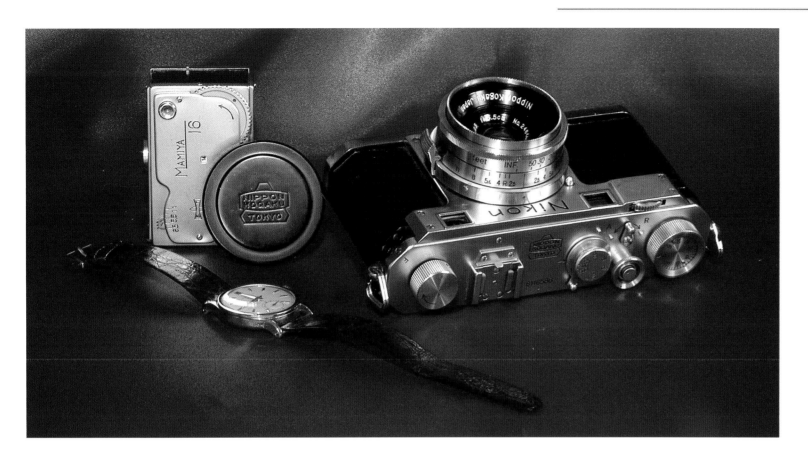

RIGHT: The author's 1953 Nikon S with a contemporary 3.5cm f/2.5 Nikkor. While the Nikon brand represented the best Japan had to offer, the Patek Philippe seen here was an example of Europe's finest craftsmanship from the same period. The delightful Mamiya 16 is an 'Occupied' model, by the way.

BELOW: Lenses for the Nikon S, including the 8.5cm f/1.5 – the first Nikkor with a black barrel. The lens markings are significant: 'W-Nikkor' denotes a wide-angle lens (although the later 2.1cm model was an exception to this general rule), while letters that follow 'Nikkor' on 2.1cm, normal and telephoto lenses indicate the number of elements in the lens using a combination of Latin and Greek words (see Appendix II), while a red 'C' means the lens was coated. Actually all post-war Nikkor lenses were coated to effectively reduce flare, and the 'C' was ultimately dropped in the late 1950s.

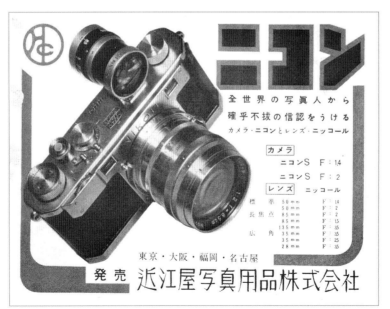

ABOVE: A 1954 Nikon S paired with an 8.5cm f/2 lens and Varifocal finder. By the mid-1950s the original, individual chrome finders, and the far more practical Variframe and Varifocal universal finders (the latter two being introduced in 1948 and 1951, respectively), had largely been replaced by more modern black items. At the same time Nikon marketed a so-called Sports Frame Finder (similar to the Nikonos finder in principle). The Variframe and Varifocal finders were produced for Leica and Contax cameras, too, and can be readily identified by an 'L' or 'C' stamped on their base.

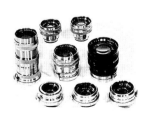

FAR LEFT: A 1954 advert featuring the Nikon S and the same selection of lenses as shown in the picture above.

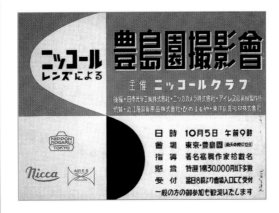

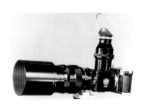

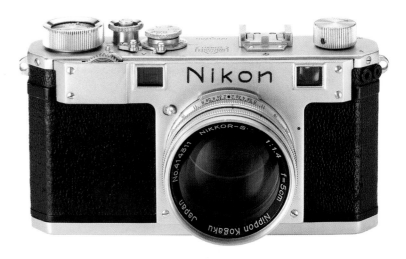

The technique of pressing molten glass into its initial form to cut down on waste was introduced in 1953, as well as two new external mount wide-angle lenses – a 2.5cm f/4 model and a 2.8cm f/3.5, which really pushed the technology envelope at the time. Then, in the following year, two new telephoto lenses were added to the line-up: the deservedly popular 10.5cm f/2.5, which formed the basis of several designs to follow, and a 25cm f/4, the latter being the first Nikkor developed for use with Nippon Kogaku's reflex housing.

Becoming Known to the Outside World

The Type I, M and S were basically the same camera. Indeed, all carried the same internal reference number (6FB), with production batches being identified as 6FB-1, 6FB-2 and so on. However, the S (which accounted for 36,746 of the 39,127 6FB variants produced) was the first Nikon to be sold in the USA, launched at the start of 1951 and sold through small premises in California Street, San Francisco.

At this time, one has to wonder how many people would have been willing to part with the $349 required to purchase an S with a 5cm f/1.4 lens, especially when one could buy a world-famous Leica IIIf with Leitz Summitar lens for $385. It was impossible to sell the Nikon any cheaper, since the fixed exchange rate of °360 to the dollar had been introduced in April 1949, and this was what ultimately decided the price.

On the other hand, there was the Kodak Pony at just $30, so it was obvious that both imports were aimed squarely at professionals. Of course,

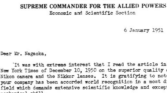

professionals tend to stick with equipment they know and trust, and only one year earlier the Nikon brand was still virtually unknown outside Japan. So how did Nippon Kogaku succeed in beating the overwhelming odds stacked against it?

Ironically, given the devastation following the Second World War, the Korean War was perhaps Japan's salvation. When the conflict broke out in June 1950, the Allied Occupation and geographical location of Japan led to many orders being placed for military and industrial equipment, signalling a turning point in the history of several companies that were still trying to emerge from the aftermath of 1945: Nippon Kogaku can be counted among them.

Over the last century, wherever there have been wars, there have been war correspondents covering events. This is a highly dangerous, fast-moving job, where capturing one specific moment on film can literally tell a thousand words, and one that is extremely demanding on photographic equipment. Ease of use, exceptional optical performance, reliability and rugged resistance to shocks, dirt and the elements are of paramount importance to a photo-journalist.

The majority of foreign professionals were using either Zeiss or Leitz lenses at this time, but Nippon Kogaku got a big break when a young Japanese photographer named Jun Miki showed David Douglas Duncan of *Life* magazine and Horace Bristol of *Fortune* a few shots he had taken of Duncan with an 8.5cm f/2 Nikkor. Amazed by the clarity of the images, and having a little time to spare in Tokyo before the two men flew out to Korea, a visit to the Nippon Kogaku works was arranged. A number of test shots proved that Nikkor optics were indeed

Nikon

The 35mm Camera That Was
Built to Optical Standards

From the very first, the Nikkor lenses were a sensation. But what a problem and a challenge they presented. Existing fine-camera standards proved inadequate if we were to benefit from their extraordinary performance. A new concept of camera body-and-mechanism was needed to match their quality.

Certainly, if we were to have a camera mechanism that would do justice to these lenses, then conventional *mechanical* standards would have to be laid aside; *optical* criteria would have to be employed. This meant that every tolerance would have to be narrowed down; machining and tooling would have to be refined. This meant that design thinking and quality control would have to draw upon the techniques as employed in the making of the finest scientific instruments, and as never previously used in camera manufacture.

These ideas were put to work and the Nikon camera was born. And the result has more than justified the painstaking effort and care that have gone into its creation. It is no wonder that the Nikon camera and Nikkor lenses have won acclaim among the most critical camera users in the world . . . the professionals . . . the men who live by photography. It is no wonder . . . because here is a camera that mechanically matches the performance of a magnificent lens . . . a camera that was built to optical standards.

Nikon camera with Coated 50mm f1.4 Nikkor lens is priced at $359 list; with Coated 50mm f2. Nikkor lens $269 list.

Nikon cameras and Nikkor lenses are made by Nippon Kogaku, Tokyo, Japan.

See your Photo Dealer or write to Dept. 000
NIKON INCORPORATED
277 FIFTH AVENUE, NEW YORK 16, N. Y.

FAR LEFT: **Nikon Inc. was established in late 1953 on Fifth Avenue, New York, where Canon and Carl Zeiss had their US offices. This picture shows the first US premises at 277 Fifth Avenue, to the south of Central Park.**

LEFT: **An early Nikon Inc. advertising proof. At this time there were only four full-time workers, although they were soon joined by Nippon Kogaku technical support staff manning the nearby Japan Camera Center.**

Mitch Bogdanovitch, Eastern Optical's resident lens expert, observed: 'The lenses are highly accurate and efficient, and by comparison with German lenses more uniform in quality.' He was especially keen on the 5cm f/1.4 and 13.5cm f/3.5 Nikkors, adding: 'Their lenses have excellent colour correction, and perform better at wide apertures than do Zeiss lenses.'

Martin Forscher, who examined the Nikon body, stated:

> In the past, Japanese cameras have looked nice on the outside but on examining the interior it was found they were crudely made and inefficient, reflecting a low standard of craftsmanship. The Nikons, however, are made to close tolerances of accuracy and are well finished. Of course, since the camera hasn't been around for very long and hasn't been used too much, it may be that faults will develop which are not now visible. However, this does not seem likely, as the Japanese apparently have approached the design problem intelligently and as a result have simplified the mechanism.

The article ended with the interest indicated by *Life* magazine in the Japanese equipment, and a note saying that supplies would be available from January 1951 via the Overseas Finance & Trading Company Inc. of San Francisco, which had been importing Nippon Kogaku binoculars and scientific equipment for several years.

something quite special, and both duly used screw-mount lenses on their Leicas to record the entire conflict. Carl Mydans, also from *Life*, was another convert, initially using Nikkors on his Contax bodies, while Hank Walker (who was featured in advertising in a number of Japanese photography magazines) used Nikon bodies as well as Nikkor lenses to cover the troubles in Korea.

Following a series of tests in America, the highly respected *Life* magazine bought twenty complete outfits for its staff photographers, the first of many journals to do so. Word quickly spread outside the trade after Jacob Deschin told the Nikon story in a *New York Times* article dated 10 December 1950. After briefly describing the background of how Nippon Kogaku came to the attention of America's top photographers, Deschin outlined what equipment was available, and then added a few comments made by representatives of the Eastern Optical Company, the firm that had carried out the tests for *Life*.

RIGHT: In early 1956 Nikon Inc. moved to larger premises at 251 Fourth Avenue, as listed in this advert from the time. Fourth Avenue is located in the west side of Brooklyn, New York, and also played host to the Leica head office, albeit a couple of blocks away. Unlike earlier Nikons, the S2 was featured in a number of American magazines, including *Popular Photography*, *US Camera* and *Modern Photography*. The *Consumer's Research Bulletin* even went so far as to call the S2 the best 35mm camera in the world. The Japanese brand had at last gained general acceptance in the USA.

BELOW: The Nikon S2 instruction book.

BELOW RIGHT: Japanese advertising for the S2 dating from the early spring of 1955. Sporting an f/2 normal lens, it cost ¥68,500, while the faster f/1.4 lens added ¥14,500 to the invoice. Its main Japanese competitors were the Canon IV Sb, the Nicca 3-S and IV, and the Leotax.

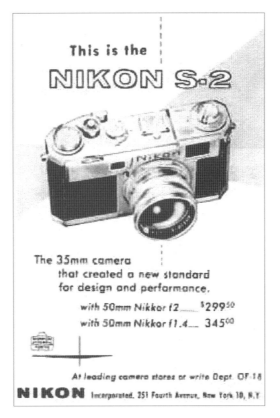

This is the
NIKON S-2

The 35mm camera
that created a new standard
for design and performance.

with 50mm Nikkor f2 ___ $299.50
with 50mm Nikkor f1.4 ___ 345.00

At leading camera stores or write Dept. OF-18

NIKON Incorporated, 251 Fourth Avenue, New York 10, N.Y.

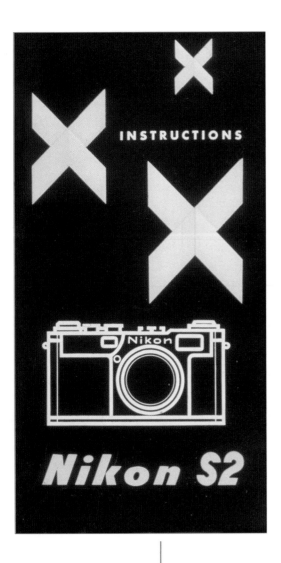

INSTRUCTIONS

Nikon S2

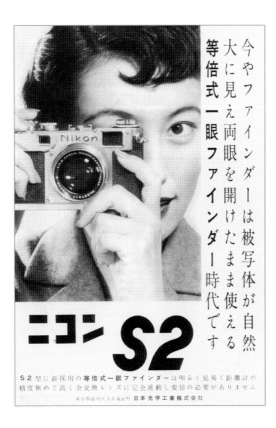

今やファインダーは被写体が自然
大に見え両眼を開けたまま使える
等倍式一眼ファインダー時代です

ニコン S2

S2型に新採用の等倍式一眼ファインダーは明るく見易く距離計の
精度極めて高く全安換レンズに完全連動し変倍の必要がありません

東京都品川区大井表町　日本光学工業株式会社

The publicity generated by this report and others in enthusiast publications, however, eventually led to the foundation of Nikon Inc. in the USA. This was largely the responsibility of Joseph Ehrenreich who, in the process of securing sole distribution rights for Nikon camera equipment in North America, also had an influence on product development, giving the factory in Japan a far clearer idea of what was required in this lucrative market.

Having established the Nikon Optical Corporation Inc. in New York three months earlier to cover importation, service and market research, Nikon Inc. was duly formed in October 1953. The following month Nikon Optical Corporation was renamed Nippon Kogaku USA Inc. Guided by the highly experienced Ehrenreich, both concerns played an enormous role in promoting the Nikon brand outside Japan.

The Japanese maker certainly had a lot of catching up to do: an American Leica advert from this period stated that 99 out of 100 colour photographs taken by *National Geographic* staff were shot using Leica cameras. To convert people from the mentality that the old established European brands were unbeatable would be a lengthy process, but the fight was made somewhat easier by the arrival of a new Nikon body – the S2.

The S2

Professional photographers were consulted to find out what improvements they would like to see in Nikon equipment, and this worthwhile relationship between the factory and selected end users continues to this day. Design work on the Nikon S2 began in 1953, under Masahiko Fuketa, and a couple of prototypes were ready for testing by the summer of that year.

While the Nikon I, M and S all looked very similar, the S2 was quite different in appearance. It was physically smaller, despite the revised internals to suit a larger frame size (now a standard 36 × 24mm), and the viewfinder was much bigger. From a technical point of view, though, the S2 featured a number of important improvements compared to its immediate predecessor.

The rangefinder and viewfinder were improved (the latter now covering 90 per cent of the frame rather than just 85 per cent), a faster top shutter speed was employed, and a flash socket with adjustable synch speed was introduced, along with an integrated contact for a Nikon flashgun (the BC III, with its better electrical connections and revised reflector dish, replaced the BCB II in November 1954, while the collapsible BC IV was introduced to augment the III in October 1955) in front of the accessory shoe.

At the same time, the S2 was considerably lighter than the S body, tipping the scales at 535g instead of 645g for the earlier camera. Holding the two bodies together, the difference is actually quite noticeable, with the lighter black lenses of later years making the S2 that much easier to handle again.

The winding mechanism was completely revised after the debut of the Leica M series (the 1954 M3 being the pathfinder of the line), the wind-on knobs being replaced by a modern lever arrangement that has continued

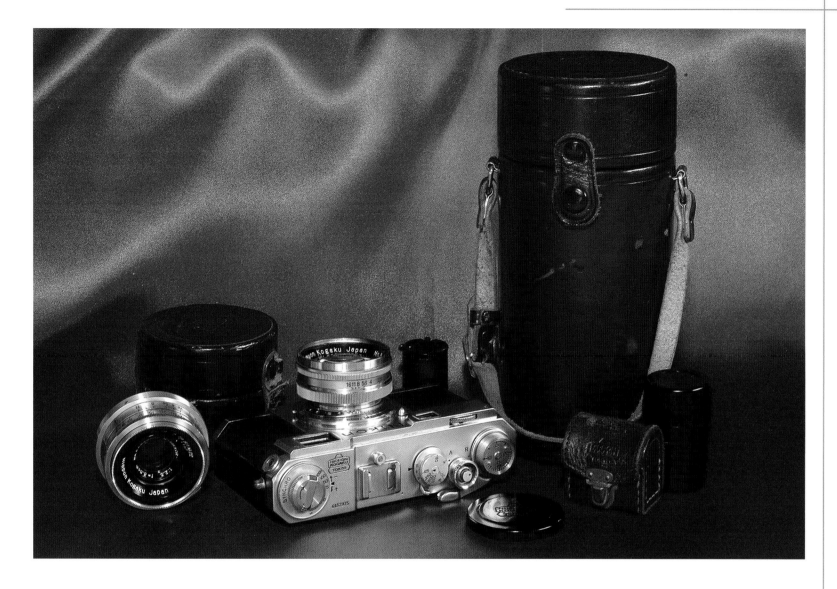

LEFT: An early S2 pictured with contemporary 5cm f/1.4 and 3.5cm f/2.5 Nikkors, and various Nippon Kogaku cases. These cases were lined with a wine-red velvet.

almost unchanged, at least in principle, to this day. This allowed a photographer to be ready to take the next shot that much faster, and gave the new Nikon a distinct advantage over the contemporary Contax and Canon. A single locking mechanism for the back (instead of the two formerly used) also helped reduce the time needed to change films.

The S2 featured so many enhancements over the S that, after deciding to add the new winding mechanism, it took the engineers some time to perfect the design. It was eventually signed off in October 1954, going on sale to the general public both at home and abroad two months later. The S2 carried the 16FB internal reference number, with production batches numbered from 16FB-1 onwards, the last one being 16FB-31 (dated June 1958, but not completed).

The birth of the S2 was timely, since the Leica M series had threatened to leave Nippon Kogaku in the dark ages. Like the Nikon S2, it featured a lever winding mechanism for the first time, and also adopted bayonet-mount lenses rather than the traditional screw thread. But the German camera offered the additional advantages of a variable frame viewfinder to correspond with lens usage, a single shutter speed dial, a self-timer, and faster film loading from the rear. At least adding a modern winder at the last minute kept the latest Nikon in touch with the new Leica.

The cost of ownership, however, was restrictive on both the Japanese and the German camera. In mid-1956, for instance, the S2 with a 5cm f/2 lens was $299 in the States (twice the price of a Zeiss Ikon Contaflex), while upgrading to an f/1.4 lens added

LEFT: European imports were initially handled by the Tokyo branch of Sweden's Western Trading Company, although restrictions were enforced in a number of countries immediately after the war. By the mid-1950s, however, Nikon's fame had spread throughout the world, and demand was high. To ensure the firm's reputation for quality and reliability was upheld, by August 1954 an even stricter testing procedure was introduced.

RIGHT: A Japanese advert from late 1955. The black covering on the S2 was leatherette rather than the real leather used on earlier RF models; the all-black S2 became available to order from the autumn of 1955. Incidentally, for display purposes a number of Nikon 'dummy' cameras were released over the years, taken from the production line before the body received many of its internal components. The most common dummy RF model, by far, was the S2.

LEFT: The company's advertising had featured several names and several different typefaces. In May 1954 it was decided to standardize the logo, which featured either a single form of *kanji* or the words 'Nippon Kogaku KK' in Roman characters. Towards the end of the 1950s Ehrenreich in America requested that all products carry the Nikon name, but for the time being only cameras would sport the famous moniker.

BELOW: The S2 catalogue of October 1956, showing a vast array of lenses and accessories. All regular wide-angle and the smaller telephoto RF lenses had external mounts, while the normals came with internal mounts. As usual, there is always an exception to any rule, and it should be noted that the 5cm f/1.1 was later modified to an external mount to better spread this heavy lens's weight. Longer telephoto lenses (of 18cm focal length and above) used a reflex housing to connect the lens to the body. The line of EL-Nikkor enlargement lenses was first introduced in January 1957.

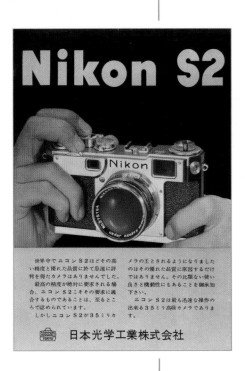

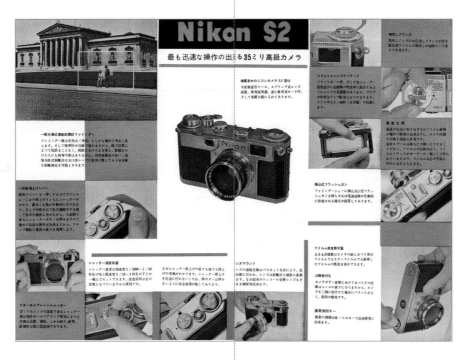

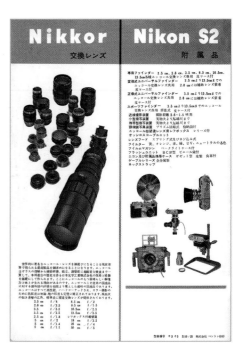

another $46 to the invoice. To put all this into perspective, a brand new Volkswagen Beetle would have cost $1,495 at this time! Nonetheless, 56,715 S2s were made, with around two-thirds of that total finding their way to American shores.

The System Grows

By 1955 competition among the camera makers was fierce, so Nippon Kogaku strengthened its sales and service network, and increased its level of general advertising quite significantly, as well as greater promotion within the trade. After all, by this time, around three-quarters of the company's turnover was attributed to camera equipment, and it was no longer prudent to rely simply on its good reputation.

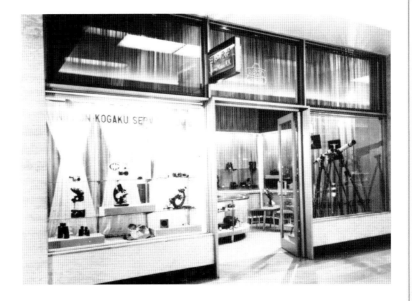

LEFT: **By the mid-1950s Nippon Kogaku had a domestic sales and service network that could live up to the reputation of its much-admired products. This is the Tokyo Service Centre in Marunouchi, where staff were also on hand to offer amateur photographers advice on how to get the most from their equipment.**

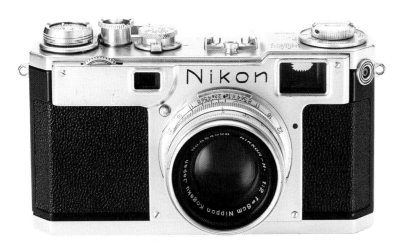

A 614 series S2 with a 5cm f/2 Nikkor.

Incidentally, cameras marked with the letters 'EP' in a diamond were usually sold through domestic part-exchange shops. The marking has been seen on everything from bodies and lenses down to accessories such as flashes and finders. There was nothing actually wrong with these items as such, they were simply sold this way to clear soiled or excess stock – unsold goods can attract tax in larger companies in Japan, so it is not a good idea to hold vast quantities of any item.

The range of Nikkor lenses was very extensive by the mid-1950s, with no fewer than eleven (covering eight different focal lengths) being carried over from the S body era. In 1955 a pair of new reflex mounted lenses joined the line-up: an 18cm f/2.5 version (it was also suitable for the F series when an adapter ring was used) and a 50cm f/5 model, the latter being as expensive (¥120,000) as it was immense and therefore remained quite a rarity; one has to bear in mind that a starting salary for a freshman

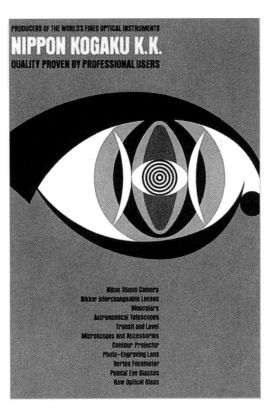

bank clerk was only around ¥6,000 a month at this time, and a bowl of noodle soup was about ¥40! But at least the 500mm lens was a good reply to Leica's 400mm telephoto, and offered an alternative to the 800mm Serenar offered by Canon since 1953.

The Nikkor lens line-up then underwent a drastic weight-saving programme via the extensive use of aluminium and alloys, wherever possible without reducing performance and quality, the first being the external

ABOVE: **Nippon Kogaku stepped up its advertising campaign in the mid-1950s, hoping to fight off the competition and promote the many other optical goods produced by the company.**

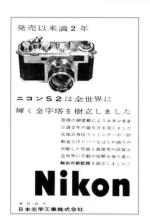

ABOVE: **An early 1957 advert for the S2, seen here with a lightweight 5cm f/1.4 lens, readily distinguished by its black finish.**

RIGHT: **The author's 1958 'Black Dial' S2 pictured with a contemporary 5cm f/2 Nikkor, and a BC V flash unit. Note the old-style battery and capacitor.**

mount 2.5cm f/4, but virtually all followed suit in the spring of 1956, the new lighter versions being readily identified by their black-painted barrels.

At about the same time the lens manufacturing process was simplified, while the Nikon reflex housing was redesigned, becoming far more modern in appearance, and the 25cm f/4 lens gained a preset diaphragm mechanism (like that of the 18cm and 50cm Nikkors). In addition, a new 3.5cm f/1.8 lens was introduced, along with a 5cm f/1.1 model to counter the f/1.2 version announced by Canon, Nikon's main Japanese rival.

Two rather unusual lenses came out prior to the launch of the SP: the collapsible 5cm f/3.5 Micro-Nikkor, which came with a chrome finish only, and the 3.5cm f/3.5 Stereo-Nikkor. The stereo camera was something of a fad, especially in America, although it was doubtless the fact that Leica offered a stereo lens that prompted Nikon to develop one. It was very similar to the German original, but despite a series of full-page advertisements and a five-year shelf life, fewer than 200 kits were sold in total.

As for accessories, small copying outfits were available from early May 1954, with the much-improved 'S-A' version superseding the original 'S' outfit in May 1956. A professional macro copy outfit, the 'P' version, was

listed from December 1954, with the 'PA' coming on line three-and-a-half years later, in mid-1958.

Close-up and microscope attachments (the Microflex) were also produced, the close-up kits coming with an auxiliary lens (rather like a screw-in filter) and a bracket containing the necessary correcting optics for the rangefinder and viewfinder.

Introduced in May 1956, the underwater casing for the RF Nikons looked very similar in design to the so-called lightweight aerial cameras produced by Nippon Kogaku during the Second World War. The Nikonos of later years was undoubtedly a far more practical proposition.

A 'Pro' Body

The Nikon camera had already gained the respect and custom of many professional photographers, but the SP quickly acquired legendary status. A few parts were carried over from the S2, but basically the SP was a brand

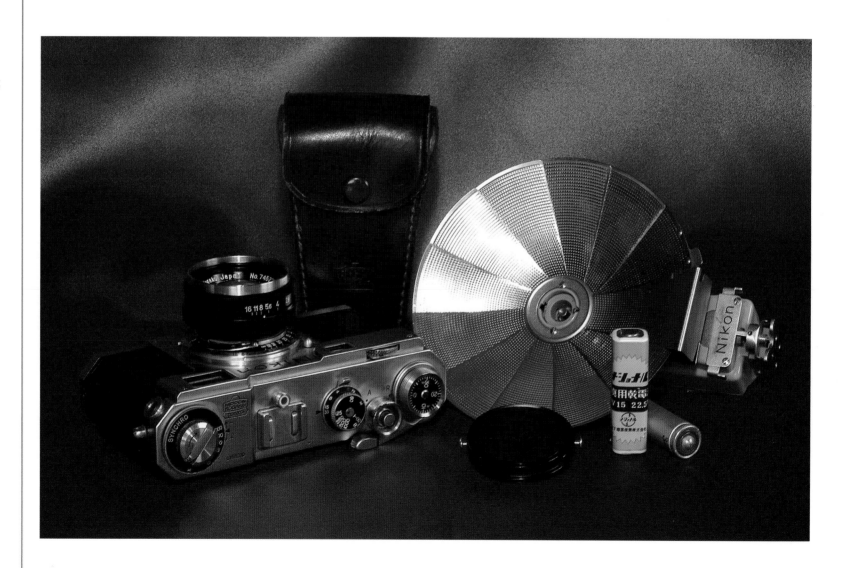

new camera, employing all the know-how Nippon Kogaku had amassed on the RF mechanism.

Introduced in all markets in September 1957, the SP, while far from cheap, was a Nikon body that could equal the company's unrivalled reputation for superior optics. Indeed, much of the Nikon F's design – undoubtedly one of the best cameras ever produced – can be seen in the SP, and the two bodies share a great deal of their respective components.

The SP was given a new, extremely precise shutter mechanism, with shock and noise reduction, and speeds selected on a single black dial. A self-timer was included in the specification for the first time at Nippon Kogaku, and there was an interlock on the shutter release to avoid firing the flashgun without first advancing the film. Incidentally, the standard setting for flash synch was slightly faster on the SP, but still limited to 1/60th of a second at this stage, up from 1/50th. Other speeds were selected by turning the shutter speed dial to 'T', then lifting it to select the 'X' or colour-coded high, medium or low settings. The BC V flash had just been introduced, with a slightly better collapsible reflector design compared to the one on the BC IV it replaced.

An interesting feature on the SP was another black dial under the rewind lever that selected illuminated finder-frame lines for the various common lenses in the Nikkor range (5, 8.5, 10.5 and 13.5cm, clicking into place one inside the other). A second finder, mounted close to the viewfinder, covered

BELOW: **Japanese publicity material heralding the arrival of the Nikon SP. With regard to the SP designation, the P was said to represent 'professional'. About ten prototypes were needed before the technically challenging viewfinder arrangement was perfected, but judging by the reaction of contemporary users, both at home and abroad, the effort was certainly worthwhile. The SP is still recognized as one of the best 35mm cameras ever made.**

BELOW RIGHT: **The SP instruction book. The SP was introduced at ¥98,000 with an f/1.4 normal, or ¥139,500 with the f/1.1 version.**

BELOW: **An advert for the domestic market from late 1957, at a time when the S2 was considered the second body for the SP. Both models would have used the BC V (or BC-5) flashgun, introduced in July 1957. Note the different body script introduced on the SP and used on all the RF models that followed.**

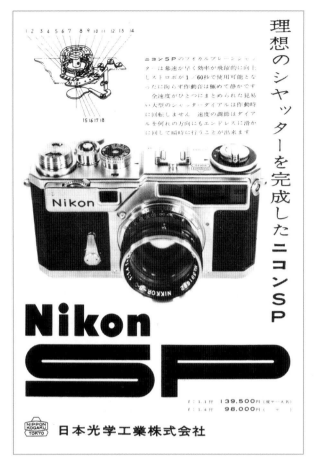

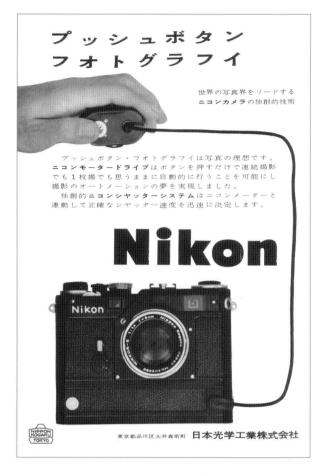

A striking poster for the SP. Note the new 'Nikon' typeface used in the company's advertising, which would gradually supersede the older style script, even appearing on an illuminated mast in Kyoto for maximum impact. Nippon Kogaku was lucky to have teamed up with Yusaku Kamekura of Nippon Design Centre fame, as he established the early Nikon house style, and even had a hand in the design of the Nikon F.

A Japanese SP advert from early 1958. A rangefinder field illuminator was made available for the SP, helping the user to pick out frame lines in low light conditions. By the way, some SPs have been found with the wide-angle finder blanked off. Collectors have branded these cameras as SP2 models, although there are no external markings to distinguish one from a regular SP body, and the numbers fall within those allocated in regular production batches.

The S36 motor drive came with an integrated camera back, and added little to the camera's weight or bulk. Indeed, with an external DC power source, it was very compact, and allowed single or continuous exposures until the film ran out. Several minor cosmetic changes were applied to the RF MD throughout its production run, and an S72 version was marketed for the S3M, the only difference being the calibrations on the frame counter. A coupled Nikon exposure meter was introduced at the same time as the S36 motor drive. Mounted on the accessory shoe, early versions were grey with an ASA range of 6–800, while later black versions were calibrated from ASA 6–3200. It could be used with the SP and the rangefinder cameras that followed.

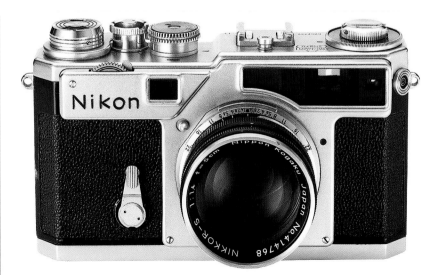

LEFT: A 620 series SP with a 5cm f/1.4 Nikkor.

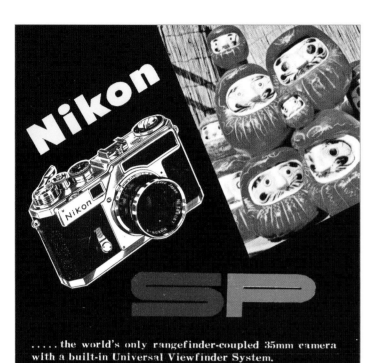

Nikon

SP

..... the world's only rangefinder-coupled 35mm camera with a built-in Universal Viewfinder System.

The Nikon SP is undoubtedly the most advanced rangefinder-coupled 35mm camera of our time. Its built-in Universal Viewfinder System alone distinguishes it as the only rangefinder-coupled "35" to realize the full potential of lens interchangeability—enabling you to choose and use the "right" lens for the picture, faster and with greater confidence.

The Universal Viewfinder System of the Nikon SP provides the correct viewing fields for six focal length lenses—28, 35, 50, 85, 105 and 135mm—the six focal lengths used most often in 35mm photography. There's no need for accessory finders—no time wasted slipping them on and off. There is nothing to interfere with the speed and ease of handling that is an integral part of the quality that Nikon users enjoy.

The ingenious grouping of the SP's controls is another case in point. With thumb on the film transport, middle finger on the focusing wheel and forefinger on the body release, it is possible to advance the film, focus the lens and trip the shutter with three fingers of one hand—in as little time as it takes to say: "advance—focus—shoot".

One of the most compelling features of the SP is its acceptance of Nikkor lenses, acknowledged today to be the finest in 35mm optics, as standard equipment. Nikkor lenses for the Nikon SP range from 21mm extreme wide-angle to 1000mm super-telephoto.

..... and these are the performance-tested features shared by the Nikon Automatic Reflex

* single-stroke film transport * high-speed rewind crank * non-rotating shutter speed selector dial * shutter speeds: 1 sec. to 1/1000 th * automatic "0" reset exposure counter * color-coded flash synch control * calibrated self-timer * removable back * fixed take-up spool *

Accessory includes Electric Motor Drive, Coupled Exposure Meter, and an impressive array of other special purpose items to meet every picture situation.

Nikon S3, identical to the Nikon SP, but equipped with built-in trifocal finder for 35, 50 and 105mm lenses.

With 50mm Nikkor F:2 or F:1.4 lens.

2.8 and 3.5cm lenses with fixed frame lines, virtually eliminating the need for a separate, accessory shoe-mounted finder. The choice of lenses available to the SP user was quite staggering, this latest Nikon inheriting no fewer than seventeen options (covering a total of eleven focal lengths) from the S2.

While an S2 had been displayed with an electronic motor drive (MD) at the 1957 IPEX show held in Washington, DC, in March, and MDs certainly were available for that model from May (forcing Leica to retaliate, although the German manufacturer had been developing and marketing mechanical motor drives since before the war), it is the SP that is recognized as the first Nikon to be offered officially in motorized form. All SPs had an MD attachment, the S36 initially winding on film at a rate of three frames per second. Once the film was finished, the frame counter automatically reset when the camera back was opened, regardless of whether the motor drive was fitted or not.

The SP body weighed in at 600g – 65g more than the S2, but still 45g lighter than the S. The SP's black dials and shutter release interlock had already been adopted on the S2 a couple of months before the SP was introduced, the changes appearing around body number 6180000. The two cameras ran alongside each other for about six months until the S3 made its debut in 1958.

While the S2 benefited from the adoption of SP features, so the SP benefited from features borrowed from the F. The latter's titanium shutter

FAR LEFT: English-language publicity material for the SP.

ABOVE: Two SP adverts featuring the 5cm f/3.5 Micro-Nikkor and the 3.5cm f/3.5 Stereo-Nikkor. Almost all RF Nikkors (and a few early F series ones, too) were marked up in centimetres rather than millimetres. The only exception to the rule is the last variation of the f/1.4 normal (launched in 1962) and, of course, the recent reproduction based on it.

curtains, for example, were introduced after May 1959, replacing the original cloth items.

The SP carried the 26F2B internal reference number, with production batches numbered from 26F2B-1 through to 13, the final batch of just under a thousand units being issued in 1964, some time after the general 1957 to 1963 sales bracket, in order to fulfil the many requests filed by members of the press in readiness for the Tokyo Olympics. Starting on body number 6200001, a total of 22,348 of these magnificent cameras was eventually made.

The S3 and its Variants

The S3 was introduced as a second body for the SP in March 1958. It used far more components in common with the 'Pro' body than had the S2 before, so production could be rationalized. Indeed, the main difference between the S3 and the SP was its viewfinder system with fixed frame lines for only 3.5, 5 and 10.5cm lenses. This made the two cameras quite different in appearance, although otherwise they were very similar, with just a new front plate and the lack of a dial for viewfinder selection under

RIGHT: Rear view of the author's SP, clearly showing the novel viewfinder arrangement. It's hard to believe that the Ricohflex is from the same era.

LEFT: The S3 instruction book.

BELOW: One of the first S3s with a 5cm Nikkor lens of an earlier vintage.

ABOVE: The S3 catalogue from the time of the model's launch. Note the electronic exposure meter, brought out with the SP in September 1957. On the subject of accessories, the so-called Panorama Head became available in March 1958, screwing into the camera's tripod socket to allow accurate multiple frame landscape shots. As for lenses, to give an example of prices in early 1958, the 2.8cm f/3.5 was ¥30,160, the 8.5cm f/2 was ¥34,840, and the 13.5cm f/3.5 was ¥31,720.

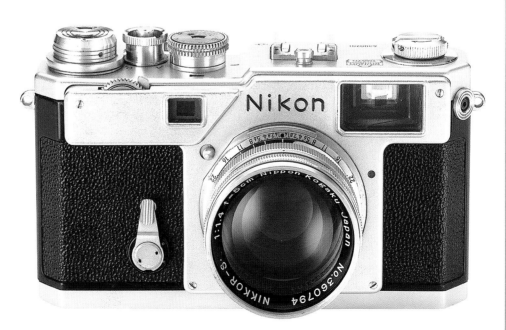

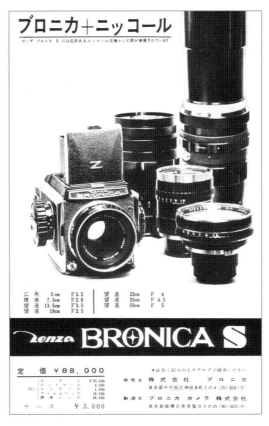

ABOVE: The Yashica 35 of 1958 looked very similar to the Contax IIa and Nikon S2/S3, but cost only ¥12,000. Yashica eventually killed off the Nicca brand and started making its own lenses at about this time. Interestingly, Tanack, which had previously made Leica-style cameras, such as the Nicca, also opted for Contax and Nikon's sharper body styling in later years, as can be seen in this domestic advert.

ABOVE RIGHT: Nippon Kogaku supplied Zenza Bronica with its medium format lenses from 1959. The arrangement lasted for many years, taking in focal lengths ranging from 40mm to 1,200mm.

the rewind crank setting them apart externally, and the S3 having a bigger prism on the inside. As such, even though its designers had hoped for a lightweight casing, at 580g the S3 body was only 20g lighter than the SP flagship model.

The choice of lenses was the same as that offered with the SP, with both gaining two more options in 1959: a compact 13.5cm f/4 for use with the newly announced bellows and the Nikon reflex housing (it was also suitable for the F series bellows when an adapter ring was used), and a new external mount 2.1cm f/4 wide-angle lens that answered Leica's introduction of a similar model in 1958 and had Canon's technicians scratching their heads for five years. As with the 2.5cm Nikkor, universal finders did not cover this focal length, so a special one was supplied with the lens. Meanwhile, the 5cm f/1.1 Nikon mount was changed from an internal one to an external one to reduce stress on the mounting point caused by the weight of the lens (the screw mount lens continued as before), and the 3.5cm f/2.5 gained a more modern-looking barrel.

The S3 carried the 26F1B internal code, with body numbers starting on 6300001. In all, 14,310 S3s were built (including a batch of 2,000 black models made in 1965), but in the meantime there were a couple of other S3 variants brought to market that deserve at least a few lines – the S4 and the S3M.

As well as 13 per cent price reductions on the existing S3 and SP cameras in spring 1959, the S4 was introduced in March that year to further reduce the cost of entry into the Nikon world at the same time as Canon brought out its budget P (or Populaire) model. By now it should be clear that a seemingly never-ending war of one-upmanship between these two great concerns has existed ever since Nippon Kogaku decided to build its own camera, and the rivalry is every bit as strong today, or perhaps even

RIGHT: Binoculars and telescopics continued to sell well alongside the Nikon cameras. In 1959 the Nikon brand name started to be applied to these products, too.

LEFT: In May 1959 Masao Nagaoka became Nippon Kogaku's Chairman, handing the position of President to HIROSHI SHIRAHAMA, shown here, who stayed in office until 1969. Sales were falling off at this time, but the launch of the new F series camera would see a revival of the company's fortunes.

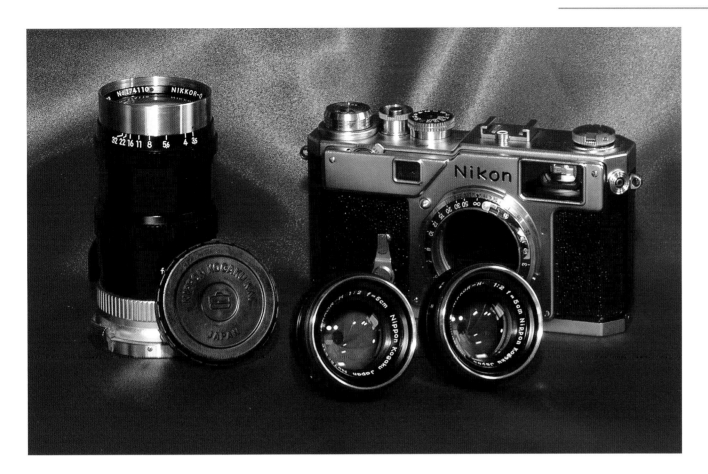

LEFT: The author's 1960 S3 with a contemporary 13.5cm f/3.5 telephoto and a pair of slightly earlier F2 normals. Note that one of the 5cm lenses has a red 'C' mark after its lens designation, while the other (made only a few months later) does not.

BELOW: A special fisheye weather observation camera produced in 1960; a similar item had been made for the Imperial Navy in 1938. The shutter on this medium format camera (priced at a staggering ¥200,000) was made by Seiko, although many popular Japanese cameras from this period used Citizen units. Both concerns are world famous for their watches nowadays.

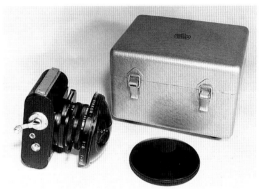

RIGHT: Two pieces of contemporary film advertising: one from Sakura (better known nowadays as Konica), and the other from Fujifilm.

more intense, as the two continually vie for the title of the world's best camera maker.

The S4 was basically an S3 without a self-timer (or MD attachment on the body underside, although this could, like the self-timer, be added at extra cost) and came with cloth shutter curtains, a 5 and 10.5cm frame line only, and an S2-type frame counter instead of the SP/S3 version.

The factory reference for the S4 was 26F4B. Of the 5,898 produced, mostly with a chrome finish, some carry 630 series body numbers, while others are in the 650 range. This camera was not exported to the USA, so most were sold in Japan, many through part exchange shops.

The S3M, introduced in April 1960, was Nikon's answer to the Leica 72, albeit the best part of a decade late. The half-frame format was never popular with fans of the German camera, so what possessed Nikon to market one at a time when the F had taken the photographic world by storm shall probably never be known.

Apart from the half-frame format (calling for a different frame counter, recalibrated to allow it to cover 72 frames) and an improved viewfinder (although still with frame lines for only 3.5, 5 and 10.5cm lenses), the

RIGHT: The black S3 – a real prize for collectors nowadays. Although general sales ended in April 1963, a special run of S3s (finished in black) was produced by Nippon Kogaku in 1965. Note the late style normal lens, introduced in October 1962, and marked in millimetres rather than centimetres.

BELOW: The Olympic Games were supposed to have been held in Tokyo in 1940, but they were cancelled owing to hostilities. Japan had to wait another twenty-four years before the games were finally hosted in the Land of the Rising Sun. At Helsinki in 1952 Nikon cameras were used mainly for snapshots, playing a supporting role to the large format Graflex; by Melbourne, in 1956, the Nikon was used more prominently, and by Rome it was evident that almost all the press covering the event used Nikon equipment. In Tokyo there was hardly another brand to be seen.

OLYMPIC NIKON SERVICE

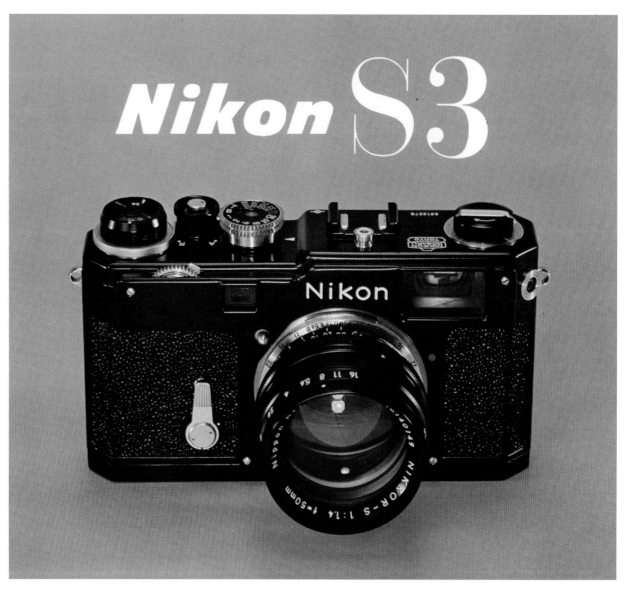

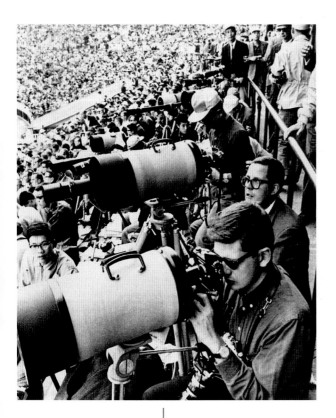

LEFT: Fortunately, in view of its great expense (introduced at ¥230,000, it was more than half the price of a contemporary small car!), the 100cm lens could be used with the F series via the use of an adapter ring, as seen here in use at the Tokyo Olympics. At this time, a friend of the author's started his teaching career on a salary of ¥12,000 per month, while a bank clerk would have drawn around ¥20,000 a month in his first year; noodle soup was ¥150, the average magazine ¥50, and a one-way trip on the newly opened *Shinkansen* line from Tokyo to Osaka was ¥2,480. It is indeed a good thing Nikon equipment was built to last.

S3M was basically the same as a standard S3. Most had a motor drive fitted (type S72), allowing up to nine frames per second for those who required it, such as those covering motorsport.

Sold worldwide, the S3M carried the 26F1MB internal reference code. Allocated the 660 series of body numbers, only 195 were made, although, as with virtually all RF models, gaps exist in the numbering, so serial numbers go much higher than one would expect given the sales volume.

By the time the S3M made it into shop windows, it was joined by three more lenses – the lightweight and compact, external mount 10.5cm f/4, and the reflex mounted 35cm f/4.5 and 100cm f/6.3 Nikkors. The 35cm lens was notable for its semi-automatic diaphragm, while the 100cm Reflex-Nikkor model was unique in that it used mirror optics, being the first series production mirror lens made for a 35mm camera. Apart from a final modification on the 5cm f/1.4 normal in late 1962, which brought

with it a significant change in its optical formula and construction, and the end of screw mount lens production in the early 1960s, this just about completes the RF lens story.

Confusion Reigns in a Land of Order

There is a great deal of myth and confusion surrounding the final RF body numbers, due in part to the fact that the SP, S3, S4, S3M and F models were produced and sold side by side. Some early S4 models carry the same 630 series body numbers as the S3, and then they mysteriously jump to 650. This is because the F was allocated the 6400001–6499999 block of serial numbers, although the legendary SLR soon exceeded the latter, and the S4 and F ended up sharing the 650 series batch designation, which seems a bit odd given the initial attempt to separate them.

Further confusion reigns with the S3M, which appears to have been given a unique serial number block (6600001–6699999). This allocation of batch numbers is often credited with being reserved for the S4, but the previous paragraph clearly disproves that theory and, although S3M production started on 6600001, there were also quite a few F cameras built using the same 660 series numbers, so, in reality, it was not reserved at all; starting at 660 simply differentiated the S3M from the S4.

No Nikons of any kind were built in the 661 to 669 series inclusive. After this large gap in body numbering, production of the F resumed with 6700001 onwards and things ran in a uniform manner thereafter. The reason for this is not related to the RF models at all – the gap was to differentiate the Photomic T body from its predecessors. As the good Lord Byron once said: ''Tis strange – but true; for truth is always strange, stranger than fiction.'

It is probably worth noting the Japanese way of counting at this point, as this should help make the Nikon numbering system (630, 640, 650 etc.) become a little clearer. Whereas most countries tend to count in hundreds, thousands and then millions, Japan goes from the hundreds to the thousands, and then increments of 10,000 before hitting 100,000,000 – the next, rather distant step up in the system. Therefore a lot of things in Japan tend to get counted in figures with four digits at the end. As a result, we find that with the F, for instance, we do not have '64' series cameras as such, but '640' series, '641' series, and so on, all the way up to the '745' series.

This rather unusual counting system goes a long way towards explaining why Nikon stuck to serial numbers with four digits at the end of batch numbers (blocks of 10,000 units) after the introduction of the 610 serial numbers that followed on from the so-called eight-digit Ss in the 609 series.

As for the presence of the eight-digit Ss, this can simply be explained away as a lack of communication between Nippon Kogaku and the company engraving the top plates. These valuable parts could not be wasted at the time, as the firm was having to save as much money as possible in order to survive. The fact that in 1950 the management was seriously considering dropping the Nikon bayonet mount in favour of the M39 screw mount already being made for Leica cameras, in order to cut production costs, clearly illustrates this point.

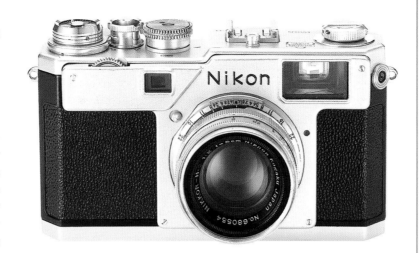

ABOVE: **The S4 instruction book.**

ABOVE LEFT: **One of the last S4s, seen here with a 5cm lens of an earlier vintage.**

LEFT: **A 1962 prototype body with TTL exposure metering and a new F-style bayonet mount.**

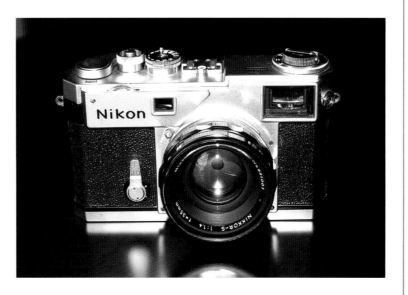

LEFT: **The prototype second-generation SP (body number 6800005), designated SPX at the factory, seen here with an experimental 35mm f/1.4 Nikkor-S lens. Superseding the earlier TTL prototype, several examples of the 1965 SPX exist with minor changes in control cosmetics. The finder arrangement was much more conventional in its appearance, but time had simply run out for the RF series.**

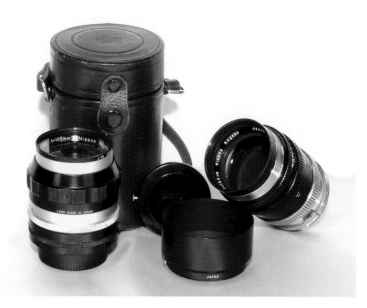

Nikon RF Replicas

Interestingly, the rangefinder camera has been making something of a comeback in recent years. The Kyocera Contax G1 and G2 were joined by the Cosina Bessa series (signalling a return of the Voigtlander name in the process), and the list of contenders in the RF market has continued to grow as enthusiasts seek out something a little different. It is ironic that, while Kyocera has just announced its desire to withdraw from the camera business, Epson – perhaps more famous for its computer printers – has even introduced a digital rangefinder with elegant 1950s styling, so this niche market is obviously still there.

Having rejected an interesting prototype called the SP20 in the early 1990s (featuring Art Deco styling, manual or fully automatic control, and a compact 24–80mm f/2.8–4 zoom lens), Nikon spotted the potential of cashing in on Japan's retro boom and the unquenchable thirst of collectors by issuing its own rangefinder camera in April 2000. This, however, was not a new RF model, but basically an exact replica of the chrome-bodied S3, even down to the 'Olympic' 50mm f/1.4 lens.

Six years in the planning, differences between old and new S3 were few, and it took the most dedicated of enthusiasts with access to an original S3 to spot them. Apart from the body numbers, the film advance lever was fractionally larger, the strap lugs were not quite as rounded, and there were detail changes on the baseplate (such as the film speed selector and 'Made in Japan' stamping) and frame counter housing. Even on opening the back, the film rails were the only notable difference.

The chrome S3, known as the 'S3 Year 2000 Limited Edition', was on sale until the summer of 2001, by which time around 8,000 units had been produced. Carrying a list price of ¥480,000, there was no problem finding an eager queue of buyers, and this prompted Nikon to introduce the 'S3 Limited Edition Black' in the spring of 2002. Again, numbers were

limited (this time officially restricted to 2,000 units rather than by the amount of orders received), and the price reflected that of the earlier RF models with a black finish – at ¥530,000, it was slightly more expensive, at least in percentage terms (the ¥50,000 difference on the chrome S3 replica would buy a couple of cheaper digital Nikons, after all).

In January 2005 Nikon announced its third replica model, a black SP mounted with a W-Nikkor 3.5cm f/1.8 lens. This exotic combination was limited to 2,500 units only, priced at ¥690,000 apiece. Known as the SP Limited Edition, bodies were given a batch of serial numbers starting with SP 0001, while the first lens was marked 0001 to match. It is interesting to note that Nikon's engineers saw this as an ideal opportunity to pass on the manufacturing and production techniques from a bygone era.

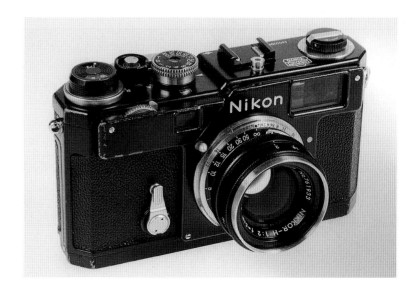

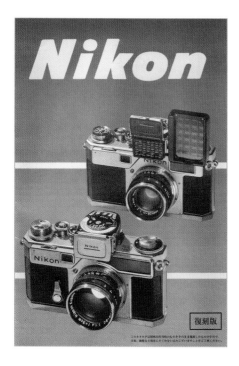

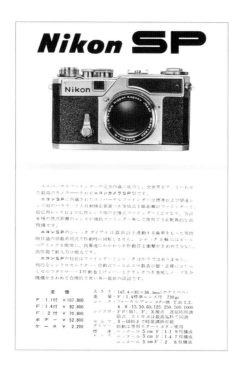

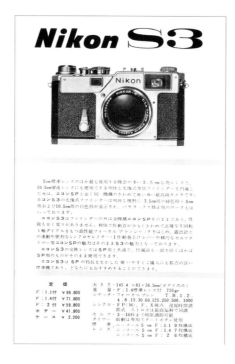

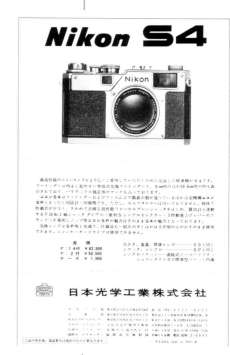

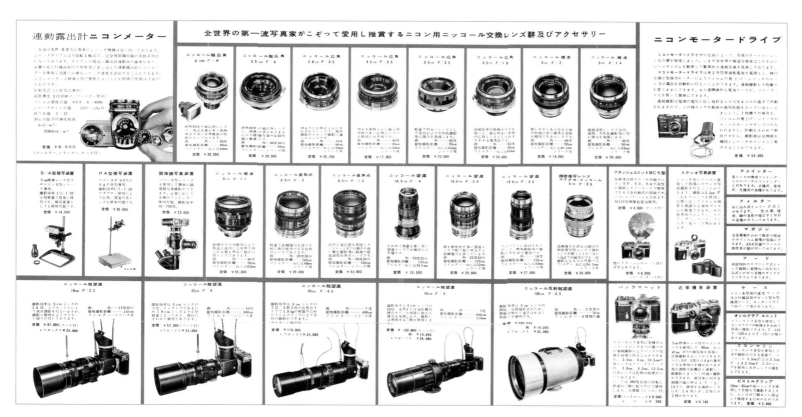

A reproduction of the Nikon rangefinder camera catalogue of 1960, including all the lenses and accessories available at that time.
Reprinted in 2000 to fit inside the S3 Limited box, it even shows the construction of each lens, and the prices at that time.
For instance, an SP was ¥85,000 with an f/1.4 lens and a case.

RIGHT: One of the very last S3Ms mounted with a contemporary 5cm f/2 Nikkor.

FAR RIGHT: Mock-up of the elegant SP20.

RIGHT: The S3 Limited, dating from 2000. Body numbers started on S3 200001, while the lenses were numbered from 150001 onwards (continuing well into the 200000s thanks to some large gaps). The S3 Black of 2002, which used the same lens, had a batch of serial numbers beginning with body S3 300001. The body (code M200) was made at the Mito plant, with the lens manufactured in Tochigi.

BELOW: The catalogue for the SP Limited Edition, issued in 2005. The first camera was presented to the JCII Camera Museum in Tokyo.

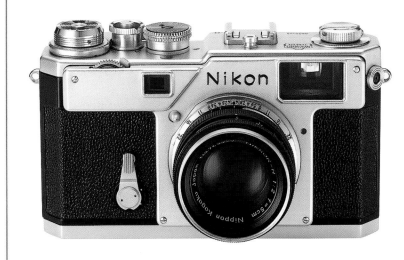

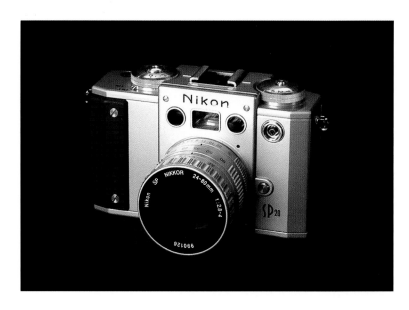

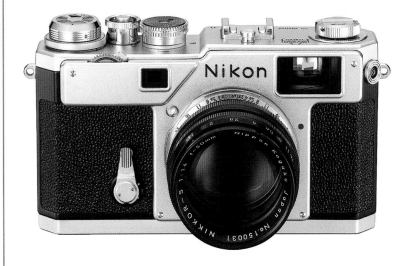

A Final Mystery

Towards the end of the 1950s, the management at Nikon Inc. in the USA requested a miniature 16mm camera to compete with the established Minox and Gami models from Europe, and the Japanese Mamiyas of the period. Fitted with a 25mm f/1.4 lens, it was not particularly small by the standards of a Minox (it was about the same length, but twice as tall and thick), although it was beautifully made. Apparently two prototypes were produced, but both have disappeared without trace. The example originally sent for appraisal is believed to be somewhere in America and the other is presumed to have been retained by the factory. However, enquiries with Nikon's head archivist drew a blank, so this little camera remains something of a mystery.

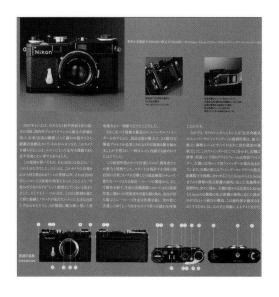

THE FIRST SLR MODELS

WITH THE DAWN OF the SLR era, it is fair to say that the Leica brand seemed to lose some of its appeal. The quality of the fabulous M series was never in question, but RF cameras were increasingly being thought of as old fashioned by many professionals. This led the German maker to introduce the Leicaflex model in 1964, but it was too little too late. The Japanese onslaught on the industry became a stranglehold as this new advance in photography took the world by storm.

Pentax had brought out a new line of M42 screw-mount cameras in 1957, replacing its ageing Asahiflex range, and leading to the respected SP of 1964 vintage. Minolta had the SR-2, with the SR-T101, perhaps the ultimate development of the SR series, launched in 1966. The Petri Penta proved quite popular, while Canon introduced its Canonflex model in May 1959, which was quickly refined into its F series, running alongside the last of the RF models (the 7 and 7S) and the budget Canonet line.

Perhaps more than any other Japanese camera, though, it was the Nikon F that made a lasting impression. The F did a great deal to boost the image of Japan, and is ever present in photographs from the 1960s, used and loved by the press since the day it was introduced. While today's professional photographers have moved on to the F5 or F6 and the top digital Nikons, at least the original F can still be seen in period dramas and films.

Probably the strongest memory of the F in recent years came courtesy of Clint Eastwood in his stunning portrayal of a photographer in the 1995

film *The Bridges of Madison County*, armed with a Nikon F on a shoot for *National Geographic*. Brilliant story, excellent props (including a fake copy of the May 1966 issue of *National Geographic*, various photos and a couple of contemporary camera bags supplied by the society) and a superb performance from the leading actor – I'm sure a lot of people wanted to own the camera Eastwood used on set.

The lure and mystique of the F is still so powerful, nearly half a century after its birth, justifying video productions and countless magazines to be published in its native country. As recently as summer 2004, one top Japanese photography magazine conducted a survey to find out which camera created the most excitement amongst its readers. Which, out of all the cameras they'd ever seen, did they most want to pick up and use? Top spot – surprise, surprise – went to the Nikon F.

The Legendary Nikon F

Development of the Nikon F (code 20FB1) started in February 1957, making it a relatively late entry into the SLR world. The first SLR, the Kine Exakta from Jhagee of Dresden, made its debut in 1936 but its finder system was far from perfect. The TTL (through the lens) penta prism eye-level viewing system was introduced by Zeiss Ikon on its Contax S in 1950, and gradually improved by others in the industry over the ensuing years. Its advantages were obvious, bringing an end to the need for a bulky reflex housing on longer telephoto lenses, for example.

From the outset it was decided that Nippon Kogaku would make the ultimate SLR to sell alongside the SP, and a list was drawn up containing the camera's necessary key features. Interestingly, using the method adopted by that genius of the automotive world Dr F.W. Lanchester, the list was compiled by looking at faults in existing designs rather than the good points.

It was decided after much research that the F should have 100 per cent coverage in the viewfinder, interchangeable finder screens, alternative finders for specific purposes (such as eye level, waist level, and action finders), a bayonet mount with a large internal diameter and a wide range of lenses, a facility to lock up the mirror, fully automatic diaphragm operation, titanium shutter curtains, and the ability to expand usage via attachments in much the same way as the Building Block System (BBS) applied to scientific equipment, signalling the true birth of the Nikon System.

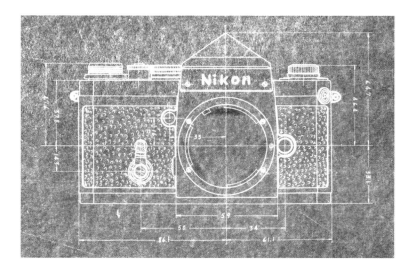

FAR LEFT: **Blueprint for the original F design.**

RIGHT: **Sectioned F body and lens, showing the incredible amount of technology crammed into the package.** COURTESY JCII CAMERA MUSEUM, TOKYO

At an early stage in the design process it was declared that as many parts as possible would be carried over from the SP, which was already recognized as being one of the world's finest cameras. Ease of operation was also cited as a necessity, as well as a strong but light body, and the latest technology would be employed to keep size and weight down to a minimum.

Three initial prototypes were made, the first Nikons to carry the famous F designation. Incidentally, 'F' was chosen as so many other SLRs used 'R' in their model numbers, and F (as in flex) was more universal in its pronunciation in the majority of languages. This was just part of Nippon Kogaku's attempt to develop worldwide appeal for the camera, since good marketing was seen as a crucial element in its success or failure.

The first prototypes were basically an SP with a mirror box in the centre and a penta prism on the upper part of the body. Much time and energy was spent refining the mechanism, getting the mirror to operate smoothly and precisely, and synchronize this movement with the shutter (the F being the first camera in the world to feature titanium shutter curtains, these being just 0.02mm thick to reduce mass, and therefore reaction time, although the first 100 or so built had RF type *Habutae* curtains) and the automatic lens diaphragm. Early SLRs suffered from having to reset the aperture manually after focusing, so an automatic system was devised to fully open the diaphragm after each frame. A mirror lock-up facility and depth-of-field preview button were also provided, adding to the complication.

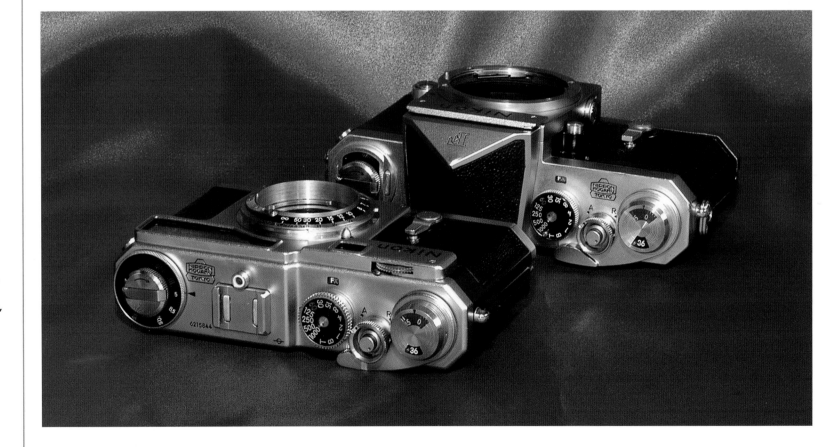

RIGHT: **Top plates of the author's SP (nearest the camera) and 640 series F. The similarities, especially on the right-hand side of the camera, are quite striking. The film advance lever was painstakingly hollowed out from behind on both, although simplified production methods were adopted as F sales took off.**

The F Bayonet

The bayonet mount caused problems, too, as the ring had to withstand a lens being fitted tightly against it thousands of times yet remain perfect, and the body had to be strong enough to support the weight of longer lenses without distortion. The F mount, with its stainless steel ring and body-mounted lens release mechanism, was ultimately perfected, and given a 44mm effective internal diameter, as opposed to 34mm for the Nikon RF series. It is certainly not mere coincidence that the diagonal across a 36 × 24mm film frame measures 43.3mm! No-one can dispute Nippon Kogaku's attention to detail – getting the engineering right from the start. This has allowed the basic F mount to be retained to this day, while other manufacturers have found themselves having to go through a number of lens generations to catch up.

Naturally, the F's lenses all had to be designed to suit this new mount, with special attention paid to the rear of the lens: unlike some of the earlier Nikkors, they could not protrude back beyond the mount too much, unless absolutely necessary, as they would have clashed with the mirror. It was then a question of balancing weight against robustness and reliability, and incorporating good handling characteristics.

At the time of the F's debut four 'Auto' lenses with automatic diaphragms and light alloy barrels were available: a 3.5cm f/2.8, a 5cm f/2, a 10.5cm f/2.5 and a 13.5cm f/3.5. Five other, longer telephoto lenses (and the 13.5cm f/4 bellows lens, mounted via the B-F tube, known as the BR-1) were shared with the RF models initially via the use of an N–F adapter ring, although many more Auto Nikkors would follow over the next few months.

There seems to be no rule regarding the locating prong on the lens (sometimes referred to as a 'crab's claw') that allows accessories such as the exposure meters and Photomic heads to ascertain the aperture setting: both sharper and more rounded versions exist from the earliest days, and continued to run alongside each other for many years. It is fair to say, however, that only the rounded type survived into the 1970s. In addition, some very early lenses had a red 'R' to indicate infra-red focusing, but this was quickly replaced by a simple red dot.

Meanwhile, the design also called for interchangeable finders and finder screens, and this was executed with a very elegant solution. The finders locked in place using pins and spring-loaded catches, while the screens sat below (lying flat on top of the mirror box); both could be changed quickly and easily using the same release button to the left of the viewfinder. With the basic structure in place, it was then easy to build up a range of alternative finders and screens to suit various situations.

Accessories were prepared well in advance of the launch, including an exposure meter that hooked onto the front of the camera (a small pin on the shutter speed dial making a positive connection with the selector on the clip-on meter), flashguns (the BC-5, which was the same as the old rangefinder BC V model, was the first to be released), and a motor drive – the world's first practical MD for an SLR.

The F-36 motor drive, with its integrated camera back, was rated at 3.6 frames per second, while the F-250 (introduced in August 1960, priced

RIGHT: The F was announced in the media in March 1959, with domestic sales beginning three months later. In the meantime Nippon Kogaku arranged a number of press gatherings around the country in order to promote their latest product. The F found approval wherever it went.

BELOW: America also first heard about the F in March 1959, at the Philadelphia Show. Exports to the States began in May, two months before other export markets. Reaction was extremely favourable, perhaps even better than that witnessed in Japan. This picture shows the F with the earliest exposure meter, introduced in September 1959, but given a slightly different lens coupling clip not long after.

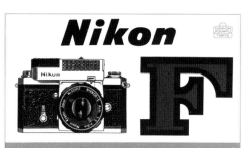

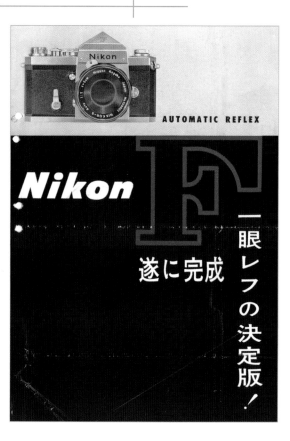

BELOW: The F instruction book.

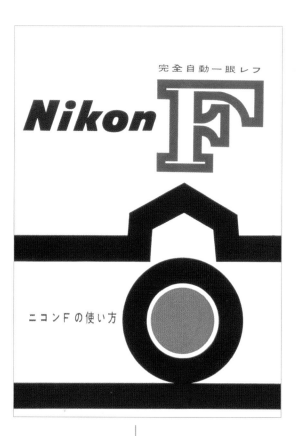

at ¥65,000) allowed bulk loading of film, with up to 250 frames being possible before the need to change rolls. In reality the F-250 was not a big seller (usually not much more than 200 units a year), but it was an important weapon in the fight to keep professional users onboard. In 1962 it was used in an unusual application for surveillance, in which it was linked to a TV, and given remote control and a zoom lens to capture movement from a distance.

The regular motor drive was used as part of the F's reliability test. The shutter was tested by shooting 10,000 frames in rapid succession using a motor drive, and only then – assuming everything still worked perfectly –

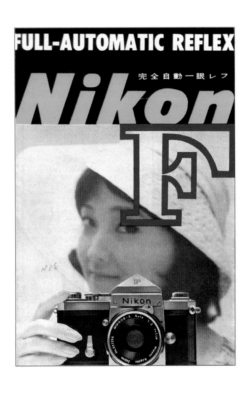

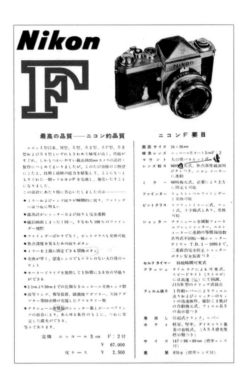

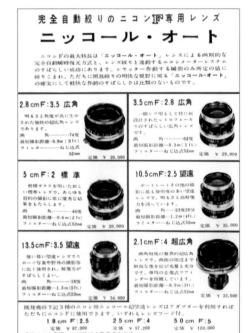

The Japanese catalogue from August 1959.

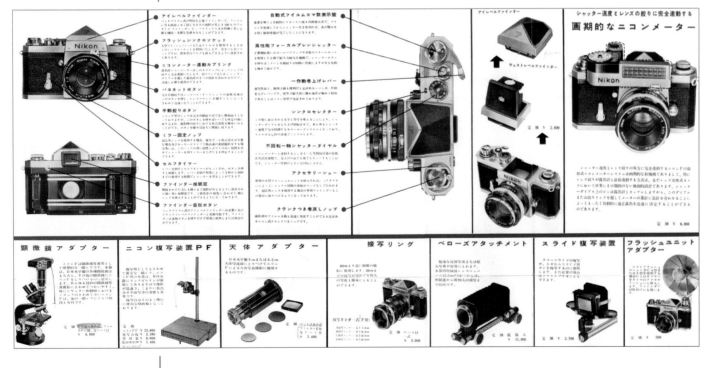

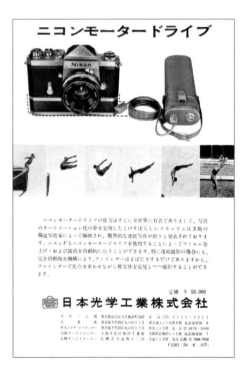

was the camera passed. Other tests included operation in extremes of heat and cold, and whilst being shaken.

Part of the F's enduring appeal lies in its styling. The die-cast body design was actually not the work of a camera designer but of Yusaku Kamekura, a graphic artist from Nippon Design Centre. It resembles the earlier S models in plan view, but the front is very distinctive, especially the beautiful prism with its instantly recognizable F logo.

The F was certainly not cheap, the body alone costing ¥47,000 when sales started in June 1959 (it was ¥67,000 with a 5cm f/2 lens, or ¥1,500 more for a black finish), but the success of the F can be gauged by the fact that Nippon Kogaku had just over 2,000 employees in that year, and within a decade the figure had shot up to almost 4,300. The number of staff continued to grow steadily thereafter.

Birth of the Zoom

By the end of 1959 the 2.1cm f/4 Nikkor advertised at the time of the F's launch had at last made it into the shops. The design of this wide-angle lens required the camera's mirror to be locked up and therefore a separate finder was needed. But it was an impressive lens and remarkably light. At the other end of the scale, December 1959 saw the introduction of the 8.5–25cm f/4–4.5 Auto Nikkor, the first zoom lens released by Nippon Kogaku (or indeed any Japanese manufacturer, for that matter). This massive zoom was

about fifteen times heavier than the weight of the 21mm Nikkor and, at ¥99,000, cost three times as much. However, it was quickly modified cosmetically after between 150 and 200 units to incorporate the familiar chrome front ring (to take a close-up lens) and a black focus ring, coming together to make it more stylish. Before the summer of 1960 came to a close, the focus and zoom rings were combined via a large resin sleeve, making the lens much easier to handle. As such there are three variations of this first Zoom-Nikkor: although it stayed in production for a decade in all, fewer than 17,000 of these early models were made before it received an internal redesign and a black front ring in 1969.

A prototype 3.5–8.5cm f/2.8–4 was displayed in 1960, but only three of these elegant zooms are known to have been built (starting with number 352801). Meanwhile, the 5.8cm f/1.4 Nikkor became the fastest F lens available in January 1960 (despite being a short-lived variant, later

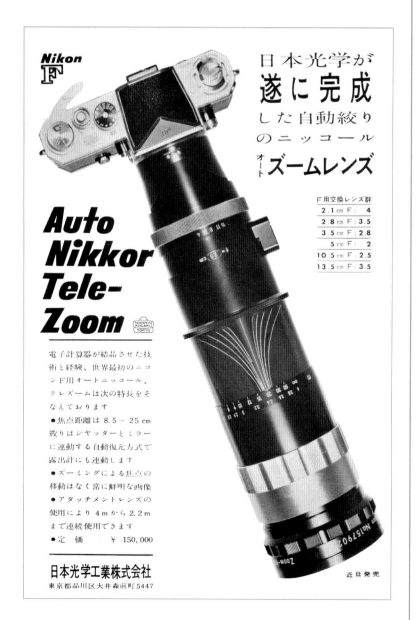

Early promotional paperwork for the F, seen here fitted with an f/2 normal.

LEFT: A domestic advert showing Japan's first zoom lens, the impressive 8.5–25cm f/4–4.5 from late 1959. Designed by Takashi Higuchi, it quickly received a few cosmetic changes before exports began in earnest, and was then revised again before the end of 1960 to incorporate a new focus/zoom ring arrangement.

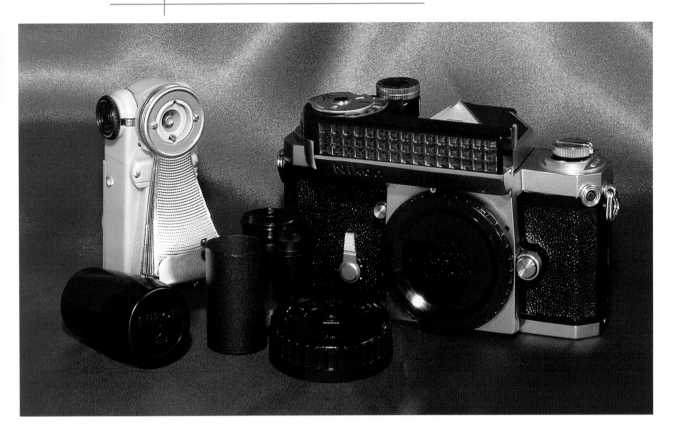

ABOVE: A 640 series F with a Type II exposure meter. The Type II and Type III meters had been introduced in August 1960, replacing the original version, and priced at ¥4,800 and ¥7,100 respectively (the Type III looked like the Type I, with squared-off edges, and cost more than the Type II due to its two metering ranges instead of one). Very early body and rear lens caps, as seen here, carried the 'Nippon Kogaku' mark, like the RF series. The SLR version was marked with an 'F' inside, although these soon gave way to the familiar BF-1 and LF-1 versions. Incidentally, the first BF-1 had an 'F' logo rather than a part number, and some later caps have an 'A' suffix for AF bodies. As with the current LF-1, the latest versions have an arrow and 'OPEN' on the front face. The BC-5 flash (in the background, next to a Nikon film cartridge) needed an adapter to fit the F's accessory shoe.

A giant telescope completed in 1960. This impressive instrument, with its 91cm lens, took Nippon Kogaku three years to develop, but telescope projects would become more and more ambitious as time rolled on.

RIGHT: An F from the early 1960s, mounted with a slightly later 50mm f/1.4 Nikkor. Note the second style of self-timer lever.

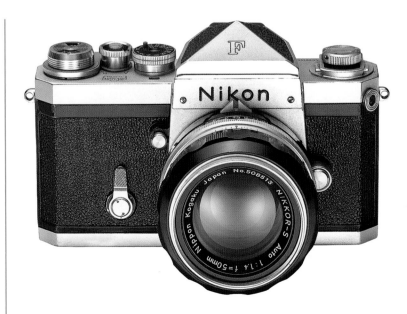

versions had an aperture ring that matched the focus ring for better handling). It was joined by three more Nikkors (a wide-angle lens and two telephotos) before the 55mm f/3.5 Micro-Nikkor put in an appearance in August 1961. At this time lenses were still marked up in centimetres, but contemporary advertising was using millimetres in the text, so from this point we shall start adopting this more universal unit of focal length measurement.

There were also changes afoot in the Nippon Kogaku Boardroom with the retirement of Masao Nagaoka as Chairman in 1961. The ensuing management reshuffle allowed the Mitsubishi empire's influence on the company to become even stronger.

By this time the waist-level finder had been updated (losing the Nippon Kogaku badge on the revised lid, but gaining an 'F' mark on the finder body), and the BC-6 flash had been introduced. Priced at just ¥1,500, this compact unit was less than half the price of the alternative BC-5 and had a fixed reflector, as opposed to the fan-type found on its immediate predecessors. Before 1961 came to an end a 500mm Reflex lens and a 200–600mm zoom joined the Nikkor range, but it was the March 1962 launch of the 50mm f/1.4

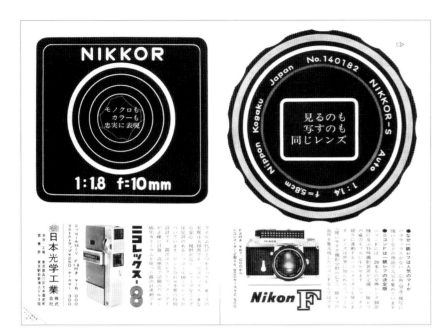

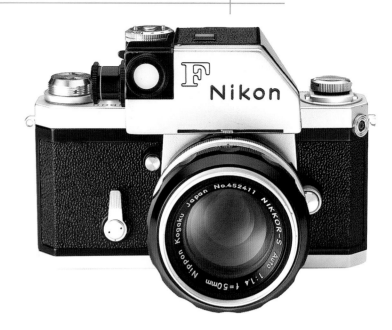

LEFT: The high-quality Nikkorex 8 cine camera was the result of a project started in 1956. Sales started at the end of 1960, and immediately worldwide sales hit 3,000 units a month. The 8P and 8F models followed, providing a firm foundation for the company in this growing field. This 1961 advert shows the cine camera alongside an F equipped with the Type II exposure meter.

ABOVE: An early F Photomic. Note that the F carried the same 'Nikon' script on the front of the body as the SP, S3, S4 and S3M. The early Nikomat models used the same typeface, too.

BELOW: The revised Photomic head, with its new switch arrangement, mounted on a contemporary F body; the Photomic head did away with the need for the clip-on meter in the foreground (a rear view of the Type II model). The lens is also a period piece, being the third version of the impressive 85–250mm zoom.

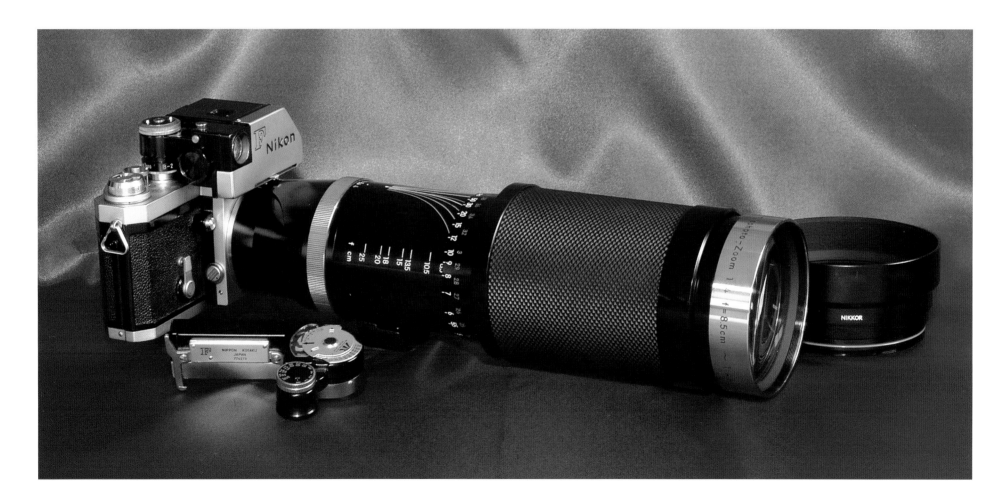

that has to be considered more important. This fast normal, which cost about ¥8,000 more than the f/2 version, would be considered the standard Nikkor lens for the majority of F buyers. A faster 35mm lens was introduced later in the year.

Rather less successful commercially, but interesting nonetheless, were the 1962 8mm f/8 fisheye (supplied with a separate finder, and the first production fisheye for an SLR camera), the 35mm f/3.5 PC-Nikkor (PC, standing for Perspective Control, allowing the lens to be shifted off centre to stop lines converging on tall buildings, for example), and a 200mm f/5.6 Medical-Nikkor with an integrated lighting ring. Early 1963 saw another zoom and a revised 55mm Micro-Nikkor, which now stopped down to f/32, put on the market, bringing the range of dedicated F-mount lenses to almost twenty variations.

Meanwhile, the Photomic head, combining a selenium cell (CdS) exposure meter and eye-level finder, was launched in April 1962. The original version had a front lens cover that switched on the meter once raised out of the way, but this was soon replaced by a more modern switch arrangement that employed two buttons. The F Photomic body was priced at ¥53,000, which was only the cost of a clip-on exposure meter more than a regular F body. It may not have had the elegance of the original, but one got a much more compact and practical package if an exposure meter was required.

The Nikkorex Line

The Nikkorex series was introduced in March 1960 to provide an affordable line of cameras to sell alongside the F. In the 1950s, photography had become an increasingly prominent hobby in Japan, no longer being restricted to professionals and diehard enthusiasts. For this reason, sales

of cheaper cameras blossomed and, for the average customer, simplified controls added to their appeal. Nippon Kogaku had to react to this trend, and used the Nikkorex brand name to keep the budget line distinct from its top-class range of RF and SLR models.

The first Nikkorex had a 5cm f/2.5 Nikkor-Q lens with a Citizen shutter integrated into the design, a Porro mirror-type finder (which was much cheaper to produce than the F's prism arrangement), and also came with a built-in CdS cell exposure meter, which was sadly not as reliable as Nippon Kogaku would have liked. Wide-angle and telephoto attachments were made available (3.8cm f/5.6 and 9cm f/5.6), but the Nikkorex 35 was replaced within a couple of years by the Nikkorex 35/2.

The Nikkorex 35/2 (or 35 II as it is sometimes known) made its debut alongside the Nikkorex F at the 1962 Japan Camera Show. No fewer than thirty companies exhibited more than two hundred cameras; the show attracted 160,000 people between 6 and 11 March, giving a clear indication of how popular photography had become in the domestic market. In fact, Japan became the world's number one camera producer in 1962, and a reduction in the Japanese tax rate that year only served to intensify demand.

The second-generation Nikkorex 35 had a Seiko shutter and a simpler film advance mechanism. This not only improved reliability, but also reduced costs, allowing the 35/2 to be sold at ¥19,800 (¥2,500, or 11 per cent, cheaper than its predecessor) when it arrived in the high street shops in April, thus allowing it to compete with cameras like the Canonet, the Konica SII, Petri Seven and Minolta AL.

In 1959 Nippon Kogaku had been approached by the Indian government regarding a technical cooperation agreement. By October 1962 plans were in place to produce around 400 Nikkorex 35s a month at India National Instruments, but an escalation in the long-running feud between India and China put an end to the project before it got off the ground.

The ¥49,300 Nikkorex F finally came out two months after its cheaper counterpart in the Nikkorex line, bridging the gap between the 35/2 and the expensive Nikon F, which was around ¥70,000 (twice the price of an Asahi Pentax S2, and ¥20,000 more than a Minolta SR-3). Featuring the same bayonet mount as the Nikon F combined with a 5cm f/1.4 Auto Nikkor and the rare Copal Square shutter, it served as an entry model into the Nikon System. The buyer could save ¥9,500 by specifying an f/2 normal instead of the faster Nikkor, and although this sounds very little in today's terms, one has to remember the compact Ricoh Auto 35 was only ¥11,500 at this time.

The other option was the Mamiya Prismat – a sister camera to the Nikkorex F and Mamiya's first SLR, but this was for export only. The Mamiya used the company's own Sekor lenses; there were indeed a couple of lenses made by Mamiya with the Nikkorex name on them – a 35mm f/2.8, and a 135mm f/2.8. Interestingly, the Ricoh Singlex of 1964 vintage was a hybrid of the Nikkorex F and the Mamiya Prismat, designed to take Nikkor optics.

The next Nikkorex was the Nikkorex Zoom 35, first displayed at the 1962 Chicago Photographic Trade Show, but not reaching the marketplace until February 1963. The Zoom 35 was distinguished by its 43–86mm f/3.5 zoom lens, which was unique to this ¥39,500 model, although it should be

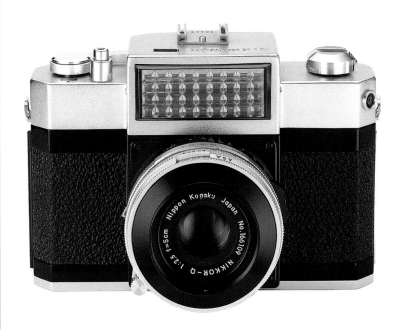

RIGHT: **Nikkorex 35: starting on body number 70001, it was built until 1962.**

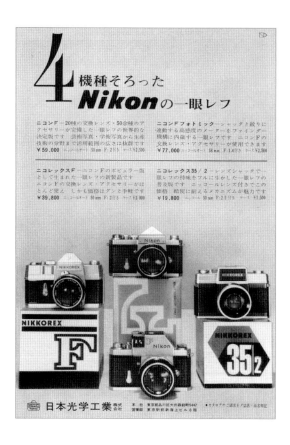

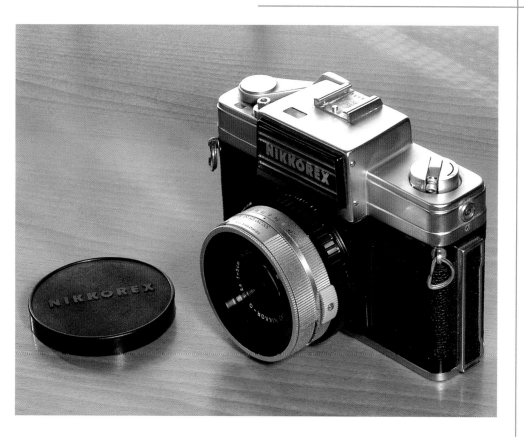

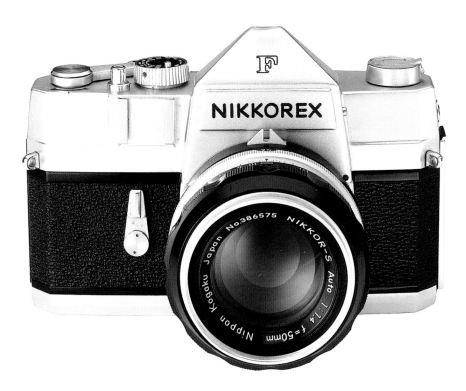

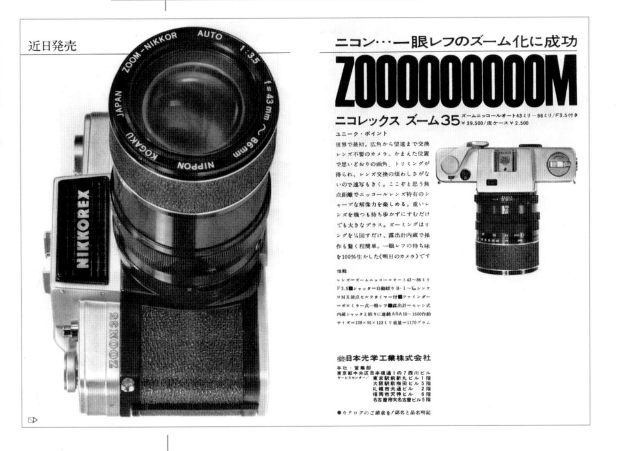

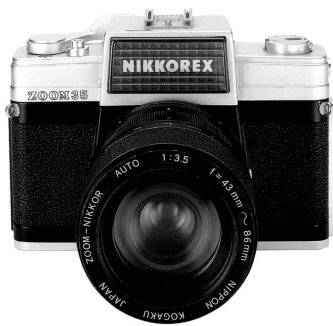

ABOVE: The short-lived Nikkorex Zoom 35. The same focal length range of 43–86mm was also used on a highly popular zoom for the Nikon F.

ABOVE: Advertising announcing the arrival of the Nikkorex Zoom 35 (production of which started on body number 270001). Topcon and Mamiya 35mm models joined the ranks of Japanese SLRs in the early 1960s, adding their respected names to the already fierce battle for market share.

RIGHT: Nikon Auto 35. Beginning on serial number 350001, it was built until 1965.

noted that an Auto Nikkor covering the same focal lengths (hence its *yon-san-hachi-roku* nickname) was released for the F at virtually the same time. The legendary F version of this lens, however, at ¥32,000, cost almost as much as the complete Nikkorex Zoom 35 outfit!

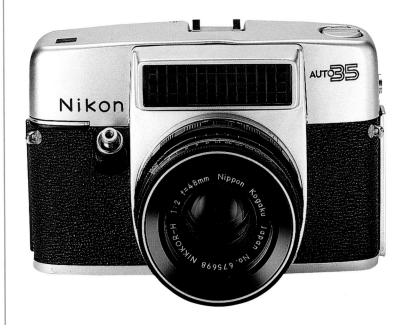

The final camera in the Nikkorex series was actually badged as a Nikon at home (although it remained a Nikkorex in most countries), which is strange given that the next generation of second bodies were branded as Nikomat models (or Nikkormat in export markets). The Nikon Auto 35 was introduced in September 1964, priced at ¥29,500. It was quite an elegant camera with a 48mm f/2 Nikkor-H lens and automatic exposure control (called EE by Nippon Kogaku – standing for Electric Eye), plus a range of accessories (including 35mm f/4 and 85mm f/4 lens attachments), but it was destined never to be popular. Like its predecessors in the Nikkorex line, these are quite difficult to find today, as most were scrapped once a metering fault occurred.

The Nikonos Story

In May 1961, with the help of Jean de Wouters and the marine scientist Jacques Cousteau, the French aqualung maker Spiro Technic developed an underwater camera called the Calypso (named after Cousteau's famous ship). Nippon Kogaku was approached via Teisan in Japan to see whether it would be interested in producing this unusual camera, knowing that the company had sold an underwater housing for its RF models.

The underwater housing was heavy and expensive, but, having inspected this little camera, Nippon Kogaku immediately saw the benefits and

marketing potential of the compact Calypso, with its novel combined shutter release and winder. In January 1962 a technical cooperation contract was signed with Spiro Technic, allowing the Japanese concern sole manufacturing rights, and sales rights for all countries outside Europe.

The die-cast casing was sealed via rubber O-rings, which deformed, becoming even more efficient, as water depth (and therefore pressure) increased. It was rated for depths of up to 50m, but also found favour as an all-weather camera. After all, Japan has a rainy season, and when a typhoon blows across one would not want to risk destroying an F or a traditional rangefinder model. For this reason the W-Nikkor 35mm f/2.5 lens released with the camera was suitable for use on land (with a flat front glass), while the UW-Nikkor 28mm f/3.5 was given a concave front glass to best match underwater conditions.

With regard to the lenses, one has to remember that the angle of view is quite different underwater, with the image from a typical 35mm lens appearing more like a 50mm normal, and everything appears to be larger. Add in the obvious need for watertight sealing and the difficult lighting conditions, calling for specialist flash units, and the technical problems surrounding such a design abound. Ultimately the lens, based on a French design, was made into a sealed unit, with another O-ring taking up the play between lens and body. The aperture was set by a rotary knob on one side of the lens, with a similar one on the other side looking after the focusing, which had to be done without the aid of a rangefinder system.

The shutter release was a fascinating device, using the film transport lever. Assuming the lock was pushed up out of the way, one pushed the lever towards the body, and a heavy spring then flicked it outwards. Pushing it back towards the body cocked the shutter, leaving it in standby mode until the lever was pushed inwards again. The shutter speed dial had a range of 1/30th to 1/500th of a second, plus a 'B' setting, and the flash synch marked up at 1/60th of a second.

The prototype Nikonos, as it was called, was first displayed in March 1963, exhibited in a fish tank, much to the surprise of many in attendance. It went on sale in August on the home market, priced at ¥28,500 with the 35mm lens. It was welcomed by a diverse set of users, selling an average of 1,300 units a month. Indeed, the Nikonos proved so popular in the early years that a dedicated Nikonos publication was issued by the factory in 1966.

Abroad, the Nikonos name was used in the USA, although the Calypso/Nikkor badge appeared on the front of European models, with the Nippon Kogaku symbol on the back. The only other variation of the original Nikonos is one with cream-coloured body trim inserts, giving the impression of a less conspicuous Nikonos V!

F Update

The *National Geographic* team chose the Nikon F to photograph its Mount Everest ascent in 1963. A total of twenty cameras were bought for this expedition, providing the opportunity for some memorable images. Many mountaineers have used Nikons since, partly because they are so rugged, and partly because they will continue to operate in temperatures as low as –25°C, or –40°C if the lubricating oil is changed to another type (as used in the jet engine industry). Nikon cameras and microscopes also went to the South Pole in 1965, and the F proved popular with the world's numerous armed forces. Most cameras in service with the military were marked as such, in line with local regulations, a number receiving some quite dramatic modifications to suit their specialist nature. In keeping with Nippon Kogaku's reputation in the world of science, there were also several Nikon models converted for medical and scientific applications over the years.

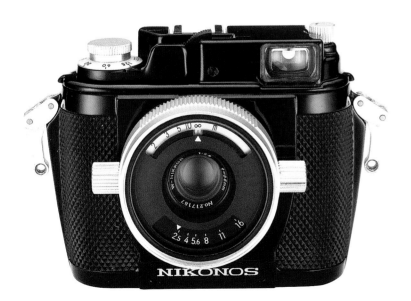

More outstanding photography is done with Nikon because more outstanding photographers are Nikon users.

NIKON F—world's finest '35'. See it at your camera dealer, or write for illustrated booklet Dept. NG-12
NIKON INCORPORATED 111 FIFTH AVENUE, NEW YORK 3, N.Y. Subsidiary of Ehrenreich Photo-Optical Industries, Inc.

FAR LEFT: The original Nikonos model mounted with a W-35mm f/2.5 lens.

LEFT: American advertising from the end of 1964.

RIGHT: An accessory and lens chart from early summer 1965. There were many accessories available for the F at the time of its launch. A waist-level finder was available for ¥2,800, the BC-5 flash was ¥3,600, and the original exposure meter was ¥6,600. The first bellows attachment, similar in design to the one used for the RF series, was priced at ¥11,000, while the 'PF' copy kit was ¥23,800. There was also a slide copy kit (at ¥2,700), and a manual pistol grip was added before the end of the year, priced at ¥1,700.

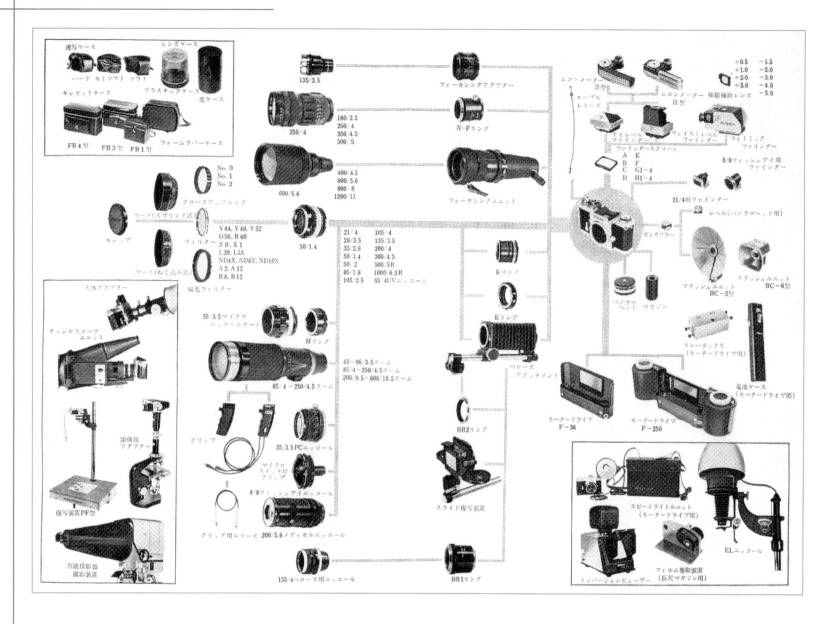

Meanwhile, the opening of the Tokyo Olympics in October 1964 brought the Nikon brand even greater exposure. With restricted press space, often high up in the stands, the Nikkor telephoto and zoom lenses came into their own. After the introduction of a cheaper 50mm f/2 lens with six elements rather than seven, 1964 saw the launch of six long lenses and a fast 85mm telephoto, since flash photography was barred from the games. The production 85mm f/1.8 was actually slightly different to the original prototypes, as the silver filter ring was changed to black, and the lens designation moved off the focus ring to the inner edge of the barrel. Stray reflections experienced with this arrangement brought about another change, however, with the engraving moved to the outer edge quite soon after. Around 96,000 were made in all before the 'C' version was introduced.

Following the Olympics, though, the Japanese camera market took a sudden and dramatic nosedive. Makers of mid-range and cheaper models found themselves struggling, and many went out of business. Only those with an excellent reputation and professional outlets (such as the press and government bodies) survived this harsh period. Nippon Kogaku, despite being in the position of having to outsource work and take on a new factory in Tochigi (north of Tokyo) to deal with Nikkor lenses and eyeglasses, even had to restrict production until March 1966 to balance stock levels against sales.

Even newly developed lenses failed to appear until the end of 1965, with faster 35mm and 135mm Nikkors, and a 55mm f/1.2, plus a cheaper version of the 1,000mm Reflex lens that followed early in 1966. At the same time, five popular lenses were facelifted, being given revised aperture ring grips for easier handling. One of these, the 55mm Micro-Nikkor, was changed yet again shortly after, with the most obvious modification being the front of the barrel changing from silver to black, while the

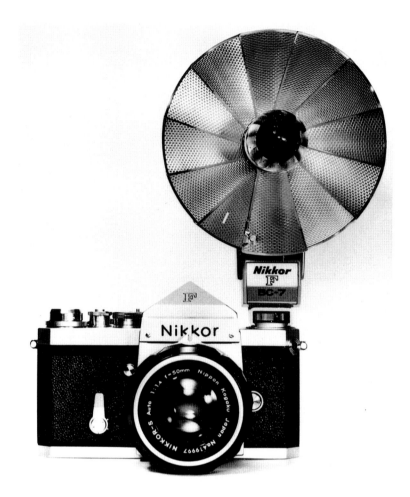

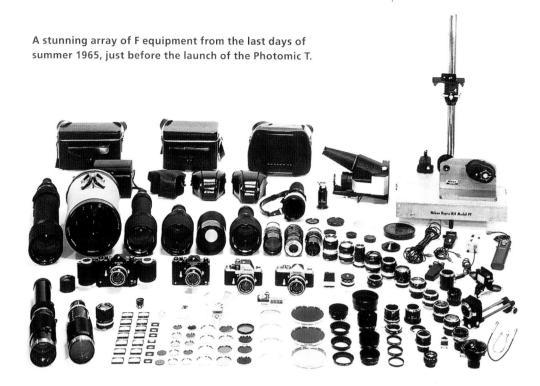

A stunning array of F equipment from the last days of summer 1965, just before the launch of the Photomic T.

The European market proved quite difficult to crack for many years. In 1959 an office was established in Rome to mastermind brand publicity, leading to the F being exhibited at Photokina for the first time in 1960. Zeiss Ikon (Contax) was quite vocal in its objections regarding the use of the Nikon name in Germany, so the Nikkor moniker was used in that market until January 1970; the early Nikon F was therefore sold as the Nikkor F and, to avoid confusion, the Nikkorex F became the Nikkor J. Nikon AG was formed in Zurich in November 1962, with Nikon Europe BV following in June 1968 (based in the Netherlands), and Nikon GmbH was eventually established in Germany in August 1971.

105mm f/2.5 lens was also updated again a couple of years later, when the optics were also revised.

There were a few new accessories, such as the BC-7 flash (the last BC model, and basically a slightly updated version of the BC-5, with a different foot to eliminate the need for an adaptor on the F) and an angle finder. The flash was ¥3,800, while the finder was ¥300 cheaper, at ¥3,500.

Despite this quiet spell, though, the Nikon F Photomic T was launched in September 1965, replacing the strict F Photomic in the line-up. This was the world's first camera with an interchangeable head to offer TTL exposure metering (once again made possible via the adoption of a CdS

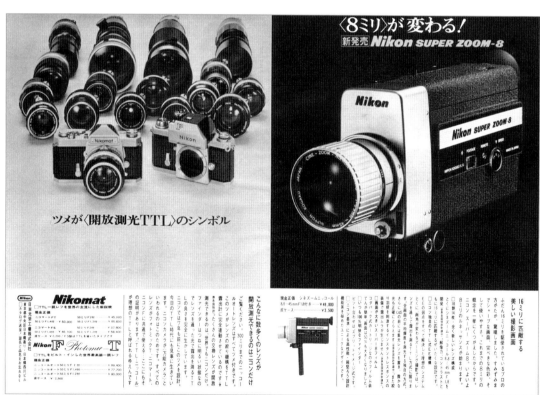

A Japanese advert from spring 1966 showing the F Photomic T, Nikomat FT/FS, contemporary Nikkor lenses, and a period 8mm cine camera. These were good times for the industry: camera production in the Land of the Rising Sun had risen from a total of 23,000 units in 1945, to 117,000 in 1950, to 935,000 in 1955, and up to 1,673,000 in 1960. By 1965 Japan was producing 3,732,000 cameras a year, and there was no sign of any let up in the pace.

ABOVE: Production in the mid-1960s. The conveyor belt system had been introduced in 1958, while the lens-polishing machine had been developed with financial help from MITI in 1956. These relatively simple aids speeded up and streamlined the manufacturing operation a great deal, in readiness for the F series.

The glass-melting furnace at Nippon Kogaku, pictured in 1967.

cell). Actually, however, the latest head was not quite fully interchangeable. Earlier heads would fit the 1965 body, but pre-670 series bodies needed to go to the Nikon service centre to be modified. The update was simple enough, involving the fitting of a new finder screen box with a cut-down back, and a red dot was engraved to the left of the camera's serial number indicating that it had been converted for use with the Photomic T head. After this, all heads were once again fully interchangeable with any 'Red Dot' F, or one carrying a 670 series or later body number – at least until the FTN came along.

Incidentally, the earliest Photomic T head catered for film speeds ranging from ISO 10 to ISO 1,600 (like the original), although this rating was quickly adjusted and the otherwise identical head was freshly calibrated from ISO 25 to ISO 6,400. It should be noted that the eyepiece cover was also changed with the arrival of the Photomic T (slightly ahead of the regular eye-level finder), gaining a heavier surround with a rounded inner profile that was threaded to accept accessories more readily.

During 1965 sales of the F broke through the 200,000 units barrier. Number 200,000, presented to David Douglas Duncan in recognition of

his services in promoting the Nikon brand abroad, would have been one of the last Fs with the Nippon Kogaku badge on the top plate (from early 1966 simple 'Nikon' script was adopted). On the subject of presentations, the Nikon image was further enhanced by an annual international awards ceremony: early recipients of the top award included Henri Cartier-Bresson, Edward Steichen, Walt Disney and David Douglas Duncan.

The Nikomat Series

Given the enormous success of the F and the less than stunning sales of the Nikkorex line, the people at Nippon Kogaku decided to look to its past for inspiration. Back when the SP was the flagship Nikon, the S3 was introduced as a second body, using many of the same components as its more expensive counterpart, but packaged in such a way as to significantly reduce its cost, and therefore its selling price. Applying the same theory and method gave birth to the Nikomat camera. It was the perfect answer to what people were searching for in the ideal second body: it looked like a Nikon and handled like a Nikon, but was far more accessible for the average enthusiast.

The Nikomat FT and FS replaced the Nikkorex F as the entry-level model into the Nikon System. Introduced in July 1965, the FT featured TTL exposure metering and a revised, quieter version of the Copal Square shutter – the type S. This necessitated a redesign of the shutter speed selector, which needed to be incorporated around the lens mount, and the diaphragm control system.

Other noteworthy features included a quick-action back release (with a clip to the side), a film speed selector on the shutter speed ring around the lens mount, and a power switch in the film advance lever. By moving the lever slightly, a red dot was revealed, meaning the simple CdS cell exposure meter in the fixed prism head was ready for action.

Although the FT had a self-timer and mirror lock-up facility, there was no way to connect a motor drive, and there was no accessory shoe. If one wanted to locate finders or a flashgun, an optional shoe had to be ordered, mounted via a threaded ring over the eyepiece. The flash could then be plugged into either the 'M' or 'X' terminals on the side of the body.

Other than this minor shortcoming, the lightweight FT was easy to use and, with the added bonus of full integration with many of the F's accessories and a 1/125th of a second flash synch speed, it proved extremely popular. With a 50mm f/1.4 lens, it cost ¥54,500, with a black body costing a touch more.

The FS was sold at the same time as the FT, losing the mirror lock-up facility and built-in exposure meter (and therefore a meter coupling as well), allowing it to be sold at ¥37,800 with a 50mm f/2 lens. Interestingly, the FT did not originally have a built-in meter either when it was first designed (only an external one). By chance a rare strike at the factory allowed time for one to be added into the blueprints!

Promotion of the Nikomat series, sold as the Nikkormat in export markets, was very heavy, with advertising literally everywhere in Japan at the

LEFT: **Nikomat FT: its run started on body FT 3100001.**

LEFT: **Nikomat FS. Like the Nikomat FT, the FS was built until 1967, with body numbers starting on FS 7400001.**

time of its launch. It was seen on trains, billboards, newspapers, magazines – even in commercial spots between movies. The effort paid off, and by spring 1967 more than 100,000 Nikomat cameras had been sold, mainly to younger enthusiasts, but there were also good sales among Americans stationed in Japan during the Vietnam conflict.

Not only did the Nikomats bring in a good deal of revenue at a critical time, they also served as an ideal test-bed for trying out new ideas and components without directly hurting the Nikon name. The Nikomat series was actually far more important in historical terms than many collectors realize.

The SLR Boom

With the amazing popularity of the SLR again making an environment of fierce competition among the Japanese camera manufacturers, Nippon Kogaku decided to remain at the top end of the market and increase the appeal of the F still further.

In 1966 the old-style external battery pack for the F-36 motor drive was changed for a new power pack that looks like a modern MD unit – one with a shutter release that could also be plugged into the mains. It was around this time that the final version of the F's waist-level finder was introduced, with the legendary 'F' mark moving from the body of the

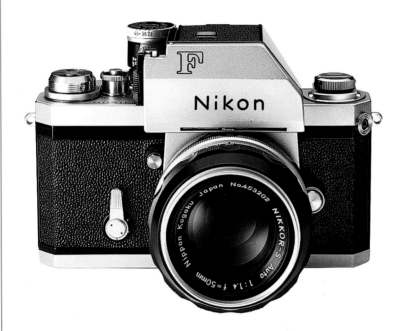

finder to the centre of the lid. More important than cosmetics, however, the new finder had a rear blind that flipped into place whenever the finder was in use to reduce the amount of stray light entering the camera, and it was found to be a tighter fit on the body, too.

As well as a reasonably priced 7.5mm f/5.6 Fisheye-Nikkor (which basically replaced the 8mm f/8), there was a 50–300mm zoom. This was not particularly light or cheap, but it did represent a world first, and was useful for the well-heeled enthusiastic amateur with a restriction on the amount of kit he could carry on a field trip, for whatever reason. Zoom lenses were still not popular with professionals during this period, although their supporters tended to be quite vocal and their appeal grew stronger with time. The original silver filter ring was soon substituted for a black one, but otherwise this 2,270g beast continued unchanged until 1975.

Meanwhile, in April 1967, Nippon Kogaku launched the Nikon F Photomic TN, a development of the F Photomic T with centre-weighted metering, improved surface coatings to reduce reflections, and a button to check on battery condition (situated next to the power switch). Three months later an action finder became available for the F, priced at ¥18,500, and another three months down the line the Type 3 bellows attachment hit the market-place. A new version of the manual pistol grip was also introduced in 1967, with a wheel in the handle to speed up the unit's connection to the camera's tripod socket.

Before 1967 drew to a close, a 24mm f/2.8 Nikkor had been added to the line-up (the first Nikkor to feature CRC – close range correction, via the use of floating elements), and 1968 brought with it a retro-focus 20mm f/3.5 lens that did not require a separate finder, and a rather special 10mm fisheye (the world's first SLR lens to adopt Orthographic Projection, hence the 'OP' designation in its full title). It was modified slightly in 1976, but production of this exotic Nikkor ended later that year on lens number 190168. An improved version of the 35mm PC Nikkor was announced at the same time as the OP lens made its debut, followed by a regular-looking 135mm lens for the bellows attachment, replacing the old RF lens that had been used previously. Earlier in the year, in February 1968, a hinged magnifier became listed, screwing into the camera's viewfinder eyepiece like the earlier angle finder.

The Popular FTN

On the camera side, October 1967 saw the introduction of the Nikomat FTN, increasing the popularity of the budget line beyond all expectations. With its centre-weighted TTL metering, semi-automatic meter coupling, and enhanced viewfinder brightness and information, this model replaced both the FT and FS. Although the FS remained available for several years, it was never particularly popular at the time, people preferring to spend the extra and get the additional features of the FT. Ironically, its relative rarity makes the FS quite collectible nowadays!

As well as the major improvements, the Nikomat FTN also benefited from a lot of detail work. At the time of purchase the owner could choose one of two fixed focusing screens (although a new one, halfway between

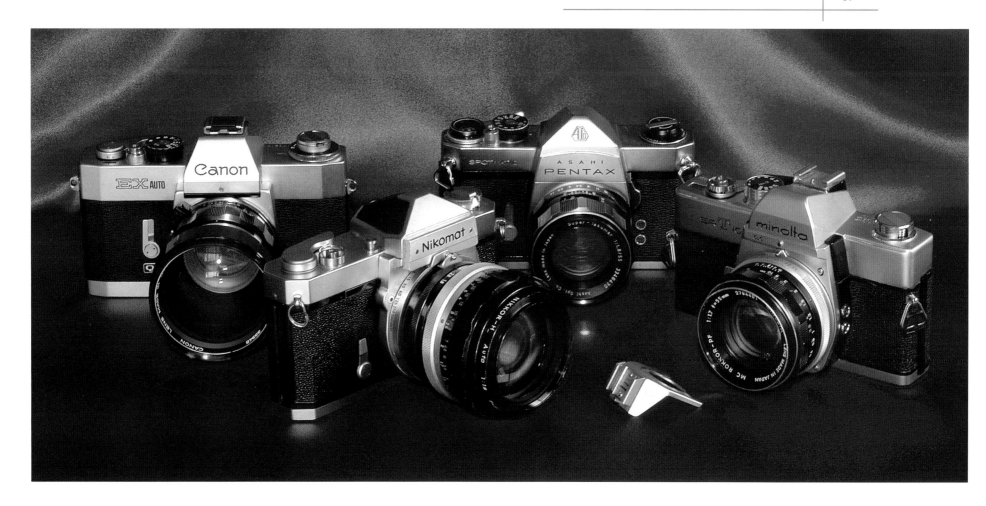

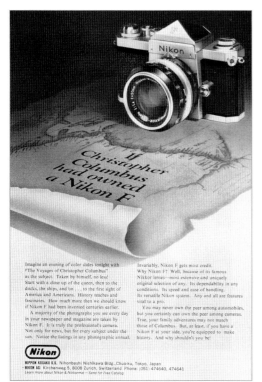

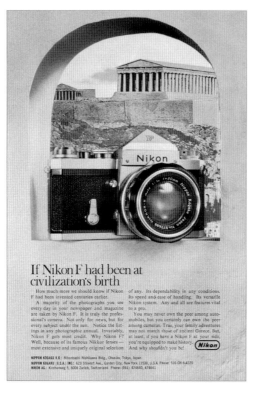

ABOVE: The Nikomat FTN, mounted with a fast 85mm lens, pictured with some of its contemporaries, including the Canon EX Auto (with its fascinating lens system), the Asahi Pentax Spotmatic SP and the Minolta SR-T101.

LEFT: Two stunning F adverts from 1968.

RIGHT: The Topcon SLR was a serious competitor for the F. This advert dates from 1968, but the brand still exists as a maker of optical instruments.

the two styles, was duly developed, bringing this option to an end), and the film speed selector was modified.

In September 1968, eleven months after the launch of the Nikomat FTN, came the debut of the Nikon F Photomic FTN, with a four-second exposure available via 'T' on the shutter speed dial, and quicker and easier lens changes due to a semi-automatic maximum aperture reading in the revised head. Perhaps more important, however, was the front fixing that locked the Photomic head down with greater pressure, although a modified nameplate was employed from the 690 series onwards to suit this latest variant. Careful

inspection is needed to spot the difference, but the new front plate had straighter edges to allow the head's legs to slide down into place. Again, earlier heads would fit the new body, but a new nameplate was needed to allow older bodies to accept the new head. It was only a question of taking out two screws and replacing them once the slimmer plate was in place, so it did not cause any great hardship.

The early part of 1969 brought with it new versions of the 200mm f/4 lens and the 300mm f/4.5 Nikkor (the latter now coming with six elements instead of the previous five), a cheaper and far more compact

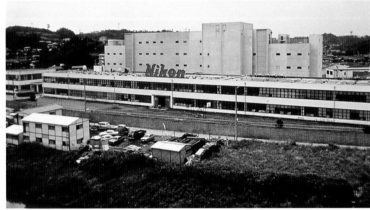

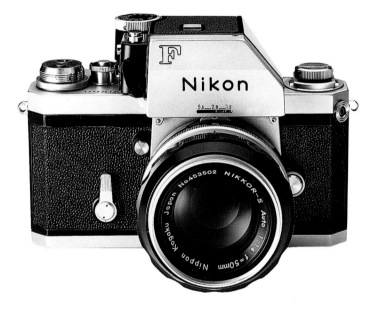

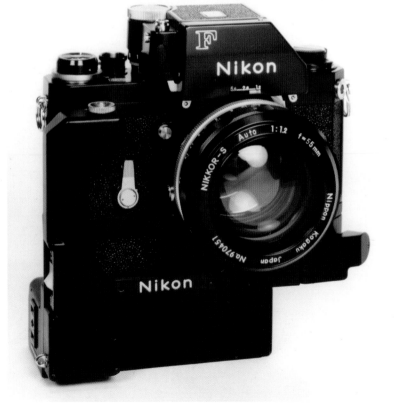

LEFT: The Nikon F Photomic FTN head on an earlier black body, complete with the F-36 motor drive, the power pack introduced in 1966, and the 55mm f/1.2 lens. It was actually a similar outfit to the one put together for NASA's space exploration programme of the early 1970s.

BELOW: F finders. With regard to the eye-level finder, as well as the obvious black and chrome variations, and the two styles of eyepiece cover, there are four forms of identification on the inner panel underneath the 'F' mark. The earliest style has 'Nippon Kogaku Japan' finely engraved into the metal, while the second version has the same text, but printed on. By the start of 1961 'Nikon F' was written in the same spot, before 'Nikon'-only appeared in the mid-1960s.

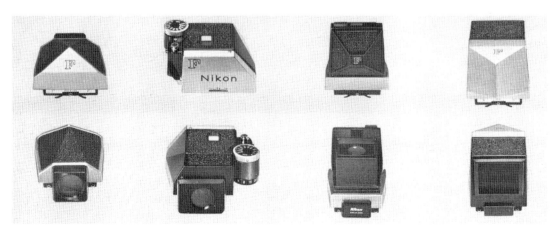

Various F focusing screens.

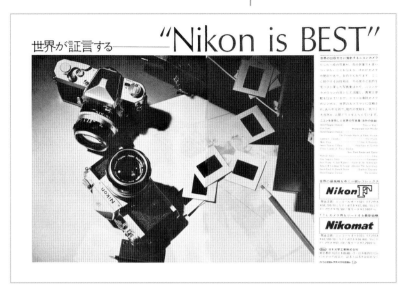

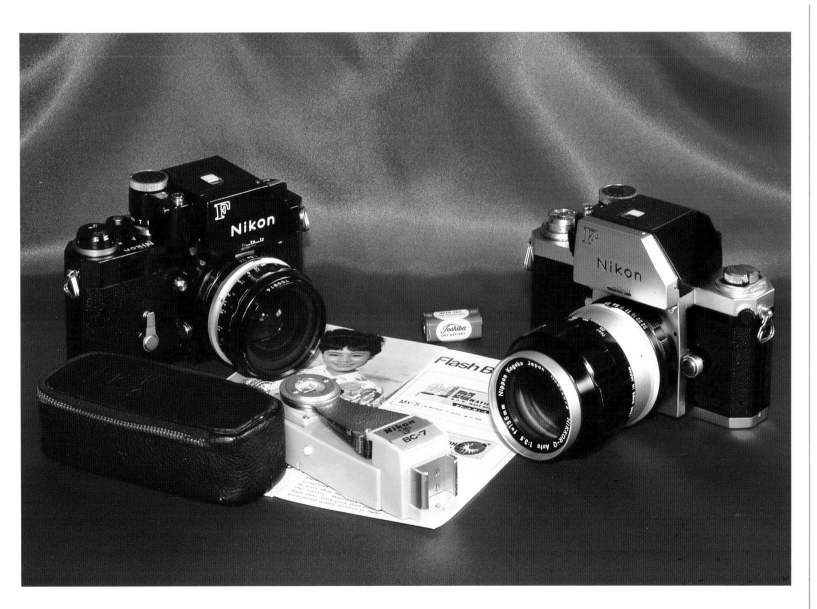

ABOVE: A Japanese advert from summer 1968. Note that the FTN had an FT body number, but a large 'N' to the right of the rewind crank. Nikomat FTN production began with body FT 3500001.

LEFT: Black and chrome F Photomic FTNs from the author's collection, pictured here with the BC-7 flash, a contemporary battery and bulb catalogue, and popular period 28mm wide-angle and 135mm telephoto lenses.

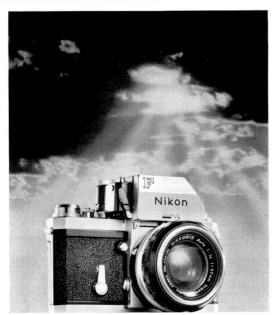

Next time you notice a camera
in a starring role...
notice it's a Nikon F

Over and over again, in movies, in magazines, in ads, Nikon F is playing a starring role. You see Nikon F in the hands of the finest fashion photographers. Taking the thrills of the racetrack in its stride. You see it at battlegrounds of war. At the parties of international playboys. Nikon F, the star among cameras.

Why?

Why does anyone reach stardom?

Performance? Right. No camera outperforms the Nikon F. With its wide range of Nikkor lenses and accessories, including the new Photomic FTN finder/Thru-The-Lens meter, this is the most versatile camera yet. Other features of a star are quality and dependability. Nikon craftsmanship guarantees you both.

But take a look next time you see a camera star. And remember this. Per-

haps the best thing about Nikon F is that it means you can have a star in your life.

Nikon

NIPPON KOGAKU K.K., Nihonbashi Nishikawa Bldg., Chuo-ku, Tokyo, Japan
NIPPON KOGAKU (U.S.A.) INC.: 623 Stewart Ave., Garden City, New York 11530, U.S.A.
NIKON AG: Kirchenweg 5, 8008 Zurich, Switzerland

LEFT: 1969 advertising featuring the F Photomic FTN.

RIGHT: Nikkor lenses from 1969, including EL-Nikkors up front, along with other specialist versions. The first front lens cover was based on the RF cap, with plastic rather than metal spring pins, and with either 'Nikon' or 'Nikkor' script (the 'Nikkor' lens cap was often supplied with Nikomat bodies, or could be bought as an accessory). Much later, the front cap was given silver-coloured script and a uniform outer ring shape.

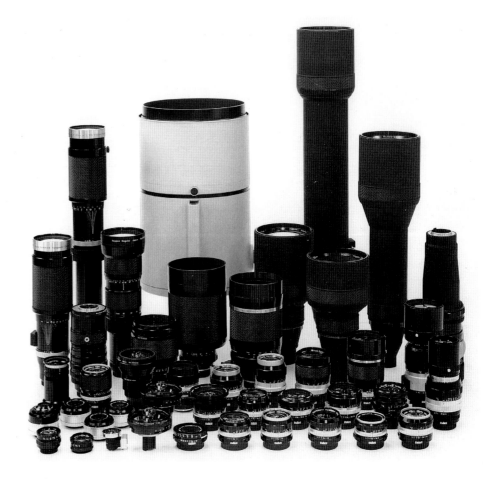

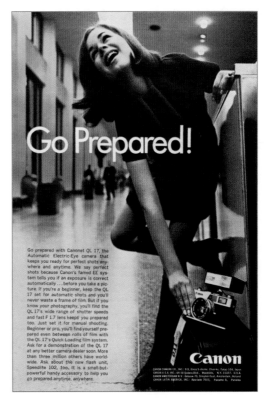

FAR LEFT: An EL-Nikkor sporting Nippon Kogaku script, photographed here with its case and a later EL-Nikkor catalogue. As well as leading the industry in camera lenses, Nippon Kogaku also made a range of Ultra-Micro Nikkors for the microfiche industry. Designed by Zenji Wakimoto, who was responsible for many of the early Nikkors, these were quite different to the regular Micro Nikkors made for the company's 35mm cameras, and led to the development of even higher-quality glass than that already in production, as well as special lens coatings. Later on the Apo EL-Nikkor was announced in June 1971, bringing the option of 35mm photography to the poster trade, and similar applications.

LEFT: A Canon advert from 1969. Not long after, the F-1 was put on the market, providing the Nikon F with some serious competition. Note that the Canon flash unit was called a Speedlite, as opposed to Nippon Kogaku's Speedlight!

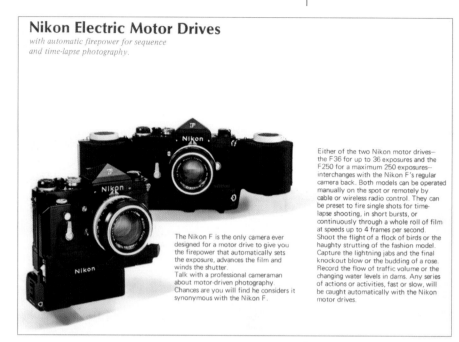

Nikon Electric Motor Drives
with automatic firepower for sequence and time-lapse photography.

The Nikon F is the only camera ever designed for a motor drive to give you the firepower that automatically sets the exposure, advances the film and winds the shutter.
Talk with a professional cameraman about motor-driven photography. Chances are you will find he considers it synonymous with the Nikon F.

Either of the two Nikon motor drives—the F36 for up to 36 exposures and the F250 for a maximum 250 exposures—interchanges with the Nikon F's regular camera back. Both models can be operated manually on the spot or remotely by cable or wireless radio control. They can be preset to fire single shots for time-lapse shooting, in short bursts, or continuously through a whole roll of film at speeds up to 4 frames per second. Shoot the flight of a flock of birds or the haughty strutting of the fashion model. Capture the lightning jabs and the final knockout blow or the budding of a rose. Record the flow of traffic volume or the changing water levels in dams. Any series of actions or activities, fast or slow, will be caught automatically with the Nikon motor drives.

500mm Reflex lens, and the GN Auto 45mm – a lightweight lens with four elements in three groups, designed specifically with flash photography in mind (the GN designation stands for Guide Number), although its compact dimensions soon proved popular with available light users, too.

On the subject of flash photography, February 1969 saw the launch of the SB-1 flashgun, the first in a famous line of electronic Speedlight flash units that continues to be developed and marketed to this day. The SB-1 looked as modern as its predecessors did old-fashioned but, priced at ¥27,000, it was only for professionals or the most dedicated of amateurs. Interesting options for the SB-1 included the SR-1 and SM-1 ring lights for close-up work, which took their power from the Speedlight (the later SR-2 and SM-2 units had their own internal power supply, or could be hooked up to the mains).

At the same time, the PB-4 bellows attachment and Type 4 slide copy kit replaced the versions already on sale, and slightly later in the year there were updated versions of the 135mm f/3.5 Nikkor and the 85–250mm zoom, too. In addition, a 6mm fisheye – the widest Nikkor lens to date – put in an appearance in May 1969, priced at a hefty ¥200,000. Like the earlier 8mm and 7.5mm fisheyes, this used Equidistant Projection. An SAP (Equi-Solid Angle Projection) prototype was made but not released. The 10mm version was unique in using Orthographic Projection.

Nippon Kogaku's President, Hiroshi Shirahama, retired in mid-1969, handing over the reins to Yutaka Sugi. By this time the camera industry had fully recovered from its post-Olympics' slump and Sugi inherited a company that was financially buoyant (export revenue increased three-fold between 1965 and 1969). Interestingly, the majority of Nippon Kogaku's income

came from cameras and lenses, but next in line was now eyeglasses, rather than microscopes and other scientific equipment.

By March 1970 a total of 400,000 Nikomat cameras had been sold, and this boosted sales of lenses, too. About 60,000 Nikkor lenses were produced in 1965, but by 1970 the annual figure had shot up to 340,000 units!

As well as a 105mm lens for the bellows attachment (the front ring design of which was quickly changed to a more traditional type with the details on the front face instead of the outer edge) and a new version of the 55mm Micro-Nikkor (resembling a 'New' lens), 1970 saw the debut of an 80–200mm zoom, and an 8mm f/2.8 fisheye that came with the advantage of not having to lock the mirror up due to its retro-focus design. Not having to use a separate finder was obviously a great benefit to pro users, but it weighed three times as much as the old 8mm lens and cost a fair bit extra, too. Still, the main advantages could not be denied, and it is not surprising that it remained in the Nikon catalogue virtually unchanged for the best part of three decades.

Multi-Coating Advances

In September 1970 the company announced a 35mm f/1.4 lens with new multi-coating technology that significantly reduced flare, thus giving a sharper image on film. Also, because less light is reflected, more can pass through the lens, meaning clearer colours, a brighter viewfinder image and enhanced exposures. It was not applied to the updated 105mm f/2.5 Nikkor launched in February 1971, or the updated 200–600mm zoom from

RIGHT: A few accessories from the author's collection, including an early bellows attachment with a 55mm Micro-Nikkor, waist-level finders, an angle finder, an eyepiece magnifier (the later DG-2 version, which would fit the F quite happily) and an AR-1 soft release button. Late accessories came in gold boxes for Nikon parts, or silver ones for the Nikomat series.

RIGHT: A few accessories from the author's collection, including an early bellows attachment with a 55mm Micro-Nikkor, waist-level finders, an angle finder, an eyepiece magnifier (the later DG-2 version, which would fit the F quite happily) and an AR-1 soft release button. Late accessories came in gold boxes for Nikon parts, or silver ones for the Nikomat series.

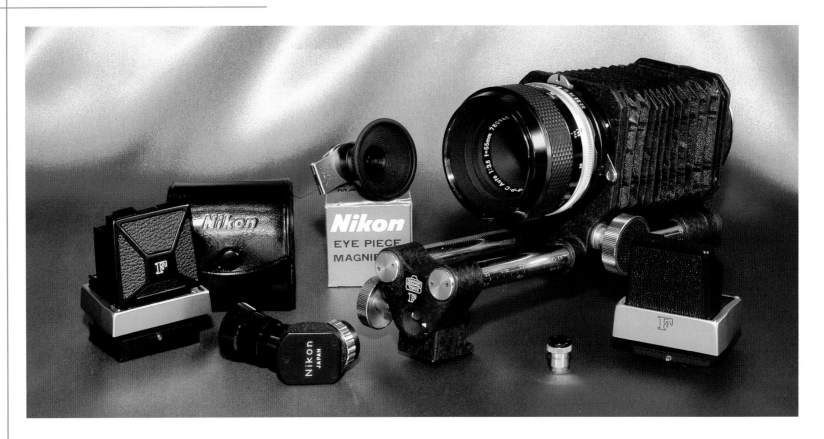

RIGHT: An experimental 80mm f/4.5 autofocus lens completed in April 1971. This landmark optic would provide the foundation stone for all future AF Nikkors.

not long after, but Nippon Kogaku started employing this BC ('Black Coating') lens coating from March 1971, when the aforementioned 35mm lens eventually went on sale.

The 28mm f/2 and 6mm f/2.8 lenses (the latter having been shown in prototype form at the 1970 Photokina event) were given the BC treatment from day one, but the highly respected 180mm f/2.8, the 300mm f/2.8, and 2,000mm Reflex would have to wait. It would not be until 1974 that this new coating spread to all the Nikkor range, as it was a difficult process to perfect, calling for changes in the Nikon Integrated Coating (NIC) system. It is easy to spot an Auto Nikkor lens with the new coating, however, as it carries a 'C' suffix after its lens code.

Apart from lenses gaining the BC coating process and the odd update, truly new Auto Nikkors were few and far between after 1972. Having taken two-and-a-half years to reach the marketplace, there was an expensive 15mm lens in March 1973 (quickly updated in the following year, with BC coated optics), plus a 16mm fisheye and 400mm f/5.6 telephoto in the same month. Apart from a handful of 300mm f/2.8 telephotos that were not released to the public (starting on serial number 640001), these were the last of the fresh Auto variants.

Meanwhile, a few Fs received a seven frame per second motor drive, an accessory shoe perched on top of the viewfinder prism, and a modified mirror lock-up toggle. With a 24v power supply, the MD could advance film in single frame mode, or at 3.5fps and 7fps, although after fixing the mirror, later modified versions were able to deliver nine frames per second

performance. Introduced in January 1972 – after the F2 had come out – these were produced for selected members of the Japanese press only, using standard issue body numbers, and came with a black finish.

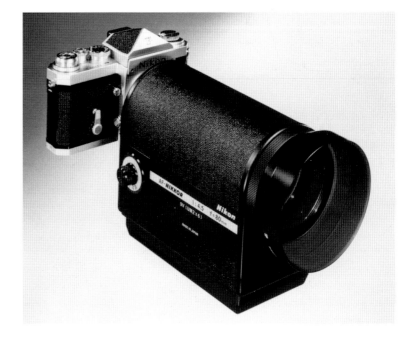

The F was a worldwide icon, with demand outstripping supply even in the domestic market. *Camera Mainichi* wrote at the time that it was sad that everyone wanted Nikon's most famous camera, but no-one could get one – at least not quickly. But while Nippon Kogaku continued to produce the F at full throttle, there was no way it would risk its reputation by cutting corners. The company was making the F as quickly as possible, and if people wanted Nikon's legendary quality, they would simply have to be patient. This level of commitment to quality control did not go unnoticed at NASA.

The NASA Connection

The Minolta was the first Japanese camera in space and, due to the conditions onboard the Mercury spacecraft, *Friendship 7*, it needed very little conversion. This was in February 1962, and led to the Minolta SR7. Hasselblad and Kodak cameras were also used, but as the Space Race intensified more specialized equipment was called for.

In 1970 NASA approached Nippon Kogaku via Joseph Ehrenreich to produce a 35mm camera suitable for the Apollo programme. In November of the same year Nippon Kogaku bought a massive stake in the American Nikon operation via Ehrenreich's EPOI business. Joseph Ehrenreich's death in 1973 left a void in the Nikon world, although he will always be

remembered; he was posthumously awarded a medal by the Emperor for his services to the Japanese camera industry.

One of the main stipulations in the NASA programme is for 100 per cent reliability. The cost of taking equipment into space is truly staggering, so there is absolutely no possibility of carrying spare bodies or lenses – those onboard have to work right first time, and then keep working in the most extreme of conditions.

NASA requirements included the utmost reliability in high and low temperature and humidity, as well as withstanding a 7g shock and being used in a vacuum. On the safety side, everything had to be inflammable, with all plastic parts changed to metal, and those needing lubrication sealed; any power source had to be isolated, and all screws and other fittings rigidly set in place with loctite. In addition, the film pack was special to suit NASA specifications (half the thickness of normal negative film), meaning the winder mechanism had to be adjusted so as not to tear the film, especially on the so-called 'Big' camera with its integrated MD and 'intervalometer' (for time-lapse photography).

The final camera specifications were released in January 1971 when the supplier contract was signed, with a request for delivery by spring ready for the Apollo 15 flight due to take off in July 1971. The first Nikon F Photomic FTN for NASA was eventually signed off in May, with nine completed by June. Fitted with a 55mm f/1.2 lens, they featured bigger controls for use with heavy gloves, no external trim and a regulation matt black finish.

FAR LEFT: **Beautiful cover from one of the last F catalogues.**

MIDDLE LEFT: **A rare colour advert for the F, this one dating from 1972, although both the 718 series body and the lens are a touch younger (the 50mm f/1.4 lens seen here became f/1.4C spec in 1971). Incidentally, the replacement of 'Nippon Kogaku' by 'Nikon' on the front of the lens is not related to the 'C' suffix, as the coating process was introduced over a number of years, so it is possible to get several variations of each Nikkor.**

ABOVE: **Stunning shot from the Apollo 17 mission, with Earth just visible in the distance.** COURTESY NASA ARCHIVES

The Apollo 15 crew took an LRV buggy on the surface of the moon, and Nikon went back there in April 1972 on the Apollo 16 mission before taking part in the last Apollo mission in December 1972. Among other things, the cameras were used to take photographs of Earth at set intervals to gauge the state of the ozone layer.

The next camera was developed for the Skylab programme, instigated in 1972. Older cameras were brought up to date, and new F-based models were produced with a motor drive and an exotic UV 55mm f/2 lens (a lens that had been available to special order in f/4 guise since the mid-1960s). Nikon microscopes were also taken into space on the Skylab mission, enabling scientists to study life in these extreme conditions.

Nikon F Body Numbers

After 1971 the F was produced at the Yokohama site, making room at the Oi factory for the F2 to be assembled there. In reality, production of the F was supposed to have ended in March 1972, but there was still a heavy demand for the classic Nikon, so it was allowed to continue into October 1973, two years after the launch of the F2.

There is a great deal of confusion surrounding F body numbers, with the same mistakes repeated often enough to make them look like fact, so below is a table containing production dates for each batch of serial numbers issued throughout the series:

NOTE TO TABLE: The series numbers 661 to 669 (inclusive) were not used – the production run started again on 670, with bodies ready to accept the Photomic T head. Note also the way in which some production dates cross over, this phenomenon due simply to the bulk manufacturing of top plates with a chrome or black finish, and the order in which they reached technicians.

F BODY SERIAL NUMBERS AND PRODUCTION DATES

SERIES	PRODUCTION DATES	SERIES	PRODUCTION DATES	SERIES	PRODUCTION DATES
640	Apr 1959 – Jan 1960	682	May 1967 – Aug 1967	715	Aug 1970 – Oct 1970
641	Jan 1960 – Aug 1960	683	Jul 1967 – Sep 1967	716	Oct 1970 – Nov 1970
642	Jul 1960 – Jan 1961	684	Aug 1967 – Oct 1967	717	Oct 1970 – Dec 1970
643	Nov 1960 – Apr 1961	685	Oct 1967 – Dec 1967	718	Nov 1970 – Jan 1971
644	Apr 1961 – Aug 1961	686	Nov 1967 – Jan 1968	719	Dec 1970 – Feb 1971
645	Sep 1961 – Feb 1962	687	Dec 1967 – Mar 1968	720	Jan 1971 – Mar 1971
646	Jan 1962 – Sep 1962	688	Feb 1968 – Apr 1968	721	Feb 1971 – Apr 1971
647	Jun 1962 – Dec 1962	689	Apr 1968 – May 1968	722	Mar 1971 – Apr 1971
648	Oct 1962 – Feb 1963	690	May 1968 – Jul 1968	723	Mar 1971 – May 1971
649	Feb 1963 – Jun 1963	691	May 1968 – Aug 1968	724	Apr 1971 – Jul 1971
650	May 1963 – Sep 1963	692	Jun 1968 – Oct 1968	725	May 1971 – Nov 1971
651	Aug 1963 – Dec 1963	693	Aug 1968 – Oct 1968	726	Jun 1971 – Jan 1972
652	Nov 1963 – Feb 1964	694	Sep 1968 – Jan 1969	727	Jul 1971 – Jan 1972
653	Jan 1964 – Apr 1964	695	Nov 1968 – Feb 1969	728	Oct 1971 – Feb 1972
654	Apr 1964 – Jun 1964	696	Jan 1969 – Feb 1969	729	Oct 1971 – Feb 1972
655	May 1964 – Sep 1964	697	Feb 1969 – Mar 1969	730	Nov 1971 – Aug 1972
656	Aug 1964 – Dec 1964	698	Mar 1969 – May 1969	731	Jan 1972 – Aug 1972
657	Oct 1964 – Jan 1965	699	Apr 1969 – Jun 1969	732	Jan 1972 – Sep 1972
658	Dec 1964 – Apr 1965	700	May 1969 – Jul 1969	733	Mar 1972 – Jul 1972
659	Mar 1965 – May 1965	701	Jun 1969 – Sep 1969	734	Mar 1972 – Oct 1972
660	May 1965 – Jun 1965	702	Aug 1969 – Sep 1969	735	Jun 1972 – Nov 1972
670	Jun 1965 – Sep 1965	703	Sep 1969 – Oct 1969	736	Aug 1972 – Jan 1973
671	Jul 1965 – Oct 1965	704	Sep 1969 – Nov 1969	737	Oct 1972 – Jan 1973
672	Oct 1965 – Dec 1965	705	Nov 1969 – Dec 1969	738	Nov 1972 – Feb 1973
673	Dec 1965 – Mar 1966	706	Dec 1969 – Jan 1970	739	Jan 1973 – Feb 1973
674	Feb 1966 – May 1966	707	Jan 1970 – Mar 1970	740	Feb 1973 – Apr 1973
675	May 1966 – Jul 1966	708	Feb 1970 – Apr 1970	741	Mar 1973 – Jul 1973
676	Jul 1966 – Sep 1966	709	Mar 1970 – May 1970	742	Apr 1973 – Jul 1973
677	Sep 1966 – Nov 1966	710	Mar 1970 – Jun 1970	743	Jun 1973 – Aug 1973
678	Nov 1966 – Jan 1967	711	Apr 1970 – Jul 1970	744	Jul 1973 – Sep 1973
679	Dec 1966 – Mar 1967	712	Jun 1970 – Aug 1970	745	Sep 1973 – Oct 1973
680	Feb 1967 – Apr 1967	713	Aug 1970 – Sep 1970		
681	Apr 1967 – Jun 1967	714	Aug 1970 – Oct 1970		

As well as changes to the finders, and the necessary modifications these sometimes brought with them, there were several other revisions applied to the body over the years. Most were carried out in the early years, usually in the interests of simplifying production or reducing costs (such as the removal of patent details from the inside of the camera back), but not always.

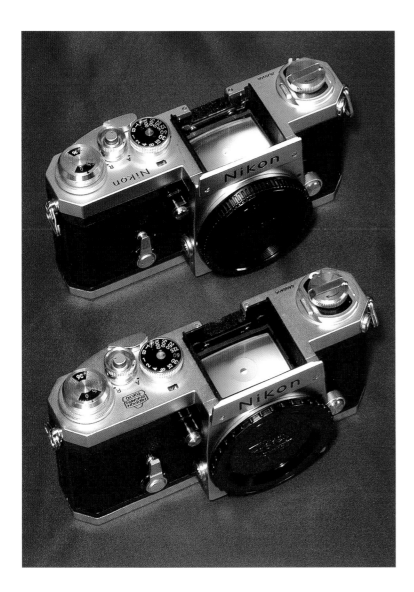

The film speed selector dial, for instance, was originally marked with red and white numerals, lining up to a single arrow. This was changed to a version with all white writing with black and red (IR) arrows shortly after production started. Even then, the earliest numbers were engraved, while after the 646 series, they were printed on. The range was ISO 10–400 for many years, but was extended to ISO 1,600 at the end of the 1960s.

On a practical note, in addition to internal changes as and when it was seen fit (such as a slight modification to the film rails, and four slots in the take-up spool instead of one), the rewind crank was given a rotating top early on, and the finder release button surround was given a groove from around the time of the 695 series, allowing a coin to be used to push the button in (it just so happens that a ¥1 coin does the job perfectly). The white plastic cover over the synchro post at the rear of the accessory shoe was also changed. From the 650 series, or thereabouts, a new version was used with a taller profile and a cut-out to give access to the spike. This was duly changed from white to black when the F2 came along, when the F also gained a new synchro terminal.

Indeed, the arrival of the F2 prompted several cosmetic changes for the F. Both the film advance and self-timer levers were given a black plastic covering, for instance, although both items had gone through several changes beforehand to simplify production. The first film advance lever had a slightly different trailing edge, and was hollowed out as much as possible to reduce weight. A more rigid casting followed, but it was still hollowed out on the back face, albeit to a lesser extent; by the 647 series the handle was completely solid, as it was easier to produce in volume. As for the self-timer, the first lever had a diagonal pattern on the top. By the 643 series the lines were vertical, but there was still a heavy groove beneath them. From about the 650 series the latter was no longer there, easing the manufacturing process.

Of course, one has to remember that these numbers will not always tie up with individual cameras. They may be cherished possessions nowadays, but most have been through years of constant use: components get damaged and replaced, and more recently many have been restored using parts from other Fs.

In any case, production of the original F finally came to an end in the autumn of 1973. When the last stocks were cleared in June 1974, a total of 862,600 units had been built and sold.

FAR LEFT: This study of a 640 series F from 1959 in front of a 1970 model (707 series) shows many of the subtle differences found in the early and late F bodies.

Nikonos Update

The original Nikonos was sold for almost five years before it was given a facelift to become the Nikonos II. While the first Nikonos had sold strongly initially, sales tailed off dramatically before picking up again, justifying this new version. Launched in May 1968, it featured a rewind crank instead of a knob, an 'R' (for rewind, or release) was added on the speed dial, and easier film loading. At the same time, the Nippon Kogaku badge on the back was replaced by a simple Nikon mark, while some European markets still demanded the Calypso/Nikkor badge on the front.

The Nikonos III of 1975 was another evolutionary model of the Calypso, with changes to the film loading and transport mechanism, enlarged controls, an improved bright line finder, beefier leverage points on the top plate (those on the first two Nikonos models tended to suffer from stress fractures after continued use, with no form of easy repair being possible), and less chamfer on the revised lower section of the body. At the same time, the frame counter was moved to a new position next to the shutter speed dial instead of being in the middle of the baseplate.

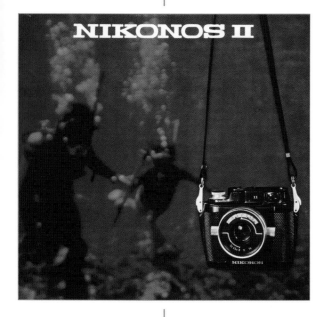

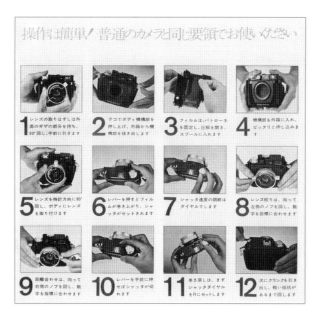

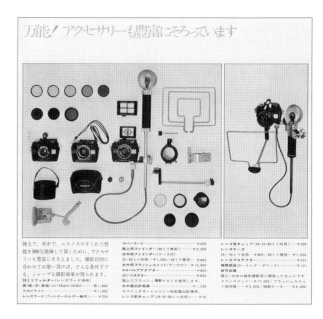

ABOVE: **Selected pages from the Nikonos II catalogue, including those showing how to handle this unusual Nikon, and the accessories available for it.**

RIGHT: **A Nikonos II advert from 1973. Stories of Nikon cameras and lenses surviving almost everything thrown at them have reached almost mythic proportions.**

FAR RIGHT: **The Nikonos III body with the later W-35mm f/2.5 lens. With the introduction of the III, Nikonos lens barrels changed from chrome to black, and gained new markings on their front rings.**

On the lens front, the original W-35mm f/2.5 was joined by a UW-28mm f/3.5 in mid-1965 and, after a close-up lens kit was released following its debut at the 1968 Photokina, an 80mm f/4 was issued in 1969.

The UW-15mm f/2.8 of 1972 vintage was the only other lens to appear during this period (an expensive fisheye, costing almost ten times the price of the regular W-35mm lens, and with a separate viewfinder twice the size of the latter!); a decade would pass before the next one was introduced. Incidentally, some lenses appear quite unlike their catalogue pictures due to an extended black ring on the front – this is actually an optional extra, offering a measure of protection to the lens during close-up work.

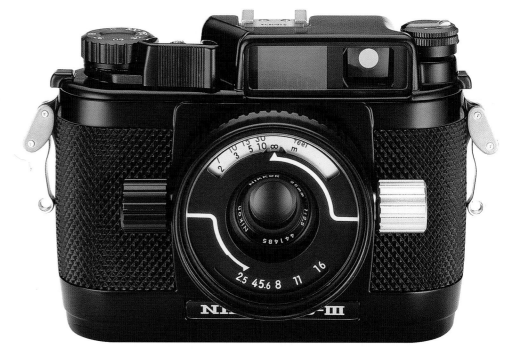

In the meantime, the barrel changed from a silver to a black finish after the arrival of the Nikonos III, the lens type script was altered on the inner ring, and the focusing and aperture knobs became colour-coded – both had been silver, but the later lenses featured a black knob for the aperture setting and a silver one for adjusting focus. The underwater flash was also updated in the mid-1970s.

The Nikon F2

After an interesting experiment with the EX lens system, Canon truly caught up with Nikon with the introduction of the F-1 and FTb in March 1971. Shortly after, Olympus was able to move on from the Pen following the announcement of its legendary OM-1 model, and in 1973 Minolta brought out its X-1 to compete with the other Japanese heavyweights. Nippon Kogaku, however, already had an answer to this new threat in the Nikon F2.

Although at first glance it is quite difficult to tell an F and an F2 apart, it does not take long to realize that the two are in fact significantly different, mainly because the project was started with a clean sheet of paper. Indeed, rather than adopt a traditional Nippon Kogaku code with a

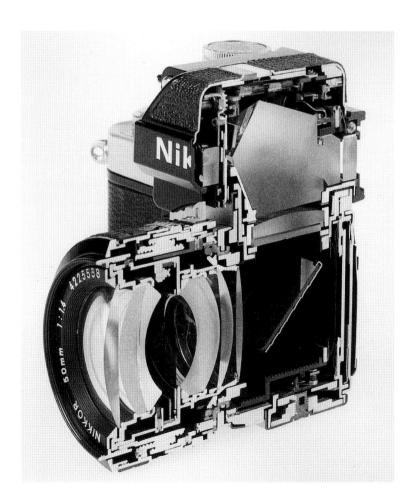

combination of numbers and letters, the F2 was simply called the 'A' camera (as if to emphasize a new approach) when work started on it in September 1965. Notwithstanding, it was eventually given the 30FB code!

It is an interesting revelation that the design team led by Akihiko Sato (two people were assigned to the body mechanism, one to the finder, and four or five to developing the range of accessories) considered the F to be the F2's main rival. Their four main goals included designing a camera of the highest quality, with quick and easy operation, a facility for system expansion (as with the F), and compliance with the long-term aim of full automation.

The first twenty prototypes were completed between March and July of 1970 (batch UF-1). Satisfied that the F2 met Nippon Kogaku's performance and reliability targets, components were duly produced throughout the various Nikon factories ready for the August 1971 press launch. The styling was slightly softer (all done completely in-house), but it was an

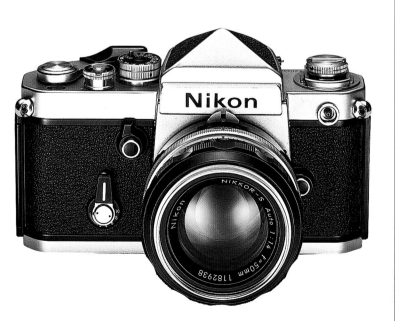

LEFT: The Japanese launch of the F2 was attended by dealers, members of the press and specialist users. The Tokyo event was attended by 3,000 people, and was followed by similar gatherings in Osaka (as seen here), Sapporo, Sendai, Nagoya, Hiroshima and Fukuoka.

FAR LEFT: Sectioned F2 body and lens. COURTESY JCII CAMERA MUSEUM, TOKYO

LEFT: Chrome version of the regular F2, seen here mounted with a 50mm Nikkor. The script on the front of the F2 was much sharper than before. The Nikomat series (along with the EM, and the F3 when they arrived) also adopted this new style typeface. Interestingly, though, with the front nameplate now coming as an integral part of the finder, older 'Nikon' script appeared on the body, albeit out of sight once a head was attached.

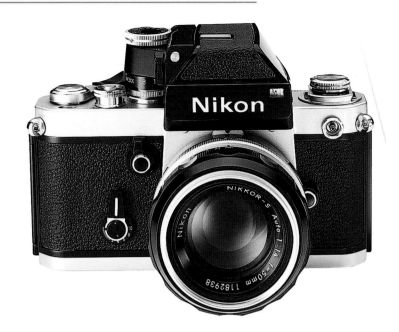

obvious evolution of the legendary F, which had reached the peak of its development. This can be ascertained by the fact that none of the F2's major internal components were found in the contemporary F.

The maximum shutter curtain speed was twice that of the F, allowing a top shutter speed of 1/2,000th of a second; the Speedlight synch speed was also increased, now up to 1/80th of a second. Interestingly, most of those who built the shutter at the Oi works were lady technicians, as they had a lighter touch with the delicate components. Once everything was in place the low weight of the parts paid off, allowing a higher shutter speed with no reliability concerns, but setting things up required a steady, gentle hand.

Other features included a larger mirror and, despite there being more information displayed in the finder, a smaller TTL exposure 'Photomic' head, achieved by moving its power source to the body. The shutter release button was moved forward (drawing complaints at first, which lessened with time), while the collar around it was given a different function – it now locked the shutter, or could select the 'T' setting that used to be on the speed dial. At the same time, the frame counter was moved in front of the winder crank rather than on/in it, and the film winding mechanism was refined, with the lever also doubling as a power switch. At last, the F2 came with a modern hinged back (in double-skinned aluminium), although it could be removed easily for a bulk film back (or early databack) by tripping the spring-loaded pin found inside the hinge.

The earlier Nikkor lenses and many accessories (such as certain finders and flashguns) would happily work on the F2, although many new ones would be introduced over the ensuing years. Incidentally, in addition to offering greater versatility, the separate head was retained to give the camera long-term reliability – it was acknowledged that cutting-edge electronic wizardry allowed advances in technology and features that would appeal to users, but it was not expected to last as long as mechanical elements of the design, so easy replacement was considered a must.

The regular F2 body (with its DE-1 eye-level finder) was introduced at ¥64,200 (or ¥3,000 more if a black finish was specified); this model ultimately stayed in production all the way through to the introduction of the F3. The F2 Photomic was announced at the same time, commanding just under ¥20,000 more owing to its advanced DP-1 head. Sold until September 1978, a black body was initially ¥2,500 extra on this model, as the Photomic head was already finished in that colour as standard.

A special Nikon Fair was held in Tokyo in September 1971 to coincide with the start of sales; no fewer than 260,000 people attended in just six days! This was actually a higher attendance figure than the one recorded for that year's national camera show.

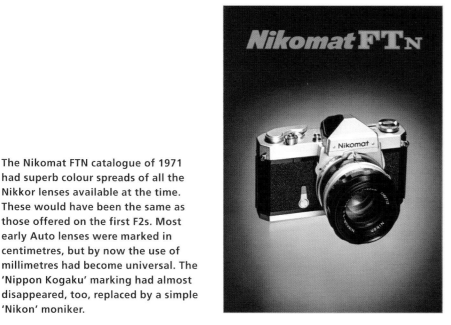

The Nikomat FTN catalogue of 1971 had superb colour spreads of all the Nikkor lenses available at the time. These would have been the same as those offered on the first F2s. Most early Auto lenses were marked in centimetres, but by now the use of millimetres had become universal. The 'Nippon Kogaku' marking had almost disappeared, too, replaced by a simple 'Nikon' moniker.

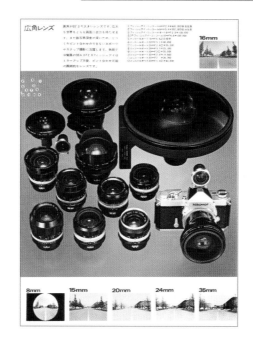

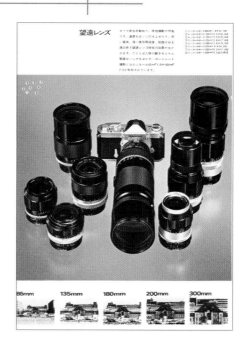

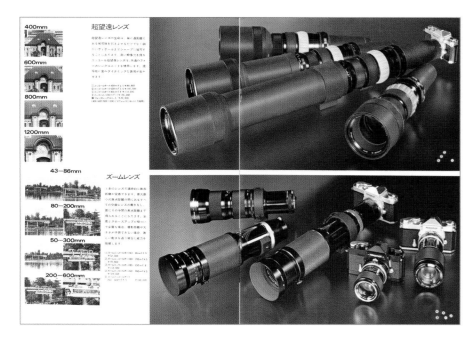

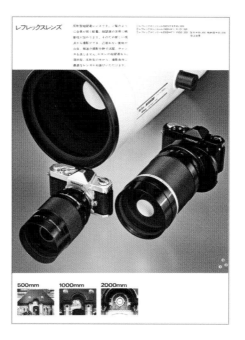

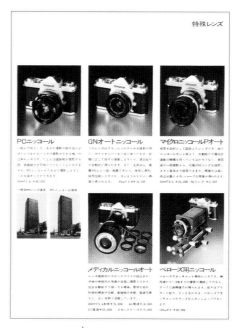

Although the F2 was announced in America in August, and in Europe the following month, export sales officially began in October. Accessories included various focusing screens (ultimately, nearly twenty would be listed, based on the type A, B, C, D, E, G, H, J, K, L, M, P and R, and priced at ¥1,800 apiece), the ¥18,000 DA-1 action finder, DW-1 and DW-2 waist-level finders (the latter, listed at ¥15,000, being a magnified version, as opposed to the regular ¥4,000 version), eyepiece correction lenses and rubber cups, and the DL-1 Photomic head illuminator, priced at a very reasonable ¥3,000.

Perhaps the most coveted of accessories, however, was the ¥70,000 MD-1 motor drive, put on sale a few days after the F2 was launched. Rated at four to five frames per second, it was fairly straightforward to fit, as the F2 already had an MD connection in place on the bottom of the body. Although the back release had to be removed from the baseplate, anyone with a small coin could do it, and it then stored neatly in the MD-1 unit for safekeeping until it was needed again. Powered by the MB-1 battery pack, this added a fair amount of weight to the package and a further ¥10,000 to the invoice. If one went for the MH-1/MN-1 charger and battery combination, to boost performance via an increase from 12v supply to 15v, another ¥17,000 was required, or one could opt to plug into the national grid with the costly MA-2 AC/DC converter.

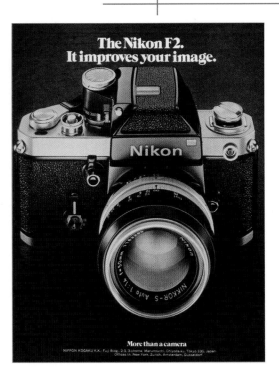

1972 advertising for the F2 Photomic.

American advert from summer 1972 for the Nikomat FTN, seen here mounted with a 50mm f/2 lens.

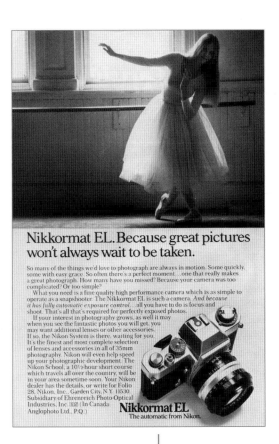

Two pieces of advertising showing the Nikkormat EL – one with a black body, the other with a chrome finish. Nikkormat EL body numbers started on 5100001. Sales of the Nikomat series broke through the 1 million units barrier in 1973.

The Nikomat Series Matures

The launch of the Nikomat EL, the first Nikon to feature an electronic shutter, came in December 1972. It was not the first camera to feature one, by a long way, but it was an important milestone in Nippon Kogaku history nonetheless. It was also the first Nikon since the ill-fated Nikkorex Auto 35 to feature an aperture priority AE mode, and the very first to use TTL metering on which to base its calculations. Again, this was hardly new, but necessary if Nippon Kogaku was to keep abreast of the competition.

All one had to do was set the lens aperture and, with the speed dial in the 'A' position, an automatic shutter speed was calculated according to the value registered by the camera's integrated TTL exposure metering, which used CdS cells. Shutter speeds were stepless from four seconds to 1/1,000th of a second, controlled by a monolithic integrated circuit (IC) unit – a world first for a camera, and a showcase for Nikon's micro-electronics technology.

One small 6v battery proved sufficient in terms of life and cold weather performance, but a mechanical shutter mode was provided in the Copal Square SE unit just in case of battery failure, set at 1/90th of a second. A battery condition monitor was to the left of the eyepiece, with the battery itself tucked away nicely under a spring-loaded lid at the base of the mirror box. The film advance lever was again employed as a power switch for the metering system, but on the EL moving it to reveal the red dot also unlocked the shutter release.

Within the fixed prism head (with a fixed focusing screen), the viewfinder image included an interesting meter guide that used the same scale as the shutter speed indicator, with two needles providing the information – getting these 'match needles' to overlap each other was required if one wanted to take the exposure advice offered by the camera's little black box.

The EL had an automatic exposure lock and mirror-up facility, and the accessory shoe worked automatically as a hotshoe whenever a flashgun was attached to the camera; the type of flash synch was selected by raising the collar around the shutter speed dial, and choosing either the white bulb for 'M' or the red lightning bolt for the 'X' position. The film speed dial was moved to the top plate for the first time, and there was a new back release, opened by tripping a lock and then lifting the rewind crank housing. It was a touch more fiddly than the early Nikomat release design, but the chance of opening the back by accident was much less likely with this new arrangement.

Launched at ¥60,500 for a chrome body (or ¥63,000 with a black finish), the EL, as with the earlier Nikomat cameras, was capable of using most of the lenses in the extensive Nikkor line-up. Sold alongside the FTN, both Nikomat models would continue to be developed as the 1970s progressed, ultimately offering the user a choice between fully manual or semi-automatic control. Interestingly, the EL had the same type 'Nikon' script on the prism as the F2, while the FTN continued with the softer, more traditional script. When the Nikomat FT2 came out in 1975, its graphics were brought into line with the F2 and EL.

'Progress Waits for No Man'

The old saying certainly rings true in the camera world, and new developments in electronics technology brought about a whole new range of Photomic heads and accessories that would have been unthinkable only a few years earlier.

Although there was no big fanfare over the launch of the compact SB-2 and SB-3 flash units at the end of 1972 (for the F/F2 and Nikomat series, respectively, and priced at ¥22,000 apiece), or even the MF-1 250-frame back brought out for the F2 in March 1973, the world stood up and took notice when Nippon Kogaku announced the Photomic S head, because it allowed another breakthrough in photography.

Making its debut in March 1973, the ¥40,000 Photomic S head (or DP-2) featured a larger metering area with greater sensitivity (although CdS cells continued to be employed), LED indicators in place of the traditional needle that moved between +/- poles, and an automatic exposure feature was released via the DS-1 EE (Electric Eye) control unit, launched at the same time. This little black box hooked onto the camera via the lens mount, and slipped underneath the rewind crank for added security.

Although expensive, especially if one added the cost of a DH-1 to recharge the special 3.6v battery needed to power the DS-1, with the availability of a motor drive, the Photomic S head, a DS-1 unit and an experimental 80mm f/4.5 centre-weighted AF lens (finalized in April 1971), the F2 design brief for the provision of full automation was successfully completed. It would be some time yet before the automatic SLR would be ready for market, but at least this leading-edge technology attracted a lot of attention wherever it was shown, confirming the hard-earned image of the Nikon brand as one that reflects and encourages innovation. But then the oil crisis put an end to much of the jubilation, as production costs rose out of control. Nippon Kogaku's management had to put a severe plan in motion to counter this level of inflation, but yet, through it all, demand for Nikon cameras remained strong.

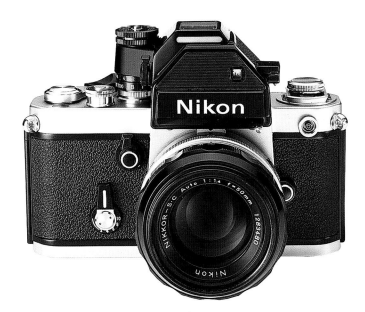

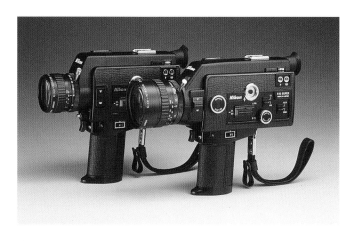

ABOVE LEFT: The F2 Photomic S.

LEFT: The R8 and R10 of 1973 vintage brought Nikon 8mm cine cameras into the modern era, bringing 16mm-type quality to the general public. The company would continue to develop this line of the business in the ensuing years.

ABOVE: A compatibility chart from 1973, showing the various lenses and accessories available at the time.

RIGHT: The sheer number of minor variations seen in the 'Auto' series of lenses will keep collectors busy for years. As well as the later 'C' versions, one can see that the oldest 50mm lens, to the left, has a different aperture ring to the example in the centre (also made around 1963), and carries 'Patent Pending' on the barrel. This wording does not appear on the centre lens. The later version, which dates from early 1970, has the same aperture ring as the 1963 model, but no screws on the heavier focusing ring, dual distance scales, and 'Nippon Kogaku' has

already been replaced by 'Nikon' on the front trim ring on this fast-moving item. In addition, the words 'Lens Made In Japan' can be seen on the barrel. As for the 200s (from 1966 and 1973), the differences are much more obvious once placed side by side.

BELOW: A US advert from 1973, with contemporary Nikon and Nikkormat cameras shown with a works Ferrari racer.

BELOW MIDDLE LEFT: Nikon brochure for the SB-4 flash unit, introduced in March 1974.

BELOW MIDDLE RIGHT: A Japanese F2 Photomic catalogue from spring 1974.

BELOW FAR RIGHT: American advertising for the F2, comparing the legendary Nikon with such cars as the Ferrari Daytona, Jaguar E-type and Maserati Bora – all true high-performance machines from the period.

Meanwhile, the F2 Photomic S was introduced at ¥96,200 (or ¥2,500 more for one with a black body) in the spring of 1973, running alongside the ¥48,500 Nikon F, the ¥62,000 F Photomic FTN, the ¥64,200 F2, the ¥82,200 F2 Photomic, the ¥32,000 Nikomat FTN and the ¥60,500 Nikomat EL.

New Accessories and 'New' Lenses

The spring of 1974 brought with it the budget SB-4 flash, and the so-called data imprinter for the F2. Then, in September, in addition to a wireless control unit, the MD-2 motor drive was introduced. The MD-2 replaced the MD-1, although the MB-1 power pack continued unchanged. New for the MD-2, however, was the MF-3 back (easily recognized by its heavy grip on the winder side of the camera), which worked in conjunction with MD-2 to prevent film fully rewinding if the user felt this to be of benefit – a small amount of film was left sticking out of the cartridge after being rewound.

The first batch of 'New' Nikkor lenses made their debut in November 1974. The 20mm f/4 was truly new, as was the 28mm f/2.8, but the fast-moving normals (a 50mm f/1.4 and 50mm f/2) were older lenses brought up to date cosmetically, with heavy rubber focusing rings and less in the way of metallic finishes visible.

Over the next few months three 'New' wide-angle Nikkors and a couple of telephoto lenses followed, although March 1975 will probably be best remembered for the launch of the Nikomat FT2 body. As well as a few cosmetic differences that had been applied to the last of the Nikomat FTNs, such as the black cover over the winding crank and self-timer lever, and black inserts on the depth-of-field preview and lens release buttons (bringing the cheaper camera more in line with the F2 in terms of

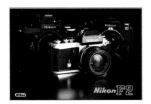

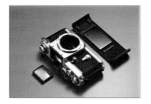

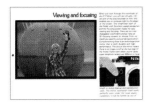
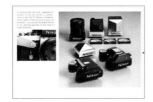
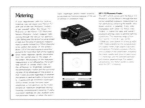
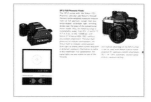

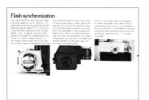
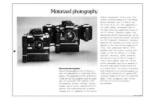
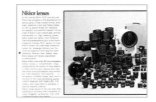
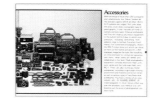

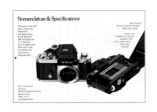

appearance), the main distinguishing feature was the adoption of an accessory shoe on top of the revised prism, complete with a central hot-shoe contact. There was also a new, finer grained body covering that looked less plasticky, and a single flash synch terminal setting the latest camera apart from its predecessor. Announced at ¥41,000, the FT2 was a fair bit more expensive than the FTN it replaced, but it was also far more modern and practical, offsetting the additional cost.

After releasing a splendid contraption called an 'intervalometer' by the factory (the MT-1, used for time-lapse photography), more 'New' lenses followed as spring turned to summer. No fewer than thirteen Nikkors were released during this period, including a 28mm f/4 PC variant, facelifted versions of the 50–300mm and 80–200mm f/4.5 zooms, and the world's first retro-focus type wide-angle zoom, the 28–45mm f/4.5, launched in August 1975.

Another significant development at this time was the use of PC102 glass (better known as ED, or Extra-Low Dispersion glass), solving many of the colour balance problems related to longer lenses; even infra-red (IR) wave-lengths could be brought into focus on the film. July 1975 witnessed the debut of the first of many Nikkors to employ ED glass: the 300, 600, 800 and

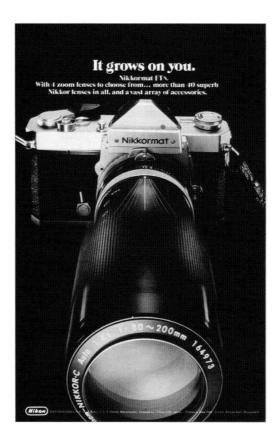

1975 European advert for the Nikkormat FTN, seen here with a handy 80–200mm zoom.

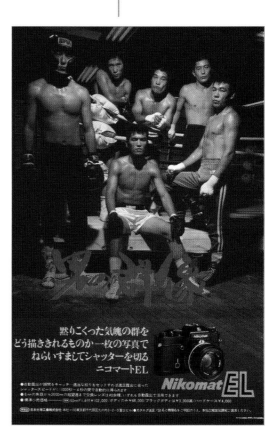

A domestic advert for the Nikomat EL dating from late 1975.

RIGHT: More effort was made in the mid-1970s to promote the Nikon brand in the mind of the public after the general slump in world trade following the war in the Middle East that sparked off an oil crisis, as this contemporary photograph of Sapporo clearly illustrates.

FAR RIGHT: The Nikomat FT2 mounted with a contemporary 105mm F2.5 telephoto, and seen here with a TC-200 teleconverter, a couple of Nikon filters (with case), plus a Nikomat EL with an F2 normal.

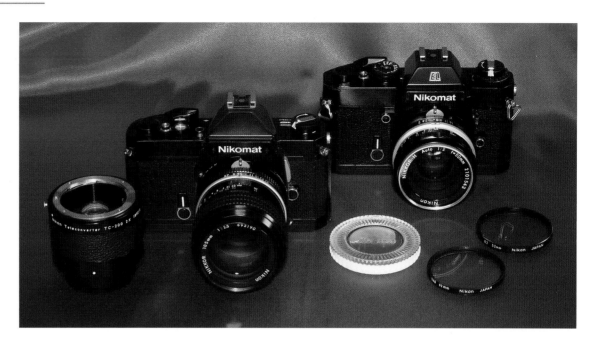

BELOW: A beautiful advert for the Nikkormat FT2. This is a relatively early model, as Nikomat FT2 production started on body FT 5000001, seen here with a 'New' 50mm f/1.4 Nikkor. The FT2 was sold until 1978.

BELOW RIGHT: Leica advertising for the R3, a new generation of electronic SLR that put the legendary German maker back in the fight. Ironically, despite the historical references, most were made in Portugal, but it forced Nippon Kogaku to respond with its own semi-automatic 'Pro' body.

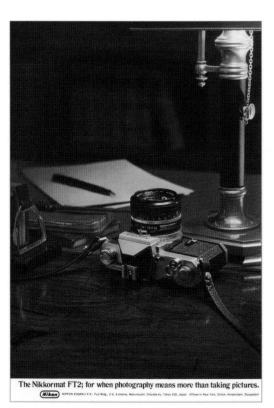

The Nikkormat FT2; for when photography means more than taking pictures.
NIPPON KOGAKU K.K.: Fuji Bldg., 2-3, 3-chome, Marunouchi, Chiyoda-ku, Tokyo 100, Japan. Offices in New York, Zürich, Amsterdam, Düsseldorf.

1,200mm telephoto lenses led the way, coming with the AU-1 focusing unit (superseding the older FU-type units). Leading-edge technology has a price, however, and in this case it was quite high. The 300mm f/4.5 is a perfect illustration, as the regular version, issued only four months earlier, cost ¥66,000, while the ED glass lens was listed at ¥180,000! Still, new production techniques and increased volumes in the years that followed would soon bring ED lenses within reach of the average enthusiast.

In addition to an exotic 13mm 'Auto' Nikkor (with the rather unusual HD designation instead of SD to represent its sixteen elements, to fit in with the previous use of *hex* for six elements), two more 'New' lenses (a 35mm f/2 wide-angle and a 105mm Micro-Nikkor), the SB-5 flash (a more modern interpretation of the SB-1) and the RA-350 Nikon AF enlarger were introduced before 1975 drew to a close, but 1976 would be another busy year.

Another Price War

The Contax RTS came out in 1975, providing the basis for a whole series of Japanese Kyocera cameras using the famous German brand name. Kyocera, of course, also owned the Yashica business, which had been linked with Nicca in the 1950s.

Following an attempt to revive sales of its compact cameras via the CL series (a joint project with Minolta), Leica introduced its first all-electronic SLR, the R3, in 1976, which gave way to the R4 four years later. Meanwhile Canon brought out the automatic AE-1 in March 1976, upgrading it in 1981, the same year in which the New F-1 flagship model made its debut. But it was the birth of the original AE-1 that posed the immediate threat – an SLR with AE plus a 50mm f/1.4 lens at well under ¥100,000

(¥81,000 to be exact). This sparked off another price war, with the Pentax ME and Minolta XD joining the fight.

Nippon Kogaku had only just brought out the ELW, which was ¥81,000 for a body alone. The ELW (supplied in black only) was basically an EL with a relocated power switch and the necessary connections for the AW-1 auto winder, introduced to go with the new body. The AW-1 cannot really be described as a motor drive, as continuous firing was not possible, but this compact accessory (it employed the camera's own shutter release to keep dimensions and weight to a minimum) was undoubtedly useful, and introduced automatic film transport to the regular SLR Nikons – previously this had been the realm of the 'Pro' bodies only. Unfortunately, adding a decent lens and the AW-1 unit took a basic ELW outfit up to around ¥140,000, making it far from competitive in the price-conscious, mid-range market.

While the engineers and designers set about their task of developing a worthy competitor in the entry-level arena, a batch of sixteen 'New' lenses appeared in spring 1976, including a fisheye, a 35mm PC-Nikkor, three wide-angle lenses, a fast normal, six telephotos and four zooms. Two of these (the 50mm f/1.4 and 135mm f/2.8) were revisions of earlier 'New' lenses, with a fresh internal layout, and carried the S suffix at the end of their type designation to differentiate them from their immediate predecessors. Within this flood of new introductions there was also a limited production 400mm f/5, which, coming with ED glass, was the fastest 400mm telephoto available at that time. Shortly after this, the only 'New' Reflex (a 1,000mm brute weighing in at 1,900g) put in an appearance and brought another generation of Nikkor lenses to an end, as the 20mm f/2.8 (fourteen elements in nine groups) shown at Photokina that year did not make it into production.

Accessories released in the early part of 1976 included the ¥27,000 ML-1 and ¥150,000 MW-1 remote and radio control sets. The DR-2 angle finder also put in an appearance, only to be replaced by the ¥11,000 DR-3 in June 1977.

During the winter of 1976 the outrageously expensive MF-2 750-frame back made its debut, priced at a whopping ¥440,000. The approved film winder was another ¥20,000, as were additional spools – five times the cost of the MZ-1 spools for the MF-1 250-frame back. The PF-3 copy kit was another debutante at this time, commanding ¥50,000 in basic form.

October 1976 saw the launch of the Nikon F Photomic SB, with its faster SPD (Silicon Photo Diode) metering cells, and improved LED indicators and

FAR LEFT: The Nikomat ELW. Bodies were numbered from W 7500001 onwards.

BELOW FAR LEFT: Nikon F2 Photomic SB.

BELOW MIDDLE: A domestic July 1976 brochure for close-up equipment.

BELOW: Japanese advertising for the F2 Photomic dating from 1976.

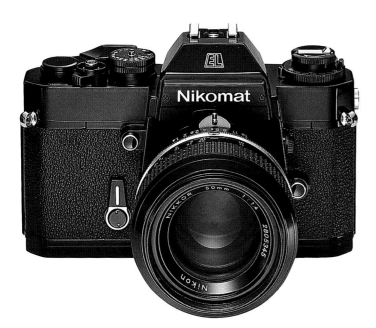

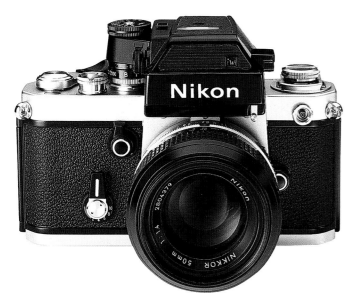

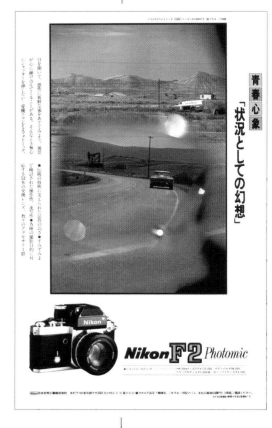

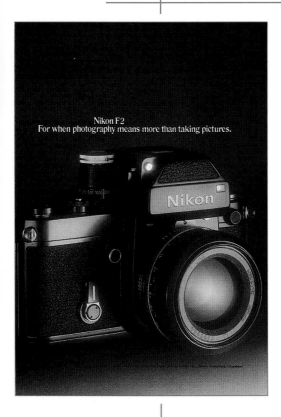

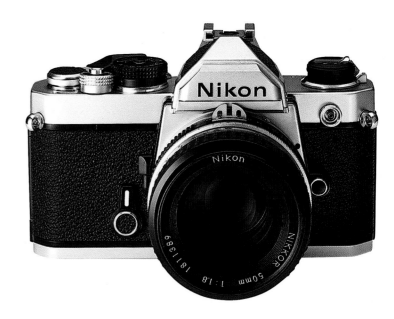

ABOVE: **A European advert for the F2 Photomic, seen here with the contemporary 50mm f/1.4 – standard issue for anyone buying a new camera.**

ABOVE MIDDLE: **An early FM advert with a Lancia Stratos on the Safari Rally providing a suitably dramatic backdrop.**

ABOVE FAR RIGHT: **The Nikon FM. Body numbers started on FM 2100001 for this model, but this is one of the later versions, readily identified by the smooth rewind crank housing.**

electronics in a more compact DP-3 head that also featured a viewfinder curtain. During its two-year run the body was priced at ¥122,000 with a chrome finish, although a black body was available for an additional ¥5,000.

At the same time as the Photomic SB came out, Nippon Kogaku announced the MF-10 and MF-11 databacks, the former (priced at ¥145,000) being for 36-exposure film, the latter for 250 frames, at ¥45,000 more. These were very complicated and bulky compared to today's ultra-slim databacks, with beautifully crafted mechanical date and time stamps, and a facility to transfer written details to the film. A few F2s were converted ready for these databacks, with slightly different internals to allow space on the negative for printing any required details. The converted cameras carry the word 'Data' marked above regular F2 serial numbers, but the expense was difficult to justify and, as such, it is a very rare find nowadays.

Nikon's eventual reply to the Canon AE-1 was the FM of May 1977 – small, light, and cheap at ¥81,000 including a 50mm f/2 lens. The FM was of a similar physical size as the Nikomat cameras, coming with a high-quality feel and aura, but substantially lighter. The lens mount made a big difference to the camera's appearance, being the familiar F mount with an Ai coupling that could be flipped out of the way to allow non-Ai Nikkors to be used (for more on this subject *see* page 87).

Although the FM had a fixed focusing screen, the use of a Copal CCS-M shutter, which travelled vertically, combined with the lack of a lock-up facility, allowed a larger mirror with a damper to be fitted. A new feature was the multiple exposure button moved to the top plate, while the self-timer lever and depth-of-field preview button were in their regular positions.

Film speed was set in the shutter speed dial in much the same way as the flash synch type selection on the EL series, while the film advance lever once again doubled up as a lock for the shutter, as on the EL.

The viewfinder image included information on exposure levels (supplied by a gallium photo diode [GPD] cell), shutter speed and aperture setting with Ai specification lenses. The Ai Nikkors had a second row of aperture values, the figures being visible in the finder thanks to the ADR (Aperture Direct Readout) system.

The earliest FMs had a knurled edge on the rewind crank housing and collar around the shutter release button, although both were replaced by smooth components in time. In the case of the crank housing this happened as soon as stocks of older components ran dry, while the collar was changed once power to the centre-weighted meter was kicked in by slightly depressing the shutter button instead of having to turn the collar; the first models also had 'Nikon' engraved above the body number, but this practice was abandoned later in the production run.

Sure enough, more powerful quartz control units replaced the older analogue items, but the FM still had a mechanical shutter. However, April 1978 saw the launch of the Nikon FE, a sister model to the FM with an electronic shutter and 'Auto' mode on the speed dial, giving automatic shutter speeds based on aperture priority. The FE with a 50mm f/1.8 Nikkor was listed at ¥95,000; 250,000 were sold each year up to 1981, making it Nippon Kogaku's most successful product for quite some time.

Although it was a long while coming, this sales figure proves beyond doubt that the company was right not to be drawn into rushing into the design and production of a competitor for the AE-1 and its ilk: its qualities had to shine brightly enough not simply to justify its asking price, but to gain conquest sales in this lucrative sector of the market. Meanwhile, at the top end of the market, where brand loyalty runs much deeper, Nippon Kogaku had introduced a new line of lenses, and the bodies to suit.

Artificial Intelligence?

Both the FM and FE took advantage of what Nippon Kogaku called 'Ai' lenses. The initials 'Ai' (or AI to be correct) stand for Automatic Maximum Aperture Indexing, a system that was introduced by Nippon Kogaku in spring 1977 to make the most of the camera's TTL exposure metering. Apart from being less bothersome to couple up to Photomic heads (a lot of the ritual 'toing and froing' associated with registering the f number of pre-Ai lenses on earlier heads was eliminated), the main advantage of these latest Nikkors was that the maximum aperture of the lens was automatically reset after each shot to ensure an accurate measurement of available light. The meter coupling ridge provides an instant identifying feature on the rear of the Ai lens, while the locating prong was retained to enable use with earlier Photomic heads and accessories, albeit with a cut-out on either side of the central slot (a second distinguishing feature to help identify the new lenses).

No fewer than nineteen Ai-type Nikkors were introduced in March 1977, followed by another five in May, thirteen in June and three more before the end of the year. These covered everything from a 6mm fisheye all the way up to a 600mm telephoto with ED glass, along with six popular zooms.

Perhaps the most interesting development came with the new 400 and 600mm telephotos, which featured internal focusing (or IF). The IF system, in the words of Nikon's own material, 'allows a lens to focus without changing its length. All optical movement is limited to the interior of the non-extending lens barrel, allowing a more compact, lightweight construction, as well as a closer focusing distance.'

Also worthy of note was the 58mm Noct-Nikkor (which sounds better in Japanese, pronounced as the 'Nocto-Nikkor'), made for night, or nocturnal, photography. This fast, rather expensive lens, first shown at Photokina in 1976, employed an aspherical front element to enhance optical performance at the maximum f/1.2 opening, but at ¥150,000 it was always going to be restricted to specialist use only.

The F2 Photomic A went on sale in March 1977 to take advantage of these new Ai lenses, although older Nikkors could still be used. Some, however, chose to update older ones to Ai specification, which was easy to do given the retention of the F mount. This policy of 'User First' has always been a key factor in Nikon's success in gaining and retaining a loyal following. The F2 Photomic A indirectly replaced the Photomic S and was readily identified by the white 'A' on the front of its DP-11 head. Since there was no longer any need to connect the lens to the head via a pin in the lens's locating prong, the shape was quite different at the front lower edge of the latest head. To keep the price in check the DP-11 featured a needle indicator and CdS metering cells.

The Photomic A was sold until April 1980 in chrome or black, with the body only being priced at ¥102,000. To put that in perspective, the strict F2 Photomic was up to ¥98,000 by this time, with ¥5,000 more required for a black body. One interesting variation to look out for is the F2 Photomic A issued only for the US market to celebrate the twenty-fifth anniversary of Nikon in America. The chrome body featured bold graphics underneath the shutter release and was restricted to 4,000 units, each packed in a special silver box.

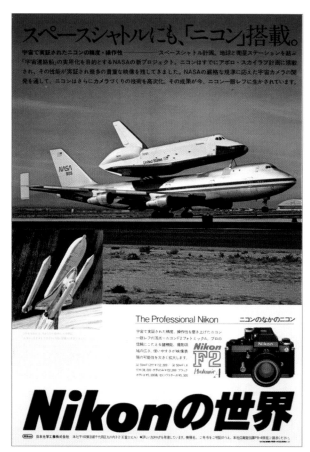

ABOVE LEFT: This European advert for the F2 Photomic A kindly gives a view of the contemporary F mount.

ABOVE: An American advert for the F2 Photomic A, seen here with the MD-3 motor drive and MB-1 power pack.

LEFT: Japanese advertising for the F2 Photomic A. Nikon cameras would soon be put into service with the Space Shuttle, seen here taking a ride on NASA's Boeing 747.

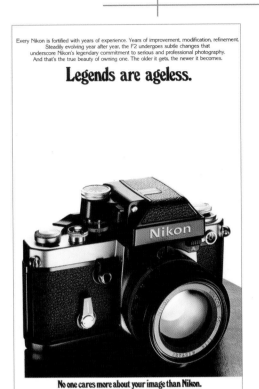

Every Nikon is fortified with years of experience. Years of improvement, modification, refinement. Steadily evolving year after year, the F2 undergoes subtle changes that underscore Nikon's legendary commitment to serious and professional photography. And that's the true beauty of owning one. The older it gets, the newer it becomes.

Legends are ageless.

No one cares more about your image than Nikon.

NIPPON KOGAKU K.K. Fuji Bldg., 2-3, 3-chome, Marunouchi, Chiyoda-ku, Tokyo 100, Japan

ABOVE: This advert dates from 1979 but, as it says, legends are timeless.

BELOW: A four-page advert from September 1977, showing the FM and some of the Nikkor lenses then available.

ABOVE: The Nikomat FT3, production of which began on body FT3 6000001.

ABOVE RIGHT: The Nikon EL2 (body numbers started on EL2 7800001). Like the Nikomat FT3, it was built until 1979, and is seen here with one of the last 50mm f/2 Nikkors – an 'Ai' spec model.

The Nikomat FT3 was launched at the same time as the F2 Photomic A and was basically an FT2 that worked in greater harmony with Ai lenses. This was actually the last of the highly successful Nikomat line, since the EL2, introduced just two months later at ¥79,000, was badged as a Nikon. The EL2 came with an Ai lens mount, SPD metering cells, which were

faster and more reliable than the CdS cells used on the ELW, and a greater spread of shutter speeds on the dial. The EL2 also had its film speed range extended from ISO 1,600 to 3,200, and was given an exposure compensation facility alongside the film speed dial. Available in chrome or black, early serial numbers were prefixed with 'EL2', although later body numbers are engraved without the prefix.

As mentioned earlier, the FM was released in May 1977. The MD-11 motor drive was made available straight away, priced at ¥33,000, and then a range of Speedlights followed: the SB-7, SB-8 and SB-9. The SB-7, which cost ¥18,000, was basically a replacement for the SB-2, while the SB-8 (with its ISO foot) took the place of the SB-3. The SB-9 was a

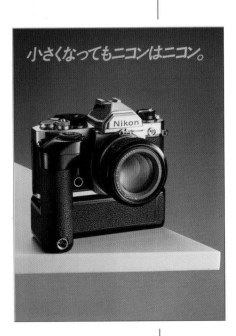

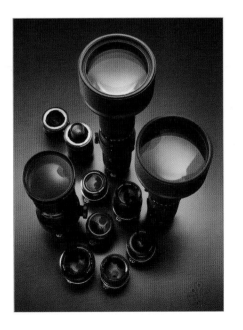

compact flash costing roughly half the price of the SB-7 and was an indirect replacement for the SB-4.

On the subject of replacements, the F2 Photomic AS took the place of the SB when it was introduced in July 1977, although the two appeared together in the price lists for some time. The AS body (with its DP-12 head, featuring LED indicators and SPD metering cells) was designed specifically for Ai-type lenses, and sold for ¥126,000 until the spring of 1980. A black body finish was available for ¥5,000 extra.

While the F2 Photomic S and SB had the DS-1 EE (Electric Eye) control unit, the A and AS had the DS-12, introduced in July 1977 at ¥55,000. Not long after, in October, the MD-3 motor drive was announced. This

was a lower-priced MD, which could be linked with the MB-1 battery pack or with the cheaper MB-2 pack. Also in 1977 a limited number of gold-plated FMs with matching 50mm f/1.4 Nikkors were released to celebrate the company's sixtieth anniversary. This was not the first time Nippon Kokagu had made presentation cameras with real gold plating and detailing, and it certainly would not be the last.

The Nikon FE made its debut in April 1978. This was basically a combination of the FM body with the EL2's internal components. That statement, although true, rather over-simplifies things, as the multiple exposure control was relocated under the film advance lever and a number of external EL2 features were included that did not appear on the FM, such as the extended film range and ISO selector under the rewind crank, and the exposure compensation facility. In addition, the FE used the Copal CCS-E shutter unit.

SPD cells were used for the metering, rather than the GPD units used on the FM, and the automatic exposure facility on the FE called for a memory device. The AE lock actually used the same lever as the self-timer. Another feature that set the FE apart from the FM was the ability to change focusing screens, even though this had to be done through the lens mount.

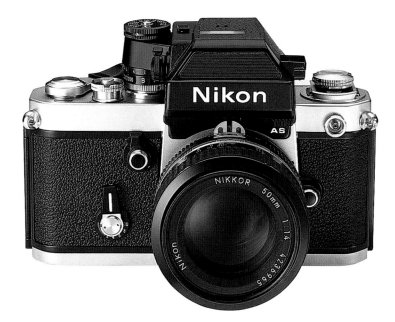

LEFT: The F2 Photomic AS with an f/1.4 Ai-spec normal. Note the colouring of the lens – each had its own distinctive hue at this time.

BELOW LEFT: The Nikon FE, introduced as a sister camera to the FM.

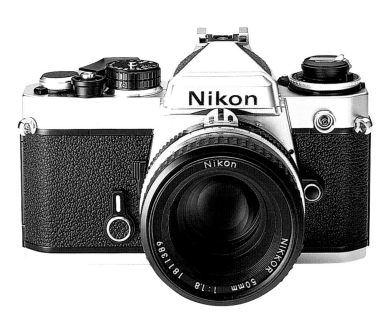

BELOW MIDDLE: A late 1977 advert showing Nikkor lenses for large format cameras. The company continues to produce large format lenses to this day, currently listing more than two dozen variations. Lenses were supplied to the Plaubel concern of Frankfurt during this period, finding service on that company's Makina cameras.

BELOW: The Nikon FE seen with the MD-11 motor drive and SB-10 Speedlight from the time. FE body numbers started on FE 3000001.

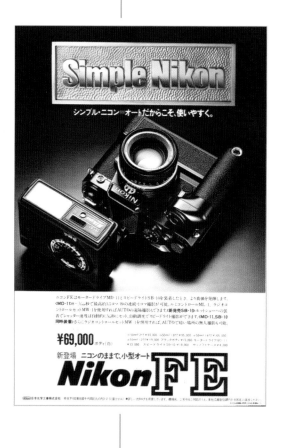

The FE came with superior flash operation, too, thanks to an extra contact in the hotshoe. Whenever a suitable Speedlight was fitted, the camera automatically selected the 1/125th of a second flash synch and provided a flash ready signal in the viewfinder. There was also a battery condition check light, but if the batteries failed for any reason there was a mechanical shutter speed (M90) included on the dial as a back-up.

The first of six more Ai lenses launched in 1978 appeared in February. This was a fast 300mm telephoto with ED glass, although three of the six Nikkors brought out that year were actually revised versions of existing models. In reality, it would have been difficult to find many worthwhile gaps in the Ai lens line-up, which sported no fewer than forty-three variations by the end of 1978 (forty-six if one counts those already superseded). Perhaps the most important Nikkor of 1978, however, was the workaday 50mm f/1.8, which replaced the long-running f/2 normal in the line-up, while the 50mm f/1.2 replaced the 55mm f/1.2 version.

The ¥180,000 SB-6 repeating flash came out in February 1978, two months before the more reasonably priced SB-10, which took the place of the short-lived SB-8 in the line-up thanks to an extra connection on the ISO foot that allowed all functions to be used on the Nikon FE. One could buy ten SB-10s for the price of an SB-6. Other accessories from this time included the DG-2 magnifier and the PB-6 bellows attachment, introduced in July.

In mid-1979 the technically improved MD-12 motor drive was introduced for the FM and FE. This ¥34,000 unit used superior electronics integration to reduce meter battery drain. The compact digital MF-12 databack (also for the FE/FM) came out shortly after; a modified version, priced at ¥18,500, that did away with the cable connection came out in spring 1981.

Another nine Ai lenses made their debut in 1979, including a 200mm Micro-Nikkor, a selection of long telephotos with ED glass and internal focusing, some additional or revised wide-angle lenses (including a faster and lighter 16mm fisheye, first shown at the 1978 Photokina event, with a new filter system that employed small filters fitted on the rear of the lens rather than the previous revolver arrangement) and a 25–50mm zoom among them. A 55mm f/2.8 Micro-Nikkor and a couple of PC-Nikkors introduced during 1980 and 1981 rounded off the Ai range, the Micro-Nikkor replacing the slower f/3.5 variant, while the 28mm f/3.5 PC-Nikkor ultimately replaced the earlier f/4 version in the price lists.

A friend of the author bought an F2 with three Nikkor lenses in 1978, costing him the equivalent of a teacher's monthly salary. There was still a hefty price to pay to buy into the Nikon System, especially if one chose a 'Pro' body, but it was a better scenario than fifteen years earlier when an F with one lens would have been six times his starting wage! Of course, Japan has a bi-annual bonus system, which makes a big difference when it comes to buying luxuries, but there is no escaping the fact that Nikon equipment has never been cheap.

Meanwhile, the extraordinary strength of the yen against the dollar made US sales difficult, putting prices up in the USA. With such a competitive market and a limit on how much prices could move, however, costs were saved in stocking and distribution to try and offset the difference. Heavier promotion was also used and Nikon Inc. organized joint events with dealers to keep the Nikon name in the spotlight at reduced cost. Interestingly, after April 1980 Nikon Inc.'s revenue was kept in dollars to avoid the problems associated with exchange rate fluctuations.

BELOW: Cover of the September 1978 Nikkor lens brochure. Looking at the fashion, could it possibly be from any other era?

BELOW RIGHT: American advertising for the FE from November 1978.

Special F2s

The FE was not the only Nikon body to make its debut in 1978; there were actually two more, although neither was released to the general public. The F2P (the 'P' standing for Press) was issued to two thousand of the world's media photographers that year. Priced at ¥98,000 apiece, titanium parts brought the body weight down to 715g, only a slight difference compared to the regular F2, but it was also stronger. Titanium was used for the finder prism, top plates, the lens mounting plate (sometimes referred to as the apron), the back and the baseplate. Finished in black only, these special F2s could readily be identified by their anti-reflective hammered paint finish.

In their triumphant assault on the second highest mountain on Earth, the 1978 American K2 Expedition brought back more than glory. The mountaineers who reached for greatness and the 28,250-foot summit photographed for mankind rare glimpses of the world from spectacular and chilling heights.

To document their dangerous ascent, it was by no mere chance that the expedition chose to use winterized Nikon equipment exclusively.

Faced with a cross-country trek in blistering heat, punishing blizzards, and temperatures dipping to 40 below, the K2 team needed the special assurance of Nikon's legendary ruggedness.

The climbers who accepted the awesome challenge of K2 didn't take chances with their equipment.

They took Nikon.

FE FM

No one cares more about your image than Nikon.

NIPPON KOGAKU K.K. Fuji Bldg . 2-3, 3-chome, Marunouchi, Chiyoda-ku, Tokyo 100, Japan

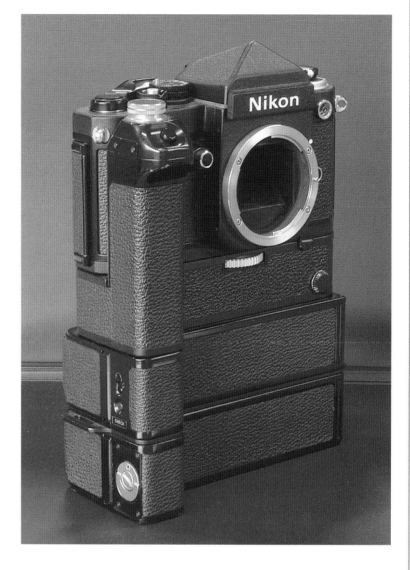

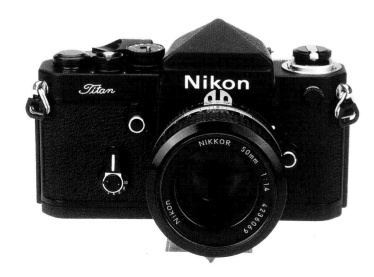

The F2H was also for press members only, making use of the MD-100 high-speed motor drive (combined with the MB-100 power pack), and building on the experience gained with the earlier F specials converted for the press to try at the Sapporo Winter Olympics and the Montreal games. Announced in November 1978 at ¥480,000, only 300 were made, all finished in black and weighing in at 2,095g. As with the F2P, titanium parts were employed for added strength and weight reduction, but the depth-of-field button was different from that fitted to the regular models (the lens diaphragm control was not automatic), and there was no self-timer or mirror lock-up facility (the latter was fixed, as the MD was capable of firing up to ten frames per second). Naturally a special winding mechanism was employed, while the maximum shutter speed was reduced to 1/1,000th of a second; there were no 'T' or 'B' settings.

After these exotic F2s, which people usually only got to see on the television being handled by professionals, June 1979 saw the launch of the F2 Titan (or F2T). This was basically an F2P released to the general public.

FAR LEFT: **Superb advertising making the most of the Nikon camera's reliability and rugged qualities as a sales point. This piece quotes the use of Nikon equipment on the 1978 American K2 Expedition, although many explorers (not to mention those working in more mundane harsh conditions) put their trust in the Japanese brand.**

LEFT: **The exotic F2H kept in Nikon's collection (body H-MD F2 7850220).**

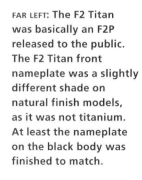

FAR LEFT: **The F2 Titan was basically an F2P released to the public. The F2 Titan front nameplate was a slightly different shade on natural finish models, as it was not titanium. At least the nameplate on the black body was finished to match.**

Around 3,500 were built, available in black or a natural finish, with 'Titan' script under the shutter button. At ¥98,000 apiece there was apparently no real profit for Nippon Kogaku, but the F2T generated much good publicity at the time and ranks as a desirable collectors' item today.

Nikon F2 Body Numbers

Just as the F has become as collectable as the Nikon rangefinder series, surely the F2 will be just as popular, in time. As the last fully mechanical Nikon, it already has its fans. With the F2 body numbers, the main number had a 'F2' prefix in front of it. The accompanying table (*opposite*) contains production dates for each batch of serial numbers issued throughout the series.

The F2 Titan had its own set of body numbers, beginning with an 'F2T' prefix followed by six digits instead of the usual seven (790001 onwards), while the earlier F2P models began with serial number F2 9200001. The F2H batch is even more confusing, using an earlier series number (F2 7850001 onwards), but with an 'H-MD' prefix to differentiate the two.

A New Era

The EM was styled by the famous Italian designer Giorgetto Giugiaro of ItalDesign. It was actually a friend of the author's, the professional photographer and top motoring journalist Kazuhiko Mitsumoto, who was instrumental in bringing these two great concerns together.

RIGHT: **Rear view of a pair of F2s, the chrome body dating from 1973, while the black Photomic is from mid-1976. Ultimately, F2 sales totalled just over 816,000 units.**

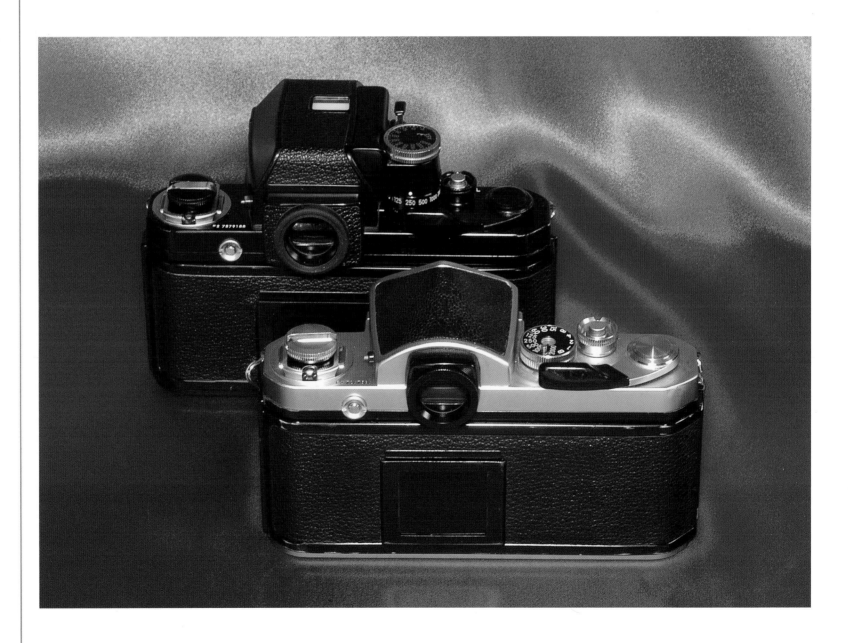

NIKON F2 SERIAL NUMBERS AND PRODUCTION DATES

SERIES	PRODUCTION DATES	CHROME/BLACK	SERIES	PRODUCTION DATES	CHROME/BLACK
710	Jul 1971 – Oct 1971	Both	758	Jul 1976 – Sep 1976	Black
711	Oct 1971 – Dec 1971	Both	759	Sep 1976 – Nov 1976	Black
712	Dec 1971 – Feb 1972	Both	760	Jan 1975 – Feb 1975	Chrome
713	Feb 1972 – Apr 1972	Both	761	Feb 1975 – Jun 1975	Chrome
714	Apr 1972 – Jun 1972	Both	762	Apr 1975 – Jun 1975	Chrome
715	Jun 1972 – Aug 1972	Both	763	Jun 1975 – Jul 1975	Chrome
716	Aug 1972 – Sep 1972	Both	764	Jul 1975 – Nov 1975	Chrome
717	Sep 1972 – Nov 1972	Both	765	Aug 1975 – Dec 1975	Chrome
720	Nov 1972 – Dec 1972	Both	766	Oct 1975 – Jan 1976	Chrome
721	Nov 1972 – Dec 1972	Both	767	Nov 1975 – Feb 1976	Chrome
722	Dec 1972 – Jan 1973	Both	768	Feb 1976 – Mar 1976	Chrome
723	Dec 1972 – Mar 1973	Both	769	Mar 1976 – May 1976	Chrome
724	Feb 1973 – Apr 1973	Both	770	Nov 1976 – Dec 1976	Black
725	Mar 1973 – May 1973	Both	771	Nov 1976 – Feb 1977	Black
726	May 1973	Both	772	Feb 1977 – Apr 1977	Black
727	May 1973 – Jun 1973	Both	773	Feb 1977 – May 1977	Black
728	May 1973 – Aug 1973	Both	774	Apr 1977 – Jul 1977	Black
729	Jul 1973 – Aug 1973	Both	775	Jun 1977 – Oct 1977	Black
730	Jul 1973 – Oct 1973	Both	776	Oct 1977	Black
731	Sep 1973 – Nov 1973	Both	777	Nov 1977 – Feb 1978	Black
732	Sep 1973 – Dec 1973	Both	778	Jan 1978 – May 1978	Black
733	Oct 1973 – Jan 1974	Both	779	Apr 1978 – Jul 1978	Black
734	Nov 1973 – Feb 1974	Both	780	May 1976 – Jul 1976	Chrome
735	Dec 1973 – Feb 1974	Both	781	Jun 1976 – Oct 1976	Chrome
736	Jan 1974 – Apr 1974	Both	782	Aug 1976 – Dec 1976	Chrome
737	Feb 1974 – Apr 1974	Both	783	Oct 1976 – Jan 1977	Chrome
738	Apr 1974	Both	784	Nov 1976 – Feb 1977	Chrome
739	Apr 1974 – Jul 1974	Both	785	Feb 1977 – Jun 1977	Chrome
740	May 1974 – Jun 1974	Both	786	May 1977 – Aug 1977	Chrome
741	May 1974 – Jul 1974	Both	787	Aug 1977 – Dec 1977	Chrome
742	Jun 1974 – Aug 1974	Both	788	May 1977 – Jan 1978	Chrome
743	Jul 1974 – Sep 1974	Both	789	Jan 1978 – Mar 1978	Chrome
744	Aug 1974 – Oct 1974	Both	790	Jul 1978 – Oct 1978	Black
745	Sep 1974 – Oct 1974	Both	791	Sep 1978 – Dec 1978	Black
746	Oct 1974 – Nov 1974	Both	792	Dec 1978 – Mar 1979	Black
747	Nov 1974 – Jan 1975	Both	793	Mar 1979 – Jun 1979	Black
748	Nov 1974 – Jan 1975	Both	794	Jun 1979 – Sep 1979	Black
749	Jan 1975 – Feb 1975	Both	795	Sep 1979 – Dec 1979	Black
750	Feb 1975 – Apr 1975	Black	796	Jan 1980 – Jun 1980	Black
751	Mar 1975 – Jul 1975	Black	800	Mar 1978 – Jul 1978	Chrome
752	Jul 1975 – Nov 1975	Black	801	May 1978 – Aug 1978	Chrome
753	Sep 1975 – Jan 1976	Black	802	Aug 1978 – Dec 1978	Chrome
754	Nov 1975 – Feb 1976	Black	803	Nov 1978 – Mar 1979	Chrome
755	Dec 1975 – May 1976	Black	804	Mar 1979 – Jul 1979	Chrome
756	Mar 1976	Black	805	Jul 1979 – Dec 1979	Chrome
757	Jun 1976 – Aug 1976	Black	806	Oct 1979 – Jun 1980	Chrome

NOTE TO TABLE: The series numbers 718 to 719 and 797 to 799 (inclusive) were not used. Note also the way in which some production dates cross over, in much the same way as they did with the Nikon F. Due to the allocation of batches for chrome and black bodies, it does not necessarily follow that a higher body number denotes a later model.

According to people on the inside, there was a good working relationship between Nippon Kogaku and Giugiaro, with both parties showing mutual respect and accommodating changes to achieve a common goal. That may sound irrelevant, but it is amazing how often a top-level styling house disregards function in the name of 'design'. This explains why the relationship has continued to this day, and why the cameras that have been spawned by this Japanese-Italian combination have always met with acclaim from critics and users alike. The EM was the first product of the long-standing Giugiaro–Nikon collaboration, but it was also the first to make extensive use of engineering plastic (EP). This had been used experimentally from September 1976, with an EP department set up at the Oi factory in mid-1977. While the chassis was produced in die-cast aluminium alloy, the Nikon EM used engineering plastic for the upper cover and back lid, plus the barrels on the Series E lenses introduced especially for the EM, the so-called 'Little Nikon'.

The lightweight EM, with its centre-weighted aperture priority automatic exposure mode, was simplified in nearly every aspect. The shutter speed selector was marked with 'A' (for AE mode), 'B' (for longer exposures) and 'M90' (for mechanical shutter release), and nothing more, unless one includes the self-timer. Although the aperture setting was not shown in the viewfinder, at least the shutter speed was, backed up by an audible warning from the SPD cell control unit when the light was too strong for the camera's top speed or too weak, dropping the shutter speed to a level where camera shake would be noticeable. The shutter was a Seiko MFC focal plane unit, incidentally, with blades that operated vertically.

There was no AE lock, or a trip lock on the back release for that matter (one just lifted the rewind crank housing), and, it has to be said, some of the early cosmetics were a little cheap looking. The backlight switch (which adjusted the AE setting by +2EV) was blue plastic on the first models, as was the battery condition check button, but these were changed to chrome in 1980, when the lens release button also gained a chrome trim ring.

There was no option to change the focusing screen, and while some bodies allowed the Ai coupling to be moved upward to accommodate earlier Nikkors, the fixed coupling on the EM prevented the use of non-Ai spec lenses. It was assumed the EM would appeal to new customers, so they could choose between an Ai Nikkor or a budget Series E lens. Actually, the Series E lenses were not only cheaper (thanks to a different coating system and the extensive use of engineering plastic), but they were also significantly lighter.

The EM was unusual in that it was launched in export markets one year before it was sold in Japan. In most cases, Nikon cameras are put on the domestic market first, or there is worldwide availability from the same date. For whatever reason, the EM was sold abroad from March 1979, and was introduced alongside the F3 in the Land of the Rising Sun from March 1980.

There was also an odd situation with the Series E lenses: 35mm f/2.5, 50mm f/1.8 and 100mm f/2.8 versions were released in March 1979, with 28mm f/2.8 and 135mm f/2.8 lenses following for export only a few months later. A 75–150mm zoom was added to the Series E line-up in May 1980, but a year later all the Series E lenses were given a facelift to make them resemble their more expensive counterparts. Ultimately, by 1982, when the last new Series E lens was introduced (a 70–210mm zoom), eight variants were available in export markets, while Japan was reduced to just five options in the budget line, as the 50mm f/1.8 became Ai-S specification very early on at home. As well as dedicated lenses, the entry-level EM was also available with the compact SB-E flash and the MD-E motor drive. The latter, with a useful grip and stylish design, used the camera's shutter release, advancing film at a rate of about two frames per second.

With a 50mm f/1.8 lens, the EM was just ¥60,000. Strong promotion, and the lure of the Nikon name in an attractive, affordable package that was light but certainly not flimsy, came together to reward Nippon Kogaku with a good return on their investment: more than 400,000 units were sold worldwide in 1980 alone.

Japanese camera production peaked in 1980 at 7.56 million units. The world of electronics was largely responsible for this massive increase in sales, with cameras becoming more advanced yet simpler to use, more compact, lighter and significantly cheaper. At the same time, the greater use of computers, robotics and automated production using the 'just in time' ordering system significantly reduced costs within the Nippon Kogaku organization. It was now a thoroughly modern manufacturing facility, allowing the company to keep up with demand.

The Pentax LX, launched in 1980, is worthy of mention owing to its extensive sales period, but the same year also saw the introduction of the Nikon F3, which was to have an incredible production run, lasting from March 1980 into the new millennium. The story of this legendary camera takes us into a new era for Nippon Kogaku.

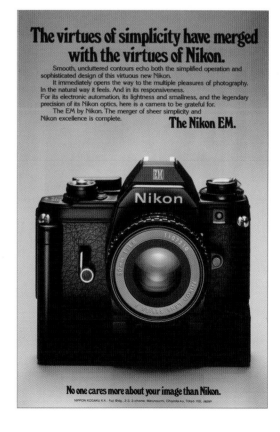

THE F3 AND F4 ERA

THE RANGEFINDER SERIES AND contemporary Nikkor lenses had catapulted the Nikon brand from the status of respected domestic maker to worldwide object of desire. The company's reputation was further strengthened when the F came along. Indeed, one 1964 advert posed the question: 'Do you know of any other product that has been on sale for just four years that has created so much love and trust?' With the F2, the Nikomat line and the Nikonos series – not to mention an extensive range of world-renowned lenses and a new generation of entry-level SLRs – the company was assured legendary status.

Having such an enviable reputation is often as not a blessing and a curse in equal measure. Anything released by a maker of fine goods, whether cameras, cars or watches, is judged against what has been produced in the past. It is rather like the son following in the footsteps of his legendary father: it is sometimes very difficult for the youngster to step out of the shadow cast by his famous forebear. And so we come to the story of the Nikon F3.

The Evergreen F3

The F3 followed much the same philosophy as that outlined for the F2 (indeed, Akihiko Sato, who had looked after the F2, was in charge of the F3 project), but with more automatic features to augment the manual controls. Basically it brought together the best features of the F2 with the electronics wizardry introduced on the EL, EL2 and FE. As such, the F3 – given the 40FB code number – was Nikon's first truly modern camera, with an electronic shutter, a built-in LCD meter and automatic exposure control. It also featured interchangeable viewfinders and screens (something still very unusual for the time, and coming with 100 per cent image viewing) and TTL flash technology.

Although started several years earlier, design work began in earnest in March 1977, bringing together engineering hard points outlined in Japan and design mock-ups from Italy. Much time was taken up perfecting the precision and reliability of the electronic shutter. Although there will always be those, including the author, who prefer mechanical watches, no-one can deny that the combination of micro-electronics and a good quartz movement is by and large more accurate, lighter, in need of less maintenance and allows more features to be added at low cost and with

little extra space required. The same is true in the camera world. Technology moves on, and one either moves with it, or gets left behind.

The first prototype was completed in November 1978. Once the AE system had been finalized, Giorgetto Giugiaro of ItalDesign was called in to complete the body styling. The F2 lacked the distinctive 'F' logo made so famous on the first Nikon 'pro' SLR, but an 'F3' mark in a similar typeface to that used in 1959 brought home the link that this latest camera was a true evolution of the original 'pro' body. Available in black only, it was the first Nikon 'pro' body not to be offered with a chrome option, and its styling was the prototype for what would become a distinctive Nikon look during the rest of the 1980s and beyond.

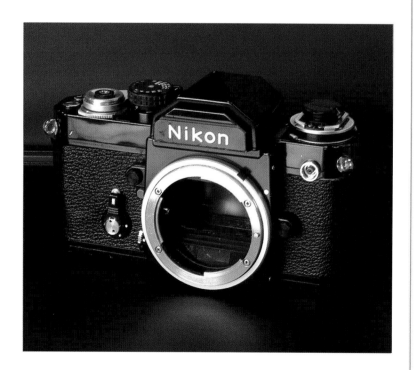

LEFT: **One of the prototypes (body 1100002) that bridges the gap between the F2 and F3.**

The F3 was the first Nikon to feature a comfortable body grip under the shutter release. This ergonomic design was to become a familiar sight on virtually all cameras after the birth of the F3, but it was a thoughtful, rather

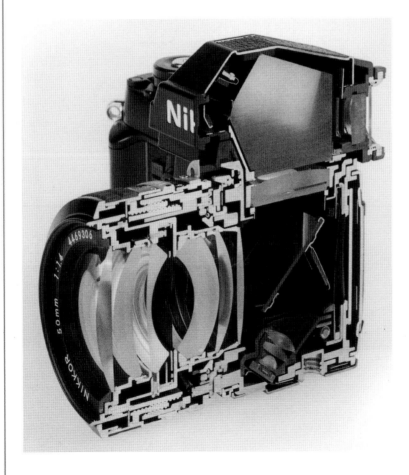

novel touch back in 1980, and much appreciated by users. Not surprisingly, a similar grip was adopted by Minolta on the X-7, and by Canon for its New F-1, introduced in September 1981 to compete head-on with the F3. Even the simple red stripe made quite an impact on future camera design.

The camera's compact size was possible mainly because of recent advances in the field of electronics and low power consumption, although all parts were reduced in number, size and weight wherever possible. Shutter speeds were controlled by a digital quartz mechanism, while the titanium focal plane shutter curtains had an electromagnetic release (the mirror was still mechanical, however, as was the film winding mechanism, unless an MD was fitted). But it was the metering system that was the key to the F3's form and function.

Whereas the meter came as part of a detachable prism in the case of the F and F2, the SPD metering cell was placed in the bottom of the F3's die-cast alloy body, light reaching it through 50,000 microscopic holes in the main mirror. In fact, less than 10 per cent of the light passed through the mirror, the rest being reflected upwards. As well as giving a brighter viewfinder image, this arrangement also made the head more compact, and accuracy was improved because the system was designed in such a way that any light passing through the eyepiece did not affect the meter reading, which was 80 per cent centre-weighted, activated by lightly pushing the shutter release (with information displayed via an LCD read-out at the top of the viewfinder image).

The top plate controls were redesigned again, with the shutter release moving to the centre pivot of the winding crank (with the camera's main power switch underneath). The winding mechanism was refined to become one of the lightest and smoothest ever produced, while still retaining that 'engineered' feel one comes to expect from a Nikon.

Selecting 'A' on the shutter speed dial allowed the user to select an aperture and then let the camera do the rest. The 'A' mode had been introduced on the Nikomat EL in 1972, although the shutter speeds were stepless on the F3, meaning an infinite number of speeds were available between eight seconds and 1/2,000th of a second for the ultimate in automatic exposure control.

A full range of manual shutter speeds was provided for the dedicated photographer, or users of older lenses that did not have the correct coupling to make all the meter connections (to take advantage of the 'A' mode, and the internal aperture setting display for that matter, one needed either Ai or Ai-S lenses). There was also a mechanical shutter release for those who found themselves in the unfortunate position of having no life left in their batteries. This thoughtful feature allowed a fixed 1/60th of a second shutter speed without the need for any power whatsoever.

A six frames per second coreless motor MD was available (the motor drive connections were already in place), with mirror lock-up and an integrated battery pack. Interestingly, the leaps and bounds in electronics technology enabled the MD-4 motor drive to run in tune with the camera's selected shutter speed, while the smooth, light film advance system employed on the F3 reduced power consumption.

The F3's automatic TTL flash exposure was another great advantage, with the contemporary SB-12 Speedlight flash working in harmony with

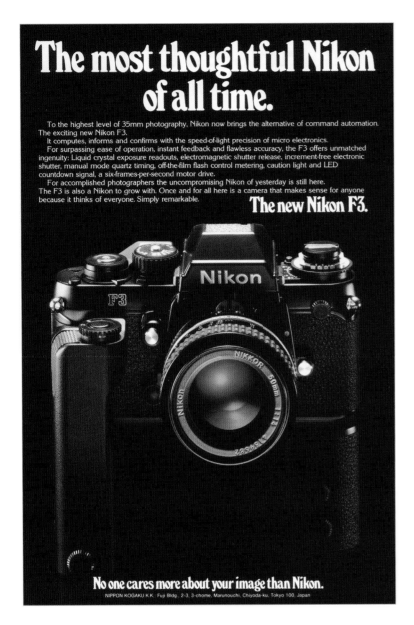

The most thoughtful Nikon of all time.

To the highest level of 35mm photography, Nikon now brings the alternative of command automation. The exciting new Nikon F3.

It computes, informs and confirms with the speed-of-light precision of micro electronics.

For surpassing ease of operation, instant feedback and flawless accuracy, the F3 offers unmatched ingenuity: Liquid crystal exposure readouts, electromagnetic shutter release, increment-free electronic shutter, manual mode quartz timing, off-the-film flash control metering, caution light and LED countdown signal, a six-frames-per-second motor drive.

For accomplished photographers the uncompromising Nikon of yesterday is still here. The F3 is also a Nikon to grow with. Once and for all here is a camera that makes sense for anyone because it thinks of everyone. Simply remarkable.

The new Nikon F3.

No one cares more about your image than Nikon.

NIPPON KOGAKU K.K. Fuji Bldg , 2-3, 3-chome, Marunouchi, Chiyoda-ku, Tokyo 100, Japan

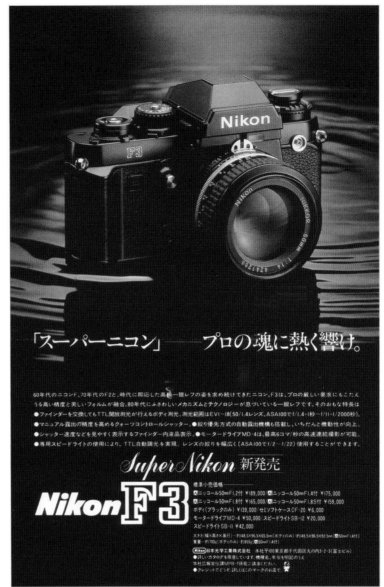

「スーパーニコン」——プロの魂に熱く響け。

Super Nikon 新発売

Nikon F3

FAR LEFT: Early advertising for the F3, seen here fitted with an Ai-spec normal and the coveted MD-4 motor drive.

LEFT: Japanese advertising for the 'Super Nikon' – the name coined for the F3 by Nippon Kogaku's marketing people. In promotional material from the time, the F3 was the Super Nikon, the FE was the Simple Nikon, the FM was the Compact Nikon, and the EM was the Little Nikon.

ABOVE: A view of early F3 production, little changed from the original F's days. However, the F3 was the last 'Pro' body to be produced at the Oi factory.

the camera settings and available light to deliver the perfect amount of flash without the need for time-consuming distance calculations and the restrictions older flash units placed on depth-of-field creativity. The system was not perfect, being offset and with a slow top flash synch speed (not to mention still having to remove the flash every time a film was changed!), but it was a considerable improvement over that of the F2, with the film speed registered automatically via a cam underneath the hotshoe. Older flashguns could be used with the 'X' setting, continuing Nippon Kogaku's policy of evolution rather than revolution to appease long-term users of the Nikon System.

The interchangeable viewfinders were similar to those offered on the earlier 'pro' bodies, but came with a far brighter image and superior fixing method; the DE-2 eye-level finder was standard fare with a new camera. The focusing screens were also new for the F3, albeit of a similar design, although changing them was much easier. Eventually sixteen main variations would be made available.

One thing familiar to all Nikon SLR users, however, was the F lens mount, carried over once again, albeit of the 1977 onwards type with the addition of a meter coupling lever to take full advantage of the Ai lens system with its meter coupling ridge integrated into each design.

Before leaving the factory, each F3 was given an incredibly tough series of tests to ensure the quality and durability expected of Nikon. Even by the strict standards of this most exacting company, the F3 testing schedule was more like camera torture. Anyone doubting that the F3 could ever live up to the F2 in terms of robustness should have been able to witness these tests, and the fact that the F3 shutter is rated to fire perfectly for at

ABOVE AND LEFT: Domestic catalogue for the Nikonos IV-A, with the inner pages showing many of the Nikonos accessories and lenses.

BELOW: The Nikonos IV-A photographed by the author alongside a Nikonos II.

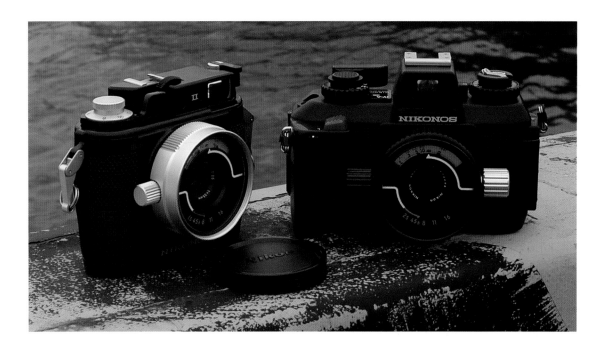

least 150,000 shots in the harshest of conditions says a lot for its reliability. Amazingly, this endurance test was carried out by hand until a machine was developed in time for the F3 project!

The F3 was sold in black only, introduced in March 1980 at ¥139,000, or ¥175,000 with a 50mm f/1.4 lens. Accessories included the MD-4 motor drive, at ¥50,000, and a pair of waist-level finders, the DW-3 being the regular version (priced at ¥9,000), with the DW-4 being magnified, at ¥11,000 more. The ¥20,000 SB-12 flash was introduced specifically for the F3. This was announced alongside the larger SB-11 Speedlight, Nippon Kogaku's first TTL-controlled flash for the contemporary Nikons and aimed squarely at professional users. A few months later the PF-4 copying kit made its debut, followed in September 1980 by the ¥35,000 DA-2 action finder.

A New Generation of Nikonos Camera

July 1980 saw the introduction of an electronic shutter and AE for the Nikonos series, giving birth to the Nikonos IV-A. The designer of the original Calypso model, Jean de Wouters, had actually helped with its development, working with Nippon Kogaku between March 1964 and the following May. But although a prototype was made in the 1960s, the design was simply too advanced for the time.

The IV-A was a complete departure from the earlier Nikonos models, with a modern body incorporating a hinged back that hid a more conventional film loading and transport mechanism. The automatic exposure system, which employed SPD metering cells, led to just four markings on the shutter speed dial – 'A' for automatic (from 1/30th to 1/1,000th of a second), 'M' for mechanical (fixed at 1/90th of a second, as was the flash synch), 'B' for long exposures, and 'R' for when the film expired and needed rewinding.

All in all, the Nikonos IV-A had a quality feel that rivalled that of the F3, from the beautiful casting work to the silky smooth operation of the winding lever. Even the over-centre clip securing the back was a wonderful piece of engineering – too loose and the effects are obvious, but making it too tight would cause distortion, with water ingress being the same result. The pressure therefore has to be just right, and guaranteed to stay that way.

Making use of the existing Nikonos lenses (four were available at the time, including a soon to be revised 15mm version, with an all-weather LW-28mm f/2.8 joining the line-up in late 1983), the IV-A body was something of a bargain at ¥54,500. The SB-101 electronic flash provided the perfect match for the Nikonos IV-A, based on the SB-11 prototype (nothing to do with the SLR version carrying the same designation). With all the paraphernalia that came with it, this impressive Speedlight weighed in at 2,670g – three times the weight of the IV-A body mounted with a 35mm lens!

With the F3, EM and new Nikonos, not to mention strong sales of Nikkor lenses, Nippon Kogaku's turnover in 1980 was twice that of 1974, calculated at a staggering ¥74,000,000,000.

Another Lens Variation

The Ai-S type lens (or AI-S, depending on whether one uses the catalogue style or that used in factory paperwork) was basically the same as an Ai Nikkor, except the movement of the diaphragm was more linear in relation to the camera's aperture coupling lever – a critical point on certain new-generation bodies with mechanical automatic aperture control, like the Nikon FA.

The official designation carried an 'S' suffix after the maximum aperture value, and while this was not shown on the lens, the Ai-S series was readily distinguished by its orange minimum aperture number on the smaller set of numbers closest to the mount (all-white on the strict Ai lens), the modified diaphragm lever design, and the addition of a signal groove to inform the camera body that an Ai-S Nikkor was attached (located at about the half past ten position if one looks at the rear of the lens with the prong at

ABOVE: **Period advertising for Nikon sunglasses, with the lower piece making the most of the company's links with Giugiaro. The alloy wheel was an aftermarket rim designed by the Italian master.**

LEFT: **Contemporary Olympus advertising showing the OM-1, OM-2, OM-10 and the XA pocket camera. Designed by Yoshihisa Maitani, the XA would revive memories of the famous Pen series and pave the way for other Japanese manufacturers – Nikon included – to introduce their own line of high-quality compact cameras.**

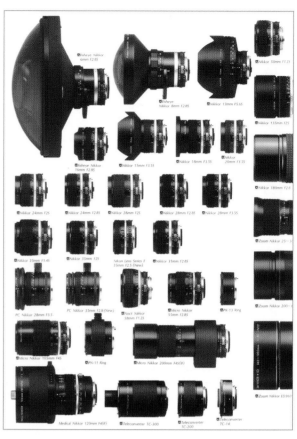

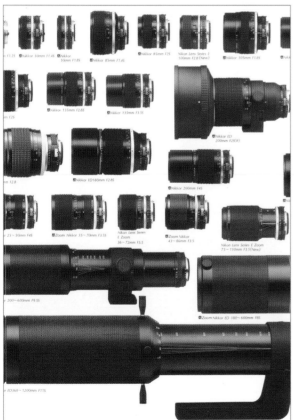

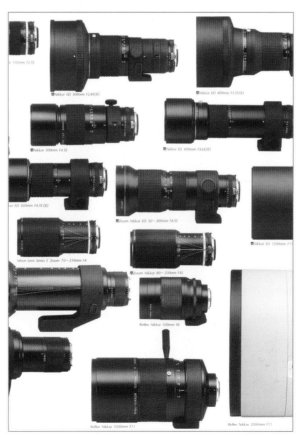

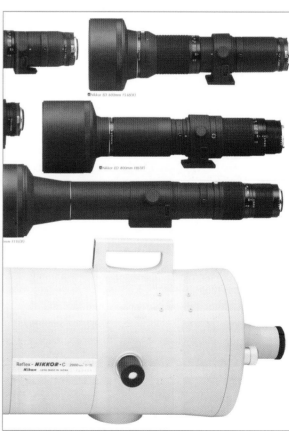

12 o'clock, and tripping a second pin on the lens mount face). There was also an indexing ridge on the inner edge of the lens to inform the camera of its focal length should the body have an automatic exposure programme.

The first Ai-S lens was actually a Series E Nikkor originally, and this came out in January 1981, eight months ahead of the bulk of new issues. As with the Ai range before it, a batch of popular fixed focal length lenses was brought out at the time of the new version's announcement, in this case seven examples from a wide-angle 28mm f/2.8S to a 105mm f/1.8S telephoto.

OPPOSITE PAGE

Cover and selected pages from the 1982 Nikkor lens catalogue. The F3 can be seen with a few contemporary lenses, giving an idea of the beautiful and varied colours in the glass, but the entire range is illustrated (to scale) on the pages that follow. A similar brochure had been issued in mid-1981 with Ai Nikkors rather than Ai-S versions.

THIS PAGE

RIGHT: Brochure for the 120mm Medical-Nikkor, seen mounted on an F3. FAR RIGHT: The FM catalogue from early 1981.

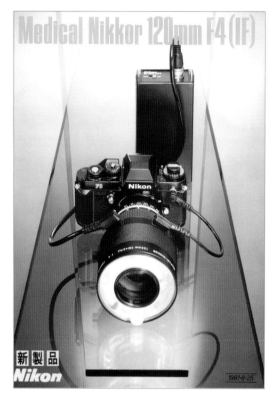

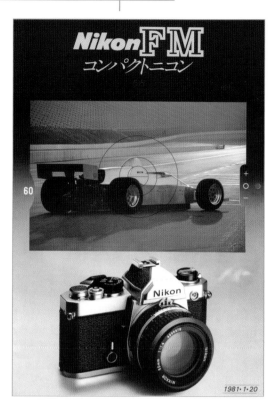

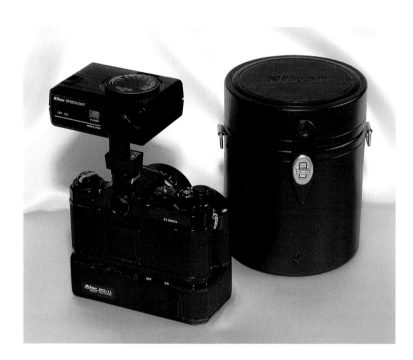

ABOVE: An FE with the MD-11 motor drive and SB-10 flash in place. Rather than a leather pouch, or even the lined black leatherette versions of the late 1960s, the SB-10 came in a simple brown plastic case.

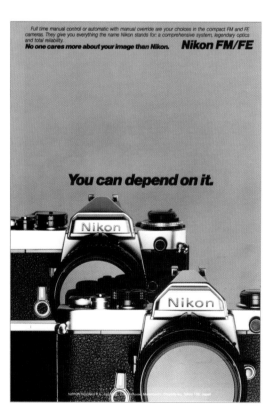

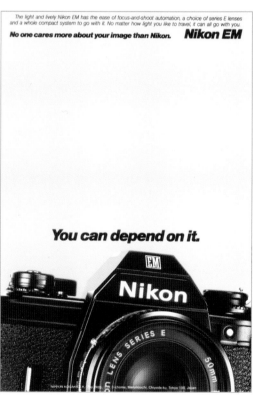

RIGHT: Two pieces of contemporary English-language advertising, one showing late versions of the FM and FE, the other the EM. After bringing together Nikon Inc. and EPOI, the American operation was restructured in June 1981, with offices on Walt Whitman Road, New York, and more than 500 workers. The new Nikon Inc. was a far cry from the days when four staff manned the premises on Fifth Avenue. Nikon UK had been set up in September 1979, incidentally, with the help of the Rank Organization.

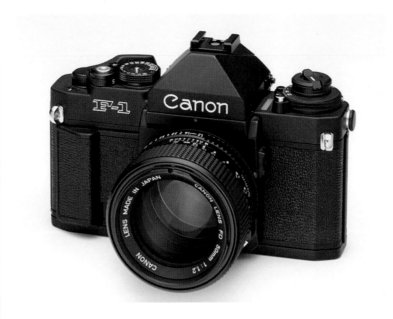

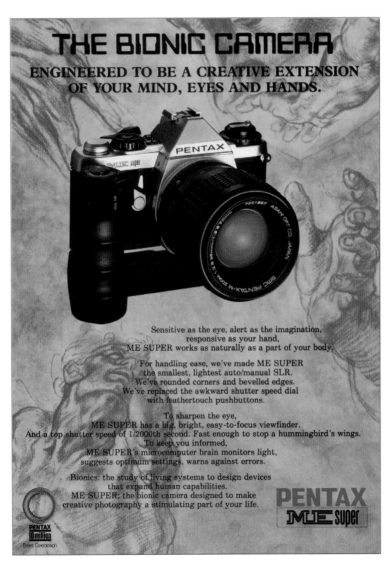

Another seven Ai-S Nikkors joined the line-up in October, including a 24mm f/2.8S, an 80–200mm zoom, a 105mm Micro-Nikkor and a 180mm telephoto with ED glass. Two months later ten additional lenses put in an appearance, with more being introduced as the weeks passed until forty-eight Ai-S Nikkors were on the market by May 1982. These included everything from a 6mm f/2.8S fisheye all the way up to a 1,200mm f/11S variant with ED glass, not to mention a range of zooms and specialist lenses, such as an internal focus 120mm Medical-Nikkor and a 58mm Noct-Nikkor.

The F3 HP and F3/T

Various backs became available for the F3, including one (the ¥100,000 MF-4, introduced in December 1981) that worked with the motor drive for 250-exposure bulk film loading. Others enabled the user to imprint information, such as the date or time, onto the negative: the MF-14 of May 1982 was the first digital databack released by Nippon Kogaku, priced at ¥19,500, although an updated version of the MF-11 (the MF-17) was also produced in mid-1983. At the same time, the MK-1 was launched at ¥15,000, giving more control over the MD speed, while the MF-6 (quickly superseded by the MF-6B) was the modern equivalent of the MF-3, preventing film from fully rewinding.

A couple of new Speedlights were also issued during this period: the ¥39,000 SB-14, which was similar to the SB-11, but a touch lighter and more compact by virtue of it requiring an external power source, whereas the SB-11 could use internal or external power. The SB-15 was the other new flash, launched four months after the SB-14 in April 1982 (there was no SB-13, by the way). The SB-15, priced at ¥19,000, was the replacement for the SB-10, but the SB-12 (the sister version for the F3) was replaced by the ¥22,000 SB-17 in mid-1983. There was also the SB-140, a variation of the SB-14, for use in UV and IR photography.

By far the most important development for the F3, however, was the DE-3 finder, which gave birth to the F3 HP in March 1982. Priced at ¥22,000 as an individual accessory, a complete F3 HP body was ¥149,000.

It has to be said that initial reaction from professionals toward the F3 was mixed. Of course, people welcomed a new Nikon 'pro' body – a cause for celebration, as it was an event that did not happen very often – but it took a while to wean diehards off the beautiful form of the F and the rugged functionality of the F2. It was also difficult for some to accept automatic exposure control, even though fully manual operation was much the same as it always had been. With the introduction of the F3 HP, however, its acceptance was assured.

The F3 HP was basically a regular F3 with the DE-2 finder replaced by a DE-3 version, which made it easier for those of us who wear glasses to see the entire screen. The popularity of the slightly taller High-Eyepoint finder, however, was such that most F3s were ultimately sold in HP guise regardless of whether the buyer wore glasses or not.

In December 1982, nine months after the F3 HP made its debut, Nikon introduced the F3/T with its titanium top and bottom plates, lens mounting

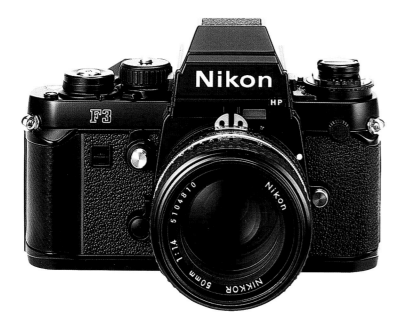

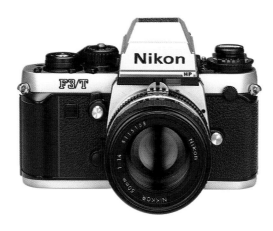

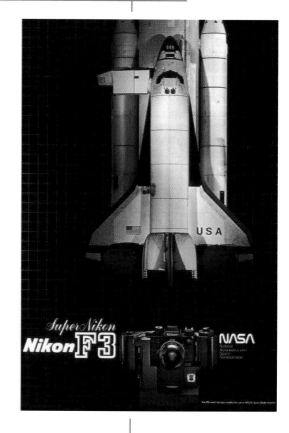

LEFT: **The Nikon F3 HP, seen here mounted with an early 50mm f/1.4S.**

ABOVE: **The Nikon F3/T, with its numerous titanium body parts. This natural finish was the only option until September 1984, when one could specify the body in this colour or black. Ironically, the black version outlived the original by 12 years.**

plate, back and prism cover (the latter prompting a new DE-4 designation for the finder). Announced at ¥195,000, the lightweight model was almost a third more expensive than the regular HP on which it was based, and ¥56,000 more than the original F3. The F3/T was unique among production models in that it brought back the chrome body option, incidentally, although most were supplied in black after that finish became available in September 1984.

Ironically, the chrome body (actually, it was a natural titanium finish, sometimes described as champagne in promotional paperwork) was dropped from the line-up in 1988, while the black version continued until 2000. It should be noted that while the F3 HP used regular serial numbers, the F3/T had its own batch of body numbers, starting on T 8200001.

F3 Specials

Nippon Kogaku's association with NASA continued when the Space Shuttle programme was instigated. Interestingly, the Nikon camera project was started in autumn 1978, long before the launch of the F3, but was only completed two months after its general release.

Conditions onboard the Shuttle required fewer modifications than had been necessary for previous NASA cameras. Other than complying with strict safety regulations, the main difference centred on the internal changes necessary to suit NASA's thinner, half-frame film. There was a bulk film magazine and a motor drive for the so-called 'Big' camera, and a standard back for the 'Small' camera. These were usually mounted with 55mm and 105mm Micro-Nikkors, although 35mm and 135mm lenses were also taken on missions – all to Ai spec, but with beefier 'Auto' focus rings to make them easier to use with heavy gloves.

The NASA F3s were first used on 14 April 1981 during the maiden flight of Space Shuttle *Columbia*. The F3P and F3HP models were also employed by NASA; later the F4 also went into space, but that particular camera needed only minor changes. Nikon made good use of its links with NASA in its advertising, and rightfully so.

Back on Earth, the Uemura Specials were produced for the famous Japanese explorer Noami Uemura. The tradition of making lighter and stronger cameras for Uemura started with the F2, with the extensive use of titanium.

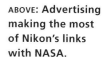

ABOVE: **Advertising making the most of Nikon's links with NASA.**

LEFT: **A Nikon F3 HP and Hasselblad finding service on the Space Shuttle *Columbia* in early 1990.** COURTESY NASA ARCHIVES

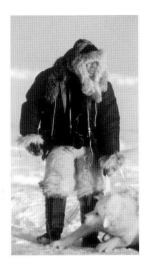

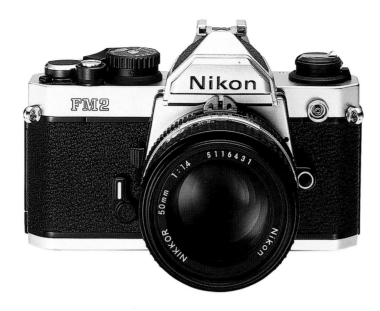

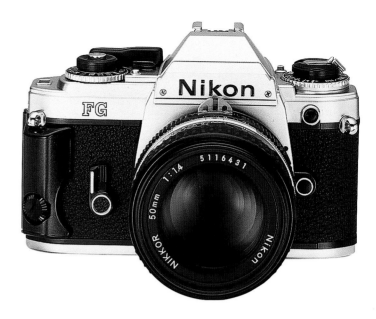

His F2s and F3s used standard body numbers: they were simply conversions on regular models (with lightweight parts, different oils to counter low temperatures, stronger springs, and a modified winding mechanism to avoid breaking the film when it was cold), but they have taken on a legendary status ever since Uemura went missing while climbing Mount McKinley. His body was never found, but he died a true hero of the Japanese nation.

More New SLRs

With the F3 safely delivered to the marketplace, engineers led by Yoshiyuki Nakano concentrated their efforts on raising shutter speeds. A target of 1/4,000th of a second was proposed – twice the top shutter speed of contemporary cameras – using lightweight components; this would also reduce inertia and the need for greater electrical power consumption. Work had actually started as early as 1977 on shutter curtains produced in pure industrial titanium (TP35), and this development proved to be an important factor in Nippon Kogaku's men attaining their goal.

In March 1982 the Nikon FM2 duly became the first camera in the world to have a 1/4,000th of a second top shutter speed. In order to achieve this the shutter blades were made from honeycomb-pattern titanium, the mirror was modified, and there were other detail changes, too.

The film transport system was revised, faster SPD metering cells were adopted, the focusing screens could be changed, the film speed range was extended (from ISO 3,200 to ISO 6,400), the multiple exposure lever from the FE was used, the self-timer and depth of field preview levers were updated, a larger shutter release button was employed and, as well as having different markings, the shutter speed dial was actually a touch taller and easier to grip than before. In addition, the FM2 would accept Ai-spec lenses only and, shortly after production started, the image in the viewfinder was made slightly different, with revised exposure indicators encroaching less on the inner frame.

The cleverly designed SB-15 Speedlight, with a head that could turn upward out of the main body for bounce flash applications, was brought out to suit this new camera, which came with an FE-type hotshoe and a higher 1/200th synch speed. The FM2, priced at ¥63,000, duly replaced the original FM in the Nikon line-up.

Two months after the FM2 made its debut, the Nikon FG put in an appearance. The FG was basically the second-generation EM, with a similar automatic aperture priority mode ('A') combined with a programme mode ('P') and enhanced manual control, and was launched at ¥81,000 with a 50mm f/1.8S Nikkor.

The FG, which would only accept Ai lenses, was the first Nikon to feature a 'P' setting, automatically balancing the quartz controlled shutter speeds and aperture settings to best suit the situation. Add in the exposure compensation

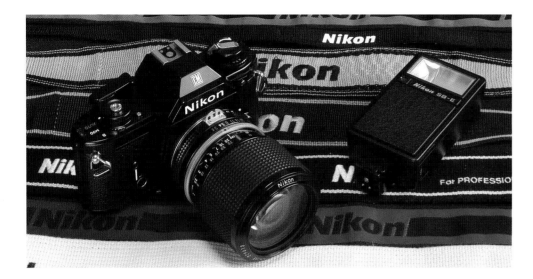

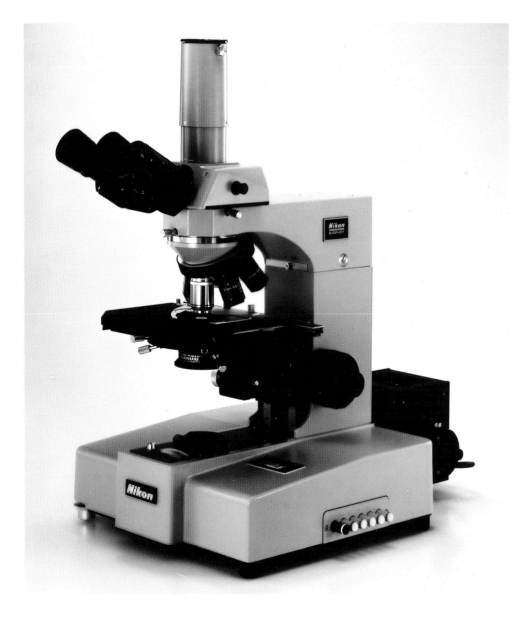

LEFT: An example of a modern Nikon microscope employing CF (Chromatic Aberration Free) lenses. Nikon microscopes and other scientific equipment continued to sell strongly. The Building Block System (BBS) was introduced in the mid-1950s, giving a basic component several specialist uses through various attachments.

BELOW: The last Nikon 8mm cine camera was sold in 1979 as the world moved into the video age. From June 1982 the company produced various cameras for home and professional use, calling for a wide range of film formats and features.

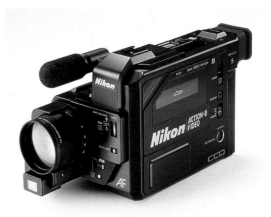

FAR LEFT: The EM, shown here with a selection of neck straps, the dedicated SB-E flash unit, and a slightly earlier Ai-spec 43–86mm zoom. Approximately 1,530,000 EMs had been built by the time production ended in 1985.

LEFT: As well as some excellent advertising in magazines, the company's presence was also strong at a number of sporting events, such as the 1983 Wimbledon Open Tennis Championship and the British Open Golf Tournament. As can be seen here, Nikon also sponsored Mazda's early attempts at conquering the Le Mans 24-hour race. In fact, there are many parallels in the history of the two concerns. Both were born as a result of the shortage of certain goods in Japan brought about by the First World War, and both ultimately changed the company name to that of their most famous products – Nippon Kogaku to Nikon, and Toyo Kogyo to Mazda. However, the original name remains registered in both cases.

facility and TTL flash control, plus a far more modern image in the viewfinder (with LEDs and battery condition information), and one can see it was quite an advance on the EM.

It did share the same backlight button arrangement and fixed focusing screen, however, and lacked a depth of field preview button, as per the EM. It also had the same M90 setting on its unusual shutter speed dial, and an audible warning for possible under- or over-exposure, although, unlike the EM, it could be cancelled on the latest model.

A grip shape like that first seen on the F3 was employed on the FG, although it was screwed in place on the latter, allowing it to be removed should the user wish to fit the new ¥26,000 MD-14 motor drive, which also fitted the EM. One could also fit the MF-15 databack to the FG, though, giving it a far more modern appearance than the basic EM. Incidentally, the FG and EM were sold alongside each other for a while, so the new camera was not a replacement for the 1979 model: it simply provided a reasonably priced alternative 'point and shoot' camera for people with a real interest in photography.

The end of 1982 saw three more Ai-S Nikkors reach the marketplace: a faster version of the 600mm telephoto lens (which had actually been around in prototype form since 1977), and a couple of zooms (one being a faster 80–200mm model, first displayed as a prototype in 1978, and the other a new lens covering the 50–135mm range). Excluding the pair of special AF lenses, only one new Nikkor was brought out in 1983, and that was a 35–105mm zoom, bringing the Ai-S line-up to a total of fifty-two variants.

In spring 1983 the ¥75,000 FE2 was brought out, naturally as a replacement for the strict FE. This latest camera, which used Ai spec lenses only, was a touch lighter than its predecessor, but more importantly, the FM2-type shutter blades (with stepless operation in 'A' mode) were given a 1/4,000th of a second top speed (with M250 as a mechanical back-up), TTL flash control was adopted, mirror vibration was reduced, there was greater control over exposure compensation settings and there were new, brighter focusing screens. Other detail changes included a larger shutter release button, revised shutter speed dial markings, a new self-timer switch, the loss of an external battery monitor, and a new hotshoe with extra contacts to mate up with the latest Speedlights.

The compact but highly advanced SB-16 flash (there were actually two – a type A and a type B, to differentiate the style of mounting used) was designed for the FE2's TTL flash control and increased synch speed, now up to 1/250th of a second, being a truly modern unit with a tilt-and-turn facility and a second, smaller flash in the main body. There was also an MF-16 databack, which would fit either the FM2 or the FE2. On the subject of accessories, July 1983 saw the introduction of the MT-2 intervalometer, which at ¥90,000 replaced the old MT-1 unit.

RIGHT: **Contemporary film advert from Agfa. There were a number of amusing variants in this memorable series.**

FAR RIGHT: **The Nikon FE2, production of which began on body number 2000001. It was sold until 1987.**

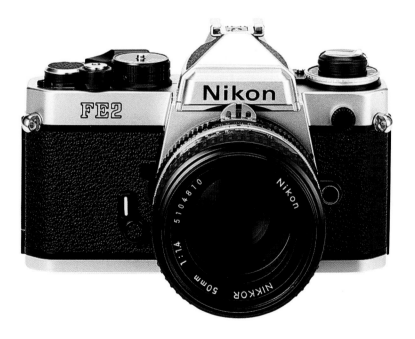

NEW AGFACOLOR 100. PICTURES SO LIFELIKE, YOU'D THINK THEY WERE REAL.

AGFACOLOR 100 FOR COLOUR PRINTS. AVAILABLE IN ALL POPULAR SIZES.
AGFA-GEVAERT. 27 GT. WEST RD. BRENTFORD MIDDLESEX TW8 9AX.

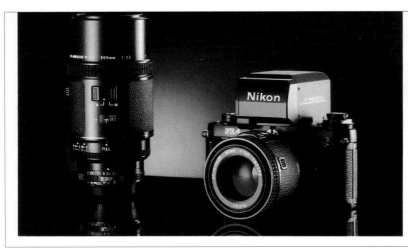

Pro Spec AF 素早いフォーカス・レスポンスを
求めるプロたちへ。

プロフェッショナルたちの苛酷な撮影条件をクリアし、より撮影領域を拡大することを目的とした、ニコンF3AF。F3をベースに、ニコン独自のTTL位相検出法を採用したオートフォーカス一眼レフです。AFファインダーDX-1付のF3AFボディに、80mmと200mmのAFニッコールレンズを組み合わせると素早いフォーカス・レスポンスのオートフォーカスが可能。さらに広範な映像エリアを拓いていく、プロスペックAF、ニコンF3AF。
※詳しくはF3AFカタログをご参照ください。

Super Nikon

Nikon **F3** AF

The F3 AF and F3P

Canon's new fully automatic T series made quite an impact when it was launched in the spring of 1983. With its dramatic styling, the T50 was quickly joined by the T70 and autofocus T80, while the T90 (a more than worthy competitor for Nikon's contemporary F-501 model) put in an appearance in February 1986. Meanwhile, the amazing Minolta 7000 was making an impression among enthusiasts in 1985, giving amateurs the chance to take professional-level photos at the touch of a single button. The 'point and shoot' era was well and truly upon us as electronics became more compact and significantly more advanced with each passing day.

Before them all, however, was the Nikon F3 AF. Having introduced a great deal of new technology with the F3 in 1980, in April 1983 Nippon Kogaku brought out its latest F3 variation, featuring a DX-1 autofocus finder mounted on an almost standard body. Indeed, the DX-1 head could be bought separately for ¥110,000, its expense being justified by the fact that it had its own focusing screen, then a field lens, a main beam divider, splitting the image to the pentaprism (and eyepiece) and another splitter that sent light to the two focus-detecting sensors.

It was all very complicated, and focusing on moving objects was found to be extremely difficult. The problem was compounded by the fact that Nippon Kogaku's engineers, led by Toru Fukuhara, wanted an easy-to-use TTL set-up, giving it quick autofocus response via a finder-based AF system. Still, all those involved persevered and the various targets set out in the design brief were eventually met successfully.

At ¥250,000 for the body alone, however, the F3 AF was probably too expensive and bulky to be fully appreciated, even though the autofocus system worked fairly quickly for the time. Due to its lack of popularity, only two lenses (both with built-in motors and ED glass, and covered to match the F3 body) were produced for the F3 AF: an 80mm f/2.8 and a 200mm f/3.5 (both starting on serial number 182001), along with a single 1.6× teleconverter, launched a year after the camera made its debut. The F3 AF was ultimately withdrawn from the market in 1988, with very few having been sold.

At the same time as the F3 AF was introduced, the F3P (the 'P' suffix standing for 'Professional') was made available, initially for Nikon Professional Services (NPS) members and recognized press photographers only, but for general release from around 1987 as a special order item. Based on the F3 HP, certain features were left off and others modified to make the camera quicker and easier to handle, as well as a touch more weatherproof given that press photographers have to go to a shoot no matter what the conditions.

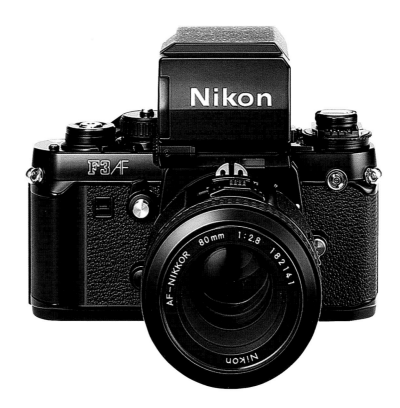

LEFT: The F3 AF mounted with an 80mm autofocus Nikkor.

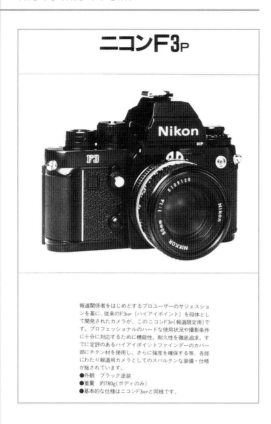

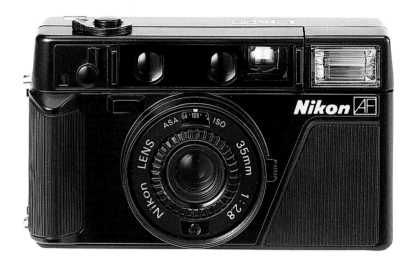

The F3P did not have a motor drive as standard, helping keep weight to a minimum, although the MD-4 was an option, as on the regular F3. However, an MF-6B back was included as part of the package and the modified finder prism was unique to the F3P, coming with an ISO accessory shoe at the top of the titanium-covered head. This not only centred the flash, it also left the rewind crank exposed, regardless of whether a Speedlight was fitted or not; the only disadvantage was the loss of the TTL flash feature. Around 25,000 F3Ps were produced, with body numbers starting on P 9000001.

A New Trend

Sales of pocket cameras exceeded those of SLRs for the first time in 1982. People – average people, that is, rather than enthusiasts – seemed to like the easy film loading and winding characteristics of these compact cameras, along with the built-in flash and autofocus facility. This level of sales activity could not be ignored, and prompted Nippon Kogaku to introduce its first pocket camera in March 1983, the Nikon L35AF.

Nippon Kogaku assembled a team to deal with compact cameras in 1979, with its first prototype duly completed in February 1982. The 35mm f/2.8 lens (constructed with five elements in four groups) was able to focus from 80cm to infinity automatically, while the striking exterior design was executed by Giugiaro in Italy. Officially launched as the L35AF,

it was given the 'Pikaichi' nickname in Japan, where it sold for the princely sum of ¥42,800.

Six months later the L35AD, a quartz date version of the Pikaichi, made its debut, costing ¥5,000 more than the basic model. Another six months down the line, the L135AF was brought to market, this being a budget version of the L35AF (thanks to a slower lens and a less advanced focusing system), which sold for ¥8,000 less than the L35AF. As well as the regular black body, there was also a red version of the L135AF sold in domestic camera shops for a limited period.

Eventually, in September 1985, the L35AF2 and L35AD2 models were announced, featuring a new lens cover design and the facility to read DX code on film cartridges that automatically informed the camera of the film speed. They were the same price as the L35AF and L35AD models they replaced and proved to be extremely popular.

One tends to have an image of pocket cameras being cheap and nasty things, but these early compact Nikons deserve special consideration: their price at the time of launch alone should indicate a quality product. Adding in the kudos of the Nikon brand name and Giugiaro's design work, I am sure these first pocket cameras will make interesting collectibles in the years to come. And no-one can ignore the fact that by 1984 the income from sales of compact cameras had already started to overhaul that of SLRs, with no fewer than 1,530,000 units sold! Meanwhile, at least SLR development continued, with the FE2 being followed by the award-winning FA.

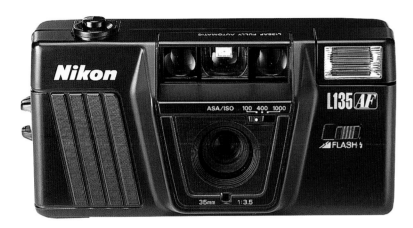

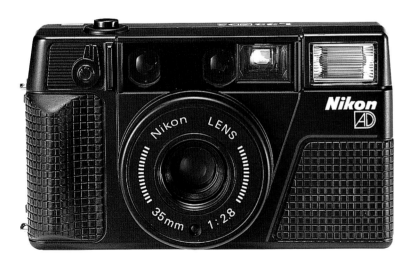

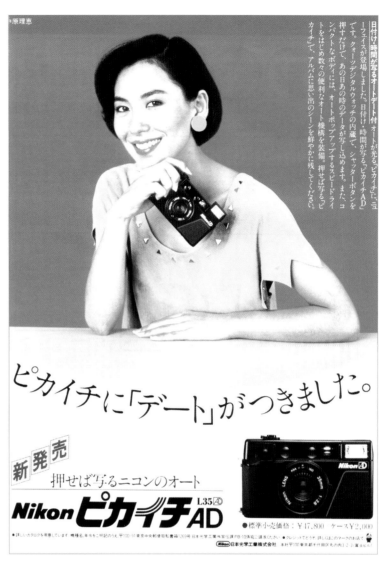

押せば写るニコンのオート

Nikon ピカイチ AD L35□

LEFT: Japanese advertising for the L35AD, the sister camera to the L35AF.

FAR LEFT: Nikon L135AF.

FAR LEFT: The L35AF2 and L35AD2 were introduced in September 1985 to replace the original Nikon pocket cameras. This is the AD version, with its quartz date back.

High-Speed Developments

As well as increasing shutter speeds, there was also a great deal of work going on behind the scenes on enhanced exposure metering. Centre-weighted metering had become common in the late 1960s, but from 1977 Nippon Kogaku had been working on matrix metering, gathering information on light conditions from five different areas. The AMP (Automatic Multi-Pattern) system's two SPD sensors each covered two corners and the centre, this method of metering giving a far more accurate reading.

In September 1983 the Nikon FA became the first camera in the world to use matrix metering, with a 4-bit microcomputer doing all the calculations to establish the best settings. With an electro-mechanical shutter boasting a 1/4,000th of a second top speed, advanced AMP metering system, TTL flash control (with a 1/250th of a second synch speed) and – another first for Nikon – shutter priority in the automatic exposure mode, complete with stepless shutter speeds, the FA deservedly took the Camera Grand Prix for 1984.

The 625g FA had a heavier-looking prism, as naturally the fixed head had to play host to a lot of advanced electronics to control the AMP system, although a switch underneath the self-timer allowed traditional centre-weighted metering if that was judged to be beneficial in certain conditions.

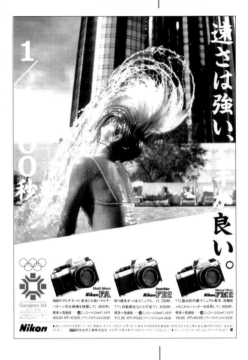

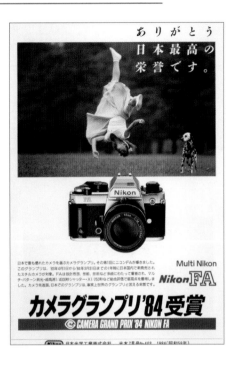

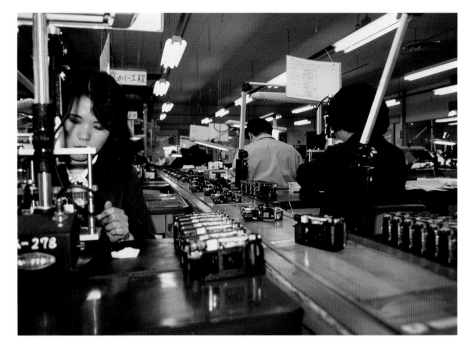

ABOVE: A Japanese advert from early 1984 showing the FA, FM2 and FE2.

ABOVE MIDDLE: Japanese advertising for the FA, proudly noting its award for the top new camera of 1984. The high top shutter speed allowed the photographer to freeze almost any action. Even the mechanical back-up shutter speed was fast, at 1/250th of a second.

ABOVE: The FA was produced at Nikon's immense Mito factory, to the north of Tokyo, sharing the facility with the Nikonos line and the new L35 pocket camera series. FA body numbers started on 5000001.

LEFT: American advert for the FA, this piece dating from April 1984.

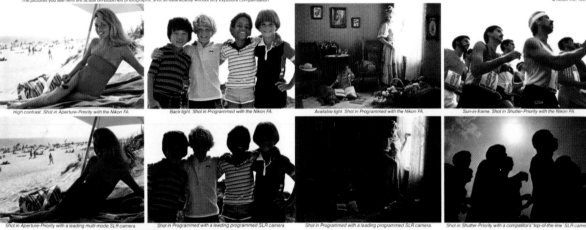

Introducing a camera that has more in common with the human eye than with other cameras. See.

The pictures you see here are actual unretouched photographs, shot simultaneously without any exposure compensation.

© Nikon Inc. 1984

High contrast. Shot in Aperture-Priority with the Nikon FA.

Back light. Shot in Programmed with the Nikon FA.

Available light. Shot in Programmed with the Nikon FA.

Sun-in-frame. Shot in Shutter-Priority with the Nikon FA.

Shot in Aperture-Priority with a leading multi-mode SLR camera.

Shot in Programmed with a leading programmed SLR camera.

Shot in Programmed with a leading programmed SLR camera.

Shot in Shutter-Priority with a competitor's "top-of-the-line" SLR camera.

The Nikon FA. The biggest advance in automatic photography since automatic exposure.

Until now, the metering system of any automatic camera could do just one thing. Measure light and give you a technically correct exposure.

But as any photographer knows, a technically correct exposure doesn't always give you the best picture.

That's why Nikon developed the FA. The first camera with AMP (Automatic Multi-Pattern) metering.

AMP is the only metering sys-

tem that can automatically give you optimum exposure, not just technically correct exposure, even under extreme lighting conditions.

So what you see in your pic-

How AMP works.

AMP metering divides your picture into five segments and then individually measures and compares each segment, evaluating such factors as contrast ratios, variations in brightness levels and percentages of light and dark areas.

It then processes this information in its own Nikon microcomputer, comparing the components of your picture with those of nearly 100,000 photographs programmed into its memory, and instantly chooses the optimum exposure.

tures is a lot more like what you saw with your eyes.

The FA gives you more choices than any other camera.

Shoot in the Dual-Program mode and the camera does it all for you. With one program for normal and wide-angle lenses and a high-speed program for Nikon AI-S and Series E lenses, 135mm and longer.

Or switch to Shutter-Priority. With the FA's top shutter speed of 1/4000 of a second, there's not much you can't catch.

If you're most concerned about controlling the sharpness of foreground and background,

Aperture-Priority is at your command.

And of course, you can also take full creative control in Manual.

Add other Nikon options, too.

When you shoot with the FA, you can take advantage of the most advanced photographic system in the world.

Use a Nikon motor drive and shoot up to 3.2 frames-per-second.

Or attach a variety of Nikon Speedlights to activate the FA's automatic TTL (through-the-lens) flash metering system, and shoot

flash pictures at sync-speeds up to 1/250 of a second.

The FA is also compatible with all current and many older Nikon lenses, and a full range of Nikon accessories.

To find out more about the kind of pictures the FA can take, write to Nikon Inc., Dept. 55, 623 Stewart Ave., Garden City, N.Y. 11530.

Or better yet, just use your eyes.

Nikon
We take the world's greatest pictures.™

It had a removable grip, like the FG, allowing for the attachment of the dedicated ¥38,000 MD-15 motor drive (or slower MD-11/12 units), and could be fitted with the MF-16 databack introduced a few months before this latest award-winning Nikon body. Inside there was a choice of three interchangeable focus screens (as on the FE2 and FM2), a damper on the mirror, and an eyepiece curtain.

The FA, introduced at ¥115,000, actually had two programme modes, which automatically switched to best suit the lens in use. The Ai-S Nikkors (plus the recent Series E and, later on, AF lenses) had an indexing ridge that informed the body of its focal length – on longer lenses, the shutter speed was higher than if a shorter (135mm or less) lens was fitted. To take full advantage of the camera's 'P', 'A', 'S' and 'M' modes, the FA therefore worked best with Ai-S Nikkor lenses, with their linear diaphragm action, but the regular F mount was still very much in evidence. The only real restriction on lenses was caused by the fixed Ai coupling and the fact that there was no mirror lock-up facility on the FA (or FE2 and FM2 for that matter), as a certain amount of light leakage was found on the new shutter arrangement if this feature was installed. Still, at this time it was the price one had to pay, albeit a small one, for faster shutter speeds, at least until the F4 came along.

On the subject of lenses, four Ai teleconverters – the TC-201S, TC-301S, TC-14AS and TC-14BS – were launched in the same month as the FA. A few days later, the compact SB-18 flash made its debut, but was sold in export markets only, mainly for use with the FG. The SB-19, on the other hand, was the domestic equivalent, priced at ¥12,000, and brought out to complement the new Nikon FG-20.

The FG-20 was announced in March 1984, at the same time as the New FM2. The FG-20 was actually closer to being the spiritual successor to the EM than the upgraded FG, as its specifications fell somewhere between the two. Basically, the FG-20 was an FG without the programme exposure mode and TTL flash control, and less information in the viewfinder, although it did have an aperture-priority automatic exposure mode, like

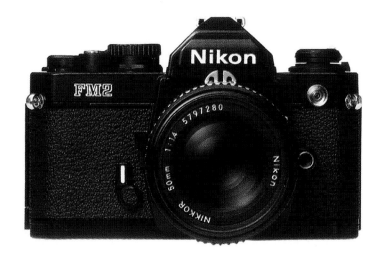

ABOVE: A 1984 compatibility chart.

LEFT: Close-up lenses and equipment from mid-1984. Accessories are few and far between nowadays and, while the lenses have moved on, the bellows and associated paraphernalia seen here are the same as those sold two decades later.

the EM. It also had the FG's improved electronics and extended film speed range, upped to ISO 3,200 from the EM's 1,600. The FG-20, with its distinctive chamfered edge on the top plate and unusual self-timer lever, was introduced at ¥68,000 with a 50mm f/1.8S lens.

The Nikon New FM2 (this name was used in promotional material, but did not appear on the body – the previous FM2 script remained) was brought to market at the same time as the FG-20. Introduced at ¥65,000 (body only), it was given enhanced metering electronics, brighter focusing screens and a higher, 1/250th of a second flash synch speed. Naturally, the latter brought with it a newly calibrated shutter speed dial, although the shape and physical size remained the same. The only major change applied to the New FM2 after this was the adoption of the F801's smooth, aluminium alloy shutter blades in late 1989.

FAR LEFT: **Large format lenses continued to be sold alongside the regular Nikkors.**

LEFT: **The Nikonos V, which came with the orange and black colour scheme illustrated here, or finished almost completely in khaki green. This example is fitted with the UW-28mm f/3.5 lens.**

The Nikonos V

The Nikonos V was a direct development of the Nikonos IV-A. Introduced in April 1984, it gained a number of manual shutter speeds to augment the existing R, B, M and A markings on the selector dial. The user was therefore given greater control and more exposure options, while the synchronized flash operation was improved via TTL metering. The SB-102 Speedlight came out the same year as the V, as did the significantly lighter, cheaper, but slightly less powerful SB-103 flash unit, and these represented the perfect Speedlight combination for the new body.

The body styling was much the same as that of the IV-A, although the area around the shutter release was revised, and close inspection reveals it is actually a brand new casting with improved sealing. The body colours were quite different: while the IV-A was supplied only with a traditional black finish, the V came in either green, or black with orange highlights. The khaki green body proved useful in wildlife photography, and although the bright orange finish looks a bit conspicuous on dry land, when in the sea, as well as matching the dedicated Speedlights, it proves useful in locating the camera in the murky depths.

This was ultimately to be the last manual focus Nikonos, as the final incarnation of the breed was to be an AF model. It would stay in production for many years, though, going on to sell for as long as the three Calypso-based models put together. The V would get an additional lens by the time production came to an end – a UW-20mm f/2.8, with a price halfway between the 15mm and 28mm UW optics – and the SB-105 flash unit eventually replaced the SB-103 in the catalogues.

Brand Image

Following on from a Japanese executive becoming President of the American operation, more effort was made to solidify a single Nikon brand image. In July 1984 the European side of the business was streamlined, with Nikon BV in the Netherlands becoming the continent's nerve centre. From now on, all countries would follow a similar advertising and marketing policy, and offer a similar level of after-sales service.

The FA Gold was launched in November 1984. Limited to 2,000 units with their own distinct set of serial numbers, and priced at ¥500,000 apiece (including a matching 50mm f/1.4 lens), these are now true collectors' items. The exotic brown leather sets off the gold plating nicely, and a unique serial number plate was mounted below the film advance lever.

Nine Ai Nikkors were launched in 1984, including an incredibly fast (and incredibly expensive) 300mm telephoto lens, a faster 20mm wide-angle, a faster Micro-Nikkor and a 500mm Reflex lens, but the majority of new additions to the line were zooms. There was a reason for this. As far as 35mm SLR lenses were concerned, in 1975 the zoom accounted for 20 per cent of sales. By 1982 its market share had risen to over 50

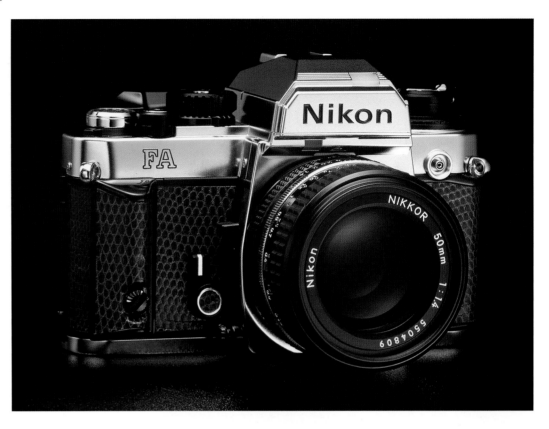

If this is what a beginner can do with the Nikon FG, imagine what you could do with a little practice.

Recently, we recruited a group of people who were novices at 35mm SLR photography, handed them Nikon FG's, and set them loose in California. Their results didn't surprise us in the least.

The Programmed FG.

Because we designed the FG to be so simple that a beginner could take great pictures with it from day one.

Yet we engineered so many sophisticated systems into the FG that it's perfect for a serious photographer, too.

You see, the FG is a camera that gives you as much or as little automation as you want.

In the programmed mode, just focus and shoot. In automatic, you can control depth of field by choosing an aperture while the camera selects the appropriate shutter speed. And in manual, you can set both for complete creative control.

What's more, with the FG's extraordinary through-the-lens flash metering system and the optional SB-15 Speedlight, even the most complex flash pictures become simplicity itself.

So try out an FG at your Nikon dealer.

Because no matter how terrific you think these pictures are, there's nowhere to go from here but up.

Nikon
We take the world's greatest pictures.

ABOVE: The FA Gold was limited to 2,000 numbered pieces, priced at ¥500,000 apiece.

ABOVE LEFT: Japanese advertising for the FA from mid-1985, promoted alongside eight contemporary Ai-S Nikkors.

LEFT: An American advert for the FG from the same period.

RIGHT: One of a series of Japanese adverts from the mid-1980s featuring professional F3 users.

per cent and three years later to 80 per cent, according to official figures. Nippon Kogaku naturally had to act accordingly, but getting the optical quality of a fixed focal length lens was a difficult task, especially with wide-angle variants. Nonetheless, the company's conscientious engineers succeeded and, with ED glass, the zoom lens gained acceptance from all users, including the pros. By the mid-1980s more than half the lenses sold by Nippon Kogaku were zooms.

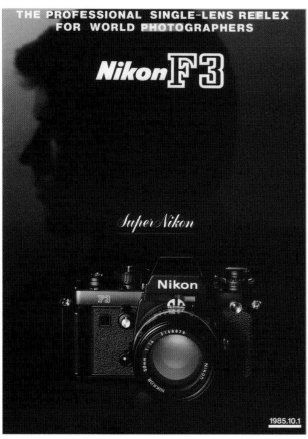

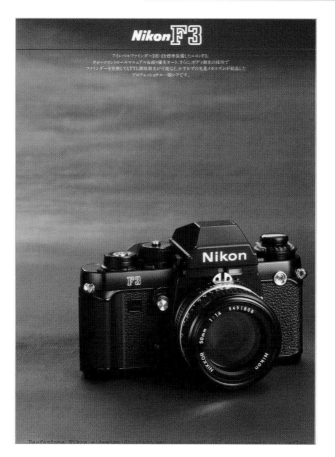

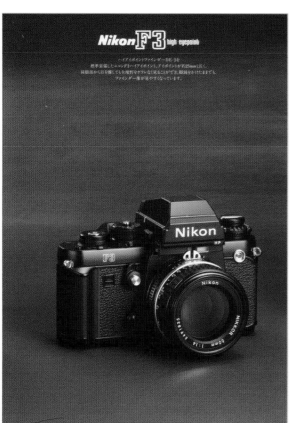

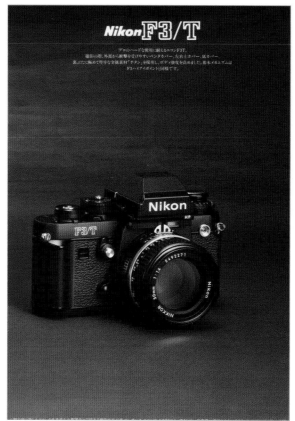

Cover from the Nikon F3 catalogue of October 1985 (one month after the ¥36,000 MF-18 databack became available for the F3), plus the inner fold revealing the strict F3, the F3 HP and F3/T. Over the years, the F3's AE switch was made to protrude less, and the viewfinder illuminator button increased in size slightly.

The Minolta 7000.
The world's best-selling and
No.1 award-winning autofocus SLR.

Minolta's Hi-Tech autofocus technology that revolutionized
SLR photography. Astonishing speed. Brilliant accuracy.
Incredible ease of operation, even in flash photography.
They're all convincing reasons why the Minolta 7000 is the
number one choice worldwide. Isn't it time to take a
firsthand look at the autofocus SLR that's second to none?

THE HI-TECH AUTOFOCUS SLR **7000**

Minolta Camera Co. Ltd. 30, 2-Chome, Azuchi-Machi, Higashi-Ku, Osaka 541 Japan

ABOVE: The F-301 was a manual focus camera, but it provided the
foundation stone for a new generation of Nikon AF SLRs.

RIGHT: Period advertising for the F-301.

ABOVE: **The Minolta 7000,
which caused quite a stir
when it became the
world's first AF camera
with a built-in motor
drive.**

Another Trend to Follow

The Minolta 7000 became the world's first AF camera with a built-in motor
drive when it made its debut in February 1985. Not only was it advanced,
it was reasonably priced, too, despite its high-quality Rokkor lenses. Canon
had its T80 waiting in the wings (it came out only two months after the
Minolta), prompting Nippon Kogaku to reply. People would ultimately
have to wait until 1986, but meanwhile there was still plenty of activity
going on at the various Nikon factories and sales outlets.

The manual focus F-301 was the first of a new generation of Nikons, with
sharp, F3-influenced styling, semi-automatic wind-on for easy film load-
ing, and a built-in motor drive (rated at 2.5 frames per second, although
a switch allowed continuous or low-speed running, as well as single shots
to be taken).

The F-301 had two 'P' modes – one normal programme, and one that
tipped the balance in favour of higher shutter speeds – selected on the
same top dial that provided the regular 'A' mode and quartz-controlled
manual speeds (ranging from one second to 1/2,000th of a second, plus
'B'). There was also a self-timer, and a cable release facility via the MC-
12A/12B remote lead.

The SPD cell-type centre-weighted automatic exposure was comple-
mented by manual over-ride, an AE lock and an audible warning system
to alert the user when the required shutter speed was too high, or too low
to avoid camera shake; this could be switched off.

The prism head contained a fixed but bright focusing screen and an
informative viewfinder (with LED indicators), and played host to an ISO
hotshoe. TTL flash control was included in the specifications, and taken a
stage further by a flash programme that automatically looked after Ai-S
lens aperture settings. Like the FA, the F-301 was able to identify an Ai-S-
specified Nikkor and adjust programmes to suit.

The quick release back had a window in it to view the film type;
although film speeds could still be set manually, the F-301 came with DX
code recognition as part of the package. An exposure compensation facil-
ity was also included, set on the same dial as the film speed underneath
the rewind crank. Incidentally, a databack was made available from day
one (the ¥25,000 MF-19), which, in addition to allowing the time and
date to be printed on the negative, also acted as an intervalometer.

As well as its body providing the foundation for the forthcoming line
of AF cameras, the lightweight F-301 – launched at ¥107,000 with a
35–70mm f/3.3–4.5S zoom – was a great success commercially, combining
the ease of a compact camera with the quality benefits of an SLR.

Interestingly, the launch of the F-301 coincided with Nikon Inc.'s efforts to
curb grey market sales. The American office requested that unique designa-
tions be allocated to US market models, so the F-301 became the N2000,
the L35AF2 became the One-Touch, and so on. This system has continued
to this day, and all the American names can be found in the appendices.

The F-501 (N2020 in the USA) made its debut in April 1986. It was basi-
cally an F-301 body with autofocus (activated by light pressure on the

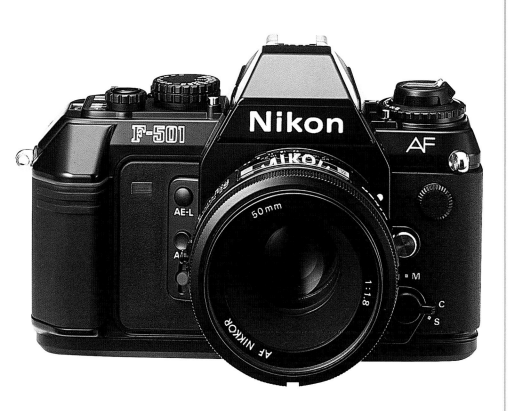

shutter release button, although a manual override was also provided alongside the two types of AF – release priority, marked with an 'S', for static subjects, and focus priority, marked with a 'C', for moving objects), and revised switches to the side of the lens mount to make room for the AF lock. Of course, careful inspection revealed a new lens mount, too, as the drive to move the focusing on the lens was provided by the body, but the basic 1959 design was still very much in evidence, allowing older Ai spec Nikkors to be used in MF mode.

The centre-weighted AE programme was much the same as that of the 301, except a third 'P' mode was added, marked 'Dual' (a combination of the other two 'P' modes, selected automatically depending on the focal length of the AF or Ai-S lens). Unlike the F-301, the F-501 came with the option of three focusing screens, and AF-TTL flash control with a suitable Speedlight.

The F-501 was introduced at ¥89,000 (body only). Accessories included the MB-3 battery pack, allowing rechargeable batteries to be used, and the ¥30,000 SB-20 Speedlight – an AF-TTL unit with a rotating flash tube to deliver different levels of flash, and integrated AF illuminator. There was also the TC-16AS teleconverter (priced at ¥29,000), which brought limited AF capability to certain MF lenses until the range of autofocus Nikkors could be expanded.

As far as MF lenses were concerned, late 1985 saw a slightly revised 50mm f/1.8 launched, along with a 105mm UV model, a couple of popular

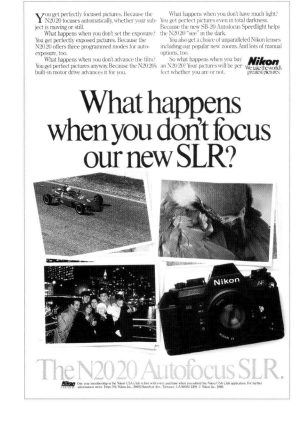

zooms, and a line of fast telephotos with ED glass and internal focusing, ranging from 200mm to 600mm focal length; an 800mm f/5.6S ED (IF) joined them in July 1986.

To suit the new F-501 AF camera, three lenses were launched straight away: a 50mm f/1.8, a 35–70mm zoom and a 70–210mm zoom. These AF lenses were instantly recognizable due to the lack of a meter coupling prong, a distinctive window over the distance scale, and CPU contacts at the rear.

In the second half of 1986 the original AF lenses were joined by three more zooms and no fewer than six regular AF Nikkors, ranging from a 24mm f/2.8S through to a fast 300mm telephoto. In between came a faster 50mm normal and a 55mm Micro-Nikkor, added at the same time.

RIGHT: **The Ai AF lens line-up from mid-1987, showing the 50mm f/1.4S, 35–135mm Zoom, 24mm f/2.8S, 180mm f/2.8S, 55mm Micro, 28mm f/2.8S, 300mm f/2.8S, 28–85mm Zoom, 35–70mm Zoom, 300mm f/4S, 50mm f/1.8S, 70–210mm Zoom and 35–105mm Zoom models.**

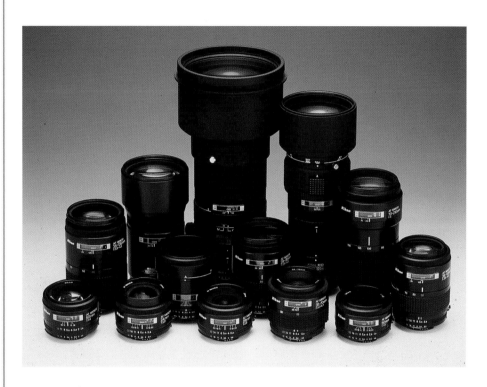

Other Developments

On the compact camera side of the business, Nippon Kogaku released four L35 series autofocus models in April 1986. The L35AW (AW standing for all-weather) was waterproof to a depth of 3 metres, but weighed only 535g, so it was significantly lighter and smaller than the contemporary Nikonos. Granted the AF system did not work underwater, but this feature was not possible with a Nikonos either until the RS came along several years later. The AF was the standard version, with the AD adding a simple databack; the L35AW could be ordered in black, orange or blue.

The other two models were the L35TWAF and L35TWAD. The AF and AD suffixes were used again, but this time matched up with the letters TW, which stood for 'tele and wide'. This perfectly described the two-position lens (giving 38mm and 65mm), which allowed the L35TW to become the first Nikon compact with what amounts to a zoom, and infinitely variable AF. These latest L35 variants were notable for their high-quality lenses.

LEFT: **EL-Nikkor lenses from the time, complete with a technical drawing showing the construction of the 210mm version.**

A couple of months later CKD ('completely knocked down') production of a number of Nikon cameras began in South Korea via Anam Precision. This was the first time overseas production had been carried out successfully, with the New FM2, FG-20 and L35AD2 being built up using Japanese made components. As well as assembling these cameras, a number of other compact models were produced in Korea in the years that followed (including the F301, F801 and F401S), and more recently certain digital cameras (such as the SQ) as well. There was also a number of joint projects instigated for the Korean market. Incidentally, the so-called 'Lemix-Nikon' FM2 can be readily identified by the circular 'L' badge above the self-timer switch.

In spring 1987 the AF3 compact camera (or AD3 with databack) replaced the L35AF2/L35AD2, coming with a lithium battery pack, shorter AF distance capability and enhanced flash functions. The RF and RD made their debuts at the same time. Even though they featured an automatic rewind facility, these were by far the cheapest compact models made by Nippon Kogaku at that time, with even the RD quartz date version costing less than the L135AF of 1984.

After the SB-21 flash units (the replacement for the SM and SR ring lights used for macro work, with the mounting being the only difference between the A and B types), the SB-22 put in an appearance in April 1987. Priced at ¥22,000, this was a slightly more compact version of the SB-20

ABOVE LEFT: **Nikon L35AWAF and L35AWAD, or Action-Touch in America. This is the top AD (quartz date) version.**

ABOVE: **Nikon L35TWAF and L35TWAD, known as the Tele-Touch in the American market. This is the cheaper AF variant.**

FAR LEFT: **The Nikon AF3 and AD3 replaced the second-generation L35 models, and carried the One-Touch moniker in the USA. This is the quartz date version.**

LEFT: **The RF and RD were budget compacts. Even the top RD model, seen here, undercut the price of the cheapest variant previously issued – the basic L135AF.**

and an excellent choice for a camera with a motor drive, as it was able to keep up with the action. Later it was upgraded to become the SB-22S.

June 1987 saw the launch of the F-401 autofocus SLR, introduced at a very reasonable ¥64,000 (body only). Known as the N4004 in the USA,

RIGHT: The Nikon F-401 was Nikon's second AF SLR. Like the F-501, it was produced at the Sendai works, and is pictured here mounted with an early autofocus f/1.8 normal. A faster f/1.4 version was also available in the AF Nikkor series.

this fairly basic model was quite different in its appearance thanks to the Image Master Control system (twin dials for aperture and power/shutter speed/mode under a clear plastic cover), while the large 'Nikon' script on the grip made the F-401 instantly recognizable. Although a hotshoe was provided, the F-401 featured TTL synch on the built-in flash (a world first), making it handier than the other three-number bodies before it, and there was a manual focus facility to go with the autofocus. However, AF lenses gave by far the best results, as the metering system was designed around them and, besides, it was a shame not to take advantage of the revised autofocus system, which was given far more sensors than the F-501 to improve focusing performance. There was also a QD version, adding a databack with a simple date and time printing function.

The TW2 (or TW2D with databack) was an ultra-thin compact camera with a lens that retracted into the body, plus a whole host of features that would normally only be found on a decent contemporary SLR. Launched in October 1987, the American name for this camera was quite fittingly the Tele-Touch De Luxe.

More AF lenses joined the Nikkor line-up at the tail end of 1987, with an internal focus 300mm f/4S being followed by three new zooms. February 1988 saw the launch of an 80–200mm zoom and a 85mm f/1.8S, but the other three AF lenses that appeared that year were simply updated versions of existing Nikkors.

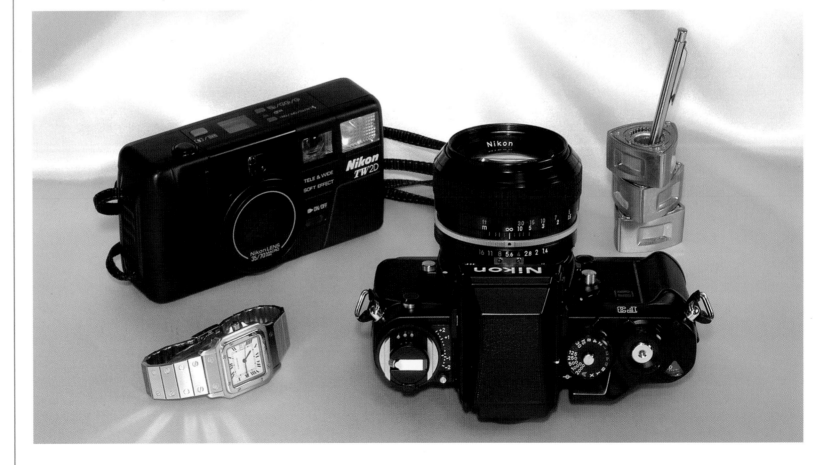

RIGHT: An F3 mounted with a 'New' lens converted to Ai spec, as were many of its contemporaries. Keeping the F mount for so long allowed users a great deal of options when it came to lens selection, especially when in possession of a 'Pro' body. The F3 has been photographed with a TW2D (the flagship of the pocket camera line), and a period Cartier Santos. Mazda fans will recognize the silver pen stand.

Although new Ai-S lenses were few and far between by now, March 1988 saw the introduction of the 500mm f/4P. Interestingly, the P-type Nikkors transmit data back to the camera body via a CPU, but were not AF – the information was used to help determine the best AE settings. The same month witnessed the launch of the ¥16,000 SB-23 Speedlight, a fairly basic, compact AF flash unit ideally suited to the F-301, F-401 and F-501. Much bigger news, however, was on the horizon.

At a board meeting convened in 1986 it was decided that a new Nikon logo and a fresh typeface would be adopted for the company's seventieth anniversary, and from April 1988 the Nikon Corporation came into being. From now on Nikon was the company name, with Nippon Kogaku registered as a subsidiary to keep it alive. The President at this time was Koji So, while the Chairman was Naritada Fukuoka. A new era had begun, but in more ways than one, as this was a time when technology progressed in giant leaps forward.

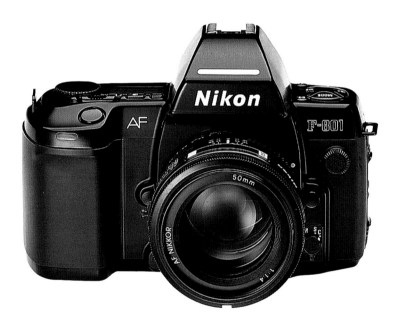

ABOVE: **Nikon advertising boards are always a prominent feature at major sporting events, such as Major League Baseball and top-flight car races. Nikon also sponsored Mitsubishi's assault on the Paris–Dakar Rally raid on a number of occasions, as witnessed by this photograph taken in 1987.** COURTESY MITSUBISHI MOTORS

LEFT: **An English-language advert for the F3, just prior to the launch of the F4.**

FAR LEFT: **Nikon F-801 mounted with an AF 50mm f/1.4 Nikkor.**

The F-801

The F-801 represented another step forward in terms of styling and advanced functions, its easy-to-use main control dial that worked in conjunction with the various mode and focus selectors to adjust almost all of the camera settings, and the LCD display on the top plate laying the foundation for a whole generation of Nikon SLRs. Launched in June 1988 at ¥104,000, the 801 was obviously designed to complement the forthcoming F4 as a second body for professionals, or to please the most dedicated of amateur photographers: either way, this new AF model had the technical specifications to satisfy both groups.

Contained within the F-801's die-cast aluminium alloy body was a low-light AF system (with MF facility), a 3.3 frames per second motor drive (a switch also allowed single shots or 2fps), a high-speed shutter with a 1/8,000th of a second top speed and aluminium alloy blades, a high-eye-point finder with a wealth of information displayed within and a choice of focusing screens, advanced matrix or centre-weighted metering allied to excellent exposure control with quick and easy fine tuning, an automatic film rewind facility, a two-shot self-timer and the very latest in flash technology.

As well as a 1/250th of a second synch speed, the F-801 took full advantage of the SB-24 Speedlight brought out at the same time (there was no built-in flash on the 801). The ¥45,000 SB-24 really was pushing the envelope. It was powerful, with a tilt-and-turn head, and was capable of delivering regular TTL flash or matrix-metered fill-in flash, with automatic or manual modes, rear curtain synch, plus a repeater flash facility, all in a relatively light, compact unit.

The MF-20 databack was launched at the same time as the F-801, giving the latter a regular date and time printing facility, although the MF-21 that appeared in the following month offered much more. Priced at ¥30,000 (¥18,000 more than the MF-20), it allowed picture number and exposure details to be recorded, and also had an AF trigger and intervalometer function. The AF trigger was an interesting feature, automatically releasing the shutter each time an object moved into the focus field.

Thanks to advances in micro-electronics and battery technology, the databack had certainly come a long way – thin, lightweight, with a small internal power source and with the kind of features that only ten years earlier would have required an enormous budget to buy all the equipment, not to mention a team of Sherpas to carry it.

The same was true with camera bodies. Among Nikon's rivals, it is interesting that, after adopting electronics for its R3, R4 and R5 SLR models, the 1988 Leica R6 featured a mechanical shutter and manual control. The R7 of 1992 went back to electronic control, giving the German company a fighting chance against the contemporary Nikons and Canons, but its desire to compete and nurture volume sales at the lower end of the market was clear after the introduction of the AF-C1 compact camera in 1989. More compact Leicas followed, many produced in conjunction with Minolta, trying to attract enthusiasts who had previously viewed the German cameras as too expensive. But while the magic of the Leica name will probably never diminish, especially among collectors (including the author), it has to be said that the Japanese brands were leaving everyone else in their wake. The Nikon F4 was a major contributor to this situation.

The Nikon F4

The basic F4 concept was established by Yoshiyuki Nakano and his team under the watchful gaze of Akihiko Sato (General Manager of the Camera Design Department) and Seijiro Noda (Design Manager) in January 1985. It was decided that the new 'Pro' body would be equipped with an advanced autofocus system with manual override, matrix metering, a high-speed shutter with reduced noise, high-speed flash synchro, a bright finder screen, built-in motor drive and improved weatherproofing.

By the autumn of that year Giugiaro had been called in and given a brief to keep certain controls in predetermined positions and sizes, and then make design proposals based on these constraints while keeping the overall package as compact as possible. Giugiaro's people sketched a vast number of proposals based on the component specifications provided by Nikon, and then made full-size wooden models of those that showed promise. Ultimately just one was selected, moving camera design forward another generation.

BELOW: The F-801 was known as the N8008 in the USA as these two American adverts clearly imply. One piece shows the N8008 with the highly advanced SB-24 Speedlight attached.

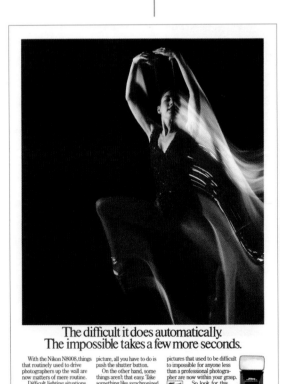

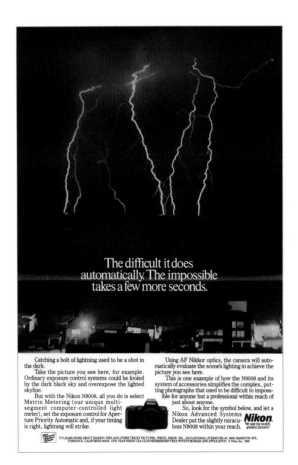

BELOW: An early F4 prototype finished in dark grey metallic (body number 1008025). Although Giugiaro's final design proposal for the F4 featured traditional black 'leather' trim on the body, the final design used a functional, synthetic black rubber coating, giving an impression similar to that of one of the NASA cameras. At the same time the F4 gained a new Nikon marking on the front of the body.

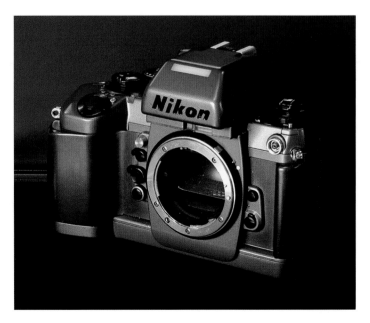

Work on pre-production prototypes started in June 1987. After the straight-edge styling of the previous 'Pro' bodies, the F4 was quite striking because of its rounded, more organic form. Like the F3, also styled in Giugiaro's studio, it looked as if it had been carved from a single piece of material – it was a sculpture, a work of art. But beneath the elegant exterior was an array of advanced features that took the photographic world by storm, bringing the professional photographer the very best features of the earlier F models, along with the added benefits of an accurate high-speed autofocus system and a built-in motor drive.

F4 – Rocket Science Personified

The Nikon F4 is a masterpiece, with no fewer than 1,850 parts coming together in an aluminium alloy casing to produce one of the most advanced cameras ever built. The F4 body contains nine IC control modules and three microcomputers, with the standard DP-20 head being another marvel of 1980s engineering, giving the user a whole host of information through the viewfinder.

The autofocus system used the high-speed AM200 module, and came with three selectable modes: manual focus, single-servo AF for still photography, and continuous AF (the latter constantly hunting for and tracking subjects automatically should they move). It ideally called for one of the new line of AF Nikkors to benefit fully from all the F4's features, although older lenses could be used if one was willing to miss out on certain programmes. Nikon's retention of the F mount was a real boon for professionals who had invested a small fortune in lenses over the years. With an AF lens, five exposure-mode programmes were available: aperture priority ('A'), allowing the user to select the opening on the lens to control depth of field; shutter priority ('S') for the manual selection of shutter speeds combined with automatic, stepless aperture settings; fully automatic operation ('P'); automatic operation using high shutter speeds ('PH'); or fully manual operation ('M').

Although the shutter speed dial was only marked up from four seconds to 1/8,000th of a second, the camera would in fact fire in a stepless

1988.9.8

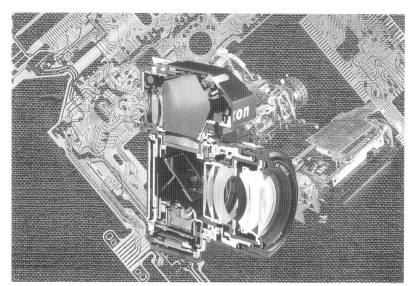

FAR LEFT: Cover of the F4 technical guide.

LEFT: The internal details of the F4 – a masterpiece that truly pushed the envelope in terms of 35mm photography at the time. The body casting was made by an outside specialist and machined at the Mito works. While the electronics were shipped in from the Sendai factory, production of the finder and final assembly was also carried out in Mito, north of Tokyo.

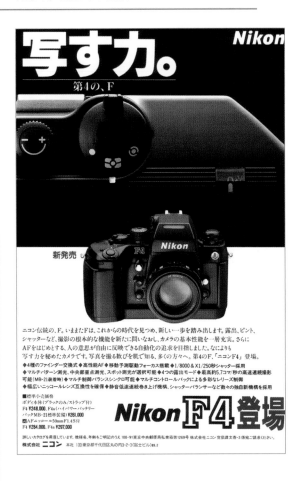

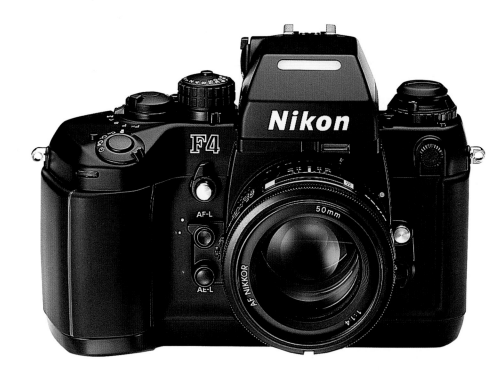

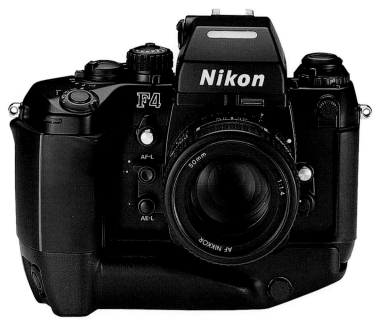

manner from 30 seconds to its maximum speed in the automatic modes, giving an amazing range of control. The top flash synch speed of 1/250th of a second was much faster than the F3 had allowed, and made possible by a new vertical, dual-curtain focal plane shutter arrangement with two sets of four blades made from rather exotic, lightweight carbon-fibre composite materials. As well as being extremely fast, the shutter action was also very smooth thanks to a patented shutter balancer. As with earlier 'Pro' bodies, the mirror had a damper mechanism and could be locked up. The depth of field preview button was inside the mirror lock-up lever, with an AF lock and AE lock positioned underneath.

The F4 featured leading-edge exposure and TTL flash metering, allowing the user to choose between spot, full-screen (a five-segment matrix), or 60 per cent centre-weighted metering to overcome difficult lighting situations. While the spot metering system was similar to that of the F3, the other two metering options employed two SPD cells located in the standard DP-20 head to pass on lighting information for the computers to process, and then duly select one of more than 100,000 exposure variations that best matched the scenario, all within a fraction of a second.

The DP-20 head had a built-in viewfinder cover to prevent stray light from entering the camera when used with a remote release or similar. A wealth of information was displayed in the viewfinder image, including a frame counter and exposure compensation details.

Everything for the Professional

In keeping with a 'Pro' body, various finders and screens were made available from the outset, the focusing screens costing ¥3,000 each. Most heads came with built-in eyesight adjustment control, and were double skinned to withstand heavy knocks. The standard ¥48,000 DP-20 eye-level finder was augmented by the ¥21,000 DW-20 and ¥39,000 DW-21 waist-level finders (the latter being magnified), and the ¥70,000 DA-20

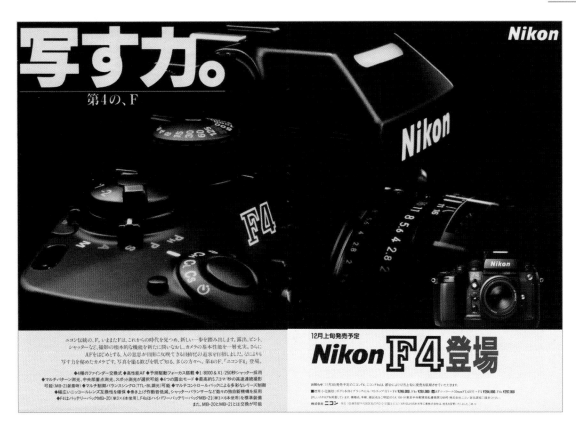

写す力。

第4の、F

Nikon

F4

Nikon

12月上旬発売予定

Nikon F4登場

SB-24

SB-23

SB-22

SB-20

SB-16B

LEFT: Tasteful Japanese advertising for the F4, this piece dating from the end of 1988.

RIGHT: Original Speedlights for the F4, including (from top to bottom) the SB-24, the SB-23, the SB-22, the SB-20 and the SB-16B.

BELOW: The author's F4S with an SB-24 Speedlight, and an IWC chronograph that seems to perfectly match the F4's character. Note the exposure compensation dial next to the shutter speed dial.

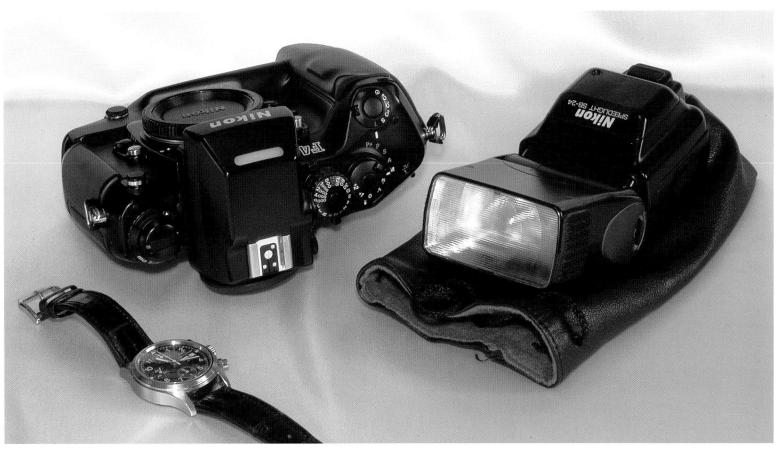

ABOVE: F4 finders, with the standard issue DP-20 at the top, followed by the DA-20 action finder, the DW-21 magnified waist-level finder, and the DW-20 (a regular waist-level finder). Prices ranged from ¥21,000 for the DW-20, all the way up to ¥70,000 for the action finder.

ABOVE RIGHT: The DW-21 finder mounted on an early F4.

action finder. These heads slid into place from the rear, finding their way home with a positive click.

The technical wizardry did not end with the body and lenses – the F4 gained a highly advanced flash system, too. The ¥45,000 SB-24 Speedlight was launched just ahead of the F4, while the SB-25 and SB-26 units that followed also gave fully automatic operation of all flash modes, from fill-in flash to illuminating the darkness. The F4 had an ISO accessory shoe mounted at the top of the standard viewfinder prism, as on the F3P, making it much more convenient when using a flash on longer shoots.

New for a 'Pro' body, however, was a built-in MD, using the same coreless motor technology that drove the autofocus and shutter systems. It delivered performance that would wind on film at a rate of between one and six frames per second depending on the film advance mode, exposure mode and whether or not the additional battery packs were fitted to the base of the regular body.

The standard MB-20 pack of the F4 could be replaced by the ¥18,000 MB-21 power pack, turning the F4 into the high-performance F4S, with its extra shutter release, higher MD speed and extended working time. The other alternative was the ¥32,000 MB-22, allowing the F4 to be hooked up to an external AC/DC supply. Remember, though, there was no mechanical back up on the F4: it relied entirely on batteries, so a manual rewind was provided to conserve energy, augmenting the powered rewind system.

While some complained of the weight, one has to remember that the F4 was always meant to be a 'Pro' body and most professionals, especially members of the press, tend to attach motor drives. An older F with a power pack and MD would have weighed considerably more and been an awful lot more bulky than the F4S, or even the forthcoming F4E.

Databacks were also listed. The ¥15,000 MF-22 was the basic databack for the F4 series, while the multi-control MF-23 back allowed the shutter to be triggered by an object moving into a predetermined focusing distance, and had an integral intervalometer. The ¥60,000 MF-23 did not become available until July 1989 and another year would pass before the MF-24 came along. The latter was a 250-exposure bulk film back (made to special order at ¥500,000). DX code film was automatically registered, but the F4 would readily accept ISO 6 to 6,400 films.

The F4 was announced worldwide in September 1988 and saw special press use at the Seoul Olympics before official sales began in December. Sales were actually supposed to begin in November, shortly after the 1988 Photokina, but initial demand was so strong that the date was postponed to allow a certain amount of stock to be built up for the shops. Ultimately sales easily topped the 5,000 units a month planned for in the production schedules, and there was a lengthy waiting list for quite some time after the launch.

Although announced at a slightly higher price, the F4 duly went on sale at ¥226,000, while the F4S commanded ¥239,000. Among its many accolades, the F4 won the Camera Grand Prix in Japan (as well as a Good Design mark), and both the European and Australian 'Camera of the Year' awards.

Contemporary Developments

The early AF lens barrels were made from glass-reinforced polycarbonate, which proved to be both rugged and lightweight, but there were complaints regarding the narrow focusing ring. Starting in 1988, many AF lenses were given new focusing rings and a revised aperture lock to make them easier to handle, and others were completely redesigned, losing the distance-scale window along the way.

A prototype 50mm f/4.5 UV lens was shown at the 1988 Photokina, but it was not issued. Notwithstanding, early 1989 saw the launch of a 35mm f/2 AF lens, followed by a 20mm f/2.8 as the summer arrived. By the autumn a new 75–300mm zoom had made its debut, sold alongside a revised version of the 35–70mm zoom, and an AF 60mm Micro-Nikkor that replaced the old 55mm f/2.8 model.

Meanwhile, on the compact camera front, the RF2 and RD2 were launched in October 1988. These facelifted budget models still had such features as focus memory and a double-shot self-timer, but the TW Zoom and TW Zoom QD brought out at the same time took the pocket camera into a new era, its slim body housing a five-step zoom lens. As such, this was the first proper zoom for a Nikon compact, as the early models had a two-position lens.

In spring 1989 the last of the two-position compacts was announced: the TW20 (and TW20 QD), with a 35/55mm Macro lens, red eye reduction and a sliding lens cover. At the same time the F-401S autofocus SLR made its debut.

The F-401S, known as the N4004S in America, went on sale in April 1989 at ¥61,000 in standard guise, or ¥66,000 with a QD back. Basically it was an F-401 with refinements in the AF system, especially in its low light

capability. A raised shutter release button was adopted, along with larger markings on the dials and improved locks to avoid unwanted settings' changes. There was even larger 'Nikon' script on the grip, but the new type designation marking above the lens release button readily identified the upgraded version.

ABOVE AND RIGHT: Contemporary advertising for Nikon sunglasses and sport optics.

ABOVE LEFT: The Nikon RD2 – sister camera to the RF2.

LEFT: The TW Zoom had a five-step zoom lens rather than a two-position item. This is the quartz date version.

LEFT: The TW20 was the last of the two-position lens compact cameras. The quartz date version is illustrated here, but it was available without a databack in certain export markets.

If it's not Nikon, it's not worth looking into.

When you buy binoculars, there's only one name worth buying. Nikon.

No other binoculars give you Nikon's legendary multi-coated lenses, clear bright images, and precision barrel and lens alignment for headache-free viewing.

And Nikon quality is something you'll see no matter what you're looking at, from ducks on Long Island to the Cardinals in St. Louis.

Nikon offers a choice of fast, smooth central focus, or individual focus binoculars with maximum depth of field. We have take-everywhere compacts that are light yet durable, plus binoculars that offer ultra-light gathering and ultra-wide field. Nikon even offers marine and sportsman binoculars that are rubber armored and nitrogen filled for waterproof and fogproof integrity.

Best of all, Nikon gives you all these at a surprisingly affordable price. Which makes Nikon not just the best binoculars you can buy, but the best buy in binoculars, too.

For more information write: Dept. N26, Nikon Inc., 19601 Hamilton Ave., Torrance, CA 90502-1309.
© 1988 Nikon Inc.

Nikon SPORT OPTICS
The Legend Continues

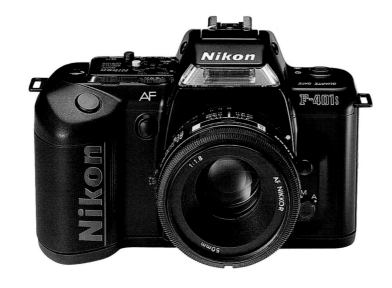

RIGHT: The F-401S – an upgraded version of the F-401, introduced three months after the death of Emperor Hirohito. Hirohito's son, Akihito, was duly installed as the new Emperor, inaugurating the Heisei era.

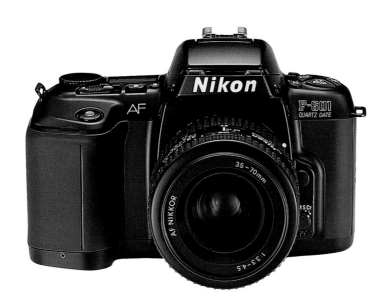

RIGHT: The F-601 was an ideal camera for everyday use, and is seen here mounted with a period 35–70mm AF zoom. Known as the N6006 in the USA it was available in regular guise or with the QD databack.

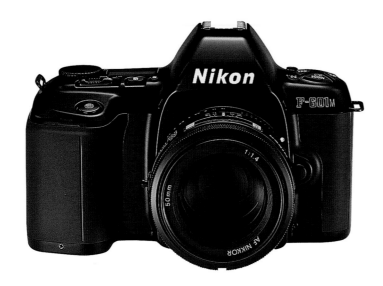

RIGHT: The F-601M was an unusual variant, being a manual focus version of an AF SLR. Oddly, AF lenses were required for many of the camera's programmes to work, and the early AF Nikkors did not lend themselves readily to this type of application, the focus rings being narrow and too light to adjust with any great accuracy.

FAR RIGHT: An American advert for the N6006 from December 1990.

Three new AF lens were launched in 1990: a revised 50mm f/1.8 normal and 28–85mm zoom, plus a 105mm Micro-Nikkor. The ¥41,000 ML-2 wireless control unit replaced the ML-1 unit in October that year, but another new SLR had made its debut in the meantime. In fact, there were three models: the regular F-601 (at ¥80,000), the ¥85,000 F-601 QD, with the facility to print simple time/date details onto a negative, and the ¥65,000 F-601M.

The F-601 was basically an F-801 with a pop-up flash similar to that of the F-401. The MD speed was much slower, though, at two frames per second, and the top shutter speed was restricted to 1/2,000th of a second. The newcomer did have an advanced metering system (including matrix, centre-weighted and spot), which actually put the F-601 ahead of the F-801 in this department. It also featured AE bracketing, and up to +/–5EV exposure compensation control. The more compact 6v battery

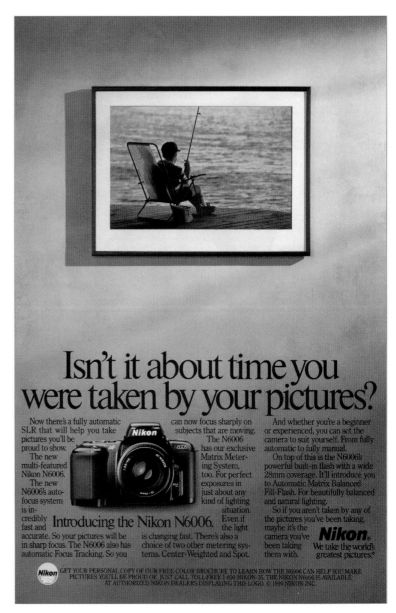

FAR LEFT: **Nikon TW Zoom 35-70 (or Zoom-Touch 400).**

LEFT: **The Nikon TW Zoom 35-80 (or Zoom-Touch 500S).**

pack was moved into the grip, making the package lighter and better balanced, and the threaded shutter release button proved to be of great benefit for cable release users.

The F-601M was a real oddity, in that it was a manual focus variant of an AF SLR. It was based on the strict F-601, but came without the autofocus system, pop-up flash and spot metering facility. Ironically, the camera's metering and the majority of its exposure modes worked only with AF lenses, as the body needed their CPU to relay information.

The TW Zoom 35-70 went on sale at the same time as the F-601, with improved autofocus and red-eye reduction. As usual, a QD version of this pocket camera was available, but five months later the TW Zoom 35-80 put in an appearance – a development of the 35-70 with an improved finder and flash.

Next up was the F-801S (or N8008S) of March 1991. Launched at ¥98,000, which was actually a fraction cheaper than the original F-801, it gained improved electronics, quicker focusing via the AM200 module from the F4 and new software, and spot metering to augment the existing centre-weighted and matrix modes. This helped put greater distance between the flagship AF SLR and the well-received F-601. The upgraded version had the 'S' suffix added to its designation to distinguish it from its predecessor, as had happened with improved Nikkor lenses in the past.

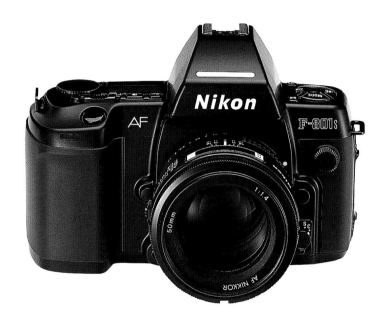

LEFT: **The F-801S – an upgraded version of the F-801.**

Progress of the F4

April 1991 saw the launch of the ¥262,000 F4E. This model used the ¥41,000 MB-23 battery pack, which released 5.7 frames per second performance without the need to plug into the national grid, and came with an extra shutter release for portrait shots, as was fitted to the pack used on the F4S. By spring 1992 more than 230,000 F4s had been sold (with no fewer than 40 per cent of these staying in Japan), compared with more than 750,000 F3s, which had been on the market for twelve years by this time.

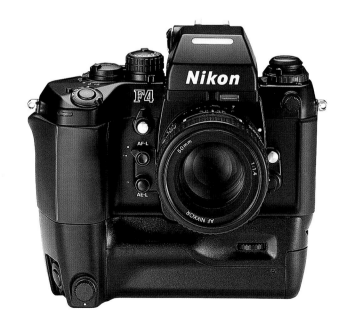

LEFT: **The Nikon F4E. The regular F4 used the MB-20 battery pack contained within the functional grip below the shutter. The F4S gave higher performance for an increase in weight caused by the larger MB-21 battery pack (using six instead of four batteries), while the F4E made the motor drive fly if one could live with the bulk of the more versatile MB-23 pack. Incidentally, the MB-22 was a converter for an external power source.**

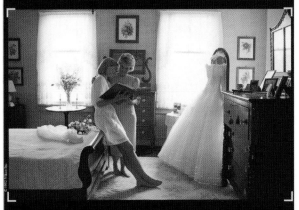

LEFT: American advertising for the N5005, known elsewhere as the F-401X.

BELOW: The F-601 QD (left) with the F-401X QD, and three generations of autofocus zoom Nikkors. The earliest lens pictured here is the 28–85mm model on the 401, while the 35–105mm is one of the facelifted versions. The 70–300mm zoom in the background is one of the more recent incarnations, with ED glass coming in an excellent value for money package.

As it happens, massive numbers of changes were applied to the 'Pro' AF model during its production life. Most will never be seen or noticed by anyone other than a service technician, but some are much easier to spot. Between 2120000 and 2180000 the F4 gained clearer numerals on the shutter speed dial, a new rubber grip pattern and taller release button, and a revised switch for metering mode selection that was less likely to be knocked.

By around 2200000 there was more of a shoulder on the handgrip, a different inner grip profile, and the battery switch was marked up to take LR6 and Ni-Cd cells instead of LR6 and KR-AA batteries; the low battery warning also came in earlier than before. Soon after, it featured a new finder release button and revised finder guide rails – a double detente being added to give an extra margin of safety when removing heads.

By 2500000 a locking pin housing had been added in the leading edge of the hotshoe, the R1 and R2 buttons had received subtle changes and, later on, a thicker, rubberized back was employed. The sensors to confirm the back is closed also give a good idea of a camera's age: while the right-hand side one was always silver metal, the left-hand pin (close to the R2

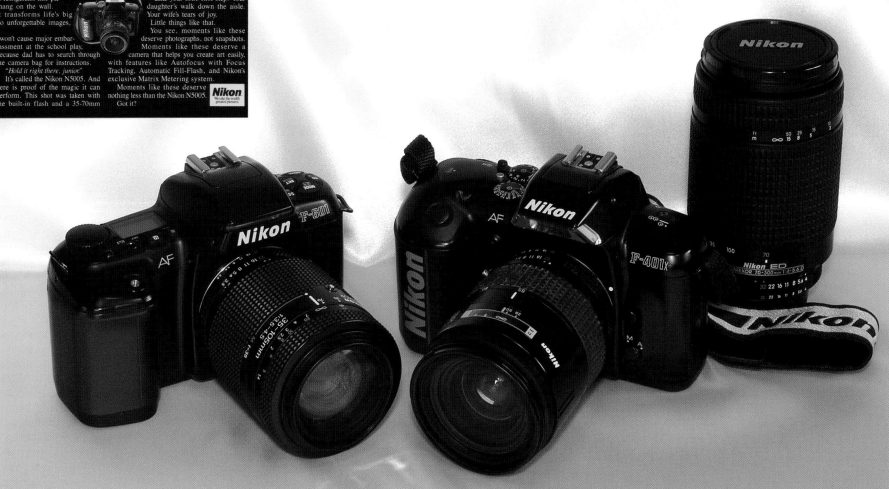

lever) changed from metal to white plastic midway through production, and the late models used a black plastic pin.

As with earlier cameras, the body numbers quoted are not gospel, since servicing and repairs often lead to newer parts on older models. There were also modified versions for NPS members with things like different markings on the shutter speed dial, and fewer locking mechanisms to speed up changing film and so on.

The F-401X was placed on the market in September 1991, priced at ¥64,000 (or ¥69,000 with a databack). The F-401X was given an enhanced AF system via the AM200 module, complete with focus tracking, and used less power than its predecessor. It was also given a better built-in flash (TTL-BL), improved matrix metering and an extended shutter speed range, with a 'T' position added to make up for the lack of a cable release facility. The new top plate design retained two dials, but the new designation was an obvious giveaway when identifying the updated 401.

As well as the updated SLR bodies, six new AF lenses were brought out in 1991. Four of them were revised versions of earlier Nikkors, but the 28–70mm zoom was a fresh design, as was the 135mm DC model. DC stood for defocus control, and allowed soft focus areas around a subject without having to resort to special filters to achieve this effect.

By January 1992 Nikon's Thailand factory was up and running. It started by making the 35–70mm f/3.3–4.5S (New) AF zoom lens, and then expanded its operation from there, moving into production of the Pronea 600i and certain Nuvis compact camera models as the years passed.

By this time there were twenty-four AF lenses in the Nikon catalogue. Autofocus lenses were by now the most popular in terms of sales, but they were still outnumbered by MF lenses in the Nikkor line-up.

Pocket Camera Proliferation

The W35 (and W35 QD) was a fresh-looking budget compact launched in September 1991. Even though it sold at well under ¥30,000 it still had five-zone autofocus and red eye reduction. The RF10 was another low-priced model, introduced six months later. Built for export only, and

FAR LEFT: An Italian Contax advert from the time – the revered German name was kept alive by the Japanese camera industry thanks to Kyocera.

LEFT: Nikon staff hard at work reviewing pocket camera designs. This side of the photographic business moves quickly, and is very fashion-oriented compared to the SLR line.

LEFT: Nikon W35 (One-Touch 200).

RIGHT: The basic RF10, also known as the Smile Taker.

FAR RIGHT: The TW Zoom 105, the QD version of which carried the 'World Time' moniker as a result of its more advanced databack.

ABOVE LEFT: The Nikon AW35.

ABOVE: The TW Zoom 85, which was called the Zoom-Touch 600 in the USA (the TW Zoom 105 was known as the Zoom-Touch 800).

LEFT: As well as Nikon livery on the various works buses, such as these at a Saitama factory, the company has recently been advertising on the coaches that run from the main airports around Tokyo Bay.

called the Smile Taker in the USA, it was sold through Nikon's Hong Kong offices.

The TW Zoom 105 was much more in keeping with the Nikon brand name, especially in TW Zoom 105 World Time guise, with its global format databack. This compact camera had an ED glass lens, a film skip mode (a world first), and improvements in the autofocus (with AF tracking), flash, viewfinder and metering systems.

Three months later, in June 1992, Nikon released the AW35 and AW35 QD models – weatherproof cameras that were ideal for snapshots on the beach. Then, in September, it was the turn of the TW Zoom 85 and TW Zoom 85 QD to take a bow. These were fully featured pocket cameras with a panorama mode and a ten-element macro zoom lens, but sold at a reasonable price.

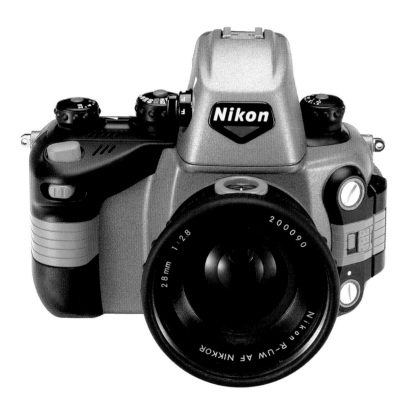

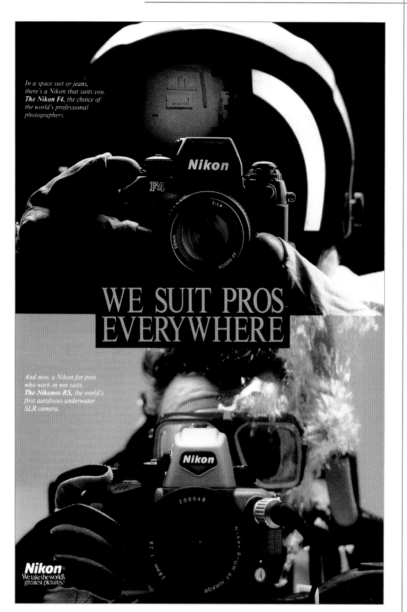

FAR LEFT: The Nikonos RS was a magnificent creation made possible by Japan's booming economy: had the financial outlook not been so healthy, one has to wonder whether the RS project would have ever developed into a production model. A highly desirable collectible nowadays, this example is mounted with one of the dedicated AF lenses – an R-UW 28mm version in this case.

The Nikonos RS

Making its debut at the DEMA Show in January 1992, development work on the Nikonos RS had actually started in the late 1980s. Introduced on the marketplace in June 1992, the Nikonos RS was a truly remarkable camera, breaking new ground in being able to use leading-edge AF and AE technology at depths of up to 100m underwater. Combined with one of the magnificent dedicated lenses on offer and the advanced SB-104 Speedlight that was released at the same time as the new camera, the owner could readily lay claim to being king of the waves.

For a few years only, the RS ran alongside the Nikonos V viewfinder model, rated to a depth of 50m. In fact, at ¥67,000 the V offered exceptional value, as there were few cameras that were truly weatherproof, let alone waterproof much beyond paddling depth. Even then, this type of camera was usually in the region of ¥30,000 or more, and was often more like a fancy pocket camera than a professional tool.

The RS was certainly not cheap at ¥390,000: that was ultimately to be its downfall since, while the V soldiered on into the new millennium, the RS was discontinued in 1996. No-one could argue that the RS wasn't worth the money, with its autofocus system, matrix metering, programme exposure modes, built-in motor drive and advanced TTL flash control, but few were in a position to justify the outlay, especially as new lenses had to be bought, too. Three AF lenses were available initially, a 28mm, a 50mm Micro and a

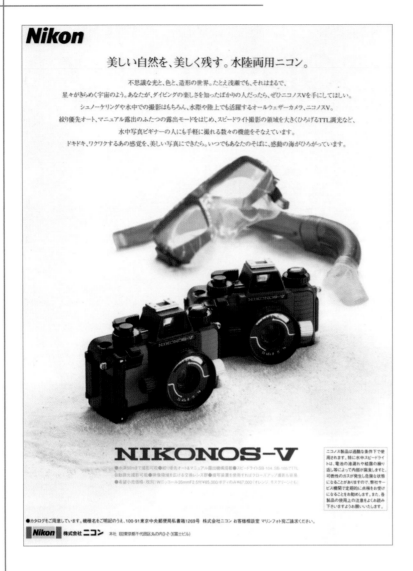

20–35mm zoom. These were joined by a 13mm AF lens a couple of years later, but even the cheapest was ¥98,000. The RS will stand as an outstanding example of Nikon technology, and a brilliant reminder of 'Bubble Time' in Japan, when the country's booming economy made anything possible.

A New Generation of AF SLRs

The F90 (or N90 in the USA) kicked off a new generation of Nikon autofocus SLRs. Launched in September 1992, it featured advanced AF and metering systems based on previous experience, with highly accurate automatic exposure settings possible when using the latest D-type Nikkors, which are described on the next page.

The AF module was the CAM 246 unit, which was faster and far more accurate than its predecessors, and allowed spot autofocus, too, for capturing those difficult subjects that would have confused earlier systems. With the hardware and software changes applied to the F90, this latest AF set-up was around a third faster than that of any previous regular autofocus model.

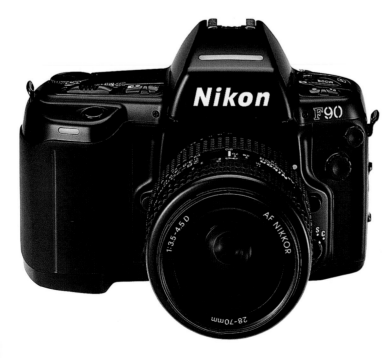

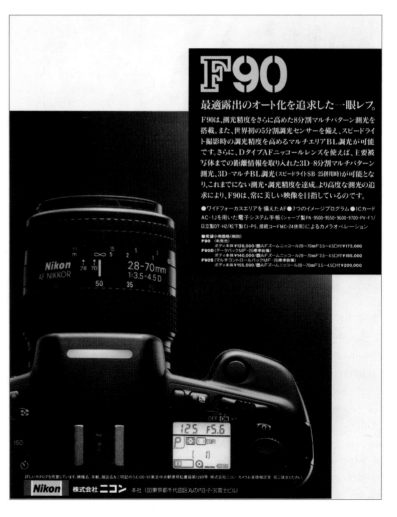

New 3D Matrix metering was adopted (using eight segments instead of the AMP's five), augmenting the camera's traditional centre-weighted and spot metering. The F90 also had various settings for typical photography situations, such as landscapes, portraits and sport, to give the best balance between lens aperture and shutter speeds: this so-called Vari-Programme took the 'P' mode to another dimension.

Top plate controls were like those of the F-601 and F-801, with the body design clearly influenced by the latter. Like the F-801, the F90 did not have a built-in flash, but the flash control system – especially when combined with the new SB-25 and the latest Nikkor lenses – was extremely advanced, using a five-segment TTL Multisensor, and incorporating red-eye reduction technology.

With a top shutter speed of 1/8,000th of a second and up to 3.6 frames per second performance from the integrated motor drive, the F90 was the perfect second body for professionals and had the advantage of being able to plug into the contemporary Sharp Organizer to download and record data. It was the first Nikon to feature this facility.

While Canon had adopted a motor in its AF lenses from the start of the autofocus era, Nikon preferred to take drive from the camera body instead. The exception to this rule was the AF-I range, which featured coreless motors in the lenses themselves. They could be used manually, but the AF only worked with modern bodies.

September 1992 also saw the introduction of the ML-3 remote control unit. Due to its shorter range than the ML-2, it was much cheaper, at only ¥18,000, but most enthusiasts preferred to invest in the SB-25 Speedlight. Priced at ¥48,000, the SB-25 flash was the replacement for the SB-24 and was perfectly matched to the F90 and AF-D series lenses.

The tail end of 1992 witnessed the launch of the Canon EOS5 and Minolta 9xi, giving the F90 some tough competition. Nikon would ultimately respond with the F90X, only to find a new threat in the Pentax Z-1P. It was an era of fast and furious development throughout the Japanese industry.

On the pocket camera front, early 1993 brought the Zoom 100, a stylish facelift of the TW Zoom 35-70 with a panorama feature, the extremely

Three F90s were made available: the strict F90 (priced at ¥128,000), the F90D with the basic MF-25 databack (¥140,000) and the ¥155,000 F90S, which came with the MF-26 multi-control back. Both backs could be bought as accessories, priced at ¥15,000 and ¥30,000, respectively.

Many of the F90's advances in technology were made possible through the new D-type Nikkors, which used their CPU to pass on focusing distances to the camera body for more accurate exposure calculations. Five D-type lenses were launched in the same month as the F90, with two telephotos and three zooms being the first to appear. The three zooms covered the popular lengths of 28–70mm, 35–70mm and 80–200mm, but only the 28–70mm version was priced to sell in volume, the other two having fairly exotic price tags to match their specifications. Even then they were quite cheap compared to the two first D-type telephoto Nikkors.

LEFT: **The Nikon Zoom 100 – a facelift of the TW Zoom 35-70 model.**

FAR LEFT: **The AF600, which was available in silver, grey or black.**

LEFT: **The Nikon AF200 from spring 1993.**

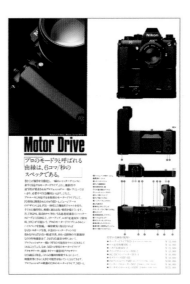

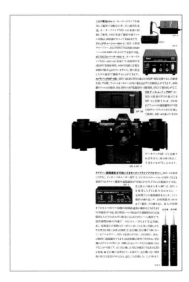

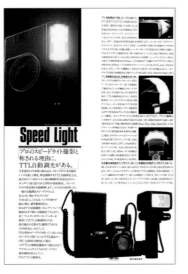

compact AF600 (available in silver, grey or black) and the cheap and cheerful AF200 and EF100 models, the last of which cost only ¥12,000!

Shigeo Ono, designer of the Nikomat series and the award-winning Nikon FA, was appointed Nikon's President in 1993 (becoming Chairman in 1997). Ono had grown up close to the factory and, as a boy, used to play with scrap lenses thrown out by the works. Given this kind of background, it was fairly inevitable that he would find a career with Nippon Kogaku, although his rise through the ranks would have been hard to imagine during his childhood.

CPUs and Exotic Metals: 1993–94

During 1993 two teleconverters and nine more AF-D Nikkors were released. It was a mixed bag of lenses, with three zooms, three Micro-Nikkors, a fisheye, a wide-angle variant and a 105mm DC lens. In the following year, seven more AF-D models were issued, including a zoom, a couple of telephotos and four more wide-angle lenses. Another two AF-I telephotos (400mm and 500mm versions) also came out during the latter half of 1994, joining a massive Ai-P zoom that shocked the world when it went on sale that January. This was the 16kg 1,200–1,700mm zoom, which, at ¥6,000,000, deserves the title of the most expensive lens ever built for the 35mm SLR system!

Meanwhile, the F3 Limited made its debut in October 1993. Restricted to 2,000 units and the Japanese market only, the F3 Limited was basically an F3P for the public, priced at ¥165,000. In addition to the special 'F3 Limited' marking on the front of these cameras, they were also given a batch of special body numbers starting on L 9500001.

Compact camera development was starting to head in the direction many enthusiasts feared, with competitive pricing being judged a necessary factor

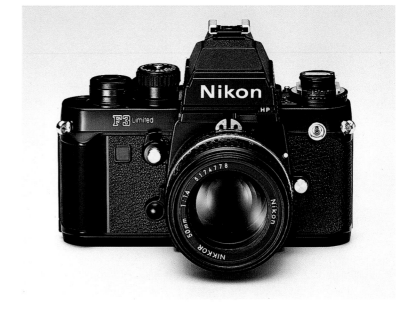

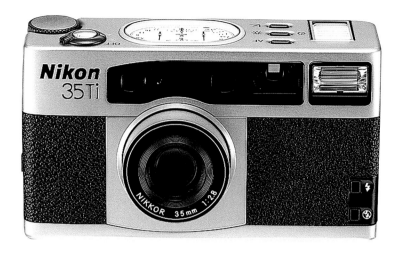

The Nikon 35Ti – the camera that brought desirability
to the line of compact 35mm models. The 'Ti' in
the model designation stood for titanium.

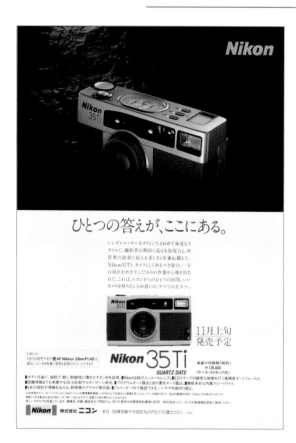

to capture market share, regardless of what that meant in terms of quality. Then, two months after the release of the F3 Limited and as if to silence the critics, the company brought out the 35Ti – 'Ti' standing for titanium, which is what most of the body panels were made in.

The 35Ti was truly worthy of the Nikon name, with a fixed 35mm f/2.8 lens made with ED glass, and a metal lens cover built into the camera. It had an advanced autofocus system (with a manual override facility), and centre-weighted or matrix metering to give programme ('P') or aperture priority ('A') type AE. The unusual display on the top plate gave information on focus distance, the aperture setting and exposure compensation details (along with a frame counter) in a manner that would make many a watchmaker proud. The 35Ti came with a built-in flash, databack and panorama mode setting, and while the top shutter speed was only 1/500th of a second, it was a jewel nonetheless, enabling enthusiasts to keep the faith. Body numbers started on 5000001.

More titanium was present in the FM2/T of December 1993 vintage. This exotic, lightweight metal was used for the top and bottom plates, and the prism cover. Otherwise, apart from its new designation on the front and a special batch of body numbers (starting on T 9000001), it was much the same as the regular New FM2.

Shortly after the FM2/T's release came the 'Year of the Dog' (1994) model, limited to just 3,001 cameras, with a dog's head engraved next to the FM2/T designation on the front of the camera. The box carried only a sticker to differentiate it from the catalogue version, and the body used standard serial numbers.

The Zoom 300 was heralded as the world's smallest compact zoom camera at the time of its launch in February 1994. The Zoom 700 VR was released not long after, using vibration reduction technology – the same principle as

ABOVE MIDDLE: Japanese advertising for the 35Ti, showing the camera's unusual top plate arrangement.

ABOVE: The New FM2 catalogue from the same period.

LEFT: The FM2/T featured titanium body parts, and while the weight difference was only 25g, there could be no denying the additional strength this exotic material brought with it.

that employed on certain expensive SLR lenses, using motion sensors to send a signal to two tiny motors that powered a lens stabilizing system. It was perhaps all the more impressive coming in such a small package.

nikkor club 146 AUTUMN 1993

FAR LEFT: Japanese advertising heralding the arrival of the FM2/T, or New FM2/T, to be totally accurate.

LEFT: Cover from the autumn 1993 edition of *Nikkor Club*.

ABOVE: The Nikon Zoom 300, or Lite-Touch Zoom.

BELOW: AF-D Nikkor lenses from autumn 1993, including the 105mm DC model, the 200mm Micro-Nikkor, the 400mm AF-I variant, the 16mm fisheye, the f/1.4 28mm wide angle (although, like the 400mm lens, it took some time to reach the marketplace), the 20–35mm zoom and the 35–80mm zoom.

※表示の価格は希望小売価格（税別）です。

▲AF　DCニッコール105mmF2D
¥120,000〈9月25日発売〉
DC（デフォーカス・イメージ・コントロール）機能により、主要被写体の前方あるいは後方のボケ味を調整することが可能です。これに加え、円形に近い絞りを採用するなど、ポートレート撮影に最適な中望遠レンズです。またリア・フォーカス方式の採用で、AF時にもすばやいピント合わせが可能です。

▲AFマイクロニッコールED200mmF4D（IF）
価格未定〈近日発売予定〉
素材にEDガラス（特殊低分散ガラス）を2枚使用し、無限遠から撮影倍率等倍まで撮影できる高性能AFマイクロレンズです。等倍時の撮影距離は、約0.5mで、その場合でも、ワーキングディスタンス（レンズ先端から被写体までの距離）は約0.26mとることができます。

▲AF-IニッコールED400mmF2.8D（IF）
価格未定〈近日発売予定〉
EDガラス4枚を使用し光学性能に優れた超望遠レンズです。高トルクを発揮するモーターをレンズに内蔵しており、F90並びにF4と組み合わせて使用した場合には、高速かつ高精度のオートフォーカスが可能です。（F90、F4以外のカメラと組み合わせの場合には、マニュアルフォーカスでの使用になります。）

▲AFフィッシュアイニッコール16mmF2.8D
¥95,000〈11月3日新発売〉
オートフォーカスが可能な、対角線画角180°の魚眼レンズです。新光学系を採用し、近距離補正方式を採ることによって、無限遠から至近まで優れた光学性能を発揮します。

▲AFニッコール28mmF1.4D
¥220,000. '94年春／発売予定
非球面レンズを採用した、明るく光学性能に大変優れた大口径レンズです。コマ収差およびフレアーが良好に補正され、開放絞りから歪やにじみの少ない点像が得られるため、夜景撮影等に特に威力を発揮します。

▲AFズームニッコール20〜35mmF2.8D
¥210,000〈11月3日新発売〉
非球面レンズ採用により、光学性能に優れ、軽量、コンパクトな大口径広角ズームレンズです。焦点距離は超広角20mmから広角35mmをカバーし、開放F値もF2.8と大変明るいレンズです。また、インナー・フォーカス方式の採用により、オートフォーカスの高速化と同時に、撮影距離による画質の変化を極力抑えています。

▲AFズームニッコール35〜80mmF4〜5.6D
¥28,000〈8月7日発売〉
非球面レンズの採用により、コンパクトにまとまり、携帯性・描写性に優れたDタイプ標準ズームレンズです。

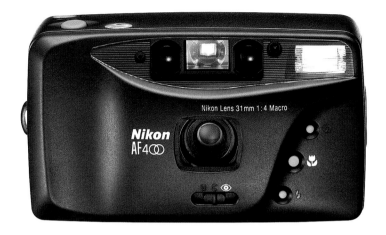

FAR LEFT: **The Zoom 700 VR with its vibration reduction technology. It was called the Zoom-Touch 105VR in the USA.**

LEFT: **Nikon AF400.**

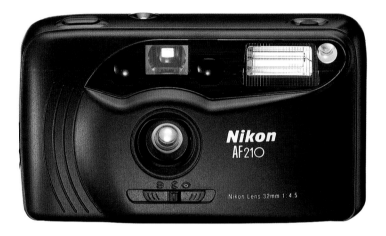

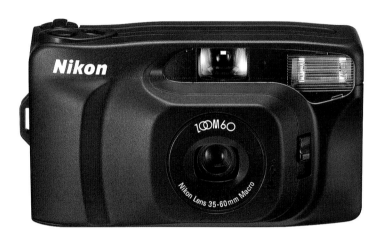

FAR LEFT: **Nikon AF210.**

LEFT: **The original Nikon Zoom 60, which was quickly updated to Zoom 60S spec. This camera, the AF400 and the AF210 were not sold on the domestic market – they were made for export only.**

April 1994 marked the debut of the somewhat more mundane F50 and F50D (known in America as the N50 and N50QD). This was basically an easy-to-use replacement for the F-401, with the Vari-Programme system from the F90, but split into 'simple' and 'advanced' modes for the F50 (the switch being located by the power button on the revised top plate). As such, in addition to the regular 'S', 'A' and 'M' modes, 'P' was made up of simple programmes for snapshots, with advanced settings catering for the needs of enthusiastic amateurs. The six-segment 3D Matrix metering was able to take full advantage of D-type Nikkors, while the autofocus system employed the AM200 AF module. Although the built-in MD was rated at only 1fps, at least there was an auto rewind feature once

the user reached the end of a roll, and the pop-up flash now came with a single release to speed up handling.

After the impressive Zoom 700 VR compact, it is hard to believe that Nikon released the AF400 (a lightweight camera with basic functions) and the low-budget AF210 and Zoom 60 in the pocket camera sector, but the release of new models (both compact and in the SLR category) was relentless during this period, and one had to accept that some of the cheaper models were simply reactions to market forces that helped fund the development of 'the good stuff', such as the 28Ti.

The 28Ti was introduced at the 1994 Photokina, featuring a 28mm lens instead of the 35Ti's 35mm one. The natural titanium finish of the

FAR LEFT: **Contemporary Canon advertising, this piece coming from Italy.**

RIGHT: The Nikon F50 mounted with a 35–80mm zoom.

FAR RIGHT: The Nikon 28Ti was introduced as a companion model for the 35Ti. However, while the 35Ti had a natural titanium finish, the 28Ti was always supplied in black. One can see the top plate controls and indicators were very similar to those of the earlier model.

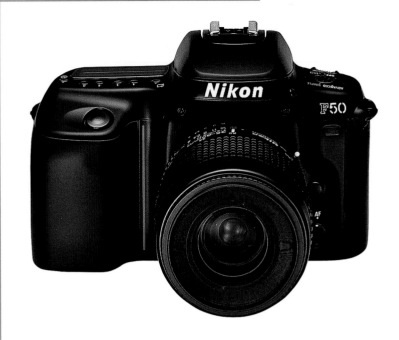

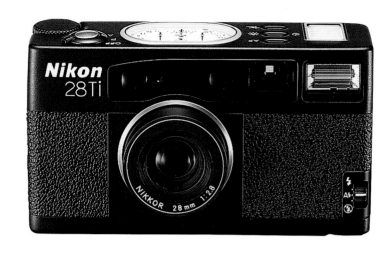

RIGHT: Advertising for the N50 – the American name for the F50.

FAR RIGHT: Domestic advertising for the 28Ti. The titanium models were far from cheap – indeed, one could have bought a collection of the regular pocket cameras for the same money as a single Ti.

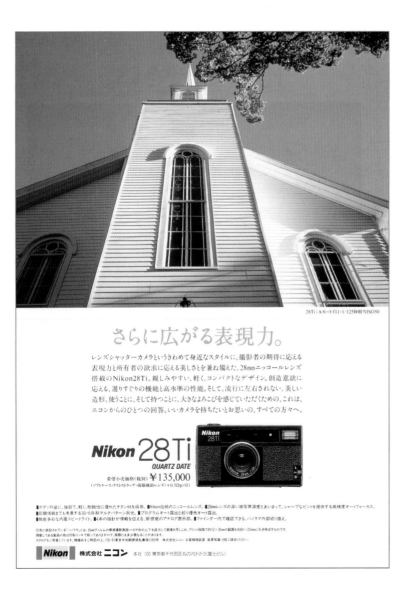

35Ti was rejected in favour of black for the 28Ti, which benefited from the enhanced flash controls found on the late 35Ti models. Otherwise, it was much the same as its predecessor, which continued to be sold alongside the newcomer. Serial numbers started on 5000001.

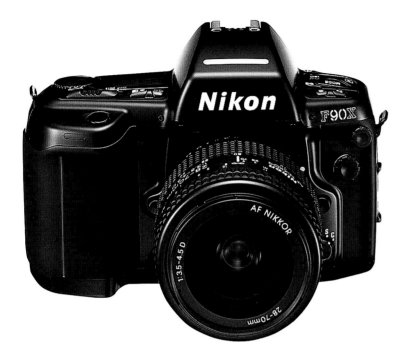

An F90 Upgrade

The F90 had been introduced as a second body for F4 users, but technology was moving fast and in October 1994 it received a number of upgrades, giving rise to the fabled F90X (or N90S). In fact, as with the strict F90, there were three versions: the regular F90 (with no databack), the F90XD (with the MF-25) and the F90XS, which came with the MF-26 back.

The F90X's AF system was much faster due to a new CPU and coreless motor lens drive mechanism, while new software allowed the camera to lock on to subjects quicker. As well as having more control over shutter speeds, it was endowed with an outrageously high-speed MD for the time, rated at 4.3 frames per second, and better sealing against the elements and dust.

The ¥18,000 MB-10 battery pack was new (with a second shutter release button – ideal for portrait shots), as were the MS-10 and MS-11

BELOW LEFT: Contemporary Kodak advertising.

BELOW: Japanese advertising for the F90X, proclaiming the model's many awards. Note the new MB-10 battery pack.

FAR LEFT: The F90X (or N90S) was a well-timed upgrade of the Nikon F90. As the perfect second body for the F4, the F90X earned the respect of many users, both from a professional background and enthusiastic amateurs.

BELOW: The three F90X variants seen from the rear, plus an F90X with the MB-10 power pack and SB-28 flash (the latter being introduced at the end of 1997).

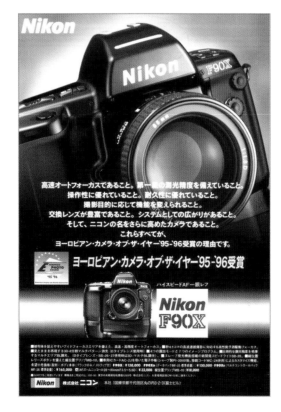

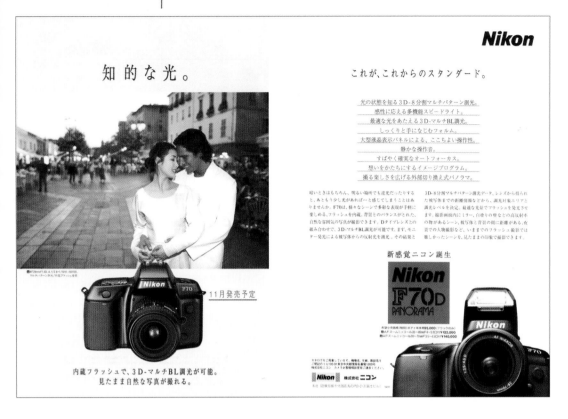

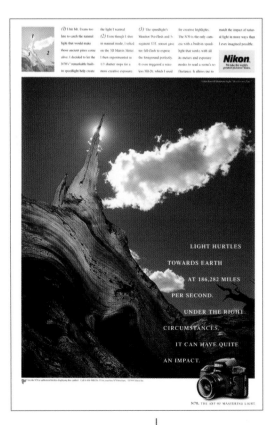

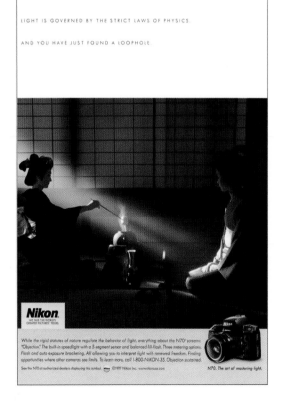

ABOVE: **Contemporary advertising for the F70, sold in F70D (quartz date) guise only in Japan.**
BELOW: **Two pieces of American advertising for the N70 – the US market's name for the F70.**

battery cases. The ¥19,000 AC-2 IC card was also listed for the F90X (the AC-1 continued for the F-801 series), allowing information to be downloaded to a Sharp Organizer. But perhaps the most important accessory was the SB-26 Speedlight. This was much the same as the SB-25, in reality, but with additional features that made it the perfect match for the latest body. Launched in October 1994, it was priced at ¥50,000. About a year later Nikon released the ¥32,000 SB-27, a compact version of the contemporary, high-tech AF flash units.

A month after the F90X made it to the marketplace, the F70 (or N70) was issued as a replacement for the F-601. It had styling similar to that of the F50, but with a new top plate design that included a large modern colour LCD information screen. Like the F90 series, the F70 came with 'P',

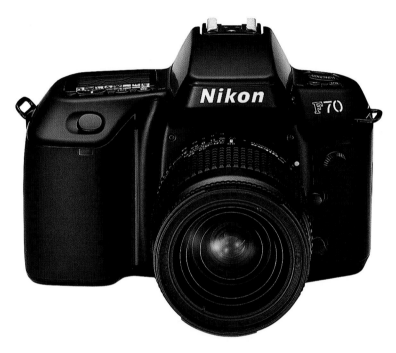

The Nikon F70, introduced to slot in between the F50 and F90 series.

'S', 'A' and 'M' modes, and Vari-Programme to control the camera's eight-segment matrix, spot and centre-weighted metering; it also accepted three custom settings. As well as advanced TTL flash control for the pop-up Speedlight, the built-in MD was capable of winding on film at speeds of up to 3.7 frames per second (although there were also single-shot and 2fps modes), and there was a switchable panorama setting with the data-back of the F70D/N70QD.

As for pocket cameras, the Zoom 60 (a simple zoom for snapshots) was upgraded to Zoom 60S specification, while the Zoom 310 was a lightweight

RIGHT: **Japanese advertising for the Zoom 310 and Zoom 500.**

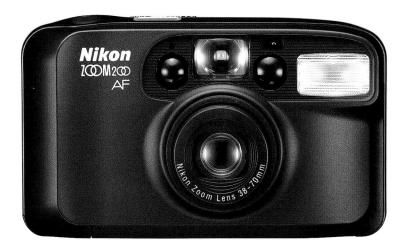

Nikon Zoom 200.

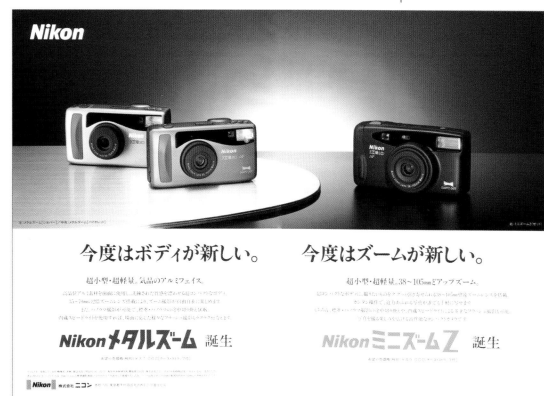

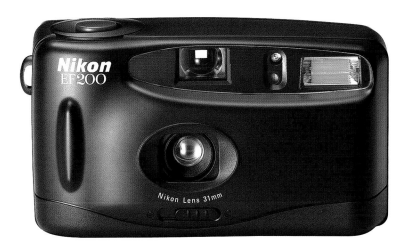

The EF200 was brought out with the AF220. Both budget models were made for export only.

contender in the popular 35–70mm category and could be ordered in silver or grey. The Zoom 500 was extremely compact considering its 38–105mm zoom lens and, like the 310, was available in standard or QD guise. The Zoom 200, an attractive and well-equipped zoom with a 38–70mm lens, was launched during the same period, as was the EF200 (a facelifted version of the bargain basement EF100); the AF220, the next step up from the EF200, followed a few months later.

Nikon bags and carrying cases from the mid-1990s.

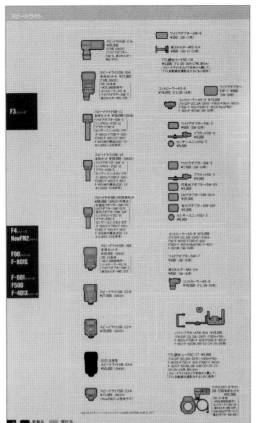

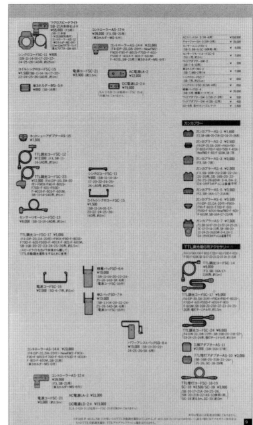

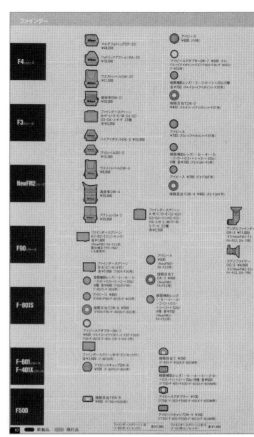

RIGHT: A compatibility chart from 1995. The current charts are a shadow of their former selves, with even the 'Pro' body SLRs having very few optional extras.

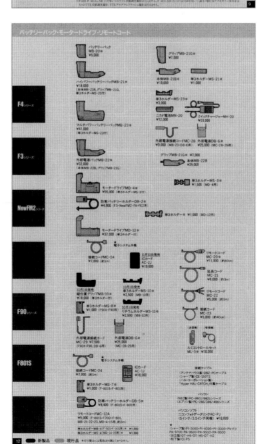

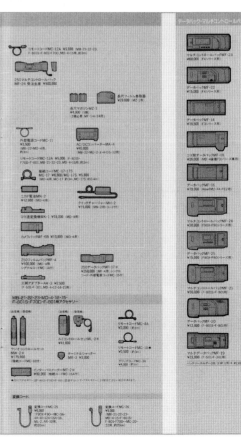

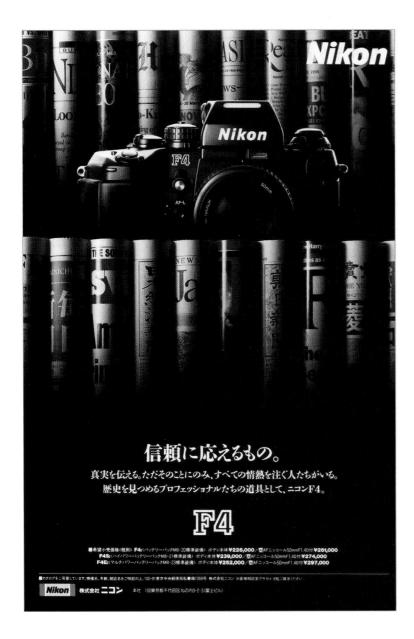

信頼に応えるもの。

真実を伝える。ただそのことにのみ、すべての情熱を注ぐ人たちがいる。
歴史を見つめるプロフェッショナルたちの道具として、ニコンF4。

F4

■希望小売価格〈税別〉 **F4**:〈バッテリーパックMB-20標準装備〉 ボディ本体 **¥226,000**／圜AFニッコール50mmF1.4D付 **¥261,000**
　　　　　　　　　F4S:〈ハイパワーバッテリーパックMB-21標準装備〉 ボディ本体 **¥239,000**／圜AFニッコール50mmF1.4D付 **¥274,000**
　　　　　　　　　F4E:〈マルチパワーバッテリーパックMB-23標準装備〉 ボディ本体 **¥262,000**／圜AFニッコール50mmF1.4D付 **¥297,000**

■カタログをご用意しています。機種名、年齢、雑誌名をご明記の上、100-91東京中央郵便局私書箱第1269号 株式会社ニコン ﾆｺﾝ情報相談室ｱｶﾒ宛 8枚にて請求ください。

Nikon 株式会社ニコン 本社 100東京都千代田区丸の内3-2-3〈富士ビル〉

moving up the price list could give almost anyone the kind of pictures that professionals would have struggled to create just a couple of decades earlier. There was, however, a growing band of enthusiasts who craved manual controls in an up-to-date package, spurred on by the 'retro boom' that was in full swing in Japan at the time.

The design brief had called for a simple, easy-to-use, rugged and reliable camera that offered good value for money, and the Nikon FM10 answered the criteria perfectly. After making its debut at the end of 1995, the FM10 finally went on sale in May 1996, at first in Asia before spreading to the other continents.

At just 420g the FM10 was extremely light, partly due to materials and partly due to the lack of certain features, such as matrix metering, TTL flash control, an MD drive or PC flash socket, and a DX code reading facility (although the window in the back allowing the film type to be seen was a useful asset). Even the databack option was not available; the FM10 was indeed very simple.

FAR LEFT: **F4 advertising from August 1995. The F3 was still being sold alongside the flagship model, and would actually outlast its younger brother.**

BELOW LEFT: **The Nikon F4 in space. This picture shows an astronaut changing film on the flight deck of the Space Shuttle *Columbia* at the end of 1995.** COURTESY NASA ARCHIVES

ABOVE: **The Nikon FM10 with its dedicated 35–70mm zoom, case and strap.**

Meanwhile, another batch of AF-D Nikkors was released for the SLR cameras. Fast 35mm, 50mm and 85mm lenses, as well as a 135mm DC model, were introduced in 1995. Four zooms were added to the line-up, too, although the 35–80mm version was actually an upgrade of an earlier lens, as was the 80–200mm Nikkor of 1996.

Simplicity Reigns

Over the years cameras had become more and more simple to use. Even SLRs had been slowly but surely reduced to 'point and shoot' cameras, but modern electronics ensured fairly good results nonetheless, and

That said, it had everything required by an enthusiast, such as a 1/2,000th of a second top shutter speed (with flash synch set at 1/125th of a second), and a hotshoe on the prism head. It also had a self-timer, depth of field preview button, and a multiple exposure switch under the film advance lever. As with some older Nikons, the wind-on lever acted as a power switch for the TTL meter (simple exposure indicators were provided in the viewfinder), and the film speed was set manually in the shutter speed dial. It was usually supplied with a dedicated 35–70mm f/3.5–4.8 zoom, although it could be bought as a body only in Japan.

Nuvis cameras were the first in the Nikon line to make use of the APS (Advanced Photo System) film cassette, a more successful evolution of the ill-fated disc concept, using a package closer to traditional 135 film, with far superior storage and reprint characteristics. An 'i' following the

RIGHT: Japanese advertising announcing the arrival of the first Nuvis models, designed to accept the APS film cartridge.

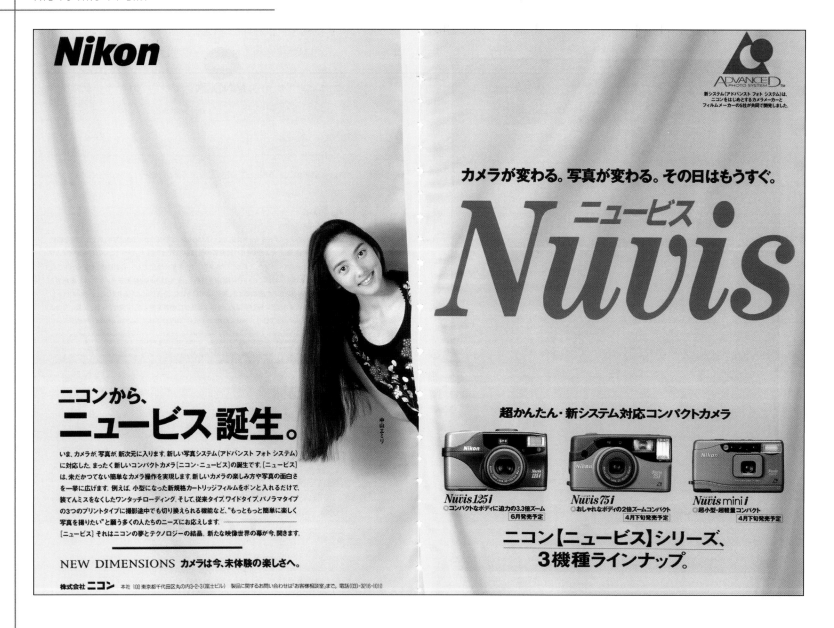

FAR RIGHT: The Nuvis 60, which was not sold in Japan. Note the small triangle and circle logo, which signifies a camera's compatibility with the APS system.

camera designation meant the camera could record data on the film, which could then be printed on the back of a print, which is a better way of noting a date and time than on the image itself. Also there was usually a choice between picture format: wide, panorama or standard 35mm.

Three Nuvis cameras were launched initially: the Mini, the 75 and the 125. The Nuvis Mini was a tiny camera with a fixed three-element 25mm lens (one has to remember that a Nuvis 25mm lens represents 31mm in 35mm SLR photography, and 30mm is heading towards 40mm), while the Nuvis 125 was the flagship model with remote control and an eleven-element 30–100mm zoom lens. The Nuvis 75 covered the middle ground, being similar to the 125, but with a five-element 30–60mm lens and a less powerful flash. There was also a Nuvis 60 released early on, made for export only, and equipped with a 25–50mm lens.

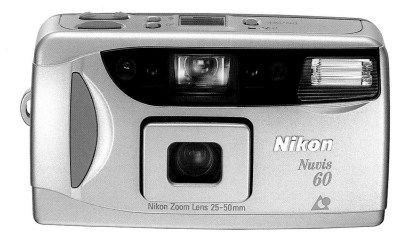

The End of Another Era

1996 will be remembered for the launch of the F5 (F4 production finished as soon as the F5 was introduced), but there was also a new F3 model launched at that time, the F3H. Issued to accredited press members only, the 1,280g F3H had an F3P head and a similar specification to the F2H, with a fixed mirror. This was to allow the MD-4H motor drive to perform. Capable of firing off an amazing 13 frames per second, it was probably the fastest rate in history, and unlikely to be beaten now that development is concentrated on digital cameras. Priced at ¥480,000, less than 500 were made, all with special body numbers starting on H 9600001.

Incredibly, as well as a whole host of basic MF models, 1996 still boasted a full line of Japanese manual 'Pro' SLR bodies for the discerning photographer. Of course, the Nikon F3 was one of them, augmented by models like the Contax ST and RTS, the Canon F-1, Pentax LX, and

Olympus OM-3Ti and OM-4Ti. Interestingly all were around the ¥200,000 mark, except for the Contax RTS at ¥350,000, proving that, no matter what mainstream society opts for, there will always be connoisseurs who appreciate these things. I remember Porsche's Helmuth Bott once saying in an interview: 'You can buy a quartz wristwatch for

Selected pages from the domestic F4 catalogue of 1996. Ultimately 360,000 F4s were made before the production lines were cleared to make way for the F5.

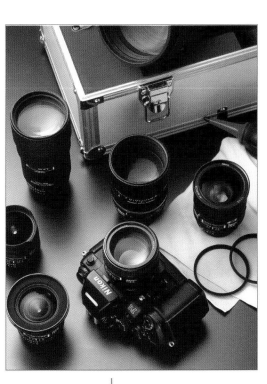

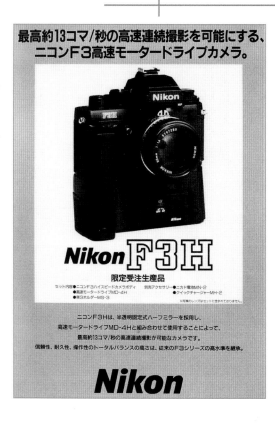

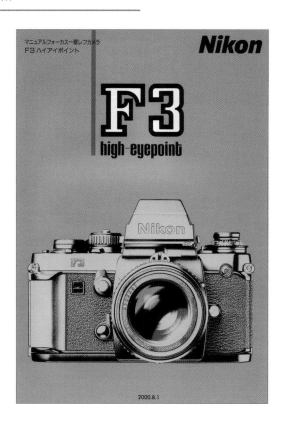

$5 nowadays, but still there are people who prefer to spend thousands on a Patek.' In other words, pricing only matters up to a point: it is perceived value and quality that counts for more at the top end of the market. The car, watch and camera worlds regularly seem to run in parallel in so many respects.

The last F3 catalogue was issued in August 2000 and featured only the F3 HP. Time finally ran out for even this model in October 2000, when the last batch of 4,000 units was completed.

FAR LEFT: Promotional material for the rare and exotic F3H.

LEFT: The final F3 catalogue, signifying the end of an era. No fewer than 790,000 F3s had been sold by the time production ended in October 2000.

BELOW: Selected pages from the 1999 F3 catalogue, which still featured the F3, the F3 HP and F3/T. The finders, motor drive (plus the MK-1 attachment) and flash unit were all familiar, as they had been around for almost two decades. The flash was the newest item on display, and even that had been introduced in June 1983.

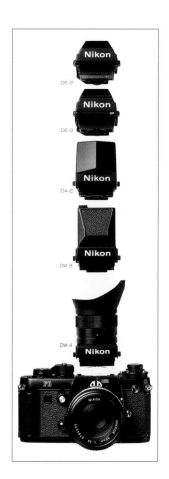

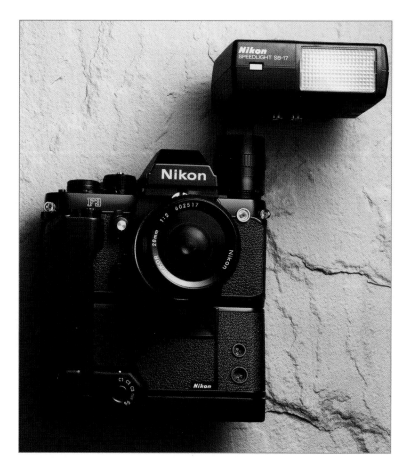

NEW F MODELS AND THE DIGITAL REVOLUTION

WHILE LEICA TRIED TO STAY in touch with the Japanese makers via the distinctive R8 of 1996, which provided the basis for the R9 introduced six years later, it was the Canon EOS-1N that provided the main threat to the Nikon F4, brought to market in November 1994 at a very similar price (between ¥215,000 and ¥265,000, depending on the specification). By that time the F4 was already a veteran in today's terms, the shelf life of electronic SLRs being far shorter than their mechanical counterparts, even in the upper echelons of the category – but Nikon already had a new 'Pro' body waiting in the wings.

The Fifth-Generation F

Making its public debut at the 1996 Photokina (held in Cologne in late September), the F5 went on sale in October 1996, the body only being priced at ¥325,000. The F5 project was led by Tetsuro Goto, with the Giugiaro studio looking after the styling, giving the camera a definite family look.

The F5 was the fastest autofocus camera in the world at that time, with a high-speed AF tracking system housed within the cast aluminium alloy body. There was also a new 3D colour-sensitive light meter, with five different metering fields. Modern sealing techniques were adopted, based on experience gained through the Nikonos system. While it was possible to fit virtually all Nikkor lenses, due to the continuation of the legendary F mount, the F5 was undoubtedly at its best when mounted with the latest Nikkors.

The F5 was much the same as the F4E in physical size, and came with two shutter releases: one in the regular position, and one on the base for when the camera was tilted on its side for portrait shots. The reason for the F5's bulk was its internal MD and power pack that combined to give seven frames per second performance, rising to eight frames per second by replacing the standard MS-30 battery pack with the optional MN-30 unit (priced at ¥16,000). There can be no denying that the F5's reliance on battery power made the provision of a manual rewind crank to back up motorized rewind a useful feature on longer shoots away from the studio.

While many complained about the weight, one has to remember that, as a 'Pro' body, it was expected that a heavy duty power pack would be fitted by most users, although it is interesting to note that the F6 has returned to a compact standard package in a bid to recapture the hearts

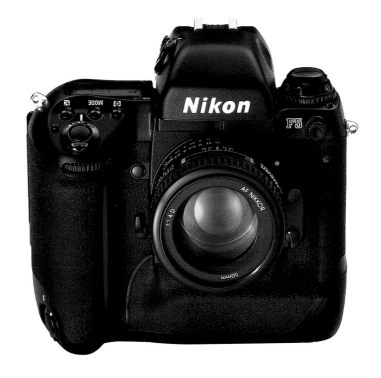

ABOVE: **One of many design proposals for the Nikon F5.**

ABOVE LEFT: **An F5 prototype machined from a solid lump of plastic. These full-size mock-ups, complete with a proper F mount to enable lenses to be fitted, allow ergonomics to be checked and help determine the final design.**

LEFT: **The Nikon F5 production model, built at Nikon's Sendai plant.** *Popular Photography* **described the F5 as 'simply the quickest shooting, most advanced safety-loaded Pro AF SLR ever.'**

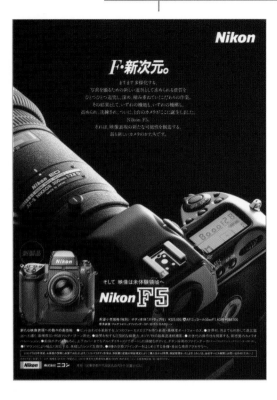

ABOVE: **Early Japanese advertising for the F5 showing top plate detail, as well as a view of the high-quality 300mm AF-S Nikkor.**

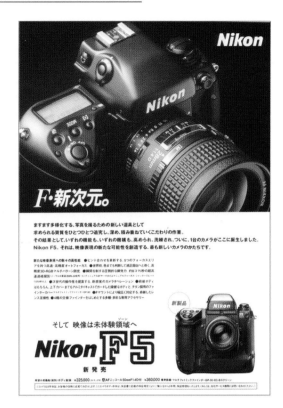

ABOVE: **Another of the early adverts, featuring an F5 mounted with a contemporary 28mm f/1.4 Nikkor on this occasion.**

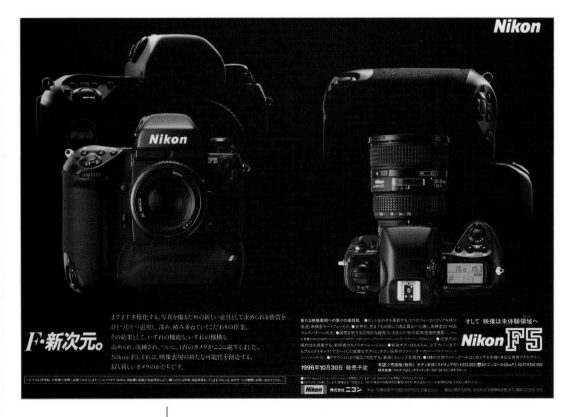

A third and final F5 advert from the time of its announcement. Details include the second shutter release button on the base of the camera, and a nice study of the fast 20–35mm zoom.

of well-heeled enthusiastic amateurs, with additional power packs available for professionals.

As well as two shutter releases, two control dials were present (one up front, and one at the rear), a feature carried over to other Nikons that followed. This allowed for quick and easy adjustment of settings, including the lens aperture. Exposure and film advance modes were much the same as those on the F4, as was the focus selection switch. A custom settings mode, however, allowed personal preferences to be registered and remembered for specific applications.

The light meter judged brightness, contrast and colour via a 1,005-pixel RGB sensitive CCD (Charge Coupled Device), and when used with later AF-D, AF-I, AF-S and AF-G lenses the focusing details and aperture setting were also taken into account. After calculating all the factors involved, a powerful micro-computer then chose one of 30,000 exposure settings. Matrix metering was the norm, augmented by centre-weighted and spot metering, all selected by a switch on the titanium prism head.

The AF system used the new Multi-CAM 1300-type sensor, allowing the camera to focus on one of five positions, clearly visible in the viewfinder or LCD screen on the top plate, while a lock-on facility allowed the focus to stay fixed despite objects moving in front of the camera. A green dot in the viewfinder indicated a good focus position, with red arrows either side indicating that some adjustment was required.

The double-bladed shutter curtains were made in a carbon-fibre type material and an aluminium alloy; the F5's shutter mechanism was good for at least 150,000 shots, as this was the number chosen for the camera's reliability test. That translates into well over 6,000 rolls of 36-exposure film! Top speed was 1/8,000th of a second, with flash synch listed at 1/300th of a second. Various TTL flash modes were incorporated into the design, including front curtain synch, rear curtain synch and slow synch. As well as exposure compensation of +/–5EV, the F5 also had auto exposure bracketing, and the facility to take multiple exposures. Noise and vibration reduction measures were taken on the shutter and mirror, with shutter speeds being monitored and automatically corrected if they strayed outside prescribed limits. The 'B' setting was electro-magnetically controlled, incidentally, and a mirror lock-up facility was included.

As one would expect with a camera of this ilk, there was a range of interchangeable focus screens (thirteen in all), along with a variety of heads to suit different applications, each coming with full 100 per cent image coverage. The standard head was the ¥55,000 DP-30 (an HP finder with dioptre correction, an ISO hotshoe and rear blind), and this was augmented by the ¥120,000 DA-30 action finder, the ¥27,000 DW-30 waist-level finder and the ¥45,000 DW-31 6× magnified waist-level finder.

A mass of information was displayed in the viewfinder, the LCD panel on the top plate, and another at the bottom of the camera back. More was provided when the standard back was replaced by the ¥20,000 MF-27 databack (for simple date/time details, etc.), or the ¥60,000 MF-28 multi-control back with its integrated intervalometer. A computer datalink facility was also provided.

A few F5s exist with modified switchgear for NPS members. Detail changes like larger, semi-exposed R1 buttons, heavier grip surfaces on the camera back, bigger AF-ON buttons and fewer locking mechanisms mark out the 'professional' versions.

The F5 was certainly an impressive camera, winning the 1997 Camera Grand Prix and numerous other prestigious awards. Indeed, in an *Asahi Camera* poll fifteen out of twenty judges gave the new Nikon the nod when naming the best buy in the 35mm SLR category; no other model managed to get more than one vote. In the background, however, a revolution was about to start in the world of photography – the digital revolution.

The Start of the Digital Era

The Nikon QV1000C was a real oddity, being termed a Still Video Camera. Sony had led the way in this field, but the early 1980s saw a rapid advance in all things electronic – one only has to look around the house or office and think back to when different pieces of equipment first became available. This technology (as always in Japan, it seems) was quickly developed to become smaller, faster and more efficient, allowing it to be used in different applications. In the case of a Still Video Camera, basically, instead of converting an image into a digital signal, it converted it into a black and white analogue recording.

Released in 1988 with 10–40mm f/1.4 and 11–120mm f/2 QV-Nikkor lenses (an adapter was available to mount regular Nikkors on the unique bayonet), the QV1000C SLR had a specification similar to the contemporary F4, except for the limited shutter speed range (1/8th to 1/2,000th of a second), although, admittedly, 35mm cameras still have a long way to go to catch up on the QV's rapid firing rate.

In summary, the QV1000C was an interesting experiment to help press members send photographs across the world quickly via a special transmission unit, but the print quality was not as good as it should have been with this system (especially some of the colour versions on sale at the time), and the Digital Still Camera would have an easy path to popularity.

The E2 series of SLR digital cameras carried the Fuji trademark alongside the Nikon one, as the two companies worked together on this project. Indeed, these two giants in the industry have continuously collaborated in this field: when Fuji introduced its own 'Pro' digital SLR body, for example, to compete with the contemporary Kodak (at a time when Nikon had brought out the D1), it used AF Nikkor lenses and Nikon Speedlights.

Introduced at the 1994 Photokina, the E2 (also known as the Fuji DS-505) was an elegant Digital Still Camera that accepted regular Nikkor lenses. Specifications were roughly in line with those of the F4, although the firing rate was only one image frame per second on this first digital model. The alternative was the E2S (Fuji DS-515), which was capable of taking three images per second. Output could be in either RS422 digital format, or in NTSC/PAL video guise.

ABOVE: **English-language version of the F5 catalogue.**

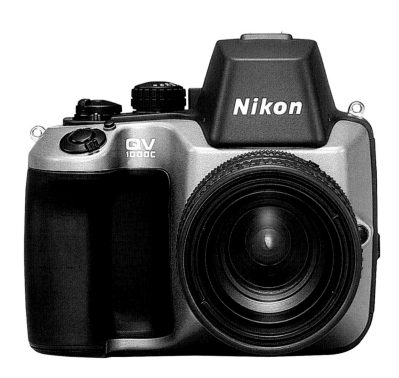

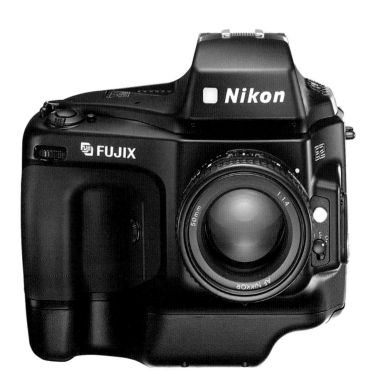

FAR LEFT: **Nikon QV1000C Still Video Camera.**

LEFT: **Nikon E2. The E2 and E2S looked the same apart from a small 'S' suffix after the E2 badge.**

At the end of 1995 the E2 cost ¥1,100,000, with the E2S ¥300,000 more. At the same time, the Kodak DCS system (first seen on the F3 HP and F801S) was mated to the Nikon F90 and Canon EOS-1N bodies, the Nikon option being outrageously expensive and making a compact AF SLR look more like an F3H. Minolta had a slightly more competitive outfit, but it was down to the likes of Casio to bring affordable new technology to the masses. Even then, ¥65,000 was the price of a nice AF 35mm or Nikon New FM2 body (and twice that of a Ricoh XR-8 or Yashica FX-3 Super), so there was still a way to go before we entered the current, almost disposable era of digital cameras.

Subtle improvements were outlined for the E2N, with an extended film speed range and enhanced flash. As before there was a Fuji version, the new model being identified by an 'A' suffix added to the existing moniker; the high-speed model was known as the E2NS. The final camera in this series was the E3 of 1998 vintage, which came with enhanced data transfer to a PC or printer, but the same maximum resolution of 1.3 million pixels. Once again, there was a Fuji model (the DS-560), and the faster E3S (known as the Fujix DS-565 in the Fuji line-up).

Coolpix for Every Pocket

Meanwhile the first of the Coolpix models had been launched, bringing compact dimensions and affordable prices to the Nikon digital camera line. The Coolpix 100 was incredibly small for the time, slotting straight into a PC card slot to download 330,000-pixel images direct to a computer after removing the handgrip. The 6.2mm f/4 lens was the equivalent to a 35mm normal, and despite the minute package the 100 featured AF, AE, a built-in flash and even a self-timer. The Coolpix 300 used the same lens as the 100, but its larger body contained a microphone for sound recordings, and a digital notepad and monitor. Surely, the ultimate gadget for gadget freaks!

RIGHT: Nikon E2N. As with the E2, the only visible difference between the E2N and E2NS was the small 'S' suffix after the model designation (the same is true of the E3/E3S combination that followed).

RIGHT: The Nikon E3, the last of the line that brought Nikon and Fuji technology together in the same package.

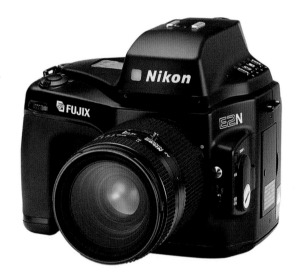

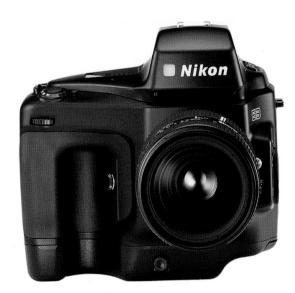

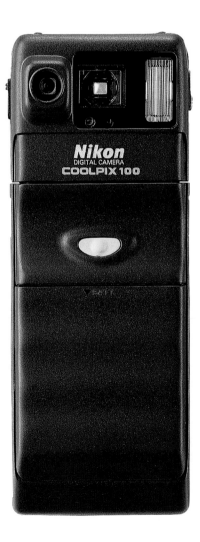

LEFT: The Coolpix 100, the first of Nikon's compact digital camera range.

ABOVE: Coolpix 300.

The Coolpix 900 was the first digital camera in the world to feature a 3× zoom, the 900's covering 5.8–17.4mm, which equates to 38–115mm on a 35mm SLR. Its unusual body, which was split in the middle (the lens and flash unit were in an upright position when not in use), played host to a more advanced AF system, enhanced three-mode metering, faster data transfer (allowing two shots per second) and a much higher image resolution of 1.3 million pixels. Shortly after, an improved version, known as the Coolpix 900S (or 910 in Japan), added a TTL flash connection for Nikon Speedlights, and used a single 8MB card instead of two 4MB items.

After the somewhat questionable styling of the 100 and 300, and the swivel head of the 900, the 210g Coolpix 600 was a very conservative but undeniably elegant design. Its fixed 5mm f/2.8 lens gave the equivalent of 36mm in traditional photography. Apart from the use of a Compact Flash card storing JPEG images at 800,000 pixels resolution, the other notable feature was its tiny dedicated Speedlight (the SB-E600), which plugged into the side of the body. When not in use, the 600 sat in the DS-60 docking station, allowing the charging of batteries and transfer of data. All very modern.

APS and 135 Hold on

The range of pocket film cameras was rapidly expanding in the meantime, with the budget Nuvis A20 and the Nuvis E10 (a lightweight sister model to the A20 with a strange front cover designed to appeal to a younger market) being joined by the Nuvis 110 (a fully featured model with striking styling that dropped in between the 75 and 125) and the flagship Nuvis 160, which covered 30–125mm with its zoom lens.

In addition to these APS models, a number of regular 35mm compact cameras were introduced during this period. There was, for example, the

FAR LEFT: **The Coolpix 900 with its unusual swivel head. It was quickly updated to 910 (or 900S) specification.**

FAR LEFT: **The elegant Coolpix 600 model.**

Polaroid instant cameras had been around in the 1960s, but didn't really become popular until the following decade. The Polaroid brand continues to this day, and a number of other makers have adopted similar systems in recent years, although digital cameras are rapidly overwhelming all types of film camera.

RIGHT: **Nikon Nuvis A20.**

FAR RIGHT: **The Nikon Nuvis E10, a sister camera for the A20 model.**

RIGHT: **The Nuvis 110i for the APS film system.**

FAR RIGHT: **Nikon Nuvis 160i.**

LEFT: **Contemporary film advertising from Fujifilm.**

AF230 (a classier version of the AF220 introduced at the 1996 Photokina alongside the EF300, which had the same body styling), the modern-looking Zoom 210 (a replacement for the Zoom 200 with a now-familiar metallic body colour) and the cheap and cheerful BF100. Moving up the ladder, there was the Zoom 800, Zoom 400 and Zoom 600 – all from the same family as the Zoom 210, with the zoom lens having a greater range the higher the number in the camera designation.

SLR Developments

Just after the compact 24–120mm AF-D zoom made its debut in October 1996, the first in a new line of Nikkors was put on the market. The AF-S lens was a development of the AF-I, incorporating a silent wave motor (SWM). These lenses were smaller, quicker to react and quieter in operation thanks to this SWM technology.

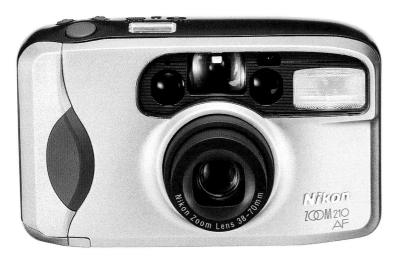

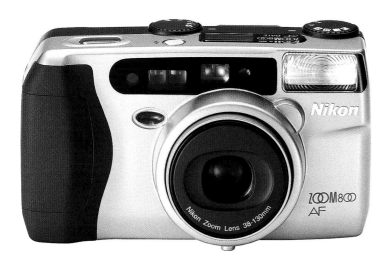

FAR LEFT: The AF230, designed for regular 135 film. There was a limited edition Michael Schumacher boxed set based on the AF230 sold in Germany, commemorating the driver's success in Formula 1.

LEFT: Nikon EF300.

FAR LEFT: The Nikon Zoom 210 was a more upmarket model in an era dominated by budget pocket cameras.

LEFT: The BF100, with its larger, brighter viewfinder arrangement.

FAR LEFT, BELOW: The Zoom 800, a flagship model in the Nikon compact camera range, but destined to be sold in export markets only.

LEFT: The Zoom 400, seen here in QD guise.

ABOVE: Nikon Zoom 600.

ABOVE: **A British advert from the time, promoting Nikon eyeglass lenses. This side of the Nikon business has steadily grown over the years.**

ABOVE RIGHT: **Domestic Nikkor lens advert from the end of 1997. The left-hand lens is a 24–120mm zoom, while the one on the right is a 70–180mm model.**

LEFT: **Body packing caps (with the basic Nikon version, plus those for the F4 and F5), rear lens caps, locking body caps, and front lens caps, with newer variations at the front. Various filters and lens hoods are shown at the rear. Lens hood designations make sense if you can speak Japanese. HS is easy enough (Hood with Spring fitting, sometimes referred to as a snap-on fitting), as are HB (Hood with Bayonet fitting) and HR (Hood in Rubber). After that, however, things get more complicated. HN stands for Hood with a *Neji komi* (screw thread) fitting, while HK means a Hood with a *Kabuse* (slip-on) fitting, usually secured with a locking screw.**

The first four AF-S Nikkors (introduced between November 1996 and June 1998) were basically replacements for the existing AF-I models, but later in 1998 there was an internal focus 80–200mm zoom incorporating the silent wave motor and ED glass. At ¥245,000, it was ¥90,000 more expensive than the AF-D version.

On the subject of AF-D lenses, a 70–180mm Micro-Nikkor was released in 1997, and three more zooms were issued in the following year: a 70–300mm zoom with ED glass, and two internal focus models (covering 28–105mm and 28–200mm).

A new lens-making process, which made traditionally expensive aspherical optics with plastic coated glass, reduced the cost of production dramatically, allowing a number of popular Nikkors to be introduced at a price much lower than one would expect. In addition, over the years, the NIC system was upgraded to the SC (Nikon Super Integrated Coating) system, giving even sharper images.

APS or Digital?

At the 1996 Photokina Nikon announced its first SLR to accept APS film – the Pronea 600i (or Pronea 6i in the USA). Going on sale at the end of the year, its organic shape made it instantly recognizable. It had a pop-up flash, and several metering modes to determine values for a full range of AE programmes that complemented a manual control option, and AF to go with MF operation. Like its compact brethren, the 'i' announced the fact that it was possible to transfer data to the film, and the three shooting formats were also carried over (wide, classic or panorama). It was endowed with a fast shooting rate, too, but its greatest advantage was the opportunity to fit a range of regular Nikkors to the F mount. However, owing to the different focal lengths on APS models when compared to regular 35mm SLRs, a dedicated range of IX-Nikkor lenses was also produced: a 20–60mm f/3.5–5.6 (equivalent to 25–75mm), a 24–70mm f/3.5–5.6 (equivalent to 30–87mm), and a 60–180mm f/4–5.6 (equivalent to 75–225mm). These were finished in black to suit the dark grey body of the 600i.

There was a digital version of the Pronea 600i as well, this being made possible by the Kodak DCS attachment, which fitted onto the base of the camera rather like a traditional MD set-up with a large battery pack. Introduced at the 1998 Photokina, this was the cheapest of the DCS variants, but would soon be outclassed by a new line of high spec, reasonably priced digital SLRs.

Meanwhile, spring 1997 saw the launch of the manual focus FE10, a sister model to the FM10 but with an automatic exposure function. Like the FM10, it was first sold in Asia and Latin America before spreading to other parts of the world by autumn 1997, and was built by Cosina to Nikon specifications. Cosina of Japan is probably best known for its RF cameras carrying the Voightlander name, although it also produces a line of long-running SLR models.

The FE10 had a top shutter speed of 1/2,000th of a second, but the flash synch speed was only 1/90th of a second. An AE lock was provided,

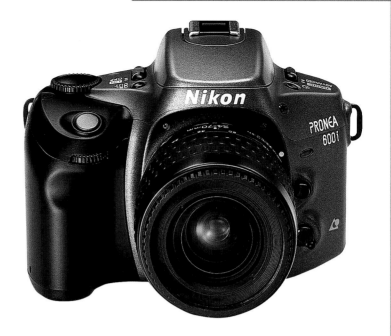

LEFT: The Pronea 600i, a camera that bridged the gap between APS compact cameras and regular 135 format SLRs. Although the F mount was retained, there was also a special range of IX Nikkors produced for the Pronea series, like the 24–70mm zoom seen in this shot.

BELOW: Japanese advertising for the Pronea, showing its dedicated lenses, and the interesting top plate and back design.

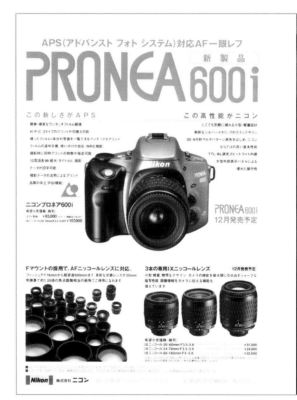

and exposure compensation adjustment was placed with the film speed dial under the rewind crank; the self-timer lever was replaced by a red button that also acted as a warning light.

The FE10 was usually supplied with a dedicated manual focus 35–70mm f/3.5–4.8 zoom, although a longer 70–210mm f/4.5–5.6 zoom was also

RIGHT: The Nikon FE10, a short-lived model introduced as a sister camera for the budget FM10.

BELOW: Cover of the FE10 catalogue, this particular brochure dating from November 1999.

BELOW MIDDLE: English-language advertising pointing out some of the many awards bestowed on the Nikon F5. Note the eightieth anniversary symbol on this late 1997 advert, commemorating eighty years since the birth of the company.

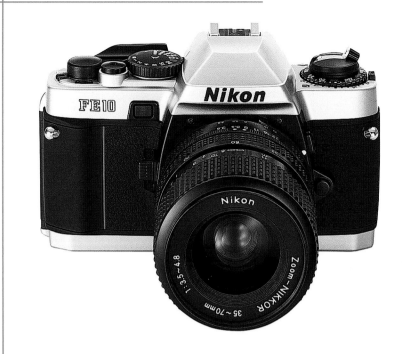

available in the budget MF series in certain export markets. Ultimately, the FE10 was killed off in 2001, but the FM10 continues to sell worldwide.

September 1997 brought with it the F50 Metallic. The Metallic version was available in standard and QD guise, bringing back the tradition of black or chrome Nikon bodies, at least on the cheaper SLRs. Two months later the SB-28 Speedlight, a slightly smaller but even more advanced version of the SB-26, was released, priced at a hefty ¥50,000.

Next up was the F60 (or N60 in the USA) of August 1998 vintage. Available in silver or black, and with or without a databack, the zinc alloy-bodied F60 was more serious looking than the F50, with a new top plate design, a control dial on the back and an ergonomic grip. The AF illumination lamp was an interesting development, helping the AM200 module-based focusing system in low-light conditions (the same lamp was also used for red eye reduction, too, helping people's eyes to react before the powerful pop-up flash was activated). Nikon's Vari-Programme, which was becoming a familiar feature by now, was included in the package.

The Pronea S made its debut at the 1998 Photokina and went on sale that September at ¥54,000. This APS film camera was small and light, with softer styling clearly aimed at the fairer sex. It had a 1/2,000th of a second top shutter speed instead of 1/4,000th, but that kind of speed was rarely going to be needed by the average enthusiast likely to be tempted into the Pronea world. Probably of more interest was the fact that the new 30–60mm f/4–5.6 lens (the equivalent to 37–75mm) issued as standard fare was finished in silver to match the body. The existing 20–60mm and 60–180mm IX-Nikkors were also made available in silver, the former gaining the 'New' nametag, while the latter was readily identified on paper by its f/4.5 aperture rather than the f/4 of the earlier version.

FAR RIGHT: The 50th Anniversary F5, released in 1998 to commemorate fifty years of Nikon cameras, and limited to 2,000 units. Note the different coloured body components, and the 'Nikon' typeface from a bygone era. The bottom left-hand corner at the rear sports an old Nippon Kogaku triangle with '50' underneath – a nice touch, as was the grey body cap and the special strap included in the camera's unique packaging.

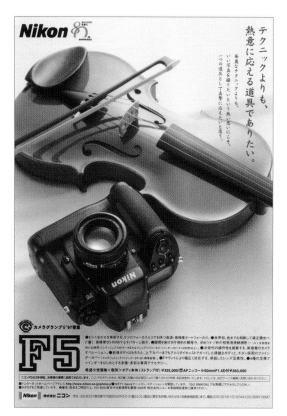

ABOVE: The Nikon F60, known in America as the N60, fitted with a contemporary 28–80mm zoom.

ABOVE: A superb mid-1998 advert for the F5, linking it with the Nikon I of fifty years earlier. In 1948 the Nikon I cost ¥57,690 with an f/2 normal. When one considers the F5 with a 50mm lens was listed at ¥363,000 fifty years later, it becomes clear that the new model offers exceptional value, even allowing for the current strength of the yen against foreign currency, once inflation is taken into account.

ABOVE MIDDLE: A final F5 advert from the period, dating from April 1998.

Although there would be no more Pronea bodies, at least the MB-11 power pack was made available (priced at ¥4,000), and the IX lenses continued into the new millennium, although stocks were running dry at the time of writing. By 2005 only two of the six IX lenses were still listed. For some reason, probably the popularity of digital photography, APS never really took off and the SLR models using this type of film were allowed to fade away quietly without anyone really noticing.

ABOVE: The Nikon Pronea S with a matching 30–60mm IX Nikkor. The Pronea S received a 'Top Design Award' at the time of its introduction.

RIGHT: A Nikon UK advert for the F60, showing the model with the alternative silver body finish, and mounted with a second-generation 35–80mm AF-D zoom.

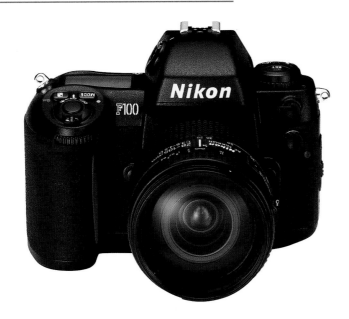

After a few accessories like the ¥12,000 SU-4 remote flash control unit and ¥18,000 DR-4 angle finder were released, it was the turn of the F100 to make its debut in December 1998.

The 'Baby F5'

The F100 was the replacement for the F90X, being of a similar size, and basically a baby F5. The right-hand side of the top plate, in particular, was like that of the F5, with the same front and rear control dials. Many components were 'floating' within the die-cast magnesium alloy body to reduce vibration (and damage after a severe knock), and superb sealing was much in evidence. Unlike the F5, though, the viewfinder image was only 96 per cent, and the shutter mechanism was guaranteed for 100,000 shots rather than the 150,000 specified for the 'Pro' body – surely enough by anyone's standards!

The F100 came with ten-segment 3D Matrix metering but did not recognize RGB colours, unlike the F5, so it was not quite up to 'Pro' body levels. The familiar 'P', 'S', 'A', 'M' and Custom settings, however, were as on the F5.

The autofocus system employed the Multi-CAM 1300 AF module (there was a choice of two focusing screens), and the advanced flash was also based on F5 practice, albeit with a slightly slower 1/250th of a second synch speed. The ISO hotshoe was in its usual position on top of the fixed HP prism head, which lacked the F5's viewfinder curtain. The manual rewind crank and mirror lock-up facility were also missing.

The MB-15 power pack was available at ¥30,000, but even without this the F100 was a nice, compact package. The maximum MD rate of 4.5 frames per second rose to 5fps with the MB-15, so the main advantage of the latter was its second shutter release and control dial for portrait shots. One could specify the ¥14,000 MN-15 lithium battery pack for the MB-15, but it required the ¥36,000 MH-15 charger. The only other major options for the F100, lenses and Speedlights notwithstanding, were the MF-29 databack (priced at ¥20,000), and the AR-10 cable release that was also used on the F-801, the F90 series, the F70 and the F5.

An updated 28–80mm AF-D zoom and an 85mm PC lens were released in 1999. Although it contained a CPU, this PC-Nikkor was in fact a manual focus lens, using the electronic gadgetry to transmit data to the body only. There were also two AF-S zooms issued in 1999, covering 17–35mm and 28–70mm focal lengths.

The next year brought with it a fast 14mm AF-D wide-angle, and three new zooms in the same series, one of which carried the 'VR' moniker. VR lenses had motion detectors in the lens barrel that sent a signal to a set of tiny motors to balance out any movement. This feature could be switched off, but there is little doubt that it was a great advantage for those occasions when a tripod was not available in poor light, or if a longer exposure setting was desired.

Only one more AF-D lens would be released (a 50mm f/1.8 model), but more variations based on the legendary F mount would continue to be issued. Between 1932 and the end of the twentieth century the company produced no fewer than 24 million Nikkor lenses.

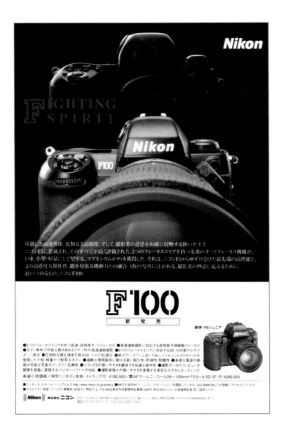

FAR LEFT: Early domestic advertising for the F100.

LEFT: American F100 advertising dating from the spring of 1999.

BELOW FAR LEFT: The F100 pictured with some impressive AF-S Nikkor lenses, including the 28–70mm and 80–200mm zooms, plus 300, 400, 500 and 600mm telephotos. Note the gold band on the lens barrels, signifying the use of ED glass.

BELOW MIDDLE: An interesting advert showing the cast body that forms the basic structure of the Nikon F100.

BELOW: The Nikon name shining brightly at the NASCAR event held at the Twin Ring Motegi circuit in 1999.

ABOVE: **Nuvis 200.**

ABOVE RIGHT: **Nuvis 300.**

RIGHT: **The Nikon AF240SV. The EF400SV, introduced as a sister model for the AF240SV, looked virtually identical.**

ABOVE: **The Nuvis S, a stylish APS camera launched at the end of 1998.**

RIGHT: **The Nikon Lite-Touch Zoom 70W, seen here in QD guise. It was updated to 70WS specification in summer 2002.**

RIGHT: **The One-Touch Zoom 90, which became the 90S in spring 2002.**

Compact Cameras and Coolpix Update

The end of 1998 saw the launch of the Nuvis S, a minute camera with a high-quality lens, including aspherical elements and CRC (Close Range Correction), and an advanced AF system. The Nuvis 200, with its good-quality zoom lens giving 24–48mm coverage, followed in mid-1999, and the 28–80mm Nuvis 300 rounded off the APS additions during this period.

The AF240SV (or Fun-Touch 6) was the successor to the AF230, while the EF400SV (Nice-Touch 5) was a sister camera to the AF240SV that replaced the EF300 in the Nikon line-up. These pocket cameras were not sold in Japan, although they could be supplied either with or without a databack. The Lite-Touch Zoom 70W and One-Touch Zoom 90 were also for export only, the latter being a very sharp-looking compact zoom with a 38–90mm lens. It was quickly updated to Zoom 90S specification in 2002. The Zoom 70W became the Zoom 70WS later that year, too.

The Nuvis S 2000 of March 2000 vintage was followed by the distinctive Nuvis V six months later, by which time Japanese shops were starting to

FAR LEFT: The Nikon Nuvis S 2000, an update of the Nuvis S.

LEFT: Lite-Touch Zoom 120ED.

BELOW FAR LEFT: Lite-Touch Zoom 140ED.

BELOW MIDDLE: Cover from the Nuvis V catalogue.

BELOW: Cover from the brochure produced for the Coolpix 700 and 950 models.

stock the Lite-Touch series, their elegant colours adding a touch of class to the Olympus Mu-style body.

The domestic market sold only QD versions of the recent pocket cameras, the Lite-Touch Zoom 120ED arriving in September 2000. Priced at ¥48,000, it was ¥4,000 cheaper than the Lite-Touch Zoom 140ED of mid-2001, since the latter's zoom lens covered a slightly greater range (38–140mm instead of 38–120mm).

The Coolpix models were also coming thick and fast, driven by market forces that demanded the latest fashionable looks and one-upmanship features. The Coolpix 950 was similar to the 900, but its die-cast aluminium body was given the Nikon SLR family look combined with the swivel head of the top Coolpix models. Maximum resolution was listed at 2.1 million pixels in the brochure.

As well as a range of accessories that made images easier to transfer and edit, a ¥14,000 2× teleconverter (TC-E2) was made available for the Coolpix models, along with an impressive-looking fisheye converter (the ¥35,000 FC-E8) and the first wide-angle converter (the ¥9,800 WC-E24). It was also possible to hook up a contemporary SLR Speedlight via the SK-E900

kit. While hardly a system camera at this stage, the appeal of the Nikon Coolpix was growing quickly, nonetheless.

The Coolpix 700 came out in March 1999 alongside the 950. This compact, traditional-looking model had a built-in flash and a fast 6.5mm f/2.6 lens. It had a reasonably high resolution of 1.9 million pixels, with a simple manual focus system augmenting the AF and Macro modes. A manual override was also provided for the advanced auto exposure system. The Coolpix 800, released nine months later, was much like the 700, but equipped with a zoom lens.

RIGHT: **Coolpix 800.**

FAR RIGHT: **Coolpix 990.**

FAR RIGHT, BELOW:
Coolpix 995.

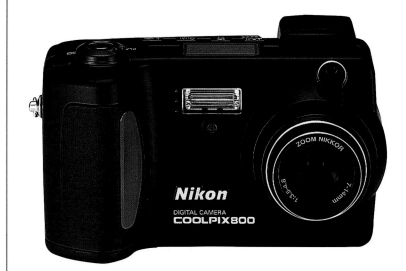

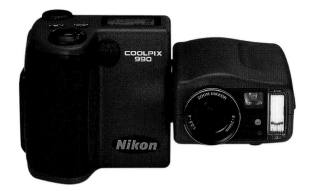

RIGHT: **Coolpix 880.**

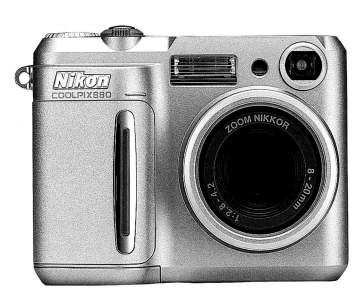

FAR RIGHT: **Coolpix 775.**

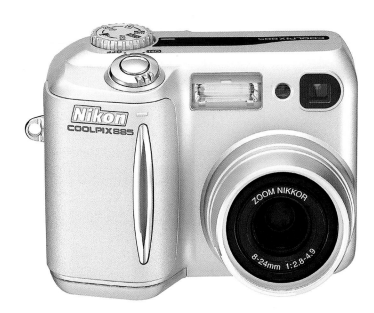

RIGHT: **Coolpix 885.**

At ¥125,000 the Coolpix 990 of April 2000 cost the same as the 950 it was based on, but had higher resolution, a slightly different lens, a faster shutter speed and lower power consumption. Just over a year later the 995 took its place, with an 8–32mm lens replacing the old 8–24mm optics, a maximum shutter speed twice that of the 990, a pop-up flash and further improvements in extending battery life.

September 2001 saw the launch of the Coolpix 880, the predecessor of today's compact digital cameras, with fresh styling that resembles the current 2005 entry-level models. Next up was the Coolpix 775, which was an ultra-compact sister camera to the 885, launched one month later in October 2001. The Coolpix 885 was a replacement for the 880, with all the latest electronic enhancements, and ultimately proved to be the last 'three number' Coolpix model.

A Pure Nikon Digital 'Pro' Body

The original Nikon D1 dates from 1993, a brutish-looking camera that obviously provided the styling cue for the E2/E3 series. The D1 that finally made it to market, however, was much closer to the Nikon F5 in its exterior design. Launched in October 1999, only a few months after Kodak made a DCS attachment for the F5, the D1 signalled the dawn of a new era in professional photography.

The magnesium alloy body had styling that can best be described as a cross between the F5 and F100, with the dimensions and leading features of the 'Pro' body. The rear LCD panel and buttons were similar to those of the F5, although the D1 had a second TFT LCD screen for viewing pictures (only 96 per cent of the image was seen in the viewfinder) and setting certain functions.

The metering system was borrowed from the F5, as was the AF hardware, although only two focusing screens were available. An interesting feature was the anti-vibration mode for when slow shooting speeds were selected, but, at the other end of the scale, the D1 was endowed with an amazing 1/16,000th of a second top shutter speed, with flash synch at 1/500th of a second. Reaction time to shutter release being depressed was admirably short for the time, with very little delay.

The D1 had a 2.7 million-pixel CCD, with several filters mounted ahead of it for truer colour reproduction. Files could be saved in either JPEG or TIFF format, and could be downloaded to either a PC or video (NTSC and PAL), although some file types listed required Nikon Capture software to process the data. A large buffer memory allowed up to 21 images to be shot at 4.5 images per second before the data needed to be written to the camera's Flash Card.

As with Coolpix models, focal lengths are slightly different on digital SLR cameras, too: one has to assume that 35mm SLR lenses are about one-and-a-half times longer in the case of the D1, so a 50mm normal will give an image like a 75mm lens in practice. This would ultimately lead to the development of a new range of Nikkors, called the DX series, but for the time being, the ability to use regular Nikkor lenses was a massive advantage for established Nikon users.

The Speedlights also needed recalibrating, so the ¥60,000 SB-28DX was launched at the same time, an advanced SB-28 flash developed specifically for the D1. As it happens, the ¥52,000 SB-29 Speedlight was

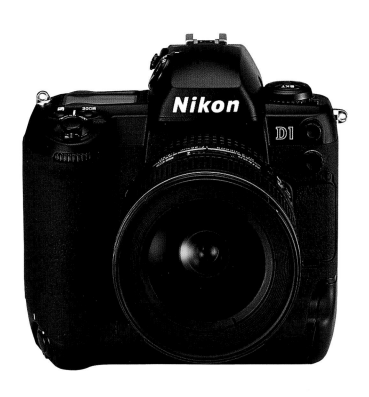

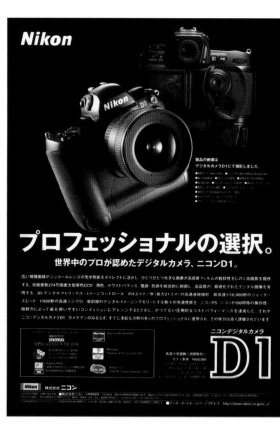

RIGHT: The Nikon F80, or N80 as it was known in the USA.

BELOW: Japanese advertising for the F80, showing the two variants sold on the domestic market – the F80D and the F80S. The strict F80, without a databack, was for export only.

BELOW MIDDLE: An American advert for the N80, with a 28–200mm zoom in the background.

BELOW FAR RIGHT: The F80 pictured with the 18–35mm and 24–85mm AF-D zooms, the 300mm f/4 AF-S telephoto, and the exotic 80–400mm zoom with vibration reduction.

issued alongside the SB-28DX as a replacement for the SB-21 models. Later an improved version known as the SB-29S was launched, the latter making its debut in 2002.

Introduced at ¥650,000, the D1 was very competitively priced for the time, forcing Kodak to reduce the price of its DCS models as soon as the new Nikon was announced.

SLRs in the New Millennium

April 2000 marked the launch of the F80 (or N80, as it was known in the USA). In fact, in Japan there was both an F80D and an F80S, the latter having the more advanced databack, while export markets could specify the model with or without a databack. As the designation number implied, the styling was pretty much a cross between the F100 and F60.

The Multi-CAM 900 AF sensor was adopted, coming with various auto-focus modes and AF illumination. The ten-segment 3D Matrix metering was fully functional with D-type Nikkors, backed up by spot and centre-weighted metering. The F80 had 'P', 'S', 'A', 'M' and Custom settings only: there was no Vari-Programme, as it was aimed at more experienced users.

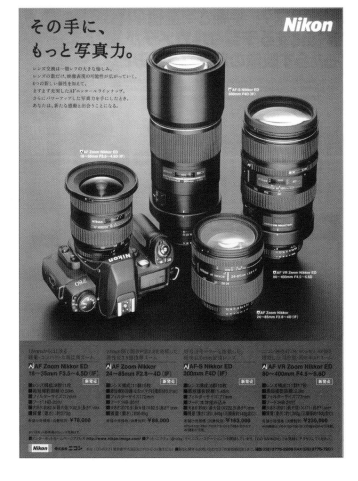

The built-in flash came with full TTL control and a 1/125th of a second synch speed. Top shutter speed was 1/4,000th of a second, and a threaded shutter release button was provided, as there was no ten-pin socket. Combined with a 2.5fps MD (regardless of whether the ¥8,000 MB-16 power pack was fitted or not) and an informative viewfinder with a new, brighter focusing screen, this made the F80 a useful second body for F5 users, or an ideal choice for the enthusiastic amateur.

There was also a 'Year of the Dragon' limited edition New FM2 for 2000. With an elegant black and gold dragon motif on the front, a unique serial number (xxxx/2000) on the rear (the 50mm f/1.4 was marked with a matching serial number), and a beautiful gold box with a red lining, this is sure to be a collectable item for years to come.

Unfortunately, 2000 also marked the end of the F3 after a lengthy production run that stretched back two decades. Another long-running model, the Nikonos V, was dropped at the end of the following year.

Meanwhile, another SLR was announced at the 2000 Photokina, the F65, although people would have to wait some time before they could buy one. Introduced as a replacement for the F60, it was called the Nikon U at home when it went on sale in March 2001. The numerous *kanji* that have the same sound as 'U' all have a nice, gentle image. The closest translation into English is 'friendly', which just about sums up the character of the F65.

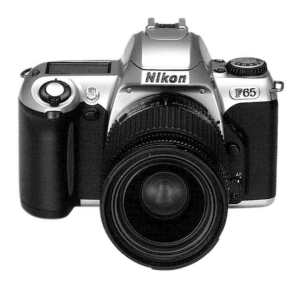

The F65 boasted full compatibility with all latest lens types, something that could not be said for its predecessor, which had some restrictions. Fitted with the Multi-CAM 900 AF module and illumination lamp from the

ABOVE FAR LEFT: **Cover of the New FM2 catalogue of mid-2000. Time was running out, however, for this evergreen model.**

ABOVE MIDDLE: **Cover of the Nikkor lens brochure from the new millennium.**

ABOVE: **The *Nikkor Club* magazine has been around for many years, and often features some stunning photography, such as this cover shot from 2000.**

LEFT: **Nikon F65 mounted with a 28–80mm zoom.**

F80, it was also much faster to react than the F60, with single or continuous servo AF selected automatically by the camera. The six-segment 3D Matrix metering was augmented by a centre-weighted function, while exposure modes included the regular 'P', 'S', 'A', 'M' and Vari-Programme, and full Auto. Equipped with a pop-up flash and a 2.5 frames per second MD, it was available without a databack outside Japan (all domestic models had the QD back), and a black body was listed alongside the standard silver version in some export markets.

Back to SLR Basics

The FM3A was launched a few months later as a new-generation FM2. The concept was 'simple' – nothing more, nothing less – a high-quality back to basics MF model in an era of digital and AF cameras with built-in MDs. Displaying less black detailing than the FM2 and with slanted script to match its contemporaries, this latest Nikon 35mm SLR came with full manual control or an aperture priority 'A' auto exposure mode (SPD cells giving centre-weighted metering), hence the FM3A designation, rather than the expected FM3 moniker. There was an AE lock on the back, along with an FE-style exposure compensation facility.

Beneath the traditional façade of the die-cast body (with serial numbers starting on 200001), there was a wealth of technology. In manual mode the shutter worked mechanically, but it switched to electronic control when the camera was in the 'A' mode. The electro-mechanical shutter, with its aluminium alloy shutter blades, had a 1/4,000th of a second top speed. A depth of field preview button was provided, as was a self-timer.

The conventional viewfinder image, with 93 per cent coverage, was enhanced by a large mirror and the choice of three focus screens (K3, B3, E3), considerably brighter than their predecessors, and priced at ¥3,000 apiece. As one would expect, the FM3A came with full TTL flash control, but a button was provided on the body offering greater control over output. The film transport system was refined, although hooking up the long-running MD-12 gave a maximum of 3.2fps performance for those in a hurry. And while there was a window in the standard back to view the film type (DX film recognition came as part of the package), the old MF-16 databack would happily fit the new camera.

The FM3A was designed to take any Ai or later lens, although a rather special 45mm Nikkor was brought out at the same time as the new body. This was a compact aluminium alloy Tessar-type 45mm GN lens – a P series model that used its CPU to transmit data back to the body. Weighing in at just 120g, like the FM3A, it was available in silver or black.

BELOW: In Japan the F65 was known as the Nikon U.

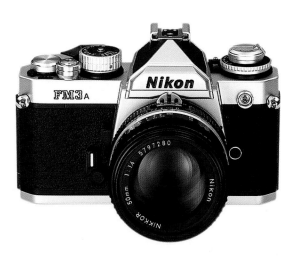

ABOVE: The Nikon FM3A, seen here mounted with a fast Ai-S normal. Many FM3As were sold with the 45mm f/2.8P lens launched at the same time. It was very unusual in that it was offered with either a silver or regular black finish to match the camera body.

RIGHT: Advertising for the FM3A, showing the two body colours.

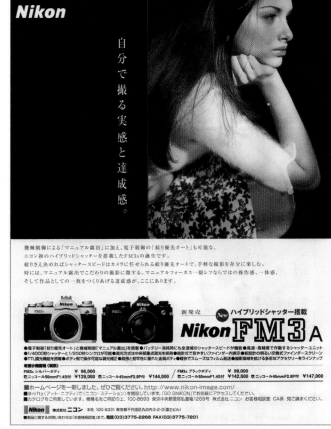

Yet another lens series made its debut in 2001. The first of the AF-G lenses was brought out with the F65. These latest G-type Nikkor lenses lacked an aperture selection ring, so would only work mounted on very modern bodies that allowed the aperture to be selected via the camera itself. A 28–80mm zoom was the first of the line, followed by a 70–300mm a few months later. These, and the two G-type lenses that arrived during 2002 and 2003, were available in either black or silver to match the camera bodies.

A number of new AF-S Nikkors were also launched during 2001, along with two teleconverters in the same series. The first was a 300mm f/4, while the other four were updated versions of the fast 300, 400, 500 and 600mm telephotos. All of these, and a handful of earlier AF-S Nikkors, were available in traditional black or a light grey finish.

Although cumulative Nikkor production reached a staggering 30 million units in November 2001, things were quiet on the lens front for 2002, with only an AF-S 24–85mm zoom, and the AF-D and AF-G variants already mentioned in the text.

It was around this time that the coveted 'Professional' neck strap became available to the public (it used to be issued to NPS members only, in two versions – one with 'Press' and one with 'Professional' script stitched in at the ends). The current strap uses a black base for 35mm cameras, and a blue base for digital users.

Meanwhile, August 2001 saw the launch of the SB-50DX Speedlight. Priced at ¥28,000, this full-function flash was aimed at overriding pop-up flash units built into certain Nikon bodies. It had a simple but effective flap that dropped down to diffuse the body's flash! Eight months later, the SB-30 – a lightweight, compact flash – made its debut, with a recommended retail price of ¥15,000.

Digital Developments

The first of two new D1 variants appeared in May 2001. The D1X was the D1 for those wanting higher resolution. Up to 5.3 million pixels resolution was made possible with the same chip size by putting two CCDs in the same area occupied by one on the D1, which therefore meant the same 1.5× factor on lens focal lengths. A larger main LCD screen was found on the back, showing 100 per cent of the image (if not in the viewfinder as yet). In addition to lower power consumption, the latest model also featured improved colour balance. The D1X was later given a larger buffer memory, too.

Two months later it was the turn of the D1H to take a bow in the shops. Priced at ¥470,000 (¥120,000 less than the D1X), this was the D1 for those wanting greater data processing speed, allowing more images to be fired in succession. Many of the improvements seen in the D1X were carried over to the D1H, but the main feature of the latter was the ability to shoot up to forty images at five frames per second before having to pause to transfer data to the card.

The Coolpix series was also maturing. The 5000 of December 2001 was styled like a small, contemporary Nikon SLR, with specifications to match, including a 1/4,000th of a second top shutter speed. To go with the

BELOW FAR LEFT: **The Nikon D1X, a development of the D1 with higher resolution.**

BELOW MIDDLE: **Tasteful advertising for the D1X.**

BELOW: **The Nikon D1H, a development of the D1 with greater shooting speed.**

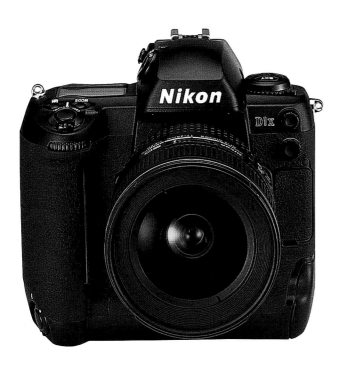

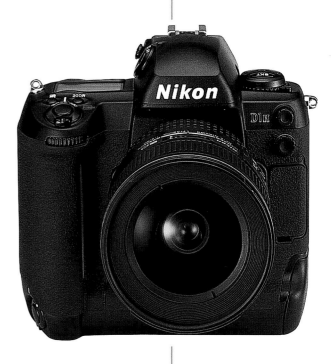

RIGHT: **Cover from the D1H catalogue, giving a clear view of the camera back.**

ABOVE: **The beauty of the Pro Digital bodies was their ability to use the full range of Nikkor lenses.**

RIGHT: **Coolpix 5000.**

RIGHT: **A Japanese advert for the Nikon Coolpix 2500.**

FAR RIGHT: **Coolpix 2000.**

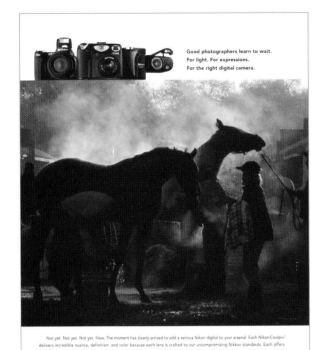

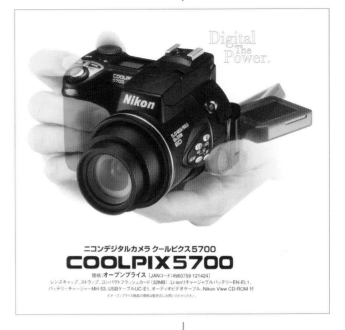

ABOVE: Coolpix 4500.

LEFT: American advertising showing the Coolpix 5700, 5000 and 4500 models.

RIGHT: Coolpix 5700.

ニコンデジタルカメラ クールピクス5700

COOLPIX 5700

camera's amazing levels of resolution, there was a high-speed data transfer system that allowed three images per second performance. The lens gave a useful equivalent of 28–85mm in traditional 35mm SLR photography, while the hotshoe would accept Speedlights; the ¥15,000 MB-E5000 power pack was made available for enhanced performance. This was the closest a Coolpix model came to being a system camera.

The Coolpix 2500 was introduced to appeal to the young and trendy, while the 2000 was an indirect replacement for the 775. The 2000 was actually one of three Coolpix models brought to market in June 2002, the others being the 4500 (basically, a new 995, with 4.1 million-pixel resolution in either JPEG or TIFF format) and the 5700. The 5700 was the ultimate Coolpix model, with body styling based on the 5000, but given an electronic viewfinder and an impressive lens that covered the equivalent of 35–280mm. The ED glass lens dominated the frontal view, with a pop-up flash and ISO hotshoe above it.

It was around this time that Nikon announced it would be making many of its digital cameras at its new plant in China, located in Wuxi, just outside Shanghai. Others would be made in Korea and Indonesia, but the top models would continue to proudly wear a 'Made in Japan' sticker.

There were two more Coolpix models released in autumn 2002: the 4300, which was basically a new 885 that could capture video for short spells, with a USB connection for easy downloading of files to a PC, and the 3500. The Coolpix 3500 was actually a development of the 2500, a camera introduced just eight months earlier!

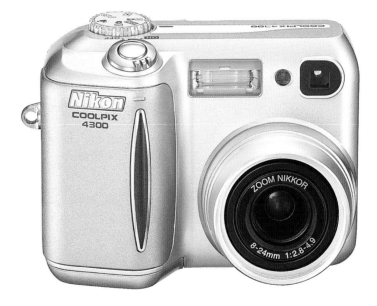

LEFT: Coolpix 4300.

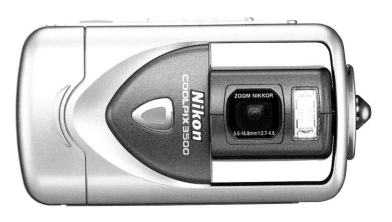

LEFT: Coolpix 3500.

Coolpix accessories by this time included more lens converters, and an ¥11,000 macro ring light (code SL-1). In addition to the TC-E2, FC-E8 and WC-E24 already mentioned, there was the ¥14,000 WC-E63 and ¥22,000 WC-E68 wide-angle converters, the ¥29,000 TC-E3ED teleconverter and the ¥7,500 ES-E28 slide copy adapter.

While the F5 had the F100 as the ideal second body, the D1 series had the D100, launched in June 2002 at ¥300,000. The body and controls had a definite family look, with the built-in flash coming with a 1/180th of a second synch speed and advanced TTL flash control with dedicated Speed-light units.

The Multi-CAM 900 AF module looked after the autofocus system requirements, while ten-segment 3D Matrix metering ensured accurate levels of exposure. With a resolution of 6.1 million pixels, a top shutter speed of 1/4,000th of a second, and a buffer memory that allowed up to six shots at three frames per second before the data needed to be written to the card, it was a highly specified camera at a reasonable price.

The standard power pack featured a lightweight rechargeable battery, which also kept the camera's dimensions compact. The ¥37,000 MB-D100 multi-function pack had additional control dials and an extra shutter release button, plus a ten-pin connection to accept accessories (although the main shutter release button was threaded for a traditional cable release).

The SB-80DX Speedlight was issued at the same time as the D100. Priced at ¥55,000, it replaced the SB-28 and SB-28DX in one go.

The End of the 35mm Pocket Camera

In addition to the Lite-Touch Zoom 90S and 70WS updates (identified by their tiny 'S' suffixes following the main camera designation), 2002 witnessed the introduction of the AF250SV and EF500SV (respectively, replacements for the AF240SV and the EF400SV), and another pair of fresh Lite-Touch cameras. The Lite-Touch Zoom 130ED was a high-spec 38–130mm zoom, while the Lite-Touch Zoom 110S was a lesser version without ED glass in its 38–110mm lens, and a slightly modified body design.

Ultimately just two more pocket cameras would find their way to the marketplace, as the new generation of compact digital models simply made them obsolete. The Lite-Touch Zoom 150ED became the top of the line model with its 38–150mm zoom in a 130ED body, while the Lite-Touch Zoom 100W of April 2003 had the rather dubious honour of being the very last Nikon 35mm pocket camera.

Interestingly, the most recent Japanese price list issued by the company contained only one compact 135 format camera; more tellingly, perhaps, the digital cameras were listed first, ahead of the 35mm SLRs. How times have changed – even as recently as 1999 the digital range was still on the back cover, with no illustrations to show what the products looked like!

At least 35mm SLRs and the paraphernalia surrounding them continued to be developed. March 2002 will be remembered for the launch of the silver-bodied Nikon Us (also known as the F55 or N55, depending on where you live), which was introduced as a replacement for the F50. Usually, an 'S' suffix was added to signify an improved version of an existing product in the old days, so it was odd for the cheapest in the SLR line to receive this moniker. Still, apart from a three-area Multi-CAM 530 AF module, five-segment metering, much slower film advance, restrictions on use of certain lenses, and the lack of an exposure compensation feature, it was otherwise quite similar to the F65.

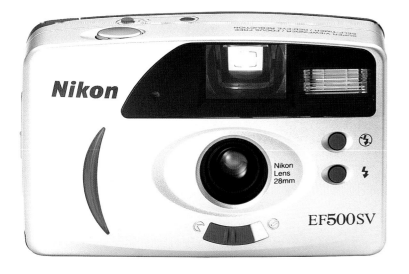

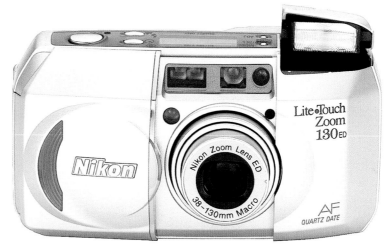

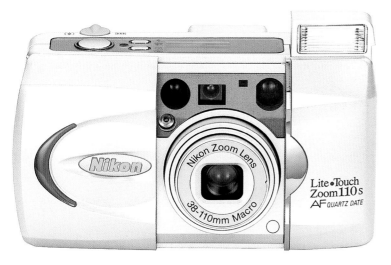

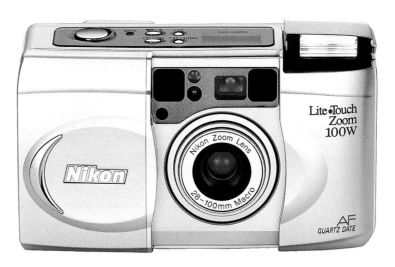

FAR LEFT: **Nikon EF500SV. As with the previous generation, the AF250SV sister camera looked very similar, with the badging and detailing to the side of the viewfinder being the only obvious differences when viewed from the front.**

LEFT: **Nikon Lite-Touch Zoom 130ED. Apart from the lens and badging, the 150ED version that followed was almost identical.**

FAR LEFT: **Nikon Lite-Touch 110S.**

LEFT: **The Lite-Touch 100W, the last compact camera introduced by Nikon, making its debut in April 2003. No more 135 format pocket cameras would be produced, the company devoting its energies toward digital products instead.**

RIGHT: Those wanting a pocket camera for print film often turn to disposable versions nowadays, such as this Konica. Freely available from convenience stores and such like, the body is recycled once the preloaded film has been processed. Konica joined forces with Minolta in 2003.

FAR RIGHT: Nikon F55, seen here in N55 guise for the American market.

BELOW: The F55 was known as the Nikon Us in Japan.

BELOW RIGHT: Specialist optical equipment is still an important part of the Nikon business. These pictures show the SB-29S ring light for close-up photography, a surveying machine, and a modern microscope.

New lenses were few and far between by this time, but two AF-S zooms were released in the first half of 2003: a fast 70–200mm model with ED glass and the vibration reduction system, and a 24–120mm version that embraced the same technology. The 70–200mm f/2.8G was available in either black or light grey.

The F60 had been replaced by the F65; a year later the F55 superseded the F50. It was to be another year before the Nikon U2 (also known as the F75 or N75) took the place of the F70. Launched in March 2003, the F75 built on the F65's specification with 25-segment 3D Matrix metering (augmenting the camera's spot and centre-weighted metering systems),

five-area AF controlled by the Multi-CAM 900 module, and an automatic AF servo, complete with a lock-on facility. While Japan's version, the ¥64,000 Nikon U2, was supplied only with a databack, standard and QD models were available abroad. Black or silver bodies, however, were listed for all markets. The only real option for the newcomer was the MB-18 power pack, priced at ¥6,000.

RIGHT: The Nikon F75, seen here sporting its American N75 designation.

The Digital Onslaught Continues

Spring 2003 brought with it the Coolpix 3100, built with simplicity in mind. While it had a resolution of 3.2 million pixels and its lens covered the equivalent of 38–115mm in 35mm photography, the Coolpix 2100 (launched at the same time as a sister model) came with a specification of 2 million pixels and a 36–108mm lens. These cameras were the first

ABOVE LEFT: On the subject of specialist equipment, Nikon still has close links with NASA, as is clearly shown by this picture of an astronaut checking an F5 prior to a mission in September 2002.

ABOVE: An American brochure from 2003 promoting the use of 35mm film cameras. Why, in the digital age? Because the picture matters.

LEFT: Top plates of the N75 and N80 compared, the latter only coming with a black body option. Note the availability of matching 28–80mm zooms.

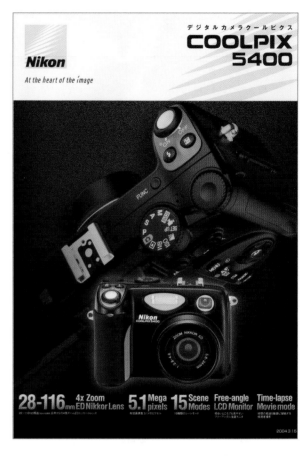

ABOVE: **American advertising for the N75.**

ABOVE MIDDLE: **Japanese advertising for the Coolpix 3100 and 2100 models.**

ABOVE FAR RIGHT: **Brochure for the Coolpix 5400.**

RIGHT: **Coolpix SQ.**

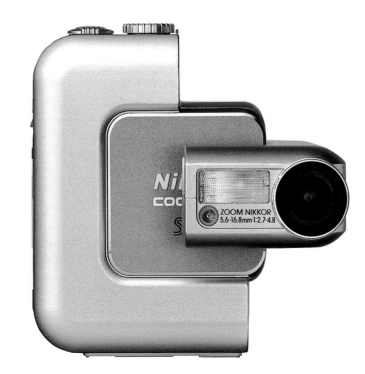

Nikons to have an open price in Japan, meaning that no recommended retail price was set by the manufacturer; it was up to the shops to set their own selling price. To help put them in perspective, in America the 3100 was priced at $300, while the 2100 retailed at $200 to become the cheapest Coolpix to be released since the range's inception. It was literally half the price of the 4300 introduced six months earlier.

Two more Coolpix cameras were issued in June 2003. The SQ was the Coolpix model for the fashion-conscious, with its distinctive square shape, 3.1 million pixels resolution and 4× zoom lens. This was $450 in the USA, but the 5400, which replaced the 5000 in the line-up, commanded $900. Compared to its predecessor the 5400 had superior optics covering a greater breadth, higher resolution, and a larger buffer memory, allowing longer bursts of continuous shooting.

If ever one needed a sign to show that digital SLR photography was here to stay, it was perhaps the development of Nikon's DX lenses. These were designed specifically for use with digital cameras owing to the difference in focal lengths, digital versus traditional 35mm format. The DX lens was perfectly matched to the image area of a digital SLR, with, for example, 12–24mm in DX format equating to about 18–36mm on a regular lens.

As it happens, a 12–24mm zoom was the first DX Nikkor to be released, priced at ¥162,000 and available from June 2003. Next up was a 10.5mm fisheye, which offered good value for money at just below ¥100,000.

The pace of development can be gauged by the fact that the F of 1959 was not replaced by the F2 until 1971, and even then the F continued to be made and sold for several years after. The D1 had arrived in late 1999, only to be split into two derivatives around eighteen months later, and then, in November 2003, the first D2 made its debut – the D2H.

As the 'H' implies, the D2H was a development of the high-speed D1H. The magnesium alloy body was given improved sealing, and the styling evolved to include extra control dials on the base to augment the second shutter release, a larger LCD panel on the top plate with enhanced information, a sharper looking head (allowing a 100 per cent viewfinder image for the first time on a digital Nikon) and shutter release button area, plus a larger screen on the back surrounded by newly exposed function buttons (F100 style).

The ¥60,000 SB-800 ushered in the start of the Creative Lighting System (CLS) era at the end of 2003. Designed to complement the advanced technology of cameras like the D2H, the term 'rocket science' readily comes to mind. Like cameras themselves, flash unit technology had progressed in leaps and bounds since the SB series was first introduced back in 1969. The ¥35,000 SB-600 was launched shortly after as the best match for the new D70.

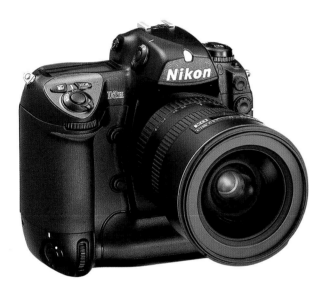

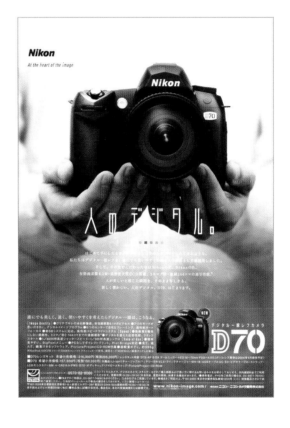

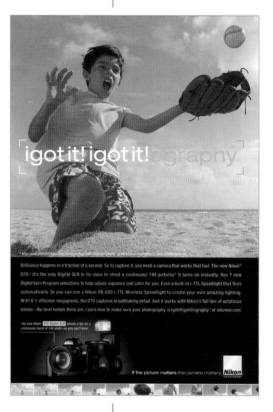

A new hybrid sensor called Lateral Buried Charge Accumulator & Sensing Transistor Array (LBCAST) using Junction Field Effect Transistor (JFET) technology replaced the older CCD unit. With new software, it was faster and used less power, but a 1.5× factor still had to be allowed for with regular lenses due to the sensor size. The autofocus system was looked after by the Multi-CAM 2000 AF module, while a lighter and more powerful battery pack supplied the necessary voltage.

Resolution was listed at 4.1 million pixels, but the D2H was all about speed. As well as fast reaction to the shutter release being pressed, the camera's buffer memory allowed up to forty images to be taken at eight frames per second before things came to a halt while the data was transferred to a card. Top shutter speed was actually reduced from 1/16,000th of a second to a still heady 1/8,000th, while the flash synch was set at 1/250th of a second.

An intervalometer was included in the package, although the WT-1 wireless transmitter was listed as a ¥70,000 option to transfer data without having to hook up directly to the camera.

A Digital SLR without Breaking the Bank

The D70 made its debut in March 2004, becoming the entry-level model in the world of Nikon digital SLRs. The D70 would be the equivalent of the F75 in the film camera line-up, with its Vari-Programme, although the styling was much closer to the D100.

As soon as it was launched the D70 received a number of awards, since its incredibly low ¥150,000 price tag had little to do with its specification. Equipped with a 6.1 million-pixel RGB CCD unit and Multi-CAM 900 AF module, the D70 would rattle off twenty pictures at three frames per second, but would run almost continuously at half that speed until the card was full. In addition to a high top shutter speed, equalling that of the D2H, the flash synch was set at 1/500th of a second, with full CLS compatibility. The D70 used the ML-L3 unit, the tiny remote control from the Lite-Touch, U and U2 cameras, priced at ¥2,000.

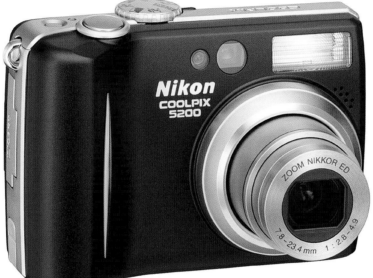

ABOVE LEFT: **The elegant Coolpix 3700.**

ABOVE: **The Coolpix 8700, with its impressive lens.**

LEFT: **The Nikon Coolpix 5200, seen here in blue. The Coolpix 4200 looked almost identical, apart from its badging.**

BELOW: **Coolpix 4100 in black.**

ABOVE: **A British brochure showing the Coolpix 3200 and 2200 models.**

The DX-spec 18–70mm zoom came out alongside the D70, priced at ¥56,000, and this was followed three months later by a 17–55mm variant in the same series. At ¥220,000 this became the most expensive lens in the DX Nikkor line-up.

The Advance of the Coolpix

Meanwhile the breeding season for Coolpix models continued unabated, with the 3700 arriving in December 2003. This stylish and compact 3.2 million-pixel camera came with a high-quality zoom lens and polished metal body. As the American catalogue said, the 3700 'Looks sharp, shoots smart.'

The Coolpix 8700 was a new version of the 5700, with reduced shutter lag, faster data processing, enhanced focusing, and resolution up to an incredible

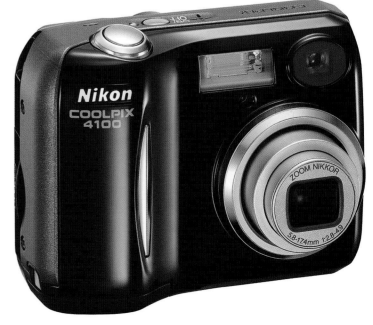

8 million pixels. The 3200 and 2200 also came out in spring 2004, replacing the 3100 and 2100 in the line-up. The Coolpix 5200 and 4200 sister models provided the next step up the ladder, with the 4100 of July 2004 vintage sitting between the two sister lines.

The Coolpix 8400 was an indirect replacement for the 5400, moving more upmarket as its '8000' series number suggested. It went on sale in October 2004, a month before the 4800 with its 8.3× ED glass zoom lens, and the 8800VR. The Coolpix 8800VR became the flagship of the Coolpix range with its impressive ED glass lens covering the equivalent of 35–350mm, and also incorporating VR technology.

By now there was an extensive collection of Coolpix accessories and digital equipment to back up the cameras, such as printers, storage devices, computer software and so on. There was also a large range of film scanners to convert negatives and slides into digital images, and the ¥75,000 yen Coolwalker for downloading and viewing data from SLR models.

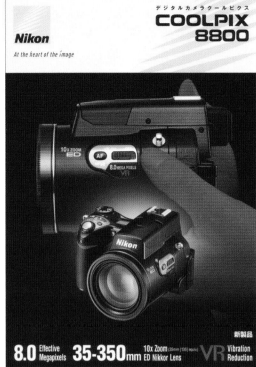

ABOVE: **Domestic catalogue for the Nikon Coolpix 8800.**

ABOVE RIGHT: **European advertising for the Coolpix 8800, showing the camera-back in detail.**

RIGHT: **A recent brochure for Nikon scanners. The Coolscan range has developed quickly alongside the Coolpix cameras.**

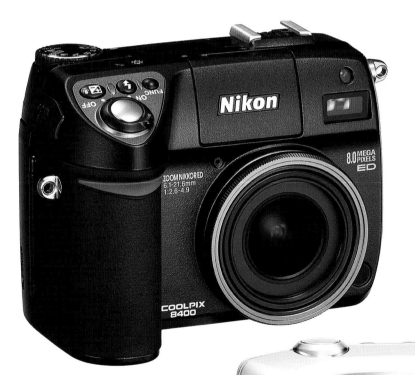

ABOVE: **Coolpix 8400.**

RIGHT: **The Coolpix 4800, with its ED glass lens.**

ABOVE: **Contemporary film advertising from Kodak. Despite the onslaught of digital photography, there will always be those who prefer to use 135 film.**

ABOVE RIGHT: **Ghosted drawing of the F6.**

New additions to the Coolpix line of lens converters and adapters included the ¥30,000 WC-E75, ¥25,000 WC-E80, ¥12,000 WM-E80, ¥80,000 TC-E3PF, ¥25,000 TC-E15ED, ¥60,000 TC-E17ED and ¥45,000 FC-E9. There were also no fewer than five underwater casings available to make up for the lack of a Nikonos camera.

F6: Last of the Line?

Developed following the concept of the need for a faster and lighter camera, with ultimate reliability and low power consumption, the F6 was launched in October 2004, priced at ¥300,000. The striking body, designed by Giugiaro, was a smaller and lighter package due to its power pack arrangement. Indeed, at 975g against 1,210g for the F5, it was far easier to handle. The top plate, bottom and front cover were produced in magnesium alloy, which is exceptionally strong and light, while the back was made in a slightly cheaper aluminium alloy. There was better sealing against dust and the elements, and new oils were adopted to allow temperature differences of −20°C to +50°C to be dismissed without any problems (Nikon's engineers actually obtained test data in authentic extreme conditions by travelling everywhere from mountain tops to tropical islands!).

The shutter, with a top speed of 1/8,000th of a second, went through its traditional 150,000-cycle check and was designed to operate with less noise and vibration. As one would expect with a 'Pro' body, it was possible to lock up the mirror and a depth of field preview button was provided.

The autofocus system was looked after by the advanced Multi-CAM 2000 AF module with no fewer than eleven focusing areas, and the option of seven interchangeable focus screens (priced at ¥5,000 each). The automatic exposure system was naturally the best available at the time, with G- and D-type lenses relaying information back to the body's micro-computer.

The camera had a built-in MD rated at 5.5 frames per second, rising to 8fps with the optional power pack, the ¥50,000 MB-40, which was one of the few accessories listed for the latest 'Pro' body. In addition to the high-speed rewind facility, the F6 had a manual rewind to save power on longer shoots.

The fixed prism head played host to the ISO hotshoe. The body's advanced flash control system supported CLS with the SB-800 and SB-600 Speedlights, and had a synch speed of 1/250th of a second. The F6 was packed with functions, but the LCD screen on the back allowed all manner of settings to be adjusted quickly, easily and effectively, with the menu coming in various languages, saving on the need for local versions to be made.

Two AF-S lenses were released in 2004: an expensive 200–400mm VR zoom at the start of the year, and a fast 200mm telephoto that also

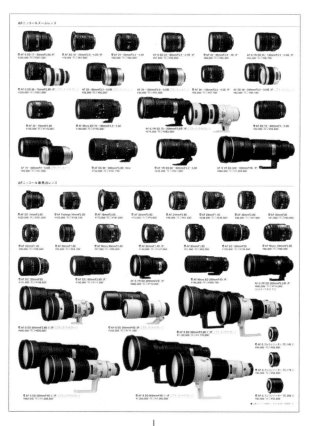

ABOVE: **Cover and inner pages from the first F6 catalogue. Nikon rightfully makes the most of the camera's proud heritage, both here and in the posters issued to authorized dealers.**

LEFT: **The Nikon F6 pictured with and without its optional MB-40 power pack. Note the eleven focusing areas of the new 'Pro' body.**

RIGHT: **The range of autofocus Nikkor lenses as of 2004.**

ABOVE: Although most cameras are AF nowadays, manual focus models still have a following. These are the latest catalogues for the FM3A and FM10. Note the elegant 45mm lens on the FM3A, colour coded to match the camera body.

encompassed vibration technology, not to mention ED glass. Both of these were G-type Nikkors for the modern SLRs, as was the most recent AF-S lens, a 300mm telephoto with ED glass and the VR control system. Apart from a 1.7× AF-S teleconverter, all other recent Nikkors have been DX series variants.

Digital Additions

Having recorded a heavy loss in 2004 on 35mm photography goods, Kodak expected digital products to outsell 135 film for the first time in 2005 – a good indicator of the direction photography is taking.

The relentless launch of Coolpix models continued, with five more variants arriving in spring 2005. The 5900 was the replacement for the 4200, while the 5600 took the place of the 4100 in the line-up. A couple of weeks later the 7900 replaced the 5200, and then two new models arrived: the stylish S1 and the 7600, which had the same lens as the 7900 in a more compact package. This took the number of cameras available in the Coolpix series up to nine, or fifteen if one includes colour variations!

Meanwhile, the D2X was launched in January 2005 as the replacement for the D1X. It came with the outrageous resolution of 12.4 million pixels and extended the range of top-level digital cameras to almost equal that of traditional AF 35mm models offered by the Japanese company.

Two months later, the D2H was uprated to D2HS specification, with an enhanced LCD monitor and information display, and faster system response and accuracy in all respects. Refined metering and exposure processing

RIGHT: Contemporary Nikon binoculars. As well as photographic, medical and industrial equipment, telescopes, fieldscopes and binoculars still feature strongly in Nikon catalogues, along with items such as magnifying glasses and laser rangefinders.

MIDDLE RIGHT: Nikon camera bags, 2005 style.

FAR RIGHT: The Nikon visitor centre in the Shinjuku area of downtown Tokyo. One can even order wine or traditional Japanese sweets and *sake* carrying the Nikon brand name.

LEFT: Promotional paperwork for the Coolpix 5600.

BELOW LEFT: The Coolpix 7900 shared the same basic body as the 5900, so they looked very similar, apart from the badging. While the 5900 came in silver only, however, the 7900 could be bought in silver, black or red.

BOTTOM LEFT: The Nikon Coolpix 7600.

BELOW: A Nikon UK advert for the Coolpix S1, a model introduced in April 2005.

RIGHT: The Coolpix S1 in its three colour options.

RIGHT: Cover of a recent *Nikon Pro* magazine. Issued to NPS members, this award-winning journal always features stunning photography, like this shot by the immensely talented Jan Vermeer, and in-depth articles on current 'Pro' models.

ABOVE: The main building at Nishi-Oi, which stands next to the older factory that became Nikon's headquarters in the immediate post-war years. Today's CEO is Shoichiro Yoshida, while the COO is Teruo Shimamura.

LEFT: A road sign outside the Nishi-Oi factory. It says Kogaku Dori ('Optical Road'), which runs quite some way before it terminates at Oimachi railway station. All the way along, the Nikon trademark and Kogaku Dori signs are proudly displayed, modern at the station end, and more in keeping with the older narrow streets halfway down it.

was allied to better colour reproduction, while modifications to the eleven-area AF system allowed subjects to be tracked at up to 290km/h. The D2HS also had the ability to take fifty shots in one burst, due to faster data transfer to a larger buffer memory, at a speed of eight frames per second.

Just as the final touches were being applied to this book, Nikon announced the D70S, an updated version of the D70, and a new entry-level digital SLR known as the D50. The D50 was scheduled to go on sale in June 2005 with an open price, and was the first D-series model to be offered in black or silver. Two new DX lenses were due to follow in the second half of 2005: an 18–55mm version and a 55–200mm model. Both were reasonably priced to suit the D50, and came with either a regular black or a silver finish to match the D50 body.

The presence of such technically advanced digital cameras and a growing line of specialist lenses to suit them begs the question as to whether there will ever be an F7 in an era when 35mm photography is becoming increasingly rare in professional circles. Well, who knows! Perhaps when I get around to writing a Second Edition of this book in a few years we'll know more...

Capture what's inside.

FAR LEFT: Cover from the Japanese D2X catalogue.

LEFT: European advertising for the new Nikon D2X.

LEFT: The Nikon D70 was upgraded to become the D70S in spring 2005.

RIGHT: An advanced information sheet for the D50, a new entry-level model in the world of Nikon digital SLR photography.

RANGEFINDER SPECIFICATIONS

The table below is a listing of all the series production Nikon rangefinder cameras produced by Nippon Kogaku (the recent reproductions are not included, but are covered in the main text). The list has been compiled in chronological order, with the date of introduction based on the Japanese sales date rather than the time of a camera's announcement.

MODEL	INTRODUCED	FRAME SIZE	SHUTTER SPEED	SYNCH FACILITY	CHROME/BLACK	WEIGHT	WINDING MECHANISM	MOTOR DRIVE
Nikon I	1948	32 × 24mm	1 – 1/500 + B + T	–	Chrome	790g	Knob	–
M	1949	34 × 24mm	1 – 1/500 + B + T	–	Chrome	835g	Knob	–
S	1950	34 × 24mm	1 – 1/500 + B + T	F + S	Chrome	845g	Knob	–
S2	1954	36 × 24mm	1 – 1/1000 + B + T	FP - X	Both	735g	Lever	MW
SP	1957	36 × 24mm	1 – 1/1000 + B + T	FP - X	Both	740g	Lever	S36
S3	1958	36 × 24mm	1 – 1/1000 + B + T	FP - X	Both	720g	Lever	S36
S4	1959	36 × 24mm	1 – 1/1000 + B + T	FP - X	Both	705g	Lever	–
S3M	1960	17.5 × 24mm	1 – 1/1000 + B + T	FP - X	Both	725g	Lever	S72

With regard to the finish, the S2 was the first body to be marketed officially in black or chrome, although a few black examples of earlier cameras are known to exist, built to special order. Weight includes the contemporary 'normal' 5cm lens, but will inevitably vary slightly from camera to camera due to the constant production changes applied to the Nikkor range.

MODEL	INTRODUCED	PRICE (YEN)	PRODUCTION ENDED	NO. BUILT (APPROX.)	SERIAL NUMBERS
Nikon I	Mar 1948	57,690	Aug 1949	750	6091–
M	Oct 1949	68,400	Dec 1950	1,650	M609761–
S	Dec 1950	74,400	Jan 1955	36,750	M6092361– 6094001–
S2	Dec 1954	83,000	Jun 1958	56,700	6135001–
SP	Sep 1957	98,000	May 1964	22,350	6200001–
S3	Mar 1958	86,000	Mar 1965	14,300	6300001–
S4	Mar 1959	52,000	July 1960	5,900	6304001– 6500001–
S3M	Apr 1960	78,200	Apr 1961	200	6600001–

Please refer to main text for a full explanation of the confusion surrounding production dates and figures on the earlier bodies, as well as the overlapping of serial numbers. The prices indicated are from the time of introduction and include a 5cm f/2 Nikkor lens on the Nikon I, a 5cm f/1.5 lens on the M, and a 5cm f/1.4 lens on all the S models through to the S3s; the S4 was released with the f/2 lens, although a faster version was optional. In addition, the price of the original range of RF models (as opposed to the recent reproductions) includes a case to suit the camera fitted with its standard lens.

RANGEFINDER LENSES

This is a listing of all the post-war lenses produced by Nikon for the rangefinder models, barring the recent reproductions.
The list has been compiled firstly in chronological order (based on the Japanese sales date rather than the time of its announcement, which is often several months ahead of availability and can be misleading), and then again in simplified form in size and speed order (with the smaller, faster lenses first, and given their full name) to provide easy cross-reference.
The final table explains the letters that follow the word 'Nikkor', used to describe the number of elements contained in each lens.

TYPE	INTRODUCED	APERTURE RANGE	ELEMENTS/GROUPS	SERIAL NUMBERS	WEIGHT	CHROME/BLACK	BAYONET/THREAD	FILTER SIZE
5cm f/3.5	Mar 1948	3.5 – 16.0	4 in 3	7051–	90g	Chrome	Both	–
5cm f/2	Apr 1948	2.0 – 16.0	6 in 3	6091–	140g	Chrome	Both	40.5mm
				7081–	145g	Chrome	Both	40.5mm
				8061–	145g	Chrome	Both	40.5mm
				8111–	155g	Chrome	Both	40.5mm
13.5cm f/4	Oct 1948	4.0 – 16.0	4 in 3	6111–	560g	Chrome	Both	40.5mm
				9041–	560g	Chrome	Both	40.5mm
3.5cm f/3.5	Jan 1949	3.5 – 16.0	4 in 3	6121–	190g	Chrome	Both	–
				9101–	190g	Chrome	Both	–
8.5cm f/2	Apr 1949	2.0 – 16.0	5 in 3	8011–	485g	Chrome	Both	48mm
				9031–	485g	Chrome	Both	48mm
				286501–	485g	Chrome	Both	48mm
5cm f/1.5	Jan 1950	1.5 – 11.0	7 in 3	9051–	190g	Chrome	Both	40.5mm
				9071–	190g	Chrome	Both	40.5mm
5cm f/1.4	Jul 1950	1.4 – 16.0	7 in 3	50050001–	200g	Chrome	Both	43mm
				316001–	200g	Chrome	Both	43mm
5cm f/2	Aug 1950	2.0 – 16.0	6 in 3	50080001–	190g	Chrome	Both	40.5mm
				617001–	175g	Chrome	Both	40.5mm
13.5cm f/3.5	Dec 1950	3.5 – 16.0	4 in 3	500601–	545g	Chrome	Both	43mm
				253001–	545g	Chrome	Both	43mm
3.5cm f/3.5	May 1952	3.5 – 22.0	4 in 3	425001–	190g	Chrome	Both	–
13.5cm f/3.5	Jun 1952	3.5 – 32.0	4 in 3	255001–	510g	Chrome	Both	43mm
3.5cm f/2.5	Jul 1952	2.5 – 22.0	6 in 4	243001–	210g	Chrome	Both	43mm
8.5cm f/1.5	Feb 1953	1.5 – 32.0	7 in 3	264001–	550g	Black	Both	60mm
8.5cm f/2	May 1953	2.0 – 32.0	5 in 3	289001–	465g	Chrome	Both	48mm
				396701–	465g	Chrome	Both	48mm
2.8cm f/3.5	Jun 1953	3.5 – 22.0	6 in 4	346001–	150g	Chrome	Both	43mm
				712001–	145g	Chrome	Both	43mm
2.5cm f/4	Nov 1953	4.0 – 22.0	4 in 4	402501–	140g	Chrome	Both	–

TYPE	INTRODUCED	APERTURE RANGE	ELEMENTS/GROUPS	SERIAL NUMBERS	WEIGHT	CHROME/BLACK	BAYONET/THREAD	FILTER SIZE
3.5cm f/3.5	Jun 1954	3.5 – 22.0	4 in 3	434001–	185g	Chrome	Both	43mm
25cm f/4	Jul 1954	4.0 – 32.0	4 in 3	271801–	1,150g	Black	Reflex	82mm
10.5cm f/2.5	Aug 1954	2.5 – 32.0	5 in 3	812001–	510g	Black	Both	52mm
				912001–	510g	Black	Both	52mm
50cm f/5	Feb 1955	5.0 – 45.0	3 in 3	647001–	8,460g	Black	Reflex	110mm
2.5cm f/4	Mar 1955	4.0 – 22.0	4 in 4	403501–	75g	Black	Both	–
18cm f/2.5	Jun 1955	2.5 – 32.0	6 in 4	373501–	1,695g	Black	Reflex	82mm
				470001–	1,695g	Black	Reflex	82mm
2.8cm f/3.5	Mar 1956	3.5 – 22.0	6 in 4	714001–	100g	Black	Both	43mm
3.5cm f/2.5	Mar 1956	2.5 – 22.0	6 in 4	258801–	115g	Black	Both	43mm
3.5cm f/3.5	Mar 1956	3.5 – 22.0	4 in 3	438801–	100g	Black	Both	43mm
5cm f/1.4	Mar 1956	1.4 – 16.0	7 in 3	374001–	145g	Black	Both	43mm
5cm f/2	Mar 1956	2.0 – 16.0	6 in 3	714001–	140g	Black	Both	40.5mm
8.5cm f/2	Mar 1956	2.0 – 32.0	5 in 3	496001–	340g	Black	Both	48mm
13.5cm f/3.5	Mar 1956	3.5 – 32.0	4 in 3	268001–	390g	Black	Both	43mm
3.5cm f/1.8	Apr 1956	1.8 – 22.0	7 in 5	351801–	160g	Black	Both	43mm
25cm f/4	May 1956	4.0 – 32.0	4 in 3	272401–	920g	Black	Reflex	82mm
				277201–	920g	Black	Reflex	82mm
3.5cm Stereo	May 1956	3.5 – 16.0	4 in 3	241801–	185g	Chrome	Bayonet	–
5cm f/1.1	Jun 1956	1.1 – 22.0	9 in 6	119601–	345g	Black	Both	62mm
5cm Micro	Oct 1956	3.5 – 22.0	5 in 4	523001–	145g	Chrome	Both	34.5mm
13.5cm Bllws	Jan 1959	4.0 – 22.0	4 in 3	578001–	215g	Black	Bellows	43mm
2.1cm f/4	May 1959	4.0 – 16.0	8 in 4	621001–	150g	Black	Bayonet	43mm
5cm f/1.1	Jun 1959	1.1 – 22.0	9 in 6	140701–	400g	Black	Bayonet	62mm
10.5cm f/4	Mar 1960	4.0 – 22.0	3 in 3	408501–	260g	Black	Bayonet	34.5mm
100cm Reflex	May 1960	6.3 –	3 in 2	100601–	9,980g	Grey	Reflex	52mm
35cm f/4.5	Jun 1960	4.5 – 22.0	3 in 3	354501–	1,665g	Black	Reflex	82mm
50mm f/1.4	Oct 1962	1.4 – 16.0	7 in 4	140001–	180g	Black	Bayonet	43mm

NOTE TO TABLE: The chrome and black lens type listings are not always 100 per cent definitive. There will be occasions when a lens with a chrome finish will appear within a batch of serial numbers allocated to black lenses in this table, and vice versa, especially during crossover periods. Some serial numbers are approximate for this reason, and serve as guidance only.

TYPE	INTRODUCED	PRICE (YEN)
2.1cm f/4 Nikkor-O	1959	33,000
2.5cm f/4 W-Nikkor	1953	29,000
2.8cm f/3.5 W-Nikkor	1953	30,160
3.5cm f/1.8 W-Nikkor	1956	27,000
3.5cm f/2.5 W-Nikkor	1952	27,560
3.5cm f/3.5 W-Nikkor	1949	19,500
3.5cm f/3.5 Stereo-Nikkor	1956	26,500
5cm f/1.1 Nikkor-N (Int Mnt)	1956	55,000
5cm f/1.1 Nikkor-N (Ext Mnt)	1959	55,000
5cm f/1.4 Nikkor-SC	1950	30,000
5cm f/1.5 Nikkor-SC	1950	27,000
5cm f/2 Nikkor-HC	1948	18,000
5cm f/3.5 Nikkor-QC	1948	–
5cm f/3.5 Micro-Nikkor	1956	31,000
8.5cm f/1.5 Nikkor-S	1953	61,360
8.5cm f/2 Nikkor-P	1949	38,000
10.5cm f/2.5 Nikkor-P	1954	31,200
10.5cm f/4 Nikkor-T	1960	15,500
13.5cm f/3.5 Nikkor-Q	1950	24,000
13.5cm f/4 Nikkor-Q	1948	23,500
13.5cm f/4 Nikkor-Q (Bellows)	1959	29,000
18cm f/2.5 Nikkor-H	1955	87,000
25cm f/4 Nikkor-Q	1954	57,200
35cm f/4.5 Nikkor-T	1960	110,000
50cm f/5 Nikkor-T	1955	120,000
100cm f/6.3 Reflex-Nikkor	1960	230,000

DESIGNATION	MEANING	TRANSLATING TO
Nikkor-T	Tres	Three elements
Nikkor-Q	Quattuor	Four elements
Nikkor-P	Pente	Five elements
Nikkor-H	Hex	Six elements
Nikkor-S	Septem	Seven elements
Nikkor-O	Octo	Eight elements
Nikkor-N	Novem	Nine elements

NOTE TO TABLE: This system of lens coding was used by Nippon Kogaku on non-zoom Nikkors well into the F2 series run in the mid-1970s. Latin is used for all but the five- and six-element entries, as the 'Q' and 'S' would have been duplicated. Instead, Greek was used for these two variations to give different letters.

NOTE TO TABLE: The price listed is usually that quoted at the time of home market introduction. Prices indicated are for lenses with the Nikon bayonet mount, and when bought as a separate item.

SLR PRO BODY SPECIFICATIONS

This is a listing of all the series production Nikon SLR cameras produced mainly for professionals and serious amateur photographers – the so-called 'pro' bodies (the F, F2, F3, F4, F5 and F6). The list has been compiled in chronological order but batched by model type for ease of reference (it should be remembered that some F3 variants were still being produced well into the F5 run), with the date of introduction based on the Japanese sales date rather than the time of a camera's announcement.

MODEL	INTRODUCED	FOCUS SYSTEM	SHUTTER SPEEDS	CHROME/BLACK	WEIGHT	MOTOR DRIVE
Nikon F	1959	Manual	1 – 1/1000 + B + T + X	Both	685g	F36, F250
F Photomic	1962	Manual	1 – 1/1000 + B + T + X	Both	830g	F36, F250
F Photomic T	1965	Manual	1 – 1/1000 + B + T + X	Both	830g	F36, F250
F Photomic TN	1967	Manual	1 – 1/1000 + B + T + X	Both	830g	F36, F250
F Photomic FTN	1968	Manual	1 – 1/1000 + B + T + X	Both	860g	F36, F250
F2	1971	Manual	1 – 1/2000 + B + T + X	Both	730g	MD-1, MD-2, MD-3
F2 Photomic	1971	Manual	1 – 1/2000 + B + T + X	Both	840g	MD-1, MD-2, MD-3
F2 Photomic S	1973	Manual	1 – 1/2000 + B + T + X	Both	880g	MD-1, MD-2, MD-3
F2 Photomic SB	1976	Manual	1 – 1/2000 + B + T + X	Both	850g	MD-2, MD-3
F2 Photomic A	1977	Manual	1 – 1/2000 + B + T + X	Both	820g	MD-2, MD-3
F2 Photomic AS	1977	Manual	1 – 1/2000 + B + T + X	Both	840g	MD-2, MD-3
F2 Titan	1979	Manual	1 – 1/2000 + B + T + X	Both	715g	MD-2, MD-3
F3	1980	Manual	8 – 1/2000 + B + T + X + A	Black	715g	MD-4
F3 HP	1982	Manual	8 – 1/2000 + B + T + X + A	Black	760g	MD-4
F3/T	1982	Manual	8 – 1/2000 + B + T + X + A	Both	740g	MD-4
F3 AF	1983	AF	8 – 1/2000 + B + T + X + A	Black	950g	MD-4
F3 Limited	1993	Manual	8 – 1/2000 + B + T + X + A	Black	780g	MD-4
F4	1988	AF	30 – 1/8000 + B + T + X + A + P	Black	1,090g	Built-in
F4S	1988	AF	30 – 1/8000 + B + T + X + A + P	Black	1,280g	Built-in
F4E	1991	AF	30 – 1/8000 + B + T + X + A + P	Black	1,390g	Built-in
F5	1996	AF	30 – 1/8000 + B + X + A + P	Black	1,210g	Built-in
F6	2004	AF	30 – 1/8000 + B + X + A + P	Black	975g	Built-in

Some variations are possible within each type, such as those bodies built for NASA or other special purposes (like the dedicated press cameras), as well as local names and limited editions like the fiftieth anniversary F5. Please refer to the main text for details on these models. Weight listed is for the body only. Motor drives are optional unless otherwise stated.

MODEL	INTRODUCED	PRICE (YEN)	PRODUCTION ENDED	SERIAL NUMBERS
Nikon F	Jun 1959	47,000	1973	6400001–
F Photomic	Apr 1962	53,000	1965	>
F Photomic T	Sep 1965	55,500	1967	>
F Photomic TN	Apr 1967	56,200	1968	>
F Photomic FTN	Sep 1968	57,700	1973	>
F2	Sep 1971	64,200	1980	F2 7100001–
F2 Photomic	Sep 1971	82,000	1978	>
F2 Photomic S	Mar 1973	96,200	1978	>
F2 Photomic SB	Oct 1976	122,000	1978	>
F2 Photomic A	Mar 1977	102,000	1980	>
F2 Photomic AS	Jul 1977	126,000	1980	>
F2 Titan	Jun 1979	98,000	1980	F2T 790001–
F3	Mar 1980	139,000	2000	1200001–
F3 HP	Mar 1982	149,000	2000	>
F3/T	Dec 1982	195,000	2000	T 8200001–
F3 AF	Apr 1983	250,000	1988	AF 8300001–
F3 Limited	Oct 1993	165,000	1994	L 9500001–
F4	Dec 1988	226,000	1996	2000001–
F4S	Dec 1988	239,000	1996	>
F4E	Apr 1991	262,000	1996	>
F5	Oct 1996	325,000	2004	3000001–
F6	Oct 2004	300,000	–	0000001–

Price is for the body only, at the time of introduction (with the standard chrome finish – a black finish was usually ¥1,500–5,000 more), and with a case classed as an optional extra. The original F was usually supplied with a 50mm f/2 lens as standard (priced at ¥67,000 in chrome), but, after this, cameras were generally supplied in 'body only' guise. Please refer to main text for a more detailed breakdown of serial numbers.

THE REGULAR SLR MODELS

This is a listing of all the series production Nikon SLR cameras produced as second bodies for professionals, or with enthusiastic amateur photographers in mind. The list has been compiled in chronological order, with the date of introduction based on the Japanese sales date rather than the time of a camera's announcement.

MODEL	INTRODUCED	FOCUS SYSTEM	SHUTTER SPEEDS	CHROME/BLACK	WEIGHT	MOTOR DRIVE
Nikkorex 35	1960	Manual	1 – 1/500 + B + X	Chrome	820g	–
Nikkorex 35/2	1962	Manual	1 – 1/500 + B + X	Chrome	840g	–
Nikkorex F	1962	Manual	1 – 1/1000 + B + X	Chrome	795g	–
Nikkorex Zoom 35	1963	Manual	1 – 1/500 + B + X	Chrome	1,170g	–
Nikon Auto 35	1964	Manual	1 – 1/500 + B + X	Chrome	840g	–
Nikomat FT	1965	Manual	1 – 1/1000 + B + X	Both	750g	–
Nikomat FS	1965	Manual	1 – 1/1000 + B + X	Chrome	715g	–
Nikomat FTN	1967	Manual	1 – 1/1000 + B + X	Both	765g	–
Nikomat EL	1972	Manual	4 – 1/1000 + B + X + A	Both	760g	–
Nikomat FT2	1975	Manual	1 – 1/1000 + B + X	Both	780g	–
Nikomat ELW	1976	Manual	4 – 1/1000 + B + X + A	Black	790g	AW-1
Nikomat FT3	1977	Manual	1 – 1/1000 + B + X	Both	740g	–
Nikon EL2	1977	Manual	8 – 1/1000 + B + X + A	Both	780g	AW-1
Nikon FM	1977	Manual	1 – 1/1000 + B + X	Both	590g	MD-11, MD-12
Nikon FE	1978	Manual	8 – 1/1000 + B + X + A + M	Both	590g	MD-11, MD-12
Nikon EM	1980	Manual	1 – 1/1000 + B + X + A + M	Black	460g	MD-E, MD-14
Nikon FM2	1982	Manual	1 – 1/4000 + B + X	Both	540g	MD-12
Nikon FG	1982	Manual	1 – 1/1000 + B + X + A + P	Both	490g	MD-E, MD-14
Nikon FE2	1983	Manual	8 – 1/4000 + B + X + A + M	Both	540g	MD-12
Nikon FA	1983	Manual	1 – 1/4000 + B + X + A + M + P	Both	625g	MD-12, MD-15
Nikon FG-20	1984	Manual	1 – 1/1000 + B + X + A	Both	440g	MD-E, MD-14
Nikon New FM2	1984	Manual	1 – 1/4000 + B + X	Both	540g	MD-12
Nikon F-301	1985	Manual	1 – 1/2000 + B + X + A + P	Black	555g	Built-in
Nikon F-501	1986	AF	1 – 1/2000 + B + X + A + P	Black	610g	Built-in
Nikon F-401	1987	AF	1 – 1/2000 + B + X + A + P	Black	650g	Built-in
Nikon F-401 QD	1987	AF	1 – 1/2000 + B + X + A + P	Black	660g	Built-in
Nikon F-801	1988	AF	30 – 1/8000 + B + X + A + P	Black	695g	Built-in
Nikon F-401S	1989	AF	1 – 1/2000 + B + X + A + P	Black	655g	Built-in
Nikon F-401S QD	1989	AF	1 – 1/2000 + B + X + A + P	Black	665g	Built-in
Nikon F-601	1990	AF	30 – 1/2000 + B + X + A + P	Black	650g	Built-in
Nikon F-601M	1990	Manual	30 – 1/2000 + B + X + A + P	Black	610g	Built-in

MODEL	INTRODUCED	FOCUS SYSTEM	SHUTTER SPEEDS	CHROME/BLACK	WEIGHT	MOTOR DRIVE
Nikon F-601 QD	1990	AF	30 – 1/2000 + B + X + A + P	Black	660g	Built-in
Nikon F-801S	1991	AF	30 – 1/8000 + B + X + A + P	Black	695g	Built-in
Nikon F-401X	1991	AF	30 – 1/2000 + T + X + A + P	Black	650g	Built-in
Nikon F-401X QD	1991	AF	30 – 1/2000 + T + X + A + P	Black	660g	Built-in
Nikon F90	1992	AF	30 – 1/8000 + B + X + A + P	Black	755g	Built-in
Nikon F90D	1992	AF	30 – 1/8000 + B + X + A + P	Black	775g	Built-in
Nikon F90S	1992	AF	30 – 1/8000 + B + X + A + P	Black	785g	Built-in
Nikon New FM2/T	1993	Manual	1 – 1/4000 + B + X	Chrome	515g	MD-12
Nikon F50	1994	AF	30 – 1/2000 + T + X + A + P	Both	575g	Built-in
Nikon F50D	1994	AF	30 – 1/2000 + T + X + A + P	Both	590g	Built-in
Nikon F90X	1994	AF	30 – 1/8000 + B + X + A + P	Black	755g	Built-in
Nikon F90XD	1994	AF	30 – 1/8000 + B + X + A + P	Black	775g	Built-in
Nikon F90XS	1994	AF	30 – 1/8000 + B + X + A + P	Black	785g	Built-in
Nikon F70	1994	AF	30 – 1/4000 + B + X + A + P	Both	585g	Built-in
Nikon F70D	1994	AF	30 – 1/4000 + B + X + A + P	Both	600g	Built-in
Nikon FM10	1996	Manual	1 – 1/2000 + B + X	Chrome	420g	–
Nikon Pronea 600i	1996	AF	30 – 1/4000 + B + X + A + P	Grey	560g	Built-in
Nikon FE10	1997	Manual	1 – 1/2000 + B + X + A	Chrome	400g	–
Nikon F60	1998	AF	30 – 1/2000 + T + X + A + P	Both	575g	Built-in
Nikon F60D	1998	AF	30 – 1/2000 + T + X + A + P	Both	590g	Built-in
Nikon Pronea S	1998	AF	30 – 1/2000 + B + X + A + P	Chrome	325g	Built-in
Nikon F100	1998	AF	30 – 1/8000 + B + X + A + P	Black	785g	Built-in
Nikon F80	2000	AF	30 – 1/4000 + B + X + A + P	Black	515g	Built-in
Nikon F80D	2000	AF	30 – 1/4000 + B + X + A + P	Black	520g	Built-in
Nikon F80S	2000	AF	30 – 1/4000 + B + X + A + P	Black	525g	Built-in
Nikon F65	2001	AF	30 – 1/2000 + T + X + A + P	Both	395g	Built-in
Nikon U (F65D)	2001	AF	30 – 1/2000 + T + X + A + P	Silver	400g	Built-in
Nikon FM3A	2001	Manual	1 – 1/4000 + B + X + A	Both	570g	MD-12
Nikon F55	2002	AF	30 – 1/2000 + T + X + A + P	Silver	350g	Built-in
Nikon Us (F55D)	2002	AF	30 – 1/2000 + T + X + A + P	Silver	360g	Built-in
Nikon F75	2003	AF	30 – 1/2000 + T + X + A + P	Both	380g	Built-in
Nikon U2 (F75D)	2003	AF	30 – 1/2000 + T + X + A + P	Both	385g	Built-in

Some variations are possible within each type, with limited editions such as the gold FA, for instance, and local names are quite common. Please refer to the main text for details on these models. Apart from the Nikkorex 35 series (all four variants, including the Auto 35 rather than the Nikkorex F, are listed with the standard lens issued with the camera), the weight listed is for the body only. Motor drives are optional unless otherwise stated.

MANUAL FOCUS MODELS

MODEL	INTRODUCED	PRICE (YEN)	US NAME
Nikkorex 35	Mar 1960	22,300	–
Nikkorex 35/2	Apr 1962	19,800	–
Nikkorex F	Jun 1962	49,300	–
Nikkorex Zoom 35	Feb 1963	39,500	–
Nikon Auto 35	Sep 1964	29,500	–
Nikomat FT	Jul 1965	31,000	Nikkormat FT
Nikomat FS	Jul 1965	23,800	Nikkormat FS
Nikomat FTN	Oct 1967	32,000	Nikkormat FTN
Nikomat EL	Dec 1972	60,500	Nikkormat EL
Nikomat FT2	Mar 1975	41,000	Nikkormat FT2
Nikomat ELW	Feb 1976	81,000	Nikkormat ELW
Nikomat FT3	Mar 1977	43,000	Nikkormat FT3
Nikon EL2	May 1977	79,000	–
Nikon FM	May 1977	57,000	–
Nikon FE	Apr 1978	69,000	–
Nikon EM	Mar 1980	40,000	–
Nikon FM2	Mar 1982	63,000	–
Nikon FG	May 1982	61,000	–
Nikon FE2	Mar 1983	75,000	–
Nikon FA	Sep 1983	115,000	–
Nikon FG-20	Mar 1984	48,000	–
Nikon New FM2	Mar 1984	65,000	–
Nikon F-301	Sep 1985	68,000	N2000
Nikon F-601M	Sep 1990	65,000	N6000
Nikon New FM2/T	Dec 1993	92,000	–
Nikon FM10	May 1996	37,000	–
Nikon FE10	Apr 1997	47,000	–
Nikon FM3A	Jul 2001	96,000	–

AUTOFOCUS MODELS

MODEL	INTRODUCED	PRICE (YEN)	US NAME
Nikon F-501	Apr 1986	89,000	N2020
Nikon F-401	Jun 1987	64,000	N4004
Nikon F-401 QD	Jun 1987	69,000	N4004QD
Nikon F-801	Jun 1988	104,000	N8008
Nikon F-401S	Apr 1989	61,000	N4004S
Nikon F-401S QD	Apr 1989	66,000	N4004S QD
Nikon F-601	Sep 1990	80,000	N6006
Nikon F-601 QD	Sep 1990	85,000	N6006QD
Nikon F-801S	Mar 1991	98,000	N8008S
Nikon F-401X	Sep 1991	64,000	N5005
Nikon F-401X QD	Sep 1991	69,000	N5005QD
Nikon F90	Sep 1992	128,000	N90
Nikon F90D	Sep 1992	140,000	N90
Nikon F90S	Sep 1992	155,000	N90
Nikon F50	Apr 1994	Export	N50
Nikon F50D	Apr 1994	68,000	N50QD
Nikon F90X	Oct 1994	138,000	N90S
Nikon F90XD	Oct 1994	150,000	N90S
Nikon F90XS	Oct 1994	165,000	N90S
Nikon F70	Nov 1994	Export	N70
Nikon F70D	Nov 1994	95,000	N70QD
Nikon Pronea 600i	Dec 1996	83,000	Pronea 6i
Nikon F60	Aug 1998	Export	N60
Nikon F60D	Aug 1998	62,000	N60QD
Nikon Pronea S	Sep 1998	54,000	–
Nikon F100	Dec 1998	190,000	–
Nikon F80	Apr 2000	Export	N80
Nikon F80D	Apr 2000	88,000	N80QD
Nikon F80S	Apr 2000	102,000	–
Nikon F65	Mar 2001	Export	N65
Nikon U (F65D)	Mar 2001	61,000	N65QD
Nikon F55	Mar 2002	Export	N55
Nikon Us (F55D)	Mar 2002	50,000	–
Nikon F75	Mar 2003	Export	N75
Nikon U2 (F75D)	Mar 2003	64,000	N75QD

Apart from the Nikkorex series (including the Nikon Auto 35), which usually came with a lens, the price quoted is for the body only at the time of introduction with the standard chrome finish – a black finish usually cost a touch more (between ¥2,500 and ¥4000) on the earlier models, and with a case classed as an optional extra.

THE DIGITAL SLR
BODIES

This section looks at the digital SLR bodies offered by Nikon in recent years, including the 'pro' models. The list has been compiled in chronological order based on the Japanese sales date. The price is for a body only, quoted at the time of home market introduction. Weight also relates to the body on its own.

MODEL	INTRODUCED	FOCUS SYSTEM	SHUTTER SPEEDS	WEIGHT	PRICE (YEN)
E2	Apr 1995	AF	1/8 – 1/2000 + B + X + A + P	1,720g	1,100,000
E2S	Apr 1995	AF	1/8 – 1/2000 + B + X + A + P	1,850y	1,400,000
E2N	Sep 1996	AF	1/8 – 1/2000 + B + X + A + P	1,720g	890,000
E2NS	Nov 1996	AF	1/8 – 1/2000 + B + X + A + P	1,850g	1,300,000
E3	Jun 1998	AF	1/8 – 1/2000 + B + X + A + P	1,670g	770,000
E3S	Jun 1998	AF	1/8 – 1/2000 + B + X + A + P	1,680g	980,000
D1	Oct 1999	AF	30 – 1/16,000 + B + X + A + P	1,100g	650,000
D1X	May 2001	AF	30 – 1/16,000 + B + X + A + P	1,100g	590,000
D1H	Jul 2001	AF	30 – 1/16,000 + B + X + A + P	1,100g	470,000
D100	Jun 2002	AF	30 – 1/4000 + B + X + A + P	700g	300,000
D2H	Nov 2003	AF	30 – 1/8000 + B + X + A + P	1,070g	490,000
D70	Mar 2004	AF	30 – 1/8000 + B + T + X + A + P	595g	150,000
D2X	Jan 2005	AF	30 – 1/8000 + B + X + A + P	1,070g	600,000
D2HS	Mar 2005	AF	30 – 1/8000 + B + X + A + P	1,070g	490,000
D70S	Apr 2005	AF	30 – 1/8000 + B + T + X + A + P	600g	Open
D50	Jun 2005	AF	30 – 1/4000 + B + T + X + A + P	540g	Open

All models except the D50 came in black only: the new budget model could be specified with a regular black body finish, or in silver. An 'Open' price allows dealers to set the selling price based on their cost (as such, there is no RRP).

SLR LENSES

This is a listing of all the lenses produced by Nikon for the SLR models. The list has been compiled firstly in chronological order (based on the Japanese sales date rather than the time of its announcement, which is often several months ahead of availability and can be misleading), and then again in simplified form in size and speed order (with the smaller, faster lenses first, and given their full name) to provide easy cross-reference.

MANUAL FOCUS LENSES

'Auto' series

TYPE	INTRODUCED	APERTURE RANGE	ELEMENTS/ GROUPS	SERIAL NUMBERS	WEIGHT	FILTER SIZE
50mm f/2	Jun 1959	2.0 – 16.0	7 in 5	520001–	200g	52mm
105mm f/2.5	Jun 1959	2.5 – 22.0	5 in 3	120101–	375g	52mm
135mm f/3.5	Jun 1959	3.5 – 22.0	4 in 3	720001–	470g	52mm
35mm f/2.8	Aug 1959	2.8 – 16.0	7 in 6	920001–	290g	52mm
				167001–	290g	52mm
21mm f/4	Nov 1959	4.0 – 16.0	8 in 4	220101–	135g	52mm
85–250mm Zoom	Dec 1959	4.0 – 16.0	15 in 8	157901–	2,100g	82mm
58mm f/1.4	Jan 1960	1.4 – 16.0	7 in 6	140001–	365g	52mm
28mm f/3.5	Mar 1960	3.5 – 16.0	6 in 6	301001–	215g	52mm
105mm f/4	Mar 1960	4.0 – 22.0	3 in 3	405001–	230g	34.5mm
85–250mm Zoom	Aug 1960	4.0 – 16.0	15 in 8	159201–	2,030g	82mm
200mm f/4	Jul 1961	4.0 – 22.0	4 in 4	169201–	630g	52mm
55mm Micro (P)	Aug 1961	3.5 – 22.0	5 in 4	171501–	240g	52mm
500mm Reflex	Sep 1961	5.0 –	5 in 4	171001–	1,600g	122mm
200–600mm Zoom	Oct 1961	9.5 – 32.0	13 in 7	170101–	2,800g	82mm
50mm f/1.4	Mar 1962	1.4 – 16.0	7 in 5	314101–	325g	52mm
8mm f/8	Jul 1962	8.0 – 22.0	9 in 5	880001–	300g	–
35mm PC	Jul 1962	3.5 – 32.0	6 in 6	102101–	290g	52mm
35mm f/2	Aug 1962	2.0 – 16.0	8 in 6	102101–	285g	52mm
200mm Medical	Dec 1962	5.6 – 45.0	4 in 4	104001–	670g	38mm
43–86mm Zoom	Jan 1963	3.5 – 22.0	9 in 7	438601–	410g	52mm
55mm Micro (P)	Mar 1963	3.5 – 32.0	5 in 4	173801–	235g	52mm
50mm f/2	Jan 1964	2.0 – 16.0	6 in 4	600001–	205g	52mm
300mm f/4.5	Jul 1964	4.5 – 22.0	5 in 5	304501–	1,060g	72mm

TYPE	INTRODUCED	APERTURE RANGE	ELEMENTS/ GROUPS	SERIAL NUMBERS	WEIGHT	FILTER SIZE
85mm f/1.8	Aug 1964	1.8 – 22.0	6 in 4	188001–	420g	52mm
400mm f/4.5	Aug 1964	4.5 – 22.0	4 in 4	400101–	1,900g	122mm
600mm f/5.6	Aug 1964	5.6 – 22.0	5 in 4	600101–	2,400g	122mm
800mm f/8	Aug 1964	8.0 – 22.0	5 in 5	800101–	2,300g	122mm
1,200mm f/11	Aug 1964	11.0 – 64.0	5 in 5	120001–	3,100g	122mm
1,000mm Reflex	Sep 1964	6.3 –	3 in 2	631001–	9,900g	122mm
21mm f/4	Dec 1965	4.0 – 16.0	8 in 4	225001–	135g	52mm
35mm f/2	Dec 1965	2.0 – 16.0	8 in 6	690101–	285g	52mm
35mm f/2.8	Dec 1965	2.8 – 16.0	7 in 6	255301–	290g	52mm
55mm f/1.2	Dec 1965	1.2 – 16.0	7 in 5	970101–	420g	52mm
				184701–	420g	52mm
135mm f/2.8	Dec 1965	2.8 – 22.0	4 in 4	135001–	620g	52mm
50mm f/1.4	Feb 1966	1.4 – 16.0	7 in 5	516801–	325g	52mm
1,000mm Reflex	Feb 1966	11.0 –	5 in 5	100001–	1,900g	122mm
50mm f/2	Jun 1966	2.0 – 16.0	6 in 4	625001–	205g	52mm
55mm Micro	Jun 1966	3.5 – 32.0	5 in 4	211001–	235g	52mm
7.5mm f/5.6	Jul 1966	5.6 – 22.0	9 in 6	750001–	315g	–
105mm f/2.5	Jul 1966	2.5 – 22.0	5 in 3	194001–	380g	52mm
50–300mm Zoom	Feb 1967	4.5 – 22.0	20 in 13	740101–	2,270g	95mm
24mm f/2.8	Aug 1967	2.8 – 16.0	9 in 7	242801–	290g	52mm
20mm f/3.5	Jan 1968	3.5 – 22.0	11 in 9	421201–	390g	72mm
10mm f/5.6	May 1968	5.6 – 22.0	9 in 6	180001–	400g	–
35mm PC	May 1968	2.8 – 32.0	8 in 7	851001–	335g	52mm
135mm Bellows	Jun 1968	4.0 – 22.0	4 in 3	890001–	260g	52mm
300mm f/4.5	Jan 1969	4.5 – 22.0	6 in 5	370001–	1,030g	72mm
GN Auto 45mm	Mar 1969	2.8 – 32.0	4 in 3	710101–	135g	52mm
500mm Reflex	Mar 1969	8.0 –	5 in 3	501001–	1000g	122mm
200mm f/4	Apr 1969	4.0 – 32.0	4 in 4	420001–	630g	52mm
6mm f/5.6	May 1969	5.6 – 22.0	9 in 6	656001–	430g	–
135mm f/3.5	May 1969	3.5 – 32.0	4 in 3	865001–	470g	52mm
85–250mm Zoom	Sep 1969	4.0 – 16.0	16 in 9	184701–	2,000g	82mm
105mm Bellows	Jan 1970	4.0 – 32.0	5 in 3	900001–	230g	52mm
55mm Micro	Apr 1970	3.5 – 32.0	5 in 4	600001–	235g	52mm
8mm f/2.8	Aug 1970	2.8 – 22.0	10 in 8	230001–	1,000g	–
80–200mm Zoom	Sep 1970	4.5 – 32.0	15 in 10	101901–	830g	52mm
105mm f/2.5	Feb 1971	2.5 – 32.0	5 in 4	407301–	435g	52mm
35mm f/1.4C	Mar 1971	1.4 – 22.0	9 in 7	350001–	415g	52mm
180mm f/2.8	Mar 1971	2.8 – 32.0	5 in 4	312001–	830g	72mm
28mm f/2C	Apr 1971	2.0 – 22.0	9 in 8	280001–	345g	52mm
200–600mm Zoom	Apr 1971	9.5 – 32.0	19 in 12	290001–	2,300g	82mm
50mm f/1.4C	Jul 1971	1.4 – 16.0	7 in 5	1280201–	325g	52mm
300mm f/2.8	Jan 1972	2.8 – 32.0	6 in 5	603001–	2,600g	122mm
6mm f/2.8C	Jun 1972	2.8 – 22.0	12 in 9	628001–	5,200g	–
2000mm Reflex	Jun 1972	11.0 –	5 in 5	200101–	17,500g	39mm
55mm f/1.2C	Oct 1972	1.2 – 16.0	7 in 5	250001–	420g	52mm
200mm Medical	Oct 1972	5.6 – 45.0	4 in 4	120101–	670g	38mm
24mm f/2.8C	Dec 1972	2.8 – 16.0	9 in 7	370001–	290g	52mm

TYPE	INTRODUCED	APERTURE RANGE	ELEMENTS/ GROUPS	SERIAL NUMBERS	WEIGHT	FILTER SIZE
50mm f/2C	Dec 1972	2.0 – 16.0	6 in 4	2140001–	205g	52mm
80–200mm Zoom	Feb 1973	4.5 – 32.0	15 in 10	140001–	830g	52mm
105mm f/2.5C	Feb 1973	2.5 – 32.0	5 in 4	500001–	435g	52mm
15mm f/5.6	Mar 1973	5.6 – 22.0	14 in 12	320001–	720g	–
16mm f/3.5	Mar 1973	3.5 – 22.0	8 in 5	272001–	330g	–
400mm f/5.6C	Mar 1973	5.6 – 32.0	5 in 3	256001–	1,400g	72mm
55mm Micro	Aug 1973	3.5 – 32.0	5 in 4	730001–	235g	52mm
35mm f/2C	Sep 1973	2.0 – 16.0	8 in 6	835001–	285g	52mm
600mm f/5.6C	Jan 1974	5.6 – 22.0	5 in 4	611001–	2,400g	122mm
28mm f/3.5C	Feb 1974	3.5 – 16.0	6 in 6	850001–	215g	52mm
43–86mm Zoom	Feb 1974	3.5 – 22.0	9 in 7	690001–	410g	52mm
200mm f/4C	Feb 1974	4.0 – 32.0	4 in 4	570001–	630g	52mm
GN Auto 45mm	Mar 1974	2.8 – 32.0	4 in 3	760001–	135g	52mm
135mm f/2.8C	Mar 1974	2.8 – 22.0	4 in 4	380001–	620g	52mm
1,000mm Reflex	Apr 1974	11.0 –	5 in 5	140001–	1,900g	39mm
15mm f/5.6C	Jun 1974	5.6 – 22.0	14 in 12	321001–	650g	–
85mm f/1.8C	Jun 1974	1.8 – 22.0	6 in 4	390001–	420g	52mm
135mm f/3.5C	Aug 1974	3.5 – 32.0	4 in 3	100001–	460g	52mm
200mm Medical	Aug 1974	5.6 – 45.0	4 in 4	125001–	700g	38mm
800mm f/8C	Aug 1974	8.0 – 22.0	5 in 5	810601–	2,300g	122mm
500mm Reflex	Sep 1974	8.0 –	5 in 3	530001–	1,000g	122mm
1,200mm f/11C	Sep 1974	11.0 – 64.0	5 in 5	131401–	3,100g	122mm
13mm f/5.6C	Jun 1975	5.6 – 22.0	16 in 12	173001–	1,250g	–
2,000mm Reflex	Feb 1976	11.0 –	5 in 5	200201–	17,500g	39mm
180mm f/2.8C	Apr 1976	2.8 – 32.0	5 in 4	350001–	830g	72mm
400mm f/4.5C	May 1976	4.5 – 22.0	4 in 4	410801–	1,900g	122mm

NOTE TO TABLE: Serial numbers are approximate, and serve as guidance only.

TYPE	INTRODUCED	PRICE (YEN)	TYPE	INTRODUCED	PRICE (YEN)
6mm f/2.8C Fisheye-Nikkor	1972	600,000	28mm f/2C Nikkor-N	1971	55,000
6mm f/5.6 Fisheye-Nikkor	1969	200,000	28mm f/3.5 Nikkor-H	1960	29,000
7.5mm f/5.6 Fisheye-Nikkor	1966	71,500	28mm f/3.5C Nikkor-H	1974	28,000
8mm f/2.8 Fisheye-Nikkor	1970	106,000	35mm f/1.4C Nikkor-N	1971	60,000
8mm f/8 Fisheye-Nikkor	1962	72,500	35mm f/2 Nikkor-O	1962	29,000
10mm f/.6 OP Fisheye	1968	109,000	35mm f/2C Nikkor-O	1973	36,000
13mm f/5.6C Nikkor-HD	1975	750,000	35mm f/2.8 Nikkor-S	1959	29,000
15mm f/5.6 Nikkor-QD	1973	160,000	35mm f/2.8 PC-Nikkor	1968	40,000
15mm f/5.6C Nikkor-QD	1974	185,000	35mm f/3.5 PC-Nikkor	1962	35,000
16mm f/3.5 Fisheye-Nikkor	1973	70,000	GN Auto 45mm f/2.8	1969	16,500
20mm f/3.5 Nikkor-UD	1968	40,000	GN Auto 45mm f/2.8C	1974	19,000
21mm f/4 Nikkor-O	1959	33,000	50mm f/1.4 Nikkor-S	1962	28,000
24mm f/2.8 Nikkor-N	1967	30,000	50mm f/1.4C Nikkor-S	1971	30,000
24mm f/2.8C Nikkor-N	1972	40,000	50mm f/2 Nikkor-S	1959	20,000

TYPE	INTRODUCED	PRICE (YEN)	TYPE	INTRODUCED	PRICE (YEN)
50mm f/2 Nikkor-H	1964	17,500	400mm f/4.5 Nikkor-Q	1964	92,500
50mm f/2C Nikkor-H	1972	21,000	400mm f/4.5C Nikkor-Q	1976	115,000
55mm f/1.2 Nikkor-S	1965	36,000	400mm f/5.6C Nikkor-P	1973	200,000
55mm f/1.2C Nikkor-S	1972	45,000	500mm f/5 Reflex-Nikkor	1961	79,500
55mm f/3.5 Micro-Nikkor	1961	24,000	500mm f/8 Reflex-Nikkor	1969	65,000
55mm f/3.5C Micro-Nikkor	1973	32,000	500mm f/8C Reflex-Nikkor	1974	75,000
58mm f/1.4 Nikkor-S	1960	24,000	600mm f/5.6 Nikkor-P	1964	105,000
85mm f/1.8 Nikkor-H	1964	33,500	600mm f/5.6C Nikkor-P	1974	135,000
85mm f/1.8C Nikkor-H	1974	38,000	800mm f/8 Nikkor-P	1964	114,000
105mm f/2.5 Nikkor-P	1959	35,000	800mm f/8C Nikkor-P	1974	170,000
105mm f/2.5C Nikkor-P	1973	33,000	1,000mm f/6.3 Reflex-Nikkor	1964	230,000
105mm f/4 Nikkor-T	1960	14,000	1,000mm f/11 Reflex-Nikkor	1966	135,000
105mm f/4 Bellows	1970	26,000	1,000mm f/11C Reflex-Nikkor	1974	145,000
135mm f/2.8 Nikkor-Q	1965	28,000	1,200mm f/11 Nikkor-P	1964	155,500
135mm f/2.8C Nikkor-Q	1974	33,000	1,200mm f/11C Nikkor-P	1974	210,000
135mm f/3.5 Nikkor-Q	1959	34,000	2,000mm f/11 Reflex-Nikkor	1972	800,000
135mm f/3.5C Nikkor-Q	1974	28,000	2,000mm f/11C Reflex-Nikkor	1976	900,000
135mm f/4 Bellows	1968	25,000			
180mm f/2.8 Nikkor-P	1971	75,000	*Zoom lenses*		
180mm f/2.8C Nikkor-P	1976	90,000	43–86mm f/3.5	1963	32,000
200mm f/4 Nikkor-Q	1961	34,500	43–86mm f/3.5C	1974	38,000
200mm f/4C Nikkor-Q	1974	40,000	50–300mm f/4.5	1967	120,000
200mm f/5.6 Medical-Nikkor	1962	70,000	80–200mm f/4.5	1970	79,000
200mm f/5.6C Medical-Nikkor	1974	90,000	80–200mm f/4.5C	1973	85,000
300mm f/2.8 Nikkor-H	1972	240,000	85–250mm f/4	1969	110,000
300mm f/4.5 Nikkor-P	1964	48,000	85–250mm f/4–4.5	1959	99,000
300mm f/4.5 Nikkor-H	1969	55,000	200–600mm f/9.5–10.5	1961	117,000

NOTE TO TABLES: The price listed is usually that quoted at the time of home market introduction, and that most of the early 'Auto' lenses were still marked in centimetres (for ease of reference, all are shown in millimetres here). The table (*right*) is the explanation of Nippon Kogaku's lens coding system, which was discontinued with the advent of the 'New' series of Nikkors. It was not applied to zoom lenses, incidentally.

DESIGNATION	MEANING	TRANSLATING TO
Nikkor-T	Tres	Three elements
Nikkor-Q	Quattuor	Four elements
Nikkor-P	Pente	Five elements
Nikkor-H	Hex	Six elements
Nikkor-S	Septem	Seven elements
Nikkor-O	Octo	Eight elements
Nikkor-N	Novem	Nine elements
Nikkor-D	Decem	Ten elements
Nikkor-UD	Undecim	Eleven elements
Nikkor-QD	Quattuordecim	Fourteen elements
Nikkor-HD	Hex + Decem	Sixteen elements

'New' series

TYPE	INTRODUCED	APERTURE RANGE	ELEMENTS/GROUPS	SERIAL NUMBERS	WEIGHT	FILTER SIZE
20mm f/4	Nov 1974	4.0 – 22.0	10 in 8	103001–	210g	52mm
28mm f/2.8	Nov 1974	2.8 – 22.0	7 in 7	382001–	240g	52mm
50mm f/1.4	Nov 1974	1.4 – 16.0	7 in 5	2797001–	310g	52mm
50mm f/2	Nov 1974	2.0 – 16.0	6 in 4	3100001–	220g	52mm
35mm f/2.8	Jan 1975	2.8 – 22.0	6 in 6	772501–	240g	52mm
18mm f/4	Feb 1975	4.0 – 22.0	13 in 9	173101–	315g	82mm
28mm f/3.5	Mar 1975	3.5 – 22.0	6 in 6	195501–	230g	52mm
135mm f/2.8	Mar 1975	2.8 – 22.0	4 in 4	430001–	600g	52mm
300mm f/4.5	Mar 1975	4.5 – 22.0	6 in 5	480001–	1,140g	72mm
24mm f/2.8	May 1975	2.8 – 22.0	9 in 7	450001–	280g	52mm
55mm Micro	May 1975	3.5 – 32.0	5 in 4	850001–	245g	52mm
105mm f/2.5	May 1975	2.5 – 32.0	5 in 4	673001–	435g	52mm
55mm f/1.2	Jun 1975	1.2 – 16.0	7 in 5	350001–	410g	52mm
80–200mm Zoom	Jun 1975	4.5 – 32.0	15 in 10	210001–	820g	52mm
85mm f/1.8	Jun 1975	1.8 – 22.0	6 in 4	410001–	430g	52mm
300mm f/4.5 ED	Jul 1975	4.5 – 22.0	6 in 4	173001–	1,100g	72mm
600mm f/5.6 ED	Jul 1975	5.6 – 22.0	5 in 4	176001–	2,300g	122mm
800mm f/8 ED	Jul 1975	8.0 – 22.0	5 in 4	850001–	2,900g	122mm
1,200mm f/11 ED	Jul 1975	11.0 – 64.0	5 in 4	150001–	3,700g	122mm
28mm PC	Aug 1975	4.0 – 22.0	10 in 8	174001–	410g	72mm
28–45mm Zoom	Aug 1975	4.5 – 22.0	11 in 7	174001–	440g	72mm
50–300mm Zoom	Sep 1975	4.5 – 22.0	20 in 13	770401–	2,900g	95mm
35mm f/2	Oct 1975	2.0 – 22.0	8 in 6	872001–	280g	52mm
105mm Micro	Nov 1975	4.0 – 32.0	5 in 3	174001–	500g	52mm
28mm f/2	Feb 1976	2.0 – 22.0	9 in 8	335001–	355g	52mm
135mm f/3.5	Feb 1976	3.5 – 32.0	4 in 3	158001–	455g	52mm
180–600mm Zoom	Feb 1976	8.0 – 32.0	18 in 11	174001–	3,400g	95mm
200mm f/4	Feb 1976	4.0 – 32.0	5 in 5	670001–	540g	52mm
200–600mm Zoom	Feb 1976	9.5 – 32.0	19 in 12	300001–	2,400g	82mm
360–1,200mm Zoom	Feb 1976	11.0 – 32.0	20 in 12	174001–	7,100g	122mm
13mm f/5.6	Mar 1976	5.6 – 22.0	16 in 12	175001–	1,240g	–
16mm f/3.5	Mar 1976	3.5 – 22.0	8 in 5	276001–	330g	–
400mm f/5.6 ED	Mar 1976	5.6 – 32.0	5 in 3	260001–	1,400g	72mm
35mm PC	Apr 1976	2.8 – 32.0	8 in 7	900001–	330g	52mm
43–86mm Zoom	Apr 1976	3.5 – 22.0	11 in 8	774001–	450g	52mm
50mm f/1.4S	Apr 1976	1.4 – 16.0	7 in 6	3750401–	260g	52mm
135mm f/2	Apr 1976	2.0 – 22.0	6 in 4	175001–	860g	72mm
135mm f/2.8S	Apr 1976	2.8 – 32.0	5 in 4	730001–	430g	52mm
400mm f/3.5 ED	Apr 1976	3.5 – 22.0	8 in 6	175101–	2,800g	39mm
35mm f/1.4	May 1976	1.4 – 22.0	9 in 7	377101–	410g	52mm
1,000mm Reflex	Aug 1976	11.0 –	5 in 5	142301–	1,900g	39mm

TYPE	INTRODUCED	PRICE (YEN)	TYPE	INTRODUCED	PRICE (YEN)
13mm f/5.6	1976	750,000	135mm f/2.8	1975	35,000
16mm f/3.5 Fisheye	1976	80,000	135mm f/2.8S	1976	35,000
18mm f/4	1975	95,000	135mm f/3.5	1976	30,000
20mm f/4	1974	50,000	200mm f/4	1976	45,000
24mm f/2.8	1975	44,000	300mm f/4.5	1975	66,000
28mm f/2	1976	66,000	300mm f/4.5 ED	1975	180,000
28mm f/2.8	1974	40,000	400mm f/3.5 ED	1976	500,000
28mm f/3.5	1975	30,000	400mm f/5.6 ED	1976	220,000
28mm f/4 PC	1975	110,000	600mm f/5.6 ED (IF)	1975	280,000
35mm f/1.4	1976	72,000	800mm f/8 ED	1975	340,000
35mm f/2	1975	38,000	1,000mm f/11 Reflex	1976	160,000
35mm f/2.8	1975	25,000	1,200mm f/11 ED	1975	420,000
35mm f/2.8 PC	1976	55,000			
50mm f/1.4	1974	34,000			
50mm f/1.4S	1976	35,000	*Zoom lenses*		
50mm f/2	1974	23,000	28–45mm f/4.5	1975	100,000
55mm f/1.2	1975	49,000	43–86mm f/3.5	1976	43,000
55mm f/3.5 Micro	1975	34,000	50–300mm f/4.5	1975	200,000
85mm f/1.8	1975	41,000	80–200mm f/4.5	1975	100,000
105mm f/2.5	1975	38,000	180–600mm f/8 ED	1976	650,000
105mm f/4 Micro	1975	65,000	200–600mm f/9.5	1976	230,000
135mm f/2	1976	95,000	360–1,200mm f/11 ED	1976	1,000,000

NOTE TO TABLE: The price listed is usually that quoted at the time of home market introduction.

'Ai' series

TYPE	INTRODUCED	APERTURE RANGE	ELEMENTS/GROUPS	SERIAL NUMBERS	WEIGHT	FILTER SIZE
20mm f/4	Mar 1977	4.0 – 22.0	10 in 8	113001–	210g	52mm
24mm f/2.8	Mar 1977	2.8 – 22.0	9 in 9	525001–	270g	52mm
28mm f/2	Mar 1977	2.0 – 22.0	9 in 8	450001–	355g	52mm
28mm f/2.8	Mar 1977	2.8 – 22.0	7 in 7	430001–	245g	52mm
28mm f/3.5	Mar 1977	3.5 – 22.0	6 in 6	1760201–	235g	52mm
35mm f/2	Mar 1977	2.0 – 22.0	8 in 6	880001–	280g	52mm
35mm f/2.8	Mar 1977	2.8 – 22.0	6 in 6	350001–	240g	52mm
43–86mm Zoom	Mar 1977	3.5 – 22.0	11 in 8	810001–	450g	52mm
50mm f/1.4	Mar 1977	1.4 – 16.0	7 in 6	3940001–	255g	52mm
50mm f/2	Mar 1977	2.0 – 16.0	6 in 4	3500001–	220g	52mm
55mm f/1.2	Mar 1977	1.2 – 16.0	7 in 5	400001–	410g	52mm
55mm Micro	Mar 1977	3.5 – 32.0	5 in 4	900001–	240g	52mm
58mm Noct	Mar 1977	1.2 – 16.0	7 in 6	172001–	480g	52mm
80–200mm Zoom	Mar 1977	4.5 – 32.0	15 in 10	270001–	830g	52mm
105mm f/2.5	Mar 1977	2.5 – 22.0	5 in 4	710001–	435g	52mm

TYPE	INTRODUCED	APERTURE RANGE	ELEMENTS/GROUPS	SERIAL NUMBERS	WEIGHT	FILTER SIZE
135mm f/2.8	Mar 1977	2.8 – 32.0	5 in 4	770001–	430g	52mm
200mm f/4	Mar 1977	4.0 – 32.0	5 in 5	670001–	530g	52mm
300mm f/4.5	Mar 1977	4.5 – 22.0	6 in 5	510001–	1,100g	72mm
400mm f/5.6 ED	Mar 1977	5.6 – 32.0	5 in 3	261151–	1,400g	72mm
6mm f/2.8	May 1977	2.8 – 22.0	12 in 9	629001–	5,200g	–
15mm f/5.6	May 1977	5.6 – 22.0	14 in 12	340001–	645g	–
50–300mm Zoom	May 1977	4.5 – 22.0	20 in 13	980001–	2,300g	95mm
50–300mm Zoom (ED)	May 1977	4.5 – 32.0	15 in 11	175101–	2,200g	95mm
105mm Micro	May 1977	4.0 – 32.0	5 in 3	186001–	500g	52mm
8mm f/2.8	Jun 1977	2.8 – 22.0	10 in 8	242001–	1,100g	–
13mm f/5.6	Jun 1977	5.6 – 22.0	16 in 12	175051–	1,200g	–
16mm f/3.5	Jun 1977	3.5 – 22.0	8 in 5	280001–	330g	–
18mm f/4	Jun 1977	4.0 – 22.0	13 in 9	190001–	325g	82mm
28–45mm Zoom	Jun 1977	4.5 – 22.0	11 in 7	210001–	440g	72mm
35mm f/1.4	Jun 1977	1.4 – 16.0	9 in 7	385001–	400g	52mm
85mm f/2	Jun 1977	2.0 – 22.0	5 in 5	175101–	310g	52mm
135mm f/2	Jun 1977	2.0 – 22.0	6 in 4	190001–	860g	72mm
135mm f/3.5	Jun 1977	3.5 – 32.0	4 in 4	193501–	400g	52mm
200mm f/2 ED	Jun 1977	2.0 – 22.0	10 in 8	176101–	2,300g	122mm
300mm f/4.5 ED	Jun 1977	4.5 – 22.0	6 in 4	190001–	1,100g	72mm
400mm f/3.5 ED	Jun 1977	3.5 – 22.0	8 in 6	176001–	2,800g	39mm
600mm f/5.6 ED	Jun 1977	5.6 – 22.0	7 in 6	176101–	2,700g	39mm
180mm f/2.8	Jul 1977	2.8 – 32.0	5 in 4	360001–	880g	72mm
24mm f/2	Oct 1977	2.0 – 22.0	11 in 10	176001–	300g	52mm
35–70mm Zoom	Dec 1977	3.5 – 22.0	10 in 9	760701–	540g	72mm
300mm f/2.8 ED	Feb 1978	2.8 – 22.0	8 in 6	605001–	2,500g	39mm
50mm f/1.8	Mar 1978	1.8 – 16.0	6 in 5	1760801–	220g	52mm
35mm f/2.8	May 1978	2.8 – 22.0	5 in 5	350001–	240g	52mm
80–200mm Zoom	May 1978	4.5 – 32.0	12 in 9	750801–	750g	52mm
50mm f/1.2	Jul 1978	1.2 – 16.0	7 in 6	177051–	390g	52mm
300mm f/4.5 ED	Dec 1978	4.5 – 22.0	7 in 6	200001–	990g	72mm
20mm f/3.5	Mar 1979	3.5 – 22.0	11 in 8	176001–	235g	52mm
200mm Micro	Mar 1979	4.0 – 32.0	9 in 6	178001–	740g	52mm
400mm f/5.6 ED	Mar 1979	5.6 – 32.0	7 in 6	280001–	1,200g	72mm
800mm f/8 ED	Mar 1979	8.0 – 32.0	9 in 7	178001–	3,300g	39mm
1,200mm f/11 ED	Mar 1979	11.0 – 32.0	9 in 8	178501–	3,900g	39mm
50mm f/1.8	May 1979	1.8 – 22.0	6 in 5	2050001–	220g	52mm
15mm f/3.5	Aug 1979	3.5 – 22.0	14 in 11	177051–	630g	–
16mm f/2.8	Aug 1979	2.8 – 22.0	8 in 5	178051–	310g	–
25–50mm Zoom	Nov 1979	4.0 – 22.0	11 in 10	178001–	600g	72mm
55mm Micro	Feb 1980	2.8 – 32.0	6 in 5	179001–	290g	52mm
35mm PC	Nov 1980	2.8 – 32.0	7 in 7	179051–	320g	52mm
28mm PC	Feb 1981	3.5 – 22.0	9 in 8	179101–	380g	72mm

TYPE	INTRODUCED	PRICE (YEN)	TYPE	INTRODUCED	PRICE (YEN)
6mm f/2.8 Fisheye	1977	720,000	105mm f/2.5	1977	39,000
8mm f/2.8 Fisheye	1977	132,000	105mm f/4 Micro	1977	66,000
13mm f/5.6	1977	770,000	135mm f/2	1977	96,000
15mm f/3.5	1979	210,000	135mm f/2.8	1977	41,000
15mm f/5.6	1977	185,000	135mm f/3.5	1977	31,000
16mm f/2.8 Fisheye	1979	83,000	180mm f/2.8	1977	91,000
16mm f/3.5 Fisheye	1977	82,000	200mm f/2 ED (IF)	1977	390,000
18mm f/4	1977	96,000	200mm f/4	1977	46,000
20mm f/3.5	1979	52,000	200mm f/4 Micro (IF)	1979	89,000
20mm f/4	1977	51,000	300mm f/2.8 ED (IF)	1978	400,000
24mm f/2	1977	70,000	300mm f/4.5	1977	67,000
24mm f/2.8	1977	45,000	300mm f/4.5 ED	1977	181,000
28mm f/2	1977	67,000	300mm f/4.5 ED (IF)	1978	125,000
28mm f/2.8	1977	41,000	400mm f/3.5 ED (IF)	1977	480,000
28mm f/3.5	1977	31,000	400mm f/5.6 ED	1977	222,000
28mm f/3.5 PC	1981	115,000	400mm f/5.6 ED (IF)	1979	230,000
35mm f/1.4	1977	73,000	600mm f/5.6 ED (IF)	1977	490,000
35mm f/2	1977	39,000	800mm f/8 ED (IF)	1979	550,000
35mm f/2.8	1977	26,000	1,200mm f/11 ED (IF)	1979	700,000
35mm f/2.8 PC (New)	1980	70,000			
50mm f/1.2	1978	50,000			
50mm f/1.4	1977	36,000	*Zoom lenses*		
50mm f/1.8	1978	26,000	25–50mm f/4	1979	110,000
50mm f/2	1977	24,000	28–45mm f/4.5	1977	101,000
55mm f/1.2	1977	50,000	35–70mm f/3.5	1977	95,000
55mm f/2.8 Micro	1980	38,000	43–86mm f/3.5	1977	44,000
55mm f/3.5 Micro	1977	35,000	50–300mm f/4.5	1977	220,000
58mm f/1.2 Noct	1977	150,000	50–300mm f/4.5 ED	1977	280,000
85mm f/2	1977	42,000	80–200mm f/4.5	1977	101,000

NOTE TO TABLE: The price listed is usually that quoted at the time of home market introduction.

'E' series

TYPE	INTRODUCED	APERTURE RANGE	ELEMENTS/GROUPS	WEIGHT	FILTER SIZE
35mm f/2.5	Mar 1979	2.5 – 22.0	5 in 5	150g	52mm
50mm f/1.8	Mar 1979	1.8 – 22.0	6 in 5	160g	52mm
100mm f/2.8	Mar 1979	2.8 – 22.0	4 in 4	215g	52mm
28mm f/2.8	Dec 1979	2.8 – 22.0	5 in 5	160g	52mm
135mm f/2.8	Dec 1979	2.8 – 32.0	4 in 4	395g	52mm
75–150mm Zoom	May 1980	3.5 – 32.0	12 in 9	520g	52mm
28mm f/2.8	May 1981	2.8 – 22.0	5 in 5	160g	52mm
35mm f/2.5	May 1981	2.5 – 22.0	5 in 5	150g	52mm
50mm f/1.8	May 1981	1.8 – 22.0	6 in 5	160g	52mm
75–150mm Zoom	May 1981	3.5 – 32.0	12 in 9	520g	52mm
100mm f/2.8	May 1981	2.8 – 22.0	4 in 4	215g	52mm
135mm f/2.8	May 1981	2.8 – 32.0	4 in 4	395g	52mm
36–72mm Zoom	Oct 1981	3.5 – 22.0	8 in 8	380g	52mm
70–210mm Zoom	Mar 1982	4.0 – 32.0	13 in 9	730g	62mm

NOTE TO TABLE RIGHT: The price listed is usually that quoted at the time of home market introduction. The lenses listed as being introduced in March 1979 were not sold in Japan until March 1980, and the other two 1979 variants were not available. The 50mm f/1.8 version became listed as an Ai-S lens in Japan in January 1981.

TYPE	INTRODUCED	PRICE (YEN)
28mm f/2.8	1979	Export
35mm f/2.5	1979	19,000
50mm f/1.8	1979	20,000
100mm f/2.8	1979	22,000
135mm f/2.8	1979	Export
Zoom lenses		
36–72mm f/3.5	1981	45,000
70–210mm f/4	1982	68,000
75–150mm f/3.5	1980	53,000

'Ai-S' series

TYPE	INTRODUCED	APERTURE RANGE	ELEMENTS/ GROUPS	SERIAL NUMBERS	WEIGHT	FILTER SIZE
50mm f/1.8S	Jan 1981	1.8 – 22.0	6 in 5	3135001–	175g	52mm
28mm f/2.8S	Sep 1981	2.8 – 22.0	8 in 8	635001–	250g	52mm
35mm f/2S	Sep 1981	2.0 – 22.0	8 in 6	105001–	280g	52mm
35mm f/2.8S	Sep 1981	2.8 – 22.0	5 in 5	521001–	240g	52mm
50mm f/1.2S	Sep 1981	1.2 – 16.0	7 in 6	250001–	360g	52mm
50mm f/1.4S	Sep 1981	1.4 – 16.0	7 in 6	5100001–	250g	52mm
85mm f/1.4S	Sep 1981	1.4 – 16.0	7 in 5	170001–	620g	72mm
105mm f/1.8S	Sep 1981	1.8 – 22.0	5 in 5	179001–	580g	62mm
24mm f/2.8S	Oct 1981	2.8 – 22.0	9 in 9	700001–	250g	52mm
28mm f/3.5S	Oct 1981	3.5 – 22.0	6 in 6	2100001–	220g	52mm
80–200mm Zoom	Oct 1981	4.0 – 32.0	13 in 9	180001–	810g	62mm

TYPE	INTRODUCED	APERTURE RANGE	ELEMENTS/ GROUPS	SERIAL NUMBERS	WEIGHT	FILTER SIZE
85mm f/2S	Oct 1981	2.0 – 22.0	5 in 5	270001–	310g	52mm
105mm f/2.5S	Oct 1981	2.5 – 22.0	5 in 4	890001–	435g	52mm
105mm Micro	Oct 1981	4.0 – 32.0	5 in 3	232001–	500g	52mm
180mm f/2.8S ED	Oct 1981	2.8 – 32.0	5 in 5	370001–	800g	72mm
20mm f/3.5S	Dec 1981	3.5 – 22.0	11 in 8	210001–	235g	52mm
24mm f/2S	Dec 1981	2.0 – 22.0	11 in 10	200001–	300g	52mm
25–50mm Zoom	Dec 1981	4.0 – 22.0	11 in 10	201001–	600g	72mm
28mm f/2S	Dec 1981	2.0 – 22.0	9 in 8	575001–	360g	52mm
35–70mm Zoom	Dec 1981	3.5 – 22.0	10 in 9	821001–	520g	62mm
55mm Micro	Dec 1981	2.8 – 32.0	6 in 5	186001–	290g	52mm
120mm Medical	Dec 1981	4.0 – 32.0	9 in 6	180001–	890g	49mm
135mm f/2.8S	Dec 1981	2.8 – 32.0	5 in 4	900001–	435g	52mm
200mm f/4S	Dec 1981	4.0 – 32.0	5 in 5	730001–	510g	52mm
300mm f/4.5S	Dec 1981	4.5 – 32.0	6 in 5	550001–	1,200g	72mm
15mm f/3.5S	Feb 1982	3.5 – 22.0	14 in 11	180001–	630g	–
16mm f/2.8S	Feb 1982	2.8 – 22.0	8 in 5	185001–	310g	–
18mm f/3.5S	Feb 1982	3.5 – 22.0	11 in 10	180051–	350g	72mm
35mm f/1.4S	Feb 1982	1.4 – 16.0	9 in 7	430001–	400g	52mm
135mm f/2S	Feb 1982	2.0 – 22.0	6 in 4	201001–	860g	72mm
300mm f/4.5S ED	Feb 1982	4.5 – 32.0	7 in 6	210001–	1,060g	72mm
400mm f/5.6S ED	Feb 1982	5.6 – 32.0	7 in 6	287601–	1,200g	72mm
800mm f/8S ED	Feb 1982	8.0 – 32.0	9 in 7	179001–	3,300g	39mm
8mm f/2.8S	Mar 1982	2.8 – 22.0	10 in 8	243001–	1,100g	–
13mm f/5.6S	Mar 1982	5.6 – 22.0	16 in 12	175901–	1,200g	–
50–300mm Zoom	Mar 1982	4.5 – 32.0	15 in 11	183001–	1,950g	95mm
300mm f/2.8S ED	Mar 1982	2.8 – 22.0	8 in 6	609001–	2,500g	39mm
58mm Noct	Apr 1982	1.2 – 16.0	7 in 6	185001–	465g	52mm
135mm f/3.5S	Apr 1982	3.5 – 32.0	4 in 4	290001–	420g	52mm
180–600mm Zoom	Apr 1982	8.0 – 32.0	18 in 11	174701–	3,600g	95mm
200mm f/2S ED	Apr 1982	2.0 – 22.0	10 in 8	178501–	2,400g	122mm
200–600mm Zoom	Apr 1982	9.5 – 32.0	19 in 12	305001–	2,500g	82mm
360–1,200mm Zoom	Apr 1982	11.0 – 32.0	20 in 12	174701–	7,900g	122mm
400mm f/3.5S ED	Apr 1982	3.5 – 22.0	8 in 6	181501–	2,800g	39mm
1,200mm f/11S ED	Apr 1982	11.0 – 32.0	9 in 8	179001–	3,900g	39mm
6mm f/2.8S	May 1982	2.8 – 22.0	12 in 9	200001–	5,200g	–
200mm Micro	May 1982	4.0 – 32.0	9 in 6	200001–	800g	52mm
600mm f/5.6S ED	May 1982	5.6 – 32.0	7 in 6	178501–	2,700g	39mm
600mm f/4S ED	Nov 1982	4.0 – 22.0	8 in 6	178001–	6,300g	39mm
50–135mm Zoom	Dec 1982	3.5 – 32.0	16 in 13	811001–	700g	62mm
80–200mm Zoom	Dec 1982	2.8 – 32.0	15 in 11	181001–	1,900g	95mm
35–105mm Zoom	Apr 1983	3.5 – 22.0	16 in 12	182701–	510g	52mm
300mm f/2S ED	Jan 1984	2.0 – 16.0	11 in 8	182001–	7,100g	52mm
200–400mm Zoom	Feb 1984	4.0 – 32.0	15 in 10	182101–	3,650g	122mm
28–50mm Zoom	Apr 1984	3.5 – 22.0	9 in 9	183001–	395g	52mm
105mm Micro	Apr 1984	2.8 – 32.0	10 in 9	182001–	515g	52mm
500mm Reflex	Apr 1984	8.0 –	6 in 6	183201–	840g	39mm

TYPE	INTRODUCED	APERTURE RANGE	ELEMENTS/ GROUPS	SERIAL NUMBERS	WEIGHT	FILTER SIZE
100–300mm Zoom	Jul 1984	5.6 – 32.0	14 in 10	183001–	930g	62mm
35–70mm Zoom	Nov 1984	3.3 – 22.0	8 in 7	2000001–	250g	52mm
20mm f/2.8S	Dec 1984	2.8 – 22.0	12 in 9	200001–	260g	62mm
35–135mm Zoom	Dec 1984	3.5 – 22.0	15 in 14	200001–	600g	62mm
50mm f/1.8S	Sep 1985	1.8 – 22.0	6 in 5	4000001–	170g	52mm
105mm UV	Sep 1985	4.5 – 32.0	6 in 6	250001–	515g	52mm
400mm f/2.8S ED	Sep 1985	2.8 – 22.0	8 in 6	200001–	5,150g	52mm
28–85mm Zoom	Dec 1985	3.5 – 22.0	15 in 11	200001–	510g	62mm
35–200mm Zoom	Dec 1985	3.5 – 22.0	17 in 13	200001–	740g	62mm
200mm f/2S ED	Dec 1985	2.0 – 22.0	10 in 8	200001–	2,550g	–
300mm f/2.8S ED	Dec 1985	2.8 – 22.0	8 in 6	610001–	2,400g	39mm
600mm f/4S ED	Dec 1985	4.0 – 22.0	8 in 6	200001–	5,650g	39mm
600mm f/5.6S ED	Dec 1985	5.6 – 32.0	7 in 6	200001–	2,800g	39mm
800mm f/5.6S ED	Jul 1986	5.6 – 32.0	8 in 6	200001–	5,450g	52mm
35–70mm Zoom	Dec 1995	3.5 – 22.0	7 in 7	200001–	200g	52mm
70–210mm Zoom	Apr 1997	4.5 – 32.0	11 in 8	200001–	575g	52mm

TYPE	INTRODUCED	PRICE (YEN)	TYPE	INTRODUCED	PRICE (YEN)
6mm f/2.8S Fisheye	1982	720,000	105mm f/2.8S Micro	1984	78,000
8mm f/2.8S Fisheye	1982	132,000	105mm f/4S Micro	1981	66,000
13mm f/5.6S	1982	770,000	105mm f/4.5S UV	1985	330,000
15mm f/3.5S	1982	210,000	120mm f4 Medical (IF)	1981	155,000
16mm f/2.8S Fisheye	1982	83,000	135mm f/2S	1982	96,000
18mm f/3.5S	1982	115,000	135mm f/2.8S	1981	41,000
20mm f/2.8S	1984	68,000	135mm f/3.5S	1982	31,000
20mm f/3.5S	1981	52,000	180mm f/2.8S ED	1981	98,000
24mm f/2S	1981	70,000	200mm f/2S ED (IF)	1982	390,000
24mm f/2.8S	1981	45,000	200mm f/4S	1981	46,000
28mm f/2S	1981	67,000	200mm f/4S Micro (IF)	1982	89,000
28mm f/2.8S	1981	42,000	300mm f/2S ED (IF)	1984	1,200,000
28mm f/3.5S	1981	31,000	300mm f/2.8S ED (IF)	1982	400,000
35mm f/1.4S	1982	73,000	300mm f/4.5S	1981	67,000
35mm f/2S	1981	39,000	300mm f/4.5S ED (IF)	1982	125,000
35mm f/2.8S	1981	26,000	400mm f/2.8S ED (IF)	1985	850,000
50mm f/1.2S	1981	50,000	400mm f/3.5S ED (IF)	1982	480,000
50mm f/1.4S	1981	36,000	400mm f/5.6S ED (IF)	1982	230,000
50mm f/1.8S	1981	20,000	500mm f/8 Reflex	1984	89,000
55mm f/2.8S Micro	1981	38,000	600mm f/4S ED (IF)	1982	750,000
58mm f/1.2S Noct	1982	150,000	600mm f/5.6S ED (IF)	1982	490,000
85mm f/1.4S	1981	90,000	800mm f/5.6S ED (IF)	1986	750,000
85mm f/2S	1981	42,000	800mm f/8S ED (IF)	1982	550,000
105mm f/1.8S	1981	75,000	1,200mm f/11S ED (IF)	1982	700,000
105mm f/2.5S	1981	39,000			

TYPE	INTRODUCED	PRICE (YEN)	TYPE	INTRODUCED	PRICE (YEN)
Zoom lenses			50–135mm f/3.5S	1982	85,000
25–50mm f/4S	1981	110,000	50–300mm f/4.5S	1982	290,000
28–50mm f/3.5S	1984	58,000	70–210mm f/4.5–5.6S	1997	Export
28–85mm f/3.5–4.5S	1985	69,000	80–200 f/2.8S ED	1982	420,000
35–70mm f/3.3–4.5S	1984	39,000	80–200mm f/4S	1981	105,000
35–70mm f/3.5S	1981	96,000	100–300mm f/5.6S	1984	69,000
35–70mm f/3.5–4.8S	1995	13,000	180–600mm f/8S ED	1982	710,000
35–105mm f/3.5–4.5S	1983	58,000	200–400mm f/4S ED	1984	700,000
35–135mm f/3.5–4.5S	1984	69,000	200–600mm f/9.5S	1982	250,000
35–200mm f/3.5–4.5S	1985	110,000	360–1,200mm f/11S ED	1982	1,100,000

NOTE TO TABLE: The price listed is usually that quoted at the time of home market introduction.

'Ai-P' and 'Ai-D' series

TYPE	INTRODUCED	APERTURE RANGE	ELEMENTS/GROUPS	SERIAL NUMBERS	WEIGHT	FILTER SIZE
500mm f/4P ED	Mar 1988	4.0 – 22.0	8 in 6	200001–	3,000g	39mm
1,200–1,700mm Zoom	Jan 1994	5.6 – 22.0	18 in 13	200001–	16,000g	52mm
85mm PC Micro	Sep 1999	2.8 – 45.0	6 in 5	200001–	775g	77mm
45mm f/2.8P	Jul 2001	2.8 – 22.0	4 in 3	200001–	120g	52mm

TYPE	INTRODUCED	PRICE (YEN)
45mm f/2.8P	2001	48,000
85mm f/2.8D PC Micro	1999	195,000
500mm f/4P ED (IF)	1988	540,000
Zoom lenses		
1,200–1,700mm f/5.6–8P ED (IF)	1994	6,000,000

NOTE TO TABLE: The price listed is usually that quoted at the time of home market introduction. The 45mm f/2.8P lens was offered in either a natural silver finish or a regular black finish.

MF Teleconverters

TYPE	FACTOR VALUE	INTRODUCED	ELEMENTS/GROUPS	WEIGHT	PRICE (YEN)
TC-1 (Auto + New)	2×	Jun 1976	7 in 5	230g	26,000
TC-2 (Auto + New)	2×	Jun 1976	5 in 5	280g	58,000
TC-14 (Ai)	1.4×	Dec 1978	5 in 5	165g	60,000
TC-14A (Ai-S)	1.4×	Sep 1983	5 in 5	145g	30,000
TC-14B (Ai-S)	1.4×	Sep 1983	5 in 5	165g	63,000
TC-14C (Ai-S)	1.4×	Jan 1984	5 in 5	200g	–
TC-200 (Ai)	2×	May 1977	7 in 5	230g	27,000
TC-201 (Ai-S)	2×	Sep 1983	7 in 5	230g	30,000
TC-300 (Ai)	2×	May 1977	5 in 5	300g	60,000
TC-301 (Ai-S)	2×	Sep 1983	5 in 5	325g	63,000

NOTE TO TABLE: The TC-14C was only supplied with the contemporary 300mm f/2S telephoto lens, and was not available separately.

AUTOFOCUS LENSES

'Ai AF' series

TYPE	INTRODUCED	APERTURE RANGE	ELEMENTS/GROUPS	WEIGHT	FILTER SIZE
80mm f/2.8S	Apr 1983	2.8 – 32.0	6 in 4	390g	52mm
200mm f/3.5S	Apr 1983	3.5 – 32.0	8 in 6	870g	62mm
50mm f/1.8S	Apr 1986	1.8 – 22.0	6 in 5	210g	52mm
35–70mm Zoom	Apr 1986	3.3 – 22.0	8 in 7	260g	52mm
70–210mm Zoom	Apr 1986	4.0 – 32.0	13 in 9	760g	62mm
28mm f/2.8S	Jul 1986	2.8 – 22.0	5 in 5	195g	52mm
50mm f/1.4S	Jul 1986	1.4 – 16.0	7 in 6	255g	52mm
28–85mm Zoom	Jul 1986	3.5 – 22.0	15 in 11	540g	62mm
35–105mm Zoom	Jul 1986	3.5 – 22.0	16 in 12	460g	52mm
24mm f/2.8S	Sep 1986	2.8 – 22.0	9 in 9	260g	52mm
180mm f/2.8S	Sep 1986	2.8 – 22.0	8 in 6	750g	72mm
300mm f/2.8S	Sep 1986	2.8 – 22.0	8 in 6	2,700g	39mm
55mm Micro	Oct 1986	2.8 – 32.0	6 in 5	420g	62mm
35–135mm Zoom	Nov 1986	3.5 – 22.0	15 in 12	685g	62mm
300mm f/4S	Jun 1987	4.0 – 32.0	8 in 6	1,330g	39mm
24–50mm Zoom	Dec 1987	3.3 – 22.0	9 in 9	375g	62mm
35–70mm Zoom	Dec 1987	2.8 – 22.0	15 in 12	665g	62mm
70–210mm Zoom	Dec 1987	4.0 – 32.0	12 in 9	590g	62mm
80–200mm Zoom	Feb 1988	2.8 – 22.0	16 in 11	1,200g	77mm
85mm f/1.8S	Feb 1988	1.8 – 16.0	6 in 6	415g	62mm

TYPE	INTRODUCED	APERTURE RANGE	ELEMENTS/GROUPS	WEIGHT	FILTER SIZE
300mm f/2.8S	Jul 1988	2.8 – 22.0	8 in 6	2,700g	39mm
35–135mm Zoom	Nov 1988	3.5 – 22.0	15 in 12	685g	62mm
180mm f/2.8S	Nov 1988	2.8 – 22.0	8 in 6	750g	72mm
35mm f/2S	Apr 1989	2.0 – 22.0	6 in 5	215g	52mm
20mm f/2.8S	Jul 1989	2.8 – 22.0	12 in 9	260g	62mm
75–300mm Zoom	Sep 1989	4.5 – 32.0	13 in 11	850g	62mm
35–70mm Zoom	Oct 1989	3.3 – 22.0	8 in 7	240g	52mm
60mm Micro	Oct 1989	2.8 – 32.0	8 in 7	455g	62mm
50mm f/1.8S	Mar 1990	1.8 – 22.0	6 in 5	160g	52mm
105mm Micro	Jul 1990	2.8 – 32.0	9 in 8	555g	52mm
28–85mm Zoom	Sep 1990	3.5 – 22.0	15 in 11	510g	62mm
135mm DC	Apr 1991	2.0 – 16.0	7 in 6	870g	72mm
24mm f/2.8S	Jun 1991	2.8 – 22.0	9 in 9	260g	52mm
28mm f/2.8S	Jun 1991	2.8 – 22.0	5 in 5	195g	52mm
28–70mm Zoom	Jun 1991	3.5 – 22.0	8 in 7	350g	52mm
50mm f/1.4S	Jun 1991	1.4 – 16.0	7 in 6	255g	52mm
35–105mm Zoom	Sep 1991	3.5 – 22.0	16 in 12	510g	52mm

TYPE	INTRODUCED	PRICE (YEN)	TYPE	INTRODUCED	PRICE (YEN)
80mm f/2.8S	1983	80,000	*Zoom lenses*		
200mm f/3.5S ED (IF)	1983	195,000	24–50mm f/3.3–4.5S	1987	56,000
			28–70mm f/3.5–4.5S	1991	45,000
20mm f/2.8S	1989	64,000	28–85mm f/3.5–4.5S	1986	69,000
24mm f/2.8S	1986	46,000	28–85mm f/3.5–4.5S (New)	1990	63,000
24mm f/2.8S (New)	1991	43,000	35–70mm f/2.8S	1987	98,000
28mm f/2.8S	1986	33,000	35–70mm f/3.3–4.5S	1986	39,000
28mm f/2.8S (New)	1991	31,000	35–70mm f/3.3–4.5S (New)	1989	27,000
35mm f/2S	1989	36,000	35–105mm f/3.5–4.5S	1986	59,000
50mm f/1.4S	1986	36,000	35–105mm f/3.5–4.5S (New)	1991	49,000
50mm f/1.4S (New)	1991	33,000	35–135mm f/3.5–4.5S	1986	72,000
50mm f/1.8S	1986	22,000	35–135mm f/3.5–4.5S (New)	1988	63,000
50mm f/1.8S (New)	1990	20,000	70–210mm f/4S	1986	69,000
55mm f/2.8S Micro	1986	55,000	70–210mm f/4–5.6S	1987	54,000
60mm f/2.8S Micro	1989	50,000	75–300mm f/4.5–5.6S	1989	69,000
85mm f/1.8S	1988	48,000	80–200mm f/2.8S ED	1988	130,000
105mm f/2.8S Micro	1990	80,000			
135mm f/2S DC	1991	128,000			
180mm f/2.8S ED (IF)	1986	99,000			
180mm f/2.8S ED (IF) (New)	1988	90,000			
300mm f/2.8S ED (IF)	1986	500,000			
300mm f/2.8S ED (IF) (New)	1988	456,000			
300mm f/4S ED (IF)	1987	129,000			

NOTE TO TABLE: The price listed is usually that quoted at the time of home market introduction. The 1983 lenses have been separated from the main list, as these were special Nikkors for the F3 AF model.

'Ai AF-I' series

TYPE	INTRODUCED	APERTURE RANGE	ELEMENTS/GROUPS	WEIGHT	FILTER SIZE
300mm f/2.8D	Sep 1992	2.8 – 22.0	11 in 9	2,950g	39mm
600mm f/4D	Sep 1992	4.0 – 22.0	9 in 7	6,050g	39mm
400mm f/2.8D	Jul 1994	2.8 – 22.0	10 in 7	6,300g	52mm
500mm f/4D	Nov 1994	4.0 – 22.0	9 in 7	4,200g	39mm

TYPE	INTRODUCED	PRICE (YEN)
300mm f/2.8D ED (IF)	1992	560,000
400mm f/2.8D ED (IF)	1994	1,050,000
500mm f/4D ED (IF)	1994	850,000
600mm f/4D ED (IF)	1992	1,160,000

NOTE TO TABLE: The price listed is usually that quoted at the time of home market introduction.

'Ai AF-D' and 'Ai AF-G' series

TYPE	INTRODUCED	APERTURE RANGE	ELEMENTS/GROUPS	WEIGHT	FILTER SIZE
28–70mm Zoom	Sep 1992	3.5 – 22.0	8 in 7	355g	52mm
35–70mm Zoom	Sep 1992	2.8 – 22.0	15 in 12	665g	62mm
80–200mm Zoom	Sep 1992	2.8 – 22.0	16 in 11	1,300g	77mm
35–80mm Zoom	Aug 1993	4.0 – 22.0	6 in 6	255g	52mm
70–210mm Zoom	Aug 1993	4.0 – 32.0	12 in 9	605g	62mm
105mm DC	Sep 1993	2.0 – 16.0	6 in 6	640g	72mm
16mm f/2.8D	Nov 1993	2.8 – 22.0	8 in 5	290g	–
20–35mm Zoom	Nov 1993	2.8 – 22.0	14 in 11	585g	77mm
24mm f/2.8D	Dec 1993	2.8 – 22.0	9 in 9	270g	52mm
60mm Micro	Dec 1993	2.8 – 32.0	8 in 7	440g	62mm
105mm Micro	Dec 1993	2.8 – 32.0	9 in 8	560g	52mm
200mm Micro	Dec 1993	4.0 – 32.0	13 in 8	1,190g	62mm
20mm f/2.8D	Mar 1994	2.8 – 22.0	12 in 9	270g	62mm
85mm f/1.8D	Mar 1994	1.8 – 16.0	6 in 6	380g	62mm
18mm f/2.8D	Apr 1994	2.8 – 22.0	13 in 10	380g	77mm
28mm f/1.4D	Jul 1994	1.4 – 16.0	11 in 8	520g	72mm
28mm f/2.8D	Oct 1994	2.8 – 22.0	6 in 6	210g	52mm
35–105mm Zoom	Dec 1994	3.5 – 22.0	13 in 10	415g	52mm
180mm f/2.8D	Dec 1994	2.8 – 22.0	8 in 6	760g	72mm
35mm f/2D	Mar 1995	2.0 – 22.0	6 in 5	205g	52mm
50mm f/1.4D	Apr 1995	1.4 – 16.0	7 in 6	230g	52mm
28–80mm Zoom	Jul 1995	3.5 – 22.0	7 in 7	225g	58mm
80–200mm Zoom	Jul 1995	4.5 – 32.0	10 in 8	330g	52mm

TYPE	INTRODUCED	APERTURE RANGE	ELEMENTS/GROUPS	WEIGHT	FILTER SIZE
35–80mm Zoom	Sep 1995	4.0 – 22.0	8 in 7	180g	52mm
24–50mm Zoom	Dec 1995	3.3 – 22.0	9 in 9	355g	62mm
85mm f/1.4D	Dec 1995	1.4 – 16.0	9 in 8	550g	77mm
135mm DC	Dec 1995	2.0 – 16.0	7 in 6	815g	72mm
24–120mm Zoom	Oct 1996	3.5 – 22.0	15 in 11	550g	72mm
80–200mm Zoom	Oct 1996	2.8 – 22.0	16 in 11	1,300g	77mm
70–180mm Micro	Sep 1997	4.5 – 32.0	18 in 14	1,010g	62mm
28–200mm Zoom	Feb 1998	3.5 – 22.0	16 in 13	520g	72mm
70–300mm Zoom	Mar 1998	4.0 – 32.0	13 in 9	505g	62mm
28–105mm Zoom	Dec 1998	3.5 – 22.0	16 in 12	455g	62mm
28–80mm Zoom	Sep 1999	3.5 – 22.0	8 in 8	265g	58mm
14mm f/2.8D	Jul 2000	2.8 – 22.0	14 in 12	670g	–
18–35mm Zoom	Sep 2000	3.5 – 22.0	11 in 8	370g	77mm
24–85mm Zoom	Oct 2000	2.8 – 22.0	15 in 11	545g	72mm
80–400mm Zoom	Nov 2000	4.5 – 32.0	17 in 11	1,360g	77mm
28–80mm Zoom	Mar 2001	3.3 – 22.0	6 in 6	195g	58mm
70–300mm Zoom	Oct 2001	4.0 – 32.0	13 in 9	425g	62mm
28–100mm Zoom	Mar 2002	3.5 – 22.0	8 in 6	245g	62mm
50mm f/1.8D	Jul 2002	1.8 – 22.0	6 in 5	155g	52mm
28–200mm Zoom	Sep 2003	3.5 – 22.0	12 in 11	360g	62mm

TYPE	INTRODUCED	PRICE (YEN)	TYPE	INTRODUCED	PRICE (YEN)
14mm f/2.8D ED	2000	220,000	*Zoom lenses*		
16mm f/2.8D Fisheye	1993	103,000	18–35mm f/3.5–4.5D ED (IF)	2000	78,000
18mm f/2.8D	1994	173,000	20–35mm f/2.8D (IF)	1993	227,000
20mm f/2.8D	1994	72,000	24–50mm f/3.3–4.5D	1995	58,000
24mm f/2.8D	1993	49,000	24–85mm f/2.8–4D (IF)	2000	88,000
28mm f/1.4D	1994	238,000	24–120mm f/3.5–5.6D (IF)	1996	84,000
28mm f/2.8D	1994	33,000	28–70mm f/3.5–4.5D	1992	45,000
35mm f/2D	1995	41,000	28–80mm f/3.5–5.6D	1995	33,000
50mm f/1.4D	1995	38,000	28–80mm f/3.5–5.6D (New)	1999	25,000
50mm f/1.8D	2002	23,000	28–80mm f/3.3–5.6G	2001	25,000
60mm f/2.8D Micro	1993	57,000	28–100mm f/3.5–5.6G	2002	30,000
85mm f/1.4D (IF)	1995	140,000	28–105mm f/3.5–4.5D (IF)	1998	55,000
85mm f/1.8D	1994	51,000	28–200mm f/3.5–5.6D (IF)	1998	82,000
105mm f/2D DC	1993	130,000	28–200mm f/3.5–5.6G ED (IF)	2003	62,000
105mm f/2.8D Micro	1993	86,000	35–70mm f/2.8D	1992	105,000
135mm f/2D DC	1995	151,000	35–80mm f/4–5.6D	1993	28,000
180mm f/2.8D ED (IF)	1994	106,000	35–80mm f/4–5.6D (New)	1995	23,000
200mm f/4D ED Micro (IF)	1993	180,000	35–105mm f/3.5–4.5D (IF)	1994	53,000
			70–180mm f/4.5–5.6D ED Micro	1997	168,000
			70–210mm f/4–5.6D	1993	51,000
			70–300mm f/4–5.6D ED	1998	52,000
			70–300mm f/4–5.6G	2001	30,000
			80–200mm f/2.8D ED	1992	128,000

TYPE	INTRODUCED	PRICE (YEN)
Zoom lenses (continued)		
80–200mm f/2.8D ED (New)	1996	154,000
80–200mm f/4.5–5.6D	1995	33,000
80–400mm f/4.5–5.6D ED VR	2000	230,000

NOTE TO TABLE: The price listed is usually that quoted at the time of home market introduction. The 28–80mm, 28–100mm, 28–200mm and 70–300mm AF-G lenses were available with a black or silver finish.

'Ai AF-S' series

TYPE	INTRODUCED	APERTURE RANGE	ELEMENTS/GROUPS	WEIGHT	FILTER SIZE
300mm f/2.8D	Nov 1996	2.8 – 22.0	11 in 8	3,100g	52mm
600mm f/4D	Nov 1996	4.0 – 22.0	10 in 7	5,900g	52mm
500mm f/4D	Jun 1997	4.0 – 22.0	11 in 9	3,800g	52mm
400mm f/2.8D	Jun 1998	2.8 – 22.0	11 in 9	4,800g	52mm
80–200mm Zoom	Dec 1998	2.8 – 22.0	18 in 14	1,580g	77mm
28–70mm Zoom	Mar 1999	2.8 – 22.0	15 in 11	935g	77mm
17–35mm Zoom	Sep 1999	2.8 – 22.0	13 in 10	745g	77mm
300mm f/4D	Feb 2001	4.0 – 32.0	10 in 6	1,440g	77mm
300mm f/2.8D II	Mar 2001	2.8 – 22.0	11 in 8	2,560g	52mm
500mm f/4D II	Jul 2001	4.0 – 22.0	11 in 9	3,430g	52mm
400mm f/2.8D II	Aug 2001	2.8 – 22.0	11 in 9	4,440g	52mm
600mm f/4D II	Aug 2001	4.0 – 22.0	10 in 7	4,750g	52mm
24–85mm Zoom	Jun 2002	3.5 – 22.0	15 in 12	400g	67mm
70–200mm Zoom	Mar 2003	2.8 – 22.0	21 in 15	1,470g	77mm
24–120mm Zoom	Jun 2003	3.5 – 22.0	15 in 13	575g	72mm
200–400mm Zoom	Feb 2004	4.0 – 32.0	24 in 17	1,360g	77mm
200mm f/2G	Sep 2004	2.0 – 22.0	13 in 9	2,900g	52mm
300mm f/2.8G	Jan 2005	2.8 – 22.0	11 in 8	2,870g	52mm

TYPE	INTRODUCED	PRICE (YEN)	TYPE	INTRODUCED	PRICE (YEN)
200mm f/2G ED VR (IF)	2004	680,000	*Zoom lenses*		
300mm f/2.8D ED (IF)	1996	600,000	17–35mm f/2.8D ED (IF)	1999	230,000
300mm f/2.8D ED (IF) II	2001	600,000	24–85mm f/3.5–4.5G ED (IF)	2002	57,000
300mm f/2.8G ED VR (IF)	2005	680,000	24–120mm f/3.5–5.6G ED VR (IF)	2003	94,000
300mm f/4D ED (IF)	2001	163,000	28–70mm f/2.8D ED (IF)	1999	220,000
400mm f/2.8D ED (IF)	1998	1,200,000	70–200mm f/2.8G ED VR (IF)	2003	270,000
400mm f/2.8D ED (IF) II	2001	1,120,000	80–200mm f/2.8D ED (IF)	1998	245,000
500mm f/4D ED (IF)	1997	980,000	200–400mm f/4G ED VR (IF)	2004	980,000
500mm f/4D ED (IF) II	2001	960,000			
600mm f/4D ED (IF)	1996	1,200,000			
600mm f/4D ED (IF) II	2001	1,200,000			

NOTE TO TABLE: The price listed is usually that quoted at the time of home market introduction. The Mark II generation of AF-S lenses was available in light grey or black, as were the 28–70mm, 70–200mm and 80–200mm f/2.8 zooms, and the 300mm f/4 telephoto. The original 300mm and 400mm f/2.8 telephoto lenses could also be specified in both colours.

'IX' series

TYPE	INTRODUCED	APERTURE RANGE	ELEMENTS/GROUPS	WEIGHT	FILTER SIZE
20–60mm Zoom	Dec 1996	3.5 – 22.0	9 in 7	170g	52mm
24–70mm Zoom	Dec 1996	3.5 – 22.0	7 in 7	170g	52mm
60–180mm Zoom	Dec 1996	4.0 – 32.0	11 in 8	270g	52mm
30–60mm Zoom	Sep 1998	4.0 – 22.0	6 in 6	95g	46mm
60–180mm Zoom	Sep 1998	4.5 – 32.0	10 in 7	220g	46mm
20–60mm Zoom	Nov 1998	3.5 – 22.0	9 in 7	170g	52mm

TYPE	INTRODUCED	PRICE (YEN)
20–60mm f/3.5–5.6	1996	51,000
20–60mm f/3.5–5.6 (New)	1998	38,000
24–70mm f/3.5–5.6	1996	24,000
30–60mm f/4–5.6	1998	20,000
60–180mm f/4–5.6	1996	32,000
60–180mm f/4.5–5.6	1998	28,000

NOTE TO TABLE: The price listed is usually that quoted at the time of home market introduction. The three original lenses were finished in black, while the later variants came in silver.

'DX' series

TYPE	INTRODUCED	APERTURE RANGE	ELEMENTS/GROUPS	WEIGHT	FILTER SIZE
12–24mm Zoom	Jun 2003	4.0 – 22.0	11 in 7	465g	77mm
10.5mm f/2.8G	Nov 2003	2.8 – 22.0	10 in 7	305g	–
18–70mm Zoom	Mar 2004	3.5 – 22.0	15 in 13	390g	67mm
17–55mm Zoom	Jun 2004	2.8 – 22.0	14 in 10	755g	77mm
55–200mm Zoom	Jun 2005	4.0 – 22.0	13 in 9	255g	52mm
18–55mm Zoom	Oct 2005	3.5 – 22.0	7 in 5	210g	52mm

TYPE	INTRODUCED	PRICE (YEN)
10.5mm f/2.8G ED Fisheye	2003	98,000
Zoom lenses		
AF-S 12–24mm f/4G ED (IF)	2003	162,000
AF-S 17–55mm f/2.8G ED (IF)	2004	220,000
AF-S 18–55mm f/3.5–5.6G ED	2005	30,000
AF-S 18–70mm f/3.5–4.5G ED (IF)	2004	56,000
AF-S 55–200mm f/4–5.6G ED	2005	40,000

NOTE TO TABLE: The price listed is usually that quoted at the time of home market introduction. The 18–55mm and 55–200mm zooms were available in silver or black.

AF Teleconverters

TYPE	FACTOR VALUE	INTRODUCED	ELEMENTS/GROUPS	WEIGHT	PRICE (YEN)
TC-14E (AF-I)	1.4×	Mar 1993	5 in 5	200g	62,000
TC-14E II (AF-S)	1.4×	Jun 2001	5 in 5	200g	50,000
TC-16S (F3 AF)	1.6×	Apr 1984	5 in 5	285g	58,000
TC-16AS (AF)	1.6×	Apr 1986	5 in 5	150g	29,000
TC-17E II (AF-S)	1.7×	Jul 2004	7 in 4	250g	50,000
TC-20E (AF-I)	2×	Mar 1993	7 in 6	355g	62,000
TC-20E II (AF-S)	2×	Jun 2001	7 in 6	355g	50,000

SPEEDLIGHT REVIEW

This section looks at all the flashguns produced for the Nikon series, going back to the days of the basic models sold with the early rangefinders, and following their progress through to the technical marvels of today.

BC series

MODEL	INTRODUCED
BCB	Dec 1950
BCB I	Jul 1951
BCB II	Jul 1952
BC III	Nov 1954
BC IV	Oct 1955
BC V	Jul 1957
BC-6	Jun 1961
BC-7	Jul 1965

The BC V witnessed the change from Roman to Arabic numerals, becoming the BC-5 after the introduction of the Nikon F. From this date onwards, all flash units were given codes using Arabic numbers.

SB series

MODEL	INTRODUCED	MODEL	INTRODUCED
SB-1	Feb 1969	SB-21A	Oct 1986
SB-2	Dec 1972	SB-21B	Oct 1986
SB-3	Dec 1972	SB-22	Apr 1987
SB-4	Mar 1974	SB-22S	Aug 1998
SB-5	Sep 1975	SB-23	Mar 1988
SB-6	Feb 1978	SB-24	Jun 1988
SB-7	Jun 1977	SB-25	Oct 1992
SB-8	Jun 1977	SB-26	Oct 1994
SB-9	Jun 1977	SB-27	Sep 1995
SB-10	Apr 1978	SB-28	Nov 1997
SB-11	Mar 1980	SB-28DX	Sep 1999
SB-12	Mar 1980	SB-29	Sep 1999
SB-14	Dec 1981	SB-29S	Jun 2002
SB-15	Apr 1982	SB-30	Apr 2002
SB-16A	Apr 1983	SB-50DX	Aug 2001
SB-16B	Apr 1983	SB-80DX	Jun 2002
SB-17	Jun 1983	SB-140	Dec 1985
SB-18	Oct 1983	SB-600	Jun 2004
SB-19	Mar 1984	SB-800	Nov 2003
SB-20	Apr 1986	SB-E	Mar 1980

NOTE TO TABLE: The SB series Speedlights are listed in number order, rather than chronological order. The BC series models were released in a more orderly fashion.

THE NIKONOS SYSTEM

This section looks at the Nikonos bodies, the dedicated lenses, and the underwater flash units produced from 1963 to date.

Nikonos bodies

MODEL	INTRODUCED	PRICE (YEN)	FOCUS SYSTEM	WEIGHT	PRODUCTION ENDED	SERIAL NUMBERS
Nikonos	Aug 1963	28,500	Manual	495g	1968	900001–
Nikonos II	May 1968	35,000	Manual	540g	1975	960001–
Nikonos III	Jun 1975	60,000	Manual	620g	1980	3100001–
Nikonos IV-A	Jul 1980	54,500	Manual	740g	1984	4100001–
Nikonos V	Apr 1984	73,000	Manual	700g	2001	3070001–
Nikonos RS	Jun 1992	390,000	AF	2,130g	1996	0000001–

The price is for a body only from the Nikonos IV-A onwards, quoted at the time of home market introduction. The earlier Calypso-type models came with a 35mm f/2.5 lens included in the price.

Nikonos lenses

MODEL	INTRODUCED	PRICE (YEN)	ELEMENTS/GROUPS	APERTURE RANGE	WEIGHT	SERIAL NUMBERS
W-35mm f/2.5	Aug 1963	18,000	6 in 4	2.5 – 22.0	160g	180001–
UW-28mm f/3.5	Jul 1965	38,000	6 in 5	3.5 – 22.0	175g	100001–
80mm f/4	Apr 1969	38,000	4 in 4	4.0 – 22.0	275g	100001–
UW-15mm f/2.8	Jun 1972	164,000	9 in 5	2.8 – 22.0	320g	150001–
UW-15mm f/2.8N	Jun 1982	196,000	12 in 9	2.8 – 22.0	665g	200001–
LW-28mm f/2.8	Sep 1983	30,000	5 in 5	2.8 – 22.0	240g	280001–
UW-20mm f/2.8	Jul 1985	77,000	9 in 7	2.8 – 22.0	340g	200001–
R-UW AF 28mm f/2.8	Jun 1992	98,000	6 in 6	2.8 – 22.0	550g	200001–
R-UW AF Micro 50mm f/2.8	Jun 1992	165,000	10 in 9	2.8 – 22.0	1,100g	300001–
R-UW AF 20–35mm f/2.8	Jun 1992	410,000	10 in 10	2.8 – 22.0	1,750g	400001–
R-UW AF 13mm f/2.8	Jun 1994	240,000	10 in 7	2.8 – 22.0	970g	200001–

The Nikonos lenses are listed in release order only, as there are so few. The price reflects that at the time of home market introduction, the latter being noted in the second column.

Nikonos flash units

MODEL	INTRODUCED	PRICE (YEN)
Model P	Sep 1963	13,800
UWFU	Dec 1976	29,000
SB-101	Jul 1980	69,000
SB-102	Jul 1984	135,000
SB-103	Oct 1984	69,000
SB-104	Jun 1992	153,000
SB-105	Nov 1994	75,000

MODERN POCKET CAMERAS

The list has been compiled in chronological order, with the date of introduction
based on the Japanese sales date rather than the time of a camera's announcement.

MODEL	US NAME	INTRODUCED	PRICE (YEN)	LENS TYPE
L35AF	–	Mar 1983	42,800	35mm f/2.8
L35AD	–	Sep 1983	47,800	35mm f/2.8
L135AF	Nice-Touch	Mar 1984	34,800	35mm f/3.5
L35AF2	One-Touch	Sep 1985	42,800	35mm f/2.8
L35AD2	One-Touch QD	Sep 1985	47,800	35mm f/2.8
L35AWAF	Action-Touch	Apr 1986	49,800	35mm f/2.8
L35AWAD	Action-Touch QD	Apr 1986	54,800	35mm f/2.8
L35TWAF	Tele-Touch	Apr 1986	52,800	38/65mm f/3.5/5.6
L35TWAD	Tele-Touch QD	Apr 1986	57,800	38/65mm f/3.5/5.6
AF3	One-Touch	Mar 1987	Export	35mm f/2.8
AD3	One-Touch QD	Mar 1987	43,000	35mm f/2.8
RF	Fun-Touch	Mar 1987	Export	35mm f/3.5
RD	Fun-Touch QD	Mar 1987	33,500	35mm f/3.5
TW2	Tele-Touch DL	Oct 1987	Export	35/70mm f/3.5/6.8
TW2D	Tele-Touch DL Date	Oct 1987	52,000	35/70mm f/3.5/6.8
RF2	One-Touch 100	Oct 1988	Export	35mm f/3.5
RD2	One-Touch 100 QD	Oct 1988	33,500	35mm f/3.5
TW Zoom	–	Oct 1988	Export	35–80mm f/3.5–7.8
TW Zoom QD	Zoom-Touch 500	Oct 1988	59,000	35–80mm f/3.5–7.8
TW20	Tele-Touch 300	Apr 1989	Export	35/55mm f/3.8/5.7
TW20 QD	Tele-Touch 300 Date	Apr 1989	40,000	35/55mm f/3.8/5.7
TW Zoom 35–70	Zoom-Touch 400	Oct 1990	Export	35–70mm f/4–7.6
TW Zoom 35–70 QD	Zoom-Touch 400 QD	Oct 1990	48,000	35–70mm f/4–7.6
TW Zoom 35–80	Zoom-Touch 500S	Mar 1991	Export	35–80mm f/3.5–7.8
TW Zoom 35–80 QD	Zoom-Touch 500S QD	Mar 1991	58,000	35–80mm f/3.5–7.8
W35	One-Touch 200	Sep 1991	Export	35mm f/3.5
W35 QD	One-Touch 200 QD	Sep 1991	27,000	35mm f/3.5
TW Zoom 105	Zoom-Touch 800	Mar 1992	Export	37–105mm f/3.7–9.9
TW Zoom 105 World Time	Zoom-Touch 800 WT	Mar 1992	64,000	37–105mm f/3.7–9.9
RF10	Smile Taker	Mar 1992	Export	34mm f/4.5
AW35	Sport-Touch	Jun 1992	Export	35mm f/3.5
AW35 QD	Sport-Touch QD	Jun 1992	34,000	35mm f/3.5

MODEL	US NAME	INTRODUCED	PRICE (YEN)	LENS TYPE
TW Zoom 85	Zoom-Touch 600	Sep 1992	Export	32–85mm f/4.5–11
TW Zoom 85 QD	Zoom-Touch 600 QD	Sep 1992	46,000	32–85mm f/4.5–11
Zoom 100	Zoom-Touch 470	Mar 1993	Export	35–70mm f/4–7.6
Zoom 100 QD	Zoom-Touch 470QD	Mar 1993	37,000	35–70mm f/4–7.6
AF600	Lite-Touch	Mar 1993	Export	28mm f/3.5
AF600 QD	Lite-Touch QD	Mar 1993	37,000	28mm f/3.5
AF200	Fun-Touch 2	May 1993	18,500	34mm f/4.5
EF100	Nice-Touch 2	May 1993	12,000	35mm f/4.5
35Ti	–	Dec 1993	125,000	35mm f/2.8
Zoom 300	Lite-Touch Zoom	Feb 1994	Export	35–70mm f/3.5–6.5
Zoom 300 QD	Lite-Touch Zoom QD	Feb 1994	46,000	35–70mm f/3.5–6.5
Zoom 700 VR	Zoom-Touch 105VR	Apr 1994	Export	38–105mm f/4–7.8
Zoom 700 VR QD	Zoom-Touch 105VR QD	Apr 1994	68,000	38–105mm f/4–7.8
AF400	One-Touch 300	Apr 1994	Export	31mm f/4
AF400 QD	One-Touch 300 QD	Apr 1994	Export	31mm f/4
AF210	Fun-Touch 3	Apr 1994	Export	32mm f/4.5
Zoom 60	–	May 1994	Export	35–60mm f/5.7–9.3
28Ti	–	Sep 1994	135,000	28mm f/2.8
Zoom 60S	Nice-Touch Zoom	Feb 1995	Export	35–60mm f/5.7–9.3
Zoom 310	Lite-Touch Zoom 70	Feb 1995	Export	35–70mm f/3.5–6.5
Zoom 310 QD	Lite-Touch Zoom 70 QD	Feb 1995	37,000	35–70mm f/3.5–6.5
Zoom 500	Lite-Touch Zoom 105	Feb 1995	Export	38–105mm f/3.5–9.2
Zoom 500 QD	Lite-Touch Zoom 105 QD	Feb 1995	49,000	38–105mm f/3.5–9.2
Zoom 200	One-Touch Zoom	Feb 1995	Export	38–70mm f/4.7–8
Zoom 200 QD	One-Touch Zoom QD	Feb 1995	18,500	38–70mm f/4.7–8
EF200	Nice-Touch 3	Mar 1995	Export	31mm f/5.6
AF220	Fun-Touch 4	Sep 1995	Export	29mm f/4.5
Nuvis Mini	–	Apr 1996	Export	25mm f/4
Nuvis Mini i	–	Apr 1996	30,000	25mm f/4
Nuvis 75	–	Apr 1996	Export	30–60mm f/4.5–8.5
Nuvis 75i	–	Apr 1996	30,000	30–60mm f/4.5–8.5
Nuvis 125	–	Jul 1996	Export	30–100mm f/4.3–9.2
Nuvis 125i	–	Jul 1996	38,000	30–100mm f/4.3–9.2
Nuvis 60	–	Oct 1996	Export	25–50mm f/9.5
Nuvis 60 QD	–	Oct 1996	Export	25–50mm f/9.5
Nuvis A20	–	Feb 1997	Export	25mm f/5.6
Nuvis A20 QD	–	Feb 1997	Export	25mm f/5.6
Nuvis E10	–	Feb 1997	Export	25mm f/5.6
Nuvis E10 QD	–	Feb 1997	Export	25mm f/5.6
AF230	Fun-Touch 5	Jul 1997	Export	29mm f/4.5
AF230 QD	Fun-Touch 5 QD	Jul 1997	Export	29mm f/4.5
EF300	Nice-Touch 4	Jul 1997	Export	29mm f/4.5
Nuvis 110i	–	Sep 1997	Open	30–85mm f/3.8–9.5
Nuvis 160i	–	Nov 1997	50,000	30–125mm f/4.3–9.7
Zoom 210	One-Touch Zoom 70	Nov 1997	Export	38–70mm f/4.7–8
Zoom 210 QD	One-Touch Zoom 70 QD	Nov 1997	Export	38–70mm f/4.7–8
BF100	–	Dec 1997	Export	34mm f/4.5

MODEL	US NAME	INTRODUCED	PRICE (YEN)	LENS TYPE
BF100 QD	–	Dec 1997	Export	34mm f/4.5
Zoom 800	–	May 1998	Export	38–130mm f/4.5–9.5
Zoom 800 QD	–	May 1998	Export	38–130mm f/4.5–9.5
Zoom 400	Lite-Touch 80	Aug 1998	Export	38–80mm f/5–9.6
Zoom 400 QD	Lite-Touch 80 QD	Aug 1998	31,000	38–80mm f/5–9.6
Zoom 600	Lite-Touch 110	Aug 1998	Export	38–110mm f/4–10.8
Zoom 600 QD	Lite-Touch 110 QD	Aug 1998	37,000	38–110mm f/4–10.8
Nuvis S	–	Dec 1998	50,000	22.5–66mm f/5.2–7.5
AF240SV	Fun-Touch 6	May 1999	Export	28mm f/5.6
AF240SV QD	Fun-Touch 6 QD	May 1999	Export	28mm f/5.6
EF400SV	Nice-Touch 5	May 1999	Export	28mm f/5.6
EF400SV QD	Nice-Touch 5 QD	May 1999	Export	28mm Ff/.6
Nuvis 200	–	Jun 1999	30,000	24–48mm f/4.5–8.4
Nuvis 300	–	Sep 1999	45,000	28–80mm f/4.2–11
Lite-Touch Zoom 70W	–	Jan 2000	Export	28–70mm f/5.6–10
Lite-Touch Zoom 70W QD	–	Jan 2000	Export	28–70mm f/5.6–10
One-Touch Zoom 90	–	Jan 2000	Export	38–90mm f/4.8–10.5
One-Touch Zoom 90 QD	–	Jan 2000	Export	38–90mm f/4.8–10.5
Nuvis S 2000	–	Mar 2000	40,000	24–48mm f/4.5–8.2
Nuvis V	–	Sep 2000	43,000	22.5–66mm f/5.2–7.7
Lite-Touch Zoom 120ED	–	Sep 2000	Export	38–120mm f/5.3–10.5
Lite-Touch Zoom 120ED QD	–	Sep 2000	48,000	38–120mm f/5.3–10.5
Lite-Touch Zoom 140ED	–	Jul 2001	Export	38–140mm f/5.3–10.5
Lite-Touch Zoom 140ED QD	–	Jul 2001	52,000	38–140mm f/5.3–10.5
One-Touch Zoom 90S	–	Mar 2002	Export	38–90mm f/4.8–10.5
One-Touch Zoom 90S QD	–	Mar 2002	Export	38–90mm f/4.8–10.5
AF250SV	–	May 2002	Export	28mm f/5.6
AF250SV QD	–	May 2002	Export	28mm f/5.6
EF500SV	–	May 2002	Export	28mm f/5.6
EF500SV QD	–	May 2002	Export	28mm f/5.6
Lite-Touch Zoom 70WS	–	Jul 2002	Export	28–70mm f/5.6–10
Lite-Touch Zoom 70WS QD	–	Jul 2002	30,000	28–70mm f/5.6–10
Lite-Touch Zoom 110S	–	Sep 2002	Export	38–110mm f/4.5–11.9
Lite-Touch Zoom 110S QD	–	Sep 2002	33,000	38–110mm f/4.5–11.9
Lite-Touch Zoom 130ED	–	Sep 2002	Export	38–30mm f/5.3–10.5
Lite-Touch Zoom 130ED QD	–	Sep 2002	50,000	38–130mm f/5.3–10.5
Lite-Touch Zoom 150ED	–	Jan 2003	Export	38–150mm f/5.4–12.7
Lite-Touch Zoom 150ED QD	–	Jan 2003	53,000	38–150mm f/5.4–12.7
Lite-Touch Zoom 100W	–	Apr 2003	Export	28–100mm f/5.8–10.5
Lite-Touch Zoom 100W QD	–	Apr 2003	Open	28–100mm f/5.8–10.5

NOTE TO TABLE: While most countries offered a standard and QD version of each compact camera, the Japanese market tended to sell only the QD models. Several colour options were available on certain models – *see* text for details. An 'Open' price allows the dealers to set the selling price based on their cost (as such, there is no RRP).

THE COOLPIX RANGE

The list has been compiled in chronological order, with the date of introduction
based on the Japanese sales date rather than the time of a camera's announcement.

MODEL	INTRODUCED	PRICE (YEN)	LENS TYPE	SILVER/BLACK
100	Jan 1997	59,800	6.2mm f/4	Black
300	Jun 1997	84,000	6.2mm f/4	Black
900	Apr 1998	110,000	5.8–7.4mm f/2.4–3.6	Silver
600	May 1998	74,000	5mm f/2.8	Silver
910/900S	Oct 1998	99,800	5.8–17.4mm f/2.4–3.6	Silver
950	Mar 1999	125,000	7–21mm f/2.6–4	Black
700	Mar 1999	87,000	6.5mm f/2.6	Black
800	Nov 1999	89,000	7–14mm f/3.5–4.8	Black
990	Apr 2000	125,000	8–24mm f/2.5–4	Black
880	Sep 2000	88,000	8–20mm f/2.8–4.2	Both
995	Jun 2001	113,000	8–32mm f/2.6–5.1	Black
775	Sep 2001	72,000	5.8–17.4mm f/2.8–4.9	Silver
885	Oct 2001	92,000	8–24mm f/2.8–4.9	Both
5000	Dec 2001	150,000	7.1–21.4mm f/2.8–4.8	Black
2500	Mar 2002	57,000	5.6–16.8mm f/2.7–4.8	Silver
2000	Jun 2002	45,000	5.8–17.4mm f/2.8–4.9	Silver
4500	Jun 2002	105,000	7.8–32mm f/2.6–5.1	Black
5700	Jun 2002	162,000	8.9–71.2mm f/2.8–4.2	Black
4300	Sep 2002	87,000	8–24mm f/2.8–4.9	Both
3500	Nov 2002	72,000	5.6–16.8mm f/2.7–4.8	Silver
3100	Mar 2003	Open	5.8–17.4mm f/2.8–4.9	Silver
2100	Mar 2003	Open	4.7–14.1mm f/2.6–4.7	Silver
SQ	Jun 2003	Open	5.6–16.8mm f/2.7–4.8	Silver
5400	Jun 2003	Open	5.8–24mm f/2.8–4.6	Black
3700	Dec 2003	Open	5.4–16.2mm f/2.8–4.9	Silver
3200	Feb 2004	Open	5.8–17.4mm f/2.8–4.9	Silver
8700	Feb 2004	Open	8.9–71.2mm f/2.8–4.2	Black
2200	Mar 2004	Open	4.7–14.1mm f/2.6–4.7	Silver
5200	Jun 2004	Open	7.8–23.4mm f/2.8–4.9	Silver
4200	Jun 2004	Open	7.8–23.4mm f/2.8–4.9	Silver
4100	Jul 2004	Open	5.8–17.4mm f/2.8–4.9	Silver
8400	Oct 2004	Open	6.1–21.6mm f/2.6–4.9	Black

MODEL	INTRODUCED	PRICE (YEN)	LENS TYPE	SILVER/BLACK
4800	Nov 2004	Open	6–50mm f/2.7–4.4	Silver
8800VR	Nov 2004	Open	8.9–89mm f/2.8–5.2	Black
5900	Feb 2005	Open	7.8–23.4mm f/2.8–4.9	Silver
5600	Feb 2005	Open	5.7–17.1mm f/2.9–4.9	Silver
7900	Mar 2005	Open	7.8–23.4mm f/2.8–4.9	Both
S1	Apr 2005	Open	5.8–17.4mm f/3–5.4	Both
7600	Apr 2005	Open	7.8–23.4mm f/2.8–4.9	Silver

With regard to the finish, most cameras came in black or silver, although highlighted features gave further colour variations. The recent 3200, 4100 and 5600 models were silver based, but came with a variety of body colours to appeal to a wider audience; the 5200 was also available in blue, while the 7900 could be bought in red, and the S1 in white, in addition to black and silver. An 'Open' price allows the dealers to set the selling price based on their cost (as such, there is no RRP).

INDEX

Nippon Kogaku, the Nikon Corporation and its subsidiaries are mentioned throughout the book.